EXILES, DIASPORAS & STRANGERS

ANNOTATING ART'S HISTORIES

EXILES, DIASPORAS & STRANGERS

EDITED BY KOBENA MERCER

Iniva
(Institute of International Visual Arts)

The MIT Press
Cambridge, Massachusetts
London, England

Copublished by Iniva (Institute of International
Visual Arts) and The MIT Press

ISBN: 978-1-899846-45-0 (Iniva)
ISBN: 978-0-262-63358-1 (The MIT Press)

A catalogue record of this book is available from
the British Library

Library of Congress Cataloging-in-Publication Data

Mercer, Kobena, 1960—
Exiles, diasporas & strangers / Kobena Mercer.
 p. cm. — (Annotating art's histories : cross-cultural
 perspectives in the visual arts)
 Includes bibliographical references.
 ISBN 978-0-262-63358-1 (pbk. : alk. paper)
 1. Art and globalization. 2. Culture and globalization. 3.
Modernism (Art)—Cross-cultural studies. I. Title
N72.G55M47 2008
709—dc22
 2007031409

10 9 8 7 6 5 4 3 2 1

Editor: Kobena Mercer
Coordinating Editor: Rebecca Wilson
Copyeditor: Linda Schofield
Designed by Untitled
Production coordinated by
Uwe Kraus GmbH
Printed in Italy
3000 copies printed, 2007

Front cover (detail) and back cover:
Zarina Bhimji, 35mm transparency
from her notebook, 1990
Two transparencies: colour and black and white,
© Zarina Bhimji
Courtesy of the artist

Supported by The Getty Foundation

To find out more about Iniva publications or to place
an order, please contact:

Iniva (Institute of International Visual Arts)
Rivington Place
London EC2A 3BA
UK
Tel +44 20 7729 9616
Fax +44 20 7729 9509
Email booksales@iniva.org
www.iniva.org

MIT Press books may be purchased at special quantity
discounts for business or sales promotional use. For
information, please email special_sales@mitpress.mit.edu
or write to Special Sales Department, The MIT Press,
55 Hayward Street, Cambridge, MA 02142.

CONTENTS

EXILES, DIASPORAS
& STRANGERS

INTRODUCTION
KOBENA MERCER

Migration throws objects, identities and ideas into flux. It has been a defining feature of modernity yet remains only hazily understood as a significant factor in numerous 20th-century artistic formations. Taking account of life-changing journeys that transplanted artists and intellectuals from one cultural context to another, this collection sharpens distinctions between emigration and immigration, between notions of 'the stranger' and 'the other', and between experiences of exile and diaspora so as to deepen our understanding of the critical and creative role of estrangement and displacement in the story of modernism and modern art as a whole.

Migration is today a pressing concern in an era of globalisation characterised by the rapid pace of modernisation in countries such as India and China and the rise of supra-national entities such as the European Union. The art world registers the impact of such trends through the heightened attention now given to difference and diversity in the international art market and the official policies of public institutions, but what often arises is a largely de-historicised outlook that tends to identify cross-cultural aspects of the visual arts with the limited shelf-life of 'the contemporary'. Offering a broad chronological coverage that spans the previous century, the focal points of historical investigation brought together in this collection challenge such myopic viewpoints. Examining specific locales that have generated distinctive variants in the global unfolding of 20th-century art, these critical historical perspectives modify the standard narrative of art since 1900 by revealing the vertiginous consequences of travel and migration as persistently recurring factors in the visual arts of modernity.

From the inventive use of imported materials in 1920s Nigerian architecture to émigré European mentors and their relationships with Native North American artists, we find that colonial encounters created multiple trajectories in which cultural elements were loosened and detached from indigenous traditions and set into motion across a network of travelling cultures. Cutting through conventional timelines, the emergence of Aboriginal modernism in central Australia testifies to the brutal violence of territorial expropriation and enforced 'internal' migration, from the 1890s to as recently as the 1970s, while also demonstrating multidirectional patterns of counter-appropriation that renewed ancestral mark-making in the medium of stretched canvas and acrylic paint. The displacement of Central European artists and scholars seeking refuge from totalitarianism at mid-century has long held a central place in accounts of the institutional support that modernism received in the United States, but this episode takes on further ramifications once it is emplotted into a more holistic understanding of the traumatic journeys that criss-crossed the globe during the era of modernist internationalism. Where migration and travel alter the outlook of the traveller and diversify the metropolitan environments in which relocated communities make their homes, the assumption that the nation-state is merely a neutral 'container' for artistic and cultural production is cast into doubt. Seen in this light, previously minor strands in the received account of modernism and post-modernism, such as African American aesthetics or 'black' British art practices of the 1980s, do not simply demand a more inclusive narrative but a comprehensive re-conceptualisation of the analytical tools through which the objects and materials of art historical study are examined and interpreted.

Casting a glance over the art world's acceptance of 'difference' over the past 15 years, Jean Fisher and Gerardo Mosquera introduce their 2004 anthology, *Over Here: International Perspectives on Art and Culture*, by observing that, 'if the exile was the figure of early modernity, the diasporean or immigrant was the figure of postmodernity with its decentred and deterritorialised subject.'[1] When they ask, however, if contemporary art world politics has actually changed as a result of debates initiated by the post-colonial turn, their concerns point towards a paradox. The gate-keeping exclusions once dictated by the high modernist canon are acknowledged by contemporary critics, and contemporary curators have aimed to rectify previous imbalances by showcasing the geographical diversity of their choices, but the notion of 'parallel histories' that often surfaces in current discussions of global art is highly misleading because it creates an illusion of historical knowledge without the support of archival evidence. Where the laws of geometry hold that parallel lines never intersect, it is precisely the mutual entanglement of western and non-western practices that the Annotating Art's Histories series has set out to address by adopting thematic and topic-based approaches that enhance our understanding in incremental steps. The research perspectives brought together in this series assemble a body of scholarship whose insights disclose the 'slow time' in which art's intelligence unfolds, thereby revealing how more a nuanced understanding of the shared historical past enriches the aesthetic experience of individual works and oeuvres that were previously overlooked. Certain keywords in cultural theory, such as 'nomadism', may have passed through the fashion-cycle that frames our immediate sense of contemporaneity, but it should be noted that art history is only now coming to terms with questions and problematics around exile, migration and diaspora that initially came to light in the fields of literary criticism and cultural studies rather than the visual arts as such.

Describing it as 'the unhealable rift forced between a human being and a native place, between the self and its true home', Edward Said made an important distinction in his 'Reflections on Exile' (1984) between the romantic view of exile as embodied by the solitary 'flaneur' or the existential 'outsider' and the depersonalised scale of the mass migrations brought about by modern warfare and nationalist turmoil after 1945. Underscoring this dialectic between nationalism and exile, he stressed how the yearning for a 'homeland' may result, on the one hand, in a resentment that drives a redemptive quest to reclaim national sovereignty, but on the other hand, when exile leads to a sceptical view of patriotism, it may result in a decision to act 'as if one were at home wherever one happens to be.'[2] Building on George Steiner's thesis in *Extraterritorial* (1971), which argued that the modernism of such writers as Joseph Conrad, James Joyce and Samuel Beckett was shaped by an exile's awareness of two or more 'national' languages, thereby 'de-naturalising' the medium of linguistic signification,[3] Said added a testimonial account of the personal and political predicament of 'unbelonging' that arises when individuals and groups are uprooted from their formative attachments and loyalties. Where exiled identities are formed in an ex-centric relationship to the bonds of citizenship ordinarily conferred by the nation-state, deciding to act as a world citizen or cosmopolitan has the potential to de-naturalise the symbolic authority of *patria* or

Next page:
Alighiero e Boetti,
*Mappa del Mondo
(Map of the World)*, 1989

nationality. Drawing attention to the lived experiences that differentiate post-colonial perspectives on exile from modernist themes of anomie and alienation, Said foregrounded a multi-perspectival outlook in which: 'Seeing "the entire world as a foreign land" makes possible originality of vision. Most people are principally aware of one culture, one setting, one home; exiles are aware of at least two, and this plurality of vision gives rise to an awareness of simultaneous dimensions, an awareness that – to borrow a phrase from music – is *contrapuntal.*' [4]

Alongside the 'invention of tradition' thesis that also de-naturalised national identities by demonstrating how the cultural production and arrangement of material artefacts, including museum collections and public memorials, supported political mythologies of cultural homogeneity, Said's overall method of approach touched upon historical differences in the manner with which immigration has been addressed.[5] Whereas the policy ideal of assimilation underpinned the notion of the US as a 'melting pot' – a phrase derived from a 1908 Broadway play written by Israel Zangwill, an English Jew who immigrated to New York [6] – the demands of reconstruction in post-war Europe that encouraged labour migrations among formerly colonised subjects coincided with the dismantling of imperialism after World War II and in the British context this led to a reaction in which 'race' and immigration were conflated with the perceived threat of an 'alien culture'. It is worth noting that while the impact of ex-colonial immigration was readily acknowledged in literature and cinema, it was through the medium of documentary photography that such issues entered the visual arts. *A Seventh Man* (1975), by critic and novelist John Berger, provides a case in point.

Collaborating with photographer Jean Mohr to document the experiences of Turkish and Moroccan guest-workers in Germany, Berger's prose evoked a condition of transient anonymity by referring to his protagonist simply as 'He'.[7] Examining this attempt to loosen the binary terms of host/guest and native/foreigner in the discourse on immigration, theorist Nikos Papastergiadis suggests in *Modernity as exile: The Stranger in John Berger's writing* (1993), that such ambiguities of identity and identification enacted a late-modernist authorial strategy in which, 'Through his representation of the migrant, it is Berger who becomes the stranger.' [8]

As post-colonial studies emphasised a constructionist rather than reflectionist account of representation, the analysis of 'othering' that employed post-structuralist methods to investigate racism, nationalism and xenophobia cleared the ground for innovative strategies of self-representation among artists whose migrant dislocation placed them in a marginal relationship to the aesthetics and politics of modernism. Although Stuart Hall had addressed the cultural study of diaspora as early as 1975, his critique of essentialist models of blackness in 'New Ethnicities' (1988) and 'Cultural Identity and Diaspora' (1990) was directly informed by the hybrid aesthetics of post-modern practices in film and photography that set out to explore multiple forms of subjectivity hitherto suppressed by the monologic tendencies of cultural nationalism.[9] Adapting the 'imagined communities' thesis to envisage diaspora as a relational network of connective flows that circumvent the sedentary authority of the nation-state, Paul Gilroy's study of popular music was subsequently expanded in his genealogy of pan-Africanism to produce a far-reaching revision of 20th-century culture in

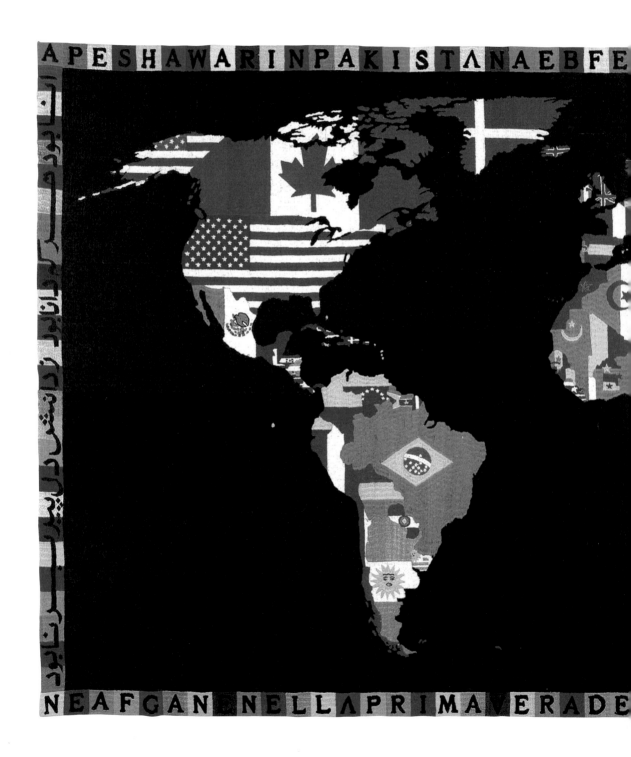

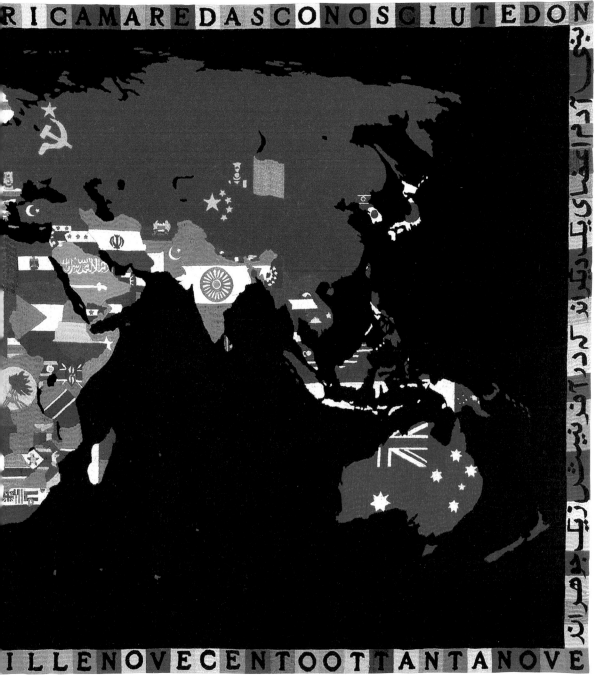

The Black Atlantic: Modernity and Double Consciousness (1993).[10]

Said argued for necessary distinctions among the categories of exile, émigré, expatriate and refugee, emphasising the voluntary character of self-elective migrations in the case of émigrés and expatriates and political factors that prevent return on the part of exiles and refugees. In addition, Gilroy characterised diaspora as the outcome of involuntary movement inaugurated by 'forced dispersal and reluctant scattering' and argued for a definition in which, 'life itself is at stake in the way that the word connotes *flight following the threat of violence* rather than freely chosen experiences of displacement.'[11] Whereas the primal catastrophe that separates a given population from its natal origin was seen in earlier models of diaspora as a tragic loss to be redeemed by the creation of a new nation-state, Gilroy's approach could be described as post-nationalist for in place of the search for unitary 'roots' he explores the various 'routes' by which signifying materials are actively appropriated by choices that create new forms of collective attachment and belonging. While the visual arts are absent from Gilroy's focus, the cultural studies model has influenced interdisciplinary approaches in Rey Chow's *Writing Diaspora* (1993), which addressed Chinese intellectuals in the US, and *The Jew in the Text* (1995) co-edited by Linda Nochlin and Tamar Garb, which included case studies in the field of visual culture.[12]

Across this brief review, what calls for attention is the relative belatedness of art history's engagement with practices that depart from or fall into the interstices of nation-based mappings of the modern artistic imagination. The paradigm shifts that have de-naturalised the received forms in which national belonging is constructed and

contested are indeed of highly recent provenance, but in seizing the opportunity to historicise the analytical methods made available by such conceptual developments, *Exiles, Diasporas & Strangers* goes beyond the merely illustrative correlation between visual materials and the abstract claims of 'theory' so as to explore instead the ways in which a close-up encounter with the 'otherness' of individual works of art demands a careful adjustment of the methodologies of historical research. In the gap between the moment of artistic creation and the moment of historical understanding, time itself plays an enigmatic role in the aesthetic life of the art object. Produced in numerous variations from 1971 onwards, Alighiero e Boetti's *Mappa del Mondo (Map of the World)* (1989) points up the disjunctive time-keeping whereby a work of art from the (recent) past intuited world-changing transformations that found a matching intellectual vocabulary only with the multi-perspectival shifts brought about by (even more recent) debates on art and globalisation. Embroidered with the participation of Afghani weavers, the work shows each nation represented by its flag, and yet the playful spread of shape and colour belies a global order that was politically vulnerable to constant change, suggesting that the knowledge documented by cartography is inherently contingent and rarely definitive. Where *Mappa*'s aesthetic strategy emerged in the context of an international movement that simultaneously developed across a range of scattered locations, it may be observed that conceptual art signalled a crisis of authority for modernism in the late 1960s, but only in light of such recent exhibitions as *Global Conceptualism: Points of Origin, 1950s–1980s* (1999) has the cross-cultural aspect of its historical formation been illuminated by a comparative approach that also

revises the periodisation of the conceptualist rupture in late 20th-century art.

While the world maps of modern art inherited from the age of Eurocentrism have been thrown off-centre by the post-colonial breakthrough, contributors to this collection take an equally critical stance with regards to the theoreticist drive towards generalisation whereby studies of colonial discourse tend to privilege the analysis of Self and Other as an 'ideal type' in the encounter between different cultural identities. As each chapter deploys critical methods in which the escalating tendencies of free-floating 'theory' are tempered by the empirical specificity of material objects and individual biographies that circulate within a global system of contact and exchange, an alternative cartography arises in response to the question: what would a typology of cross-cultural situations in 20th-century art look like? Demonstrating how these contributions add to the interdisciplinary resources indicated in the bibliography, this introduction outlines the investigative pathways now opened to art historical research as it explores a more intricate understanding of cross-cultural migration as a formative and 'world-making' aspect of modernity manifest in a multiplicity of artistic practices.

Travelling Cultures

Acknowledging scholarly and curatorial initiatives that have de-centred the notion of modernism's singular origin in the West, Ikem Stanley Okoye raises questions about the adequacy of geometric models for understanding the chronological simultaneity of 'future seeking' practices in early 20th-century Nigeria that involved artistic experimentation but eschewed the rhetoric of iconoclasm. Taking the architecture of James Onwudinjo as his focus, and offering a detailed study of the Adinembo House commissioned by a local trader in the coastal city of Okrika circa 1919 and completed between 1924 and 1926, Okoye examines a range of structural and stylistic features that act as a spatial cipher for the inversion of the classical geometry of 'centre' and 'periphery'. Owundinjo's use of reinforced concrete and a flat roof also strikes a double contrast against both the pitched roofs and brickwork associated with British colonialism and the clay and thatch materials of Igbo traditions, underscoring an adaptive usage of modern building technologies in a social environment that was receptive to 'foreign' materials brought into circulation by global trade. Describing how discarded Dutch glass bottles were adapted into the ritual construction of Anyanwu shrines during the preceding decade, Okoye highlights the migratory routes of the 'found object' and the receptivity of the religious milieu in which these secular materials were re-purposed to support indigenous values by virtue of their distinctive colour and luminescence.

Neither preserved in museum collections nor attributed to identifiable authors, objects such as the altar made of gin bottles shown in an archival photograph exist in an ambiguous state of 'unbelonging'. The axiomatic distinction between art and artefact decides whether objects belong to art history or anthropology, but archival ambiguities confound such classificatory separations. In the context of preparations for the Lyon Biennale of 2000, curator Jean-Hubert Martin declined Okoye's suggestion to include a replica of the Anyanwu shrine, even though replicas of lost or damaged works have often received official sanction within the western modernist tradition.

Corner of Georges
Braque's studio, Paris,
c.1914

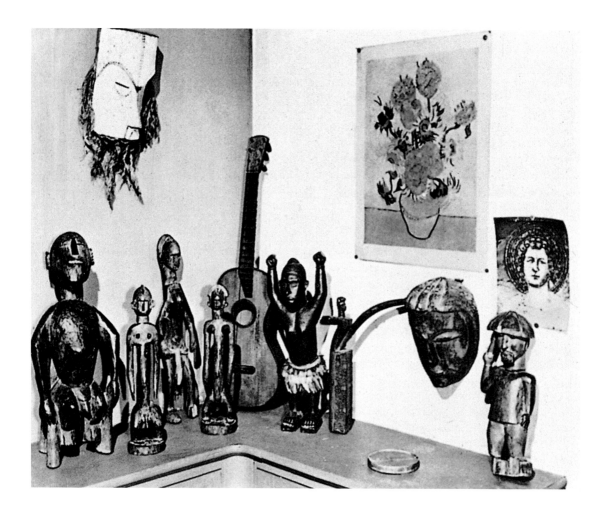

In the face of the entrenched criteria of originality and authenticity that determine the collecting practices of ethnographic and art museums, anomalies thrown up from the archive of global modernity thrust us headlong into the force-field of categorical distinctions that cultural historian James Clifford (1988) addressed in his diagram of the four semantic zones of 'the art and culture system'.

On the basis of an initial vertical opposition between the realm of original and singular 'art' objects as defined by connoisseurship, the art museum and the art market in zone one, and the realm of commercial and mass-produced objects, including commodities, curios, utilities and tourist art, defined as 'not art' in zone two, Clifford describes how the system generates a horizontal polarity in which the material objects created by collective traditions are allocated to museums of history, craft and folklore as 'culture' in zone three, while the fourth zone of 'not culture' includes scientific and technological inventions as well as avant-garde readymades that have the potential to lay bare the inner workings of the system as a whole. Showing how 'most objects – old and new, rare and common, familiar and exotic – can be located in one of these zones or ambiguously, in traffic, between two zones', his diagram demonstrates how 'the system classifies objects … [and] establishes the "contexts" in which they properly belong and between which they circulate.'[13] Laying out the vectors through which objects may be promoted or demoted from one zone to another, Clifford also identifies moments when the circulation of non-western materials is blocked: '…many recent works of tribal art … have largely freed themselves from the tourist or commodity category to which, because of their modernity, purists had often relegated them:

but they cannot move directly into zone one, the art market, without trailing clouds of authentic (traditional) culture. There can be no direct movement from zone four to zone one.'[14]

If the Anyanwu shrine eludes the purist criterion of primitivist 'authenticity' due to its imported materials, its modernity is further blindsided by the fact that unlike the readymades of the European avant-garde, which are housed in collections, it no longer exists as an artefact but only as a spectral trace recorded in a photograph.

Photography is curiously absent from Clifford's account, although it is both an agent of the process of de-contextualisation that uproots the objects of material culture from their embedded 'origins' and a witness to the simultaneity of global modernities. In this respect, it is highly revealing that the photograph documenting a corner of Georges Braque's Paris studio circa 1914 shows numerous tribal artefacts next to a reproduction of Vincent Van Gogh's *Sunflowers* (1888).[15] This contiguity suggests an equivalence between disparate materials brought together by the combined circulatory processes of market exchange and mechanical reproduction. Addressing the relationship of art and photography as one of the defining cultural conditions of modernity, Walter Benjamin took the view that the loss of 'aura' brought about by mass reproduction enabled demystification of the fetishistic logic of value-creation surrounding unique 'masterpieces' in the western canon.[16] Andre Malraux's notion of photography as creating a 'museum without walls' led to a conception of world art that would also transcend ethnocentric parochialism.[17] In view of the historical findings gathered in the *Anthology of African and Indian Ocean Photography* (1998), showing how studio portraiture flourished from the 1880s onwards,

the issues raised in Okoye's account of early Nigerian modernity reiterate a theme that has surfaced in other contributions to this series, namely the important role of photography in both disseminating western ideas and attitudes but also as a means of self-reportage that reveals the world of colonial modernity through indigenous eyes.[18]

Turning to settler societies in Canada and Australia, where interactions among indigenous artists and newly-arrived immigrants took place on the fraught terrain of colonial struggles over the 'ownership' of land, Ruth Phillips and Ian McLean each advance important new additions to the re-thinking of modernist primitivism in light of the post-colonial turn. Where the aesthetics of 'authenticity' positioned the tribal and the modern as mutually exclusive categories in the art and culture system, it foreclosed recognition of modernity as a universal condition that had taken root in diverse cultural locations around the world. The one-sided view of modernity as an 'alien invader' threatening to level or obliterate the cultural differences of non-western traditions (which therefore required paternalist protection) not only harboured proprietorial assumptions about modernism as an exclusive 'possession' of the West, but also erased the agency of adaptation and resistance on the part of the colonised that made the lived experience of colonialism a contradictory phenomenon on all sides. Dismantling the dichotomous extremes of either/or thinking that had regarded the West solely as a corrupting influence which rendered the *modern* artistic expression of native artists 'impure' and 'inauthentic', analytical methods drawn from post-colonial studies cast fresh light on the creative opportunities made possible by the

contradictions of the colonial encounter. Bringing out the historicity of cross-cultural entanglement that was glossed over by modernist primitivism, Phillips and McLean examine the dynamic conditions under which the devastating impact of imperial rule – which made native peoples exiles in their own lands – also gave rise to the counter-discourses of indigenous modernity and Aboriginal modernism.

Drawing attention to the Swedish-American background of Oscar Jacobson in Oklahoma, the Austrian émigré George Swinton in Winnipeg and the Russian-Jewish roots of Joseph Weinstein in Montreal, Phillips observes that their strategic alliances with Kiowa, Inuit and Ojibwa artists were shaped on the grounds of a shared desire to affirm a sense of 'belonging' to the landscape in which they met as strangers. Against the grain of prevailing mythologies of the 'vanishing Indian', which located native expression in the past and assigned it to folk art and ethnography, Jacobson, Swinton and Weinstein engaged in activities that encouraged the recognition of living artists in fine art contexts. Where their intellectual commitment to modernism's universalist ethos was informed by their European art education and cosmopolitan outlook, these 'stranger artists' approached 'primitive art' in cultural rather than solely aesthetic terms, thereby de-naturalising the myth of tribal extinction even as their views were inevitably captive to the ideological horizon of their times. In the contradictory statements Swinton expressed with regards to the Inuit carvings he exhibited in the 1950s, seeing them as a 'swan song' to a way of life now eroded by modernity while bearing witness to organic changes in their stylistic development, Phillips discerns a range of slippages in the discourse of

primitivism that opened a door for indigenous modernists. By enabling economic survival and self-sufficiency, the market in tribal art contributed to conditions in which an artist such as Norval Morrisseau appropriated select modernist influences as a means of continuing shamanistic traditions in an unprecedented hybrid form.

Challenging the simplistic view that market forces can only 'commodify' authentic indigeneity, Ian McLean also questions the notion that modernity entailed the achieved standardisation of western norms: what is missing on both counts is an understanding of the dialectical 'return' whereby resistance and appropriation begin to equivocate the social realities that colonial discourse claims to represent. By tracing the long march of Aboriginal art through colonial modernity, McLean argues that from the point of first contact a willingness to self-modernise activated an aesthetic sensibility in which form, rhythm and colour opened a space of communication between strangers. As missionaries and anthropologists arrived into the desert in the 1890s, carved toas and turingas were adapted from sacred to secular uses by 'outside designs' that sought to educate Kardiya (white men) even as they concealed 'inner secrets' intelligible only to initiates. While satisfying demands for the primitive, such revenue contributed to the Arrernte settlement in Hermannsburg from which the painter Albert Namatjira established himself in the 1930s as a master of the landscape genre. McLean's *White Aborigines: Identity Politics and Australian Art* (1998) explores how settler artists invested the landscape with the politics of national identity formation, and Namatjira's anti-colonial modernism takes on deeper significance once situated in the long-range view that overturns the assumption

that Aboriginal modernism began with the founding of the Papunya Tula company in 1972. The circumstances under which Aboriginal painting entered the international art world in the 1980s are local and specific: by showing why such art could be regarded as 'contemporary' – but not 'modern' – McLean's historicised account offers important implications for methods of critical engagement with cultural difference in art history as a whole.

As these chapters de-familiarise the world picture of 20th-century art, they expand upon the concept of 'travelling cultures' put forward in Clifford's (1990) view of the alternate meanings that the constituent elements of artistic and cultural production acquire as they travel and migrate through settled boundaries of national or ethnic belonging. Attuned to the unpredictable outcomes of encounters that have the potential to alter fixed points of view, this method of approach stands to one side of the identity-driven emphasis on Self and Other. In this sense, it may be argued that the notion of 'the stranger' in the social theory of Georg Simmel (1908) lends itself to the study of cross-cultural situations. Defined not 'as the wanderer who comes today and goes tomorrow, but rather as the man who comes today and stays tomorrow', the stranger's ambivalent position on the borders of group membership led Simmel to evaluate an implicit advantage in the condition of 'unbelonging':

> He is fixed within a certain spatial circle … but his position within it is fundamentally affected by the fact that he does not belong in it initially and that he brings qualities into it that are not, and cannot be, indigenous to it. […] the distance within this relation indicates that one who is close by

is remote, but his strangeness indicates that one who is remote is near.[19]

Simmel's account of 'the formal position of the stranger' – 'the purely mobile person [who] comes incidentally into contact with *every* single element but is not bound up organically, through established ties of kinship, locality, or occupation, with any single one' – identifies two key reasons why this 'social type' is esteemed. One is objectivity, 'an attitude that does not signify mere detachment and nonparticipation, but is a distinct structure composed of nearness and remoteness, indifference and involvement', and the other, 'is that he often receives the most surprising revelations and confidences, at times reminiscent of a confessional, about matters which are kept carefully hidden from everyone with whom one is close.'[20] Adding a sociological dimension to psychoanalytical views of the ambivalent fears and desires inspired by otherness and alterity, Simmel's interest in the stranger's liminal position carries an echo of the poetics of literary *ostranie* or 'estrangement' brought to light in the analysis of avant-garde texts carried out by Russian formalists in the 1920s. If the idea of 'the other' is today overused as a mere synonym for cultural differences, Mikhail Bakhtin's thoughts on the epistemic value of 'outsidedness' are equally apposite:

In order to understand it is immensely important for the person who understands to be *located outside* the object of his or her creative understanding ...It is only in the eyes of *another* culture that foreign culture reveals itself fully and profoundly ... [but] without *one's own* questions one cannot creatively understand anything other or foreign ...

Such a dialogic encounter of two cultures does not result in mixing or merging. Each retains its own unity and *open* totality, but they are mutually enriched.[21]

Time and Trauma

As they fled the terror of totalitarian Europe and entered US universities in the 1940s, émigré art historians brought highly esteemed qualities of philosophical rigour, and their arrival as exiles and strangers avowedly enriched the institutions that provided a new 'home'. What Steven Mansbach reveals, however, is that their commitment to objectivity and impartiality was effectively 'instrumentalised' by an ascendant tendency among newly-established American museums of modern art that minimised the social and political dimension of the early 20th-century avant-garde in favour of a 'neutral' emphasis on formal and stylistic innovations. Where the revolutionary aims of the Bauhaus, for example, were downplayed by Alfred Barr at the Museum of Modern Art during the 1930s, Mansbach shows how the dominant narrative of modernism that resulted was also shaped by the shell-shocked condition of exiles and émigrés traumatised by war. Assiduously avoiding the factionalism of avant-garde movements that had arisen in the European countries from which they had just escaped, scholars prized for their probity and detachment were taken to endorse a unitary formalist model that later served a highly partisan purpose when expressive freedom and liberal democracy were equated in the Cold War era of the 1950s. The account of modern art presented in influential survey texts not only evaded the political aims of the avant-garde in Western and Central Europe, but also neutralised the interplay of aesthetics and politics in the Russian avant-

garde. Modernist achievements in Eastern Europe were studiously neglected. Combined with official censure on the part of the Soviet state, whole swathes of early 20th-century art were consigned to obscurity by these overlapping forces. Archival documents of the historical avant-garde were only 'discovered' by western artists and critics in the 1960s and studies of modernism in Hungary, Bulgaria and the Balkans, for instance, are even more recent. Examining these interlocking factors, Mansbach's path-breaking study of *Modern Art in Eastern Europe* (1999) unravels a genealogy that suggests, 'The retreat into relative historical obscurity was not the result of a Western program of willfull ignorance or of cultural chauvinism. Rather, it was, in large measure, the consequence of political, social and even cultural developments in each of the respective nations of this vast expanse of eastern Europe [...]'.[22]

The contemporary writing of history has been thoroughly de-naturalised by paradigm shifts revealing how reality is not passively reflected but actively constructed by choices, preferences, emphases and evasions made in the realm of discourse. On this view, a creative understanding of the dynamics whereby certain cultural and artistic worlds were 'written out' of the archive cannot be sustained by a dualistic notion of inclusion and exclusion. The presence of radical scholars, such as Max Raphaël, in the appendix Mansbach adds to this collection, indicates a temporal delay such that Continental scholarship of the 1930s was only translated into Anglophone debates in the 1970s. Theodor Adorno wrote *Minima Moralia: Reflections from Damaged Life* as an exile in Los Angeles in the 1940s, but the text was first placed historically some 20 years later, in *The Intellectual Migration*

(1969) co-edited by Donald Fleming and Bernard Bailyn.[23] If it is a truism to suggest that the writing of history 'takes time', it is as well to observe in this context that migrant stories have no necessary belonging on any one location upon the political spectrum.

Trailing archaic associations with the practice of banishment in the ancient world, 'exile' is a form of punishment and modern uses of the term often endow it with an aura of dissidence and opposition to oppressive regimes. An 'émigré' is simply one who 'migrates out' in literal terms, but where loyalists fled the French Revolution and later returned as an ultra-conservative force, the term evokes less radical associations. Conversely, where an immigrant is one who 'migrates in' the term enjoys an affirmative resonance in settler societies, including the United States, whose national motto – *e pluribus unum* – acknowledges ethnic pluralism as a plus, in contrast to European societies that historically absorbed immigrants into corporate forms of class belonging and regarded national identity as ethnically homogenous. On the one hand, the language of migration has an intimate connection with the lived experience of modernity because uprooting is intrinsically perspectival: the immigrant who arrives as a stranger or newcomer from the point of view of the receiving society is at the same time an emigrant from the point of view of those who are left behind or who chose not to leave. On the other hand, where art was regarded within the unitary narrative as wholly 'autonomous' from society, such factors were discounted as mere background. Raymond Williams (1981) took up the close connection between migrant journeys and modernist perspectivalism in his view of western avant-garde movements as a 'paranational' formation,[24]

but the long-standing methodological tension between formalist and contextualist approaches in the historiography of the visual arts has tended to pre-empt the development of interactionist models capable of relating aesthetic innovation and socio-political conditions without reducing one to the other. What contributors to this collection demonstrate is that the 'slow time' of interdisciplinary translation results not in an inclusionism that simply adds in what was left out of the dominant narrative while preserving its underlying epistemological framework, but a holistic practice of rewriting that adjusts the bigger picture of 20th-century art in a step-by-step manner that makes the best use of conceptual innovations originating from outside the field of art history without reducing the objects of study to an 'illustration' of theory as an end in itself.

Exploring the inscription of diaspora aesthetics among successive generations of African American artists, from Aaron Douglas in the 1930s and Jacob Lawrence in the 1940s to Jean-Michel Basquiat in the 1980s, Sieglinde Lemke untangles thematic, iconographic and stylistic patterns that generated one of the alternative modernisms in 20th-century art previously closed from view by the unitary formalist narrative. Taking up Gilroy's model of diasporic modernity, her chapter shows that the linear timeline that once measured artistic 'progress' as a goal-driven teleology now gives way to a spiral-like geometry more suited to the multidirectional references of artistic practices in which memories of the ancient ancestral past coexist with future-seeking aspirations for universal freedom. Following Gilroy's contrast between the literal 'return' to the place of common origin envisioned by 19th-century

James Hampton,
The Throne of the Third Heaven of the Nations' Millennium General Assembly, c.1950–64

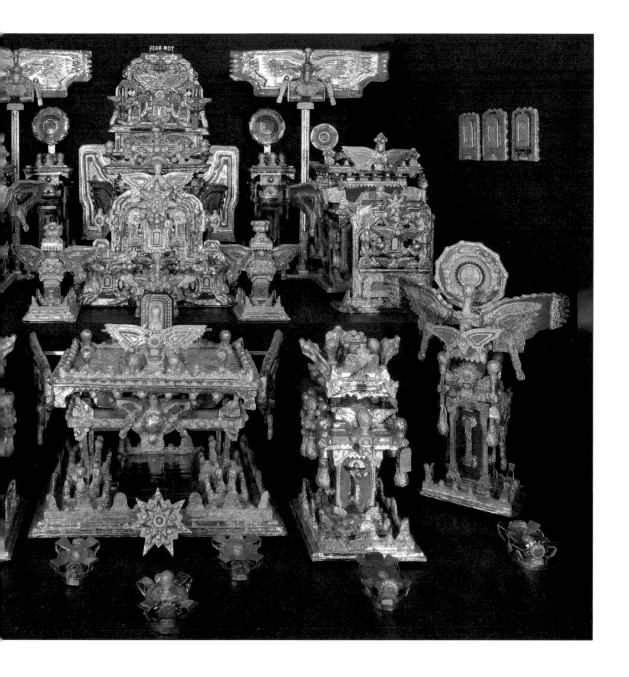

discourses of repatriation and the imaginative journeys undertaken in literary and vernacular culture, Lemke shows how the anti-illusionist break with realism that Douglas produced by using flat planes and reverse chiaroscuro evoked Africa as an idealised 'homeland', but did so in an experimental visual language of urbane modernity. As witness to the 'internal' migrations of the 1930s, Jacob Lawrence also connected American and Caribbean sites of scattering and dispersal in his Toussaint L'Ouverture series.[25] Where modernist primitivism is explicitly parodied in the intertextual practice of Basquiat's paintings, through recombinant and synthetic procedures of bricolage that were pioneered by Romare Bearden in the 1960s, Lemke delivers us to the critical moment of the post-modern break with the authoritative values of authenticity and originality that had dominated institutional narratives of modern art from the 1940s to the 1970s.

Collage held an important place within this narrative, but the preferred view of artistic intentionality as a form of engineering in which innovation was conceived as a rational 'plan' gave little room to an aesthetics of improvisation. Practitioners using found materials in vernacular contexts were 'outsider artists' beyond the milieu in which artistic modernity was defined: only with the re-assessment of readymades and 'found objects' in the critique of modernism was the act of appropriation recognised as a deliberative and purposive procedure. Facing the aesthetic inventiveness of a unique installation by self-taught artist James Hampton, *The Throne of the Third Heaven of the Nations' Millennium General Assembly* (c.1950–64), critic Robert Hughes engages in a lively description even as he accepts that the sources, methods

and 'intention' of the work defy any recognisable art historical category:

> Hampton, the son of a black Baptist preacher, was saturated in the apocalyptic imagery of *Revelation*. For 14 years, while working as a janitor, he spent hours every night creating this work from junk furniture, scrap plywood and cardboard, painstakingly covered with gold and silver foil. It is an assemblage of thrones, pulpits, crowns and plinths, adorned with a fantastic profusion of figures, friezes and winged cherubs' heads in a vaguely Assyrian style that defies identification.[25]

Unable to identify where this work 'belongs' within the art and culture system, it may be said that Hughes might benefit from a simple reference to the diasporic world-view that evokes 'Babylon' not literal-mindedly but as a place within a symbolic universe of alternate meanings that created, in Gilroy's view, a counter-discourse of modernity. In point of fact, the Black Atlantic concept originated in Robert Farris Thompson's renowned art historical studies.[26] When the historical past is opened to new forms of creative understanding at the point where concepts of intentional appropriation and discursive trans-coding in diaspora studies meet critical theories of bricolage and quotation in post-modernism, a more nuanced appreciation of how cultural elements travel and circulate opens up a connective approach. The value that painter R.B. Kitaj gives to the unsettled and contradictory dynamism of such mobile elements in *First Diasporist Manifesto* (1989) suggests not a once-and-for-all break with the era of classical modern art but a critical 'return journey' that uncovers

previously hidden scenarios of aesthetic invention and hybridisation in 20th-century life.

Turning to the 'plurality of vision' Said stressed as one of the unexpected benefits of migration,[27] the closing chapters in this collection examine works that inhabit the fractured universe brought about by the crisis of modernism since the late 1960s. The conceptual artist and philosopher, Adrian Piper, is a living practitioner, as are Gavin Jantjes, Mona Hatoum and Mitra Tabrizian, whose respective travels from South Africa, Lebanon and Iran into the 1970s London art world are studied in Amna Malik's chapter. One key advantage of historicising their distinctive contributions to conceptual art is that the critical distance that arises once the 'contemporary' passes into the 'past' allows a deeper understanding of the post-modern conjuncture in which their intentions were formed as strategic interventions. Illuminating the choices made by Sonia Boyce, Keith Piper and Black Audio Film Collective in the volatile British climate of the 1980s, Jean Fisher offers an exemplary form of art-writing that shows how interdisciplinary insight can be finely woven into the close-up attention that works of art demand, while also addressing the pressing question of trauma that recurs as a common thread linking each of the chapters in this collection.

When Adrian Piper's conceptual enquiries into xenophobia are conflated with her identity as a black female artist, we lose sight of the inner logic that led her from post-minimalist seriality to high-risk performances in which she presented herself as an 'art object'. Far from asserting autobiographical identity as a self-evident truth, her interest in the inter-subjective dynamics of looking and being-looked-at laid bare the subject/object dichotomy to explore the impersonal operations of 'the gaze' as a pre-cognitive structure that assigns *social* meaning to perceptual categories of 'race' and gender. Discussing the rejection she faced on account of her principled opposition to the linguistic turn that became the dominant tendency in first-wave conceptualism, my focus on the reasoning that connects her 1970s performances to her decision to study Kantian metaphysics frames her travels across art and philosophy as a matter of exile. Although the term is used metaphorically, Piper's abiding commitment to universalist values can be situated among diasporic traditions that challenge liberal institutions to live up to their professed ideals. Such a subversive turnaround within the dominant 'regime of truth' is expressed with characteristic wit and irony when Piper states: '...being punished for asserting your ideas leads reflexively – if you are as deeply attached to the ideal of objective universality as I am – to scrutinizing their veracity [...] epistemic insecurity is a tactical advantage in the competition for truth.'[28]

Tracing the routes whereby the 'spatial engineering' of apartheid worked its way into the inner city settings of Mona Hatoum's art of contrapuntal embodiment, Amna Malik shows how performance and photo-conceptualism opened spaces of enquiry otherwise closed by the representational codes of painting and sculpture. Examining the gendered character of exile and migration, she observes how multiple displacements erode Cartesian distinctions between the inner and outer 'skin' of bounded selfhood, a theme that relates to both the mother-daughter bond explored in Hatoum's 1980s video work and Tabrizian's photographic tableaux inspired by the psychoanalytical insights of Frantz Fanon. In light of Julia Kristeva's

thoughts on the 'female voyager', and Janet Wolff's historical studies of modernity's female 'flaneuse', the figure of the unaccompanied woman who travels abroad – provoking patriarchal anxiety as 'other' to the domestic hearth and home – finds an uncanny counterpoint in self-portraiture among 'black' British artists.[29] Uprooted from Uganda during the expulsion of diasporic South Asian communities settled in East Africa, Zarina Bhimji presented a self-portrait in an early solo exhibition, *I Will Always Be Here* (1991), that created a palimpsest of cartographic fragments of the Indian/Pakistan border (see front cover) to evoke the 'worlding' of post-colonial subjectivity on the part of a voyager already twice removed from her familial origins or *patria* in the sub-Continent.[30]

Revealing the crisis of testimony that arises when the past is not 'contained' in sanctioned narratives, public memorials or official archives, but instead roams the unconscious as an 'internal foreign object' that resists representation, Jean Fisher draws out the subtle moves and canny decisions that informed the unprecedented strategies of a generation who sought to move beyond anti-racism. In place of expressive catharsis or redemptive closure, her understanding of post-colonial trauma reveals the predicament of the storyteller as a witness to the catastrophe of modernity. Where trauma takes hold of the psyche 'against the will of the one it inhabits',[31] boundaried separations between agent/patient, victim/aggressor and self/other are thrown into a treacherous state of 'abjection'. Describing how traumatic modernities are survived and made intelligible through a poetics of remembrance, Fisher's insights into the transformative labour of artistic production resonate with Kristeva's remarks in *Strangers to Ourselves* (1991) when

the concept of *unheimlich* or 'the unhomely' is addressed: 'The foreigner is within us. And when we flee from or struggle with the foreigner, we are fighting our unconscious ...Freud does not speak of foreigners: he teaches us how to detect foreignness in ourselves. This is perhaps the only way not to hound it outside of us.' [32]

The Unfinished Story

Featuring contributors whose independent thinking has generated new knowledge and rich understandings of a diverse range of critical moments in 20th-century art, the Annotating Art's Histories series has added over 30 newly-commissioned texts to the available literature, as well as interviews, translations, bibliographies and previously unpublished documents that each speak to questions now facing art history. The conceptualisation of the 'cross-cultural' developed across the series overlaps with 'world art' and 'global art' but also lays out significant interpretative alternatives.

Studies of 'world art' by Hugh Honour (1984) and John Onians (2004) tend to locate non-western materials in antiquity and other pre-modern epochs, whereas this series has focused on the broad period between the 1890s and the 1980s to show how artistic conceptions of modernity emerged from numerous directions across the globe. By stopping short of global modernity, a paradox arises whereby modern art, western or otherwise, is not considered to be part of 'world art'. In *Real Spaces: World Art History and the Rise of Western Modernism* (2003), David Summers tackles this conundrum with a philosophical rigour that indicates the sheer scale of the Copernican revolution that has reshaped intellectual life over the past 30 years. As a focus for debate in James Elkins' anthology,

Is Art History Global? (2007), Summers' insights, however, seem to spark off fragmented disputes rather than any common dialogue among the cast of international contributors. The limitations of adopting a 'totalising' approach to the subject of 'global art' not only gives a disproportionate privilege to theory, such that no bodies of visual material are substantively discussed, but also tends to elicit a somewhat defensive stance among art historians who perceive issues of cultural difference and globalisation as an implict 'threat' to the very identity of the discipline.[33]

Conversely, when the allure bestowed upon 'theory' reinforces de-historicised views that regard cultural difference solely as a 'contemporary' matter, contributors to this series have handled interdisciplinary resources with care, placing artworks shown in colour plates in the forefront of attention. Where pressure to be all-inclusive risks either neglecting historical materials or manipulating them into a 'presentism' that aims to satisfy multicultural demands, the independent perspectives put forward in this series take pleasure in the sheer strangeness that the art of the shared historical past acquires when familiar topics are re-examined from alternate points of view.

Opting for a series format, this process-oriented conception of knowledge production offers a considered alternative to the 'anthology' or 'reader' model that implies that the conceptual challenges brought about by questions of difference are amenable to definitive resolution. By definition, the process of rewriting, re-vising and re-thinking resists the very notion of a final answer-word for it is understood that narratives about the past are always written in the future. Far from coming to an end, the research perspectives put forward across the four volumes in this series point towards avenues and departure points for future enquiry. Studying art's history in the future is likely to be all the more intriguing and rewarding precisely because the field has been enlivened by questions whose answers are not yet known. If the past is indeed 'another country', the return journey promises to make strangers of us all.

NOTES

1. 'Introduction' in Jean Fisher and Gerardo Mosquera eds, *Over Here: International Perspectives on Art and Culture*, New York and Cambridge, MA: New Museum of Contemporary Art and MIT Press, 2004, 3.
2. Edward Said, 'Reflections on Exile', *Granta*, 13, 1984, reprinted in Russell Ferguson, Martha Gever, Trinh T. Min-ha and Cornel West eds, *Out There: Marginalization and Contemporary Cultures*, New York and Cambridge, MA: New Museum of Contemporary Art and MIT Press, 1990, 357 and 366.
3. George Steiner, *Extraterritorial: Papers on Literature and the Language Revolution*, Harmondsworth: Penguin, 1971.
4. Said, 1990, op. cit., 366.
5. See Terence O. Ranger and Eric Hobsbawm eds, *The Invention of Tradition*, Cambridge and New York: Cambridge University Press, 1983.
6. Werner Sollors, *Beyond Ethnicity: Consent and Descent in American Culture*, New York and London: Oxford University Press, 1986, 66–101.
7. John Berger, *A Seventh Man: a book of images and words about the experience of migrant workers in Europe*, Harmondsworth: Penguin, 1975.
8. Nikos Papastergiadis, *Modernity as exile: The Stranger in John Berger's writing*, Manchester and New York: Manchester University Press, 1993, 118.
9. Stuart Hall, *Africa is Alive and Well and Living in the Diaspora*, Paris: UNESCO, 1975; Stuart Hall, 'New Ethnicities', in Kobena Mercer ed., *Black Film/British Cinema*, ICA Documents 7, London: Institute of Contemporary Arts, 26–31; Stuart Hall, 'Cultural Identity and Diaspora', in Jonathan Rutherford ed., *Identity: Community, Culture, Difference*, London: Lawrence and Wishart, 1990, 222–39.
10. Analytical methods first proposed in Paul Gilroy, 'Steppin' Out of Babylon – race, class and autonomy', in Paul Gilroy et al. eds, *The Empire Strikes Back: Race and Racism in 70s Britain*, London: Centre for Contemporary Cultural Studies and Hutchinson, 1982, 276–314, were further developed in Paul Gilroy, *There Ain't No Black in the Union Jack: The Cultural Politics of Race and Nation*, London: Hutchinson, 1987, especially chapter 5, 'Diaspora, utopia and the critique of capitalism', 153–222, prior to the overall framework put forward in Paul Gilroy, *The Black Atlantic: Modernity and Double Consciousness*, Cambridge, MA and London: Harvard University Press, 1993.
11. Paul Gilroy, 'Diaspora and the Detours of Identity', in Kathryn Woodward ed., *Identity and Difference* (Culture, Media and Identities series no. 1), London: Sage, 1997, 318.
12. Rey Chow, *Writing Diaspora: Tactics of Intervention in Contemporary Cultural Studies*, Bloomington: University of Indiana, 1993; Linda Nochlin and Tamar Garb eds, *The Jew in the Text: Modernity and the Construction of Identity*, London and New York: Thames and Hudson, 1995.
13. James Clifford, 'On Collecting Art and Culture', in James Clifford, *The Predicament of Culture: Twentieth-Century Ethnography, Literature and Art*, Cambridge, MA and London: Harvard University Press, 1988, 223.
14. Ibid., 225.
15. See William Rubin ed., *'Primitivism' in Modern Art: Affinity of the Tribal and The Modern*, vol. 1, New York: Museum of Modern Art, 143.
16. Walter Benjamin, 'The Work of Art in the Age of Mechanical Reproduction' (1936), in Walter Benjamin, *Illuminations*, London: Fontana, 1970, 219–53.
17. Andre Malraux, *The Psychology of Art, Volume One: Museum Without Walls* (1947), London: Secker and Warburg, 1967.
18. Pascale Martin Saint Leon, N'Gone Fall, Jean-Loup Pivin and Simon Njami eds, *Anthology of African and Indian Ocean Photography*, Paris: Editions Revue Noir, 1998.
19. Georg Simmel, 'The Stranger' (1908), in Donald N. Levine ed., *Georg Simmel: On Individuality and Social Forms, Selected Writings*, Chicago and London: University of Chicago, 1971, 143.
20. Ibid., 145.
21. Mikhail Bakhtin, 'Response to a Question from the *Novy Mir* Editorial Staff' (1970), in Mikhail Bakhtin, *Speech Genres & Other Late Essays*, Austin: University of Texas, 1986, 7.
22. Steven Mansbach, *Modern Art in Eastern Europe: From the Baltic to the Balkans, ca.1890–1939*, Cambridge and New York: Cambridge University Press, 1999, 1.
23. See Theodor Adorno, *Minima Moralia: Reflections from Damaged Life* (1951), London: Verso, 1974; Donald Fleming and Bernard Bailyn eds, *The Intellectual Migration: Europe and America, 1930–1960*, Cambridge, MA and London: Harvard University Press, 1969.
24. Raymond Williams, *Culture*, London: Fontana, 1981, 83–85.
25. Robert Hughes, 'American Visions', *Time* special issue, Spring 1997, 39.
26. See Robert Farris Thompson, *Flash of the Spirit: African and Afro-American Art & Philosophy*, New York: Vintage, 1984 and Robert Farris Thompson, 'The Song that Named the Land: The Visionary Presence of African-American Art', in Robert V. Rozelle, Alvia J. Wardlaw and Maureen A. McKenns eds, *Black Art, Ancestral Legacy: The African Impulse in African-American Art*, Dallas: Dallas Museum of Art, 1989, 97–141.

27. See Eric Hobsbawm, 'The Benefits of Diaspora', *London Review of Books*, 20, October 2005, 19–21.
28. Adrian Piper, 'Introduction: Some Very FORWARD Remarks', in Adrian Piper, *Out of Order, Out of Sight, Vol. 1: Selected Writings in Meta-Art, 1968–1992*, Cambridge, MA and London: MIT Press, xxxiv. In light of issues raised in this collection, Piper's thoughts on the work of Australian conceptual artist, Ian Burn, are highly apposite, see Adrian Piper, 'Ian Burn's Conceptualism', in Michael Corris ed., *Conceptual Art: Theory, Myth, and Practice*, Cambridge and New York: Cambridge University Press, 2004, 342–58.
29. See Anna Smith, *Julia Kristeva: Readings of Exile and Estrangement*, London: Macmillan, 1996; Janet Wolff, *Feminine Sentences: Essays on Women and Culture*, Cambridge: Polity, 1990, especially chapter 3, 'The Invisible Flaneuse', 34–50; see also Sara Ahmed, 'Home and Away: Narratives of Migration and Estrangement', *International Journal of Cultural Studies*, 2, 3, 1999, 329–47.
30. Elizabeth McGregor ed., *Zarina Bhimji: I Will Always Be Here*, Birmingham: Ikon Gallery, 1991.
31. Cathy Caruth, *Trauma: Explorations in Memory*, Baltimore: John Hopkins University Press, 1995, 5.
32. Julia Kristeva, *Strangers to Ourselves*, New York: Columbia University Press, 1991, 191.
33. See Suman Gupta, 'Territorial Anxieties', in the 'Assessments' section of James Elkins ed., *Is Art History Global?*, London and New York: Routledge, 2007, 236–47.

UNMAPPED TRAJECTORIES: EARLY SCULPTURE AND ARCHITECTURE OF A 'NIGERIAN' MODERNITY

IKEM STANLEY OKOYE

Whether its story is delivered as a metanarrative or as a splintered, fragmented series of juxtaposed histories, the idea of migration, travel and diaspora has girded both art historical accounts of 20th-century art and architecture and museological displays exploring the same period.[1] This has been especially so where such accounts have been inclusive, that is, where they have at least implied that it is possible to tell more than the art history of North America and of what was once called Western Europe. These recent art histories generally deploy an interest in the migration of artists, sometimes over more than a single generation, during the turmoil of emerging industrialism and of consolidated colonialism (or early post-coloniality). Recent narratives seem to confirm these framings when, within a single publication or research project, they have, for instance, addressed Pablo Picasso and Wilfredo Lam, or Indian artists Amrita Sher-Gil, Syed Haider Raza and Maqbool Fida Husain in their global itineraries, or Nigerian artist Ben Enwonwu during his sojourn in England.[2] Along with this, we have tracked the movements of two of their accompaniments. First are the movements of the actual objects, and by this I mean both the work of the artists and the objects to which their artworks refer or by which they are inspired. Secondly, we have tracked the migrations of the identity and subjectivity of the artists themselves. The narrative of Indian modern art constructed by Yashodhara Dalmia[3] could, if taken to an Africanist context, easily be imagined for the different but no less modern milieux of Ben Enwonu, Uzo Egonu or Rotimi Fani-Kayode. Where Indian artists in diaspora had in their modernity referred to aspects of traditional Hindu and Buddhist imagery, we notice in some of the work of the Nigerian-born artists the not infrequent insertion of the artwork of ancient Benin,[4] notwithstanding that these Nigerians in diaspora were nevertheless each in pursuit of different and varied artistic goals.[5] The migration of objects, and with them often the parallel migration of identity and subjectivity, has traversed the often only vaguely policed, relatively permeable borders of national identities that were themselves in flux, that were, in other words, simultaneously in formation and contested.[6]

Focused and sustained narratives that incorporate such de-centred and unstable flux[7] seem, however, to reveal an interesting structural characteristic of the geography through which modernity unfolded. As we have opened up our art historical enquiries to the migrant identities and objects that, for instance, secure the migrant, displaced or diasporic artist in his or her estrangement or exile (but sometimes also comfortable integration or assimilation), both the nature of the imagined maps on which we have tracked such movements as well as the intellectual topologies through which these trajectories have been understood take an unexpected form. They are not the graphs of chaos we might have anticipated, since these 'maps' do not present the apparently haphazard spatial dispersals and movements whose progressively more frequent changes in direction would challenge our ability to perceive their possible logic. Instead, such maps take on a form that is conservative, and architectural,[8] something whose geometry, often linear and trigonometric, is easily apprehended.[9]

The recently complicated historiography of a long 20th-century modernity in art (in the sense of a counterpart to the more familiar notion of the 'long 18th century') that chooses to be attentive to the mutual presences both of Yinka Shonibare

and of Andy Warhol, of Pablo Picasso and of Wosene Wosreff would, perhaps invariably, follow the trajectories of practitioners – a good number of whom are darker [10] – and would entail plotting their movement from places whose populations are largely constituted by darker skinned people in upstream migrations along lines that radiate towards destinations whose populations are largely of lighter skinned people. Such 'maps' would, in significant ways, be about non-white artists headed into the West.

I hope you have noticed that my emphasis implicates a production of centrality, that is, of movement towards a core. Its logic is centrifugal and centripetal. What I am getting at is the rhetoric we deploy in constructing a global art history of the modern era in which, almost unwittingly, our thinking, research interests and curatorial choices have preferred – perhaps because of the anxiety brought to the fore by de-centring as a scholarly possibility – to anchor themselves on the heavy stability of that world with which we were already familiar.

To take the idea of diaspora as one instance (albeit quite minor for the art that I will pursue here): many art historians and critics have produced admirably critical, suitably complex, and noteworthy narratives that nevertheless prefer not to see the danger, even the error, of underpinning diaspora by notions of originarity.[11] Instead, such accounts have gone for diaspora as a movement outwards (even if phased), from a specific and comparatively stable homeland to one of the western metropolitan destinations, as if the related transactional movements of ideas would correspond even remotely to such centrifugal trajectories.[12]

It seems to me that a more productive exploration of the 20th century would ultimately have to recognise that the flow of ideas (and of objects, identities and bodies) moved in multiple directions simultaneously, and that a mapping of such itineraries on a global scale would, indeed, resemble a diagram of chaos. The visual character of such a map of chaos would probably appear highly disorganised as it is not subject to the strictures of geometry and of symmetrical architecture with its cores and peripheries and its movements from suspect margins to assumed centres. Indeed, for one of the instances I will explore in this chapter, the important point is to initiate a critique of the spatial idea of centre and periphery itself, for such a critique not only indicates that our idea of 'flow' must be regarded as shorthand for the reality of movement that was frequently spasmodic and multidirectional, but also that the unrecognised practitioners of modernity in art and architecture in the African site were as equally engaged by the rhetorics of technology, or as afflicted by spatial anxiety and the desire for its expression, as were their peers in the West.

An Altered View Close Up

The way in which the apparent disarray of 'chaos' is altered by close-up viewing is exemplified in the lay of a small cultural space at the turn of the 19th century in West Africa, specifically the lower Niger Delta region from Port Harcourt upriver to Onicha in the period between 1895 and 1919. The alignments and dispersals of future-seeking artists and architects in this location call to mind some of the logics of western modernity as we have come to call it, even if the two modernities – that is the European and the African – are not direct outcomes of one another as is more usually thought. By approaching this historical location with alternative methods of mapping in mind,

my aim is to ask whether we need to change our construction of the history of modernity in its global dimension (by which I mean the rewriting of modernity in such a way that the key issue of simultaneity becomes more visible, replacing the idea of the singular birth of modernity in a few western locations, from which like a virus it spread slowly but surely to other more distant places).

The recent ancestors of the kind of argument I have in mind have been produced, if minimally, in scholarship on painting.[13] I will now explore the question of modern global historicity through two other arenas (architecture and sculpture) that have not been paid as much attention in the literature. I will challenge you with the question as to whether we now need to change our construction of the history of modernity if we start from the premise that for every avant-garde architect of the West such as Adolf Loos it turns out there was, for instance, a comparable southeast Nigerian such as James Onwudinjo; for every Marcel Duchamp, a Nwauzu Oka, just as in the arena of painting we have come to see that for every Paul Gauguin there was an Aina Onabolu, and that for every African artist in the West such as Uzo Egonu (an artist from Onicha and Ossomari who worked his career mainly in London) there was a European artist in the South such as Suzanne Wenger (a Viennese artist whose career evolved at Oshogbo in Nigeria). Just as Marcel Duchamp discovered his found objects and questioned the very category 'art', what if there was an African 'child' of the forge, or a blacksmith who, in ways never before imagined, was similarly questioning what could pass for art (in terms of representations and images of a traditional deity, for instance) in his comparatively non-industrialised locale?

What if the radical idea of such an African sculptor, like Duchamp's moreover, also came later to a rather unexpected currency in the sense that what once seemed a transgression soon was seen as normal artistic procedure?

Architecture

The history of modern architecture in the West often presents Le Corbusier and Mies van der Rohe as its most visible exponents.[14] Both are depicted as highly engaged with technology,[15] and with its rhetorical deployment.[16] Thus their work can be spoken of, today, in the critical language more typically reserved for art. However, from the late 1960s onwards, critical histories of modernity began to agree that the ideas that placed these two practitioners at the forefront of architectural innovation were explored to a significant degree by others (some preceding them, others their contemporaries) whose buildings experimented with many of the same concepts, although the visual and stylistic character of the work of these other architects often masked their radicality for many contemporary viewers. Although now fully integrated into the histories, Adolf Loos (Austrian architect of artist Tristan Tzara's house, but also the dreamer of a house for Josephine Baker) was one such figure, although in more popular contexts he is remembered mostly, and unfairly, for his 1908 essay 'Ornament and crime', which has become reduced to the de-contextualised utterance, 'ornament is crime'.[17]

When a history of 20th-century architecture in its global dimension comes to be written in such a way as to include Africa, I expect that it will include the work of James Onwudinjo, born in the Igbo-speaking town of Asaba in about 1878. It will likely place Onwudinjo in a similar historiographic

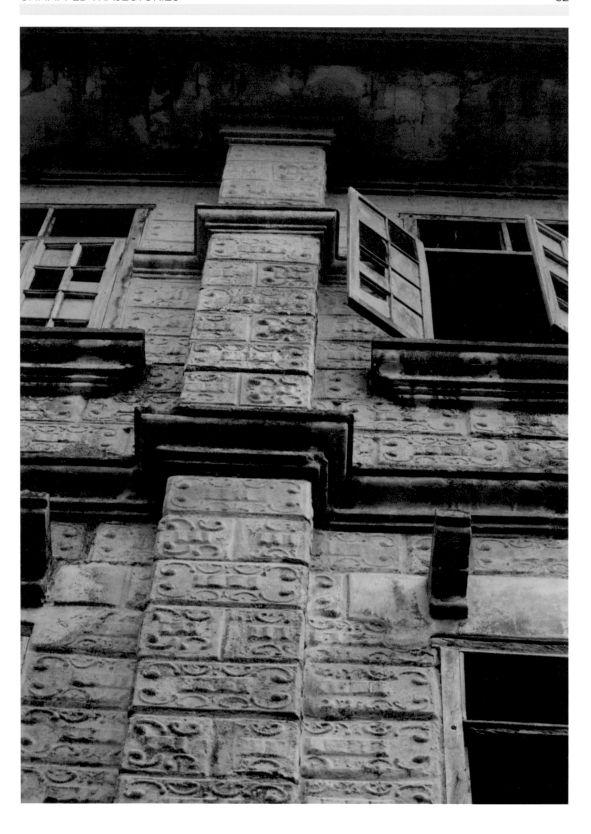

Surface detail, Adinembo
House, Okrika, Nigeria.
Architect/Builder:
James Onwudinjo

location as Loos, although unlike Loos' intensely monocultural Viennese milieu, Onwudinjo will by contrast be surrounded by a cohort of white European architects building their careers in service of imperial colonial governments. The juxtaposition of Loos and Onwudinjo would seem even more germane because though undoubtedly 'modern', Onwudinjo's architecture might appear directly opposed to Loos' if one adopted a populist viewpoint. Onwudinjo's architecture could easily be read as asserting that 'Ornament is all!'[18]

Few historians of 20th-century art or architecture have ever heard of James Onwudinjo,[19] nor of the large structure he built in the lower Niger Delta town of Okrika, which is perhaps the most important example of his work. However, once one understands the very fact of his existence and the nature of his architecture, then the necessity of rethinking the 20th century becomes incontrovertible.[20]

Onwudinjo's building, a large domestic residence, was commissioned by a wealthy Izhon produce trader.[21] I have already alluded to the way in which the house was completely covered by an ornamental scheme. However, what is most important about the house, and what is perceived experientially only by actually moving through it, is most readily grasped through its plans – drawings produced by Onwudinjo in about 1919. Briefly, the plans indicate a vertiginal organisation of spaces, and an inversion of the spatial distributions we would expect in comparable European architecture.[22] By dividing and disconnecting its own topological middle, the house not only rejects the vast, grand and experientially impressive circulatory centre that European country houses label as 'hallway' and such like, but it also moves the periphery (the marginal spaces of servants and their hidden

activity in the European country house) to the middle while exploding the uses of the 'middle' to its margins. In this sense, Onwudinjo's distinctive architecture is almost a spatial cipher of the contestation of European metropolitanism, and of the latter's assumption of its own centrality in the transactional networks of global modernity.

Also unique is a photograph of the house, which in itself provides evidence for the crucial role of technological rhetoric for Onwudinjo's architectural practice. To access this rhetoric, one must know (or recall) that against the clay and thatch buildings that formed the traditional architecture of Okrika, European colonial culture marked its difference and supposed superiority in this landscape by the superimposition of vaguely neoclassical buildings produced in red brick and sporting dominant pitched roofs. By contrast, and in opposition to both architectures, Onwudinjo proposed an architecture of reinforced concrete, deploying such materials in dialogue with cultural references to Renaissance Italy (as opposed to the historic or national architectures of colonial powers), and covering the house with a roof that is effectively flat, thus marking a contrast to both indigenous and colonial architecture. Given the ornamentalism of the house's rustic surface, Onwudinjo was playing with several interesting notions at once. One was an engagement with disappearance and invisibility (the roof), another was with solidity and hardness (concrete instead of the colonial European preference for brickwork), and, thirdly, the conceptual disconnection of both qualities from visual perception, since the same reinforced concrete surface is simultaneously hard and yet unexpectedly malleable as a *trompe-l'œil* medium.

The photograph of the building further reveals something about the processes that generated

Architectural plans of the
Adinembo House

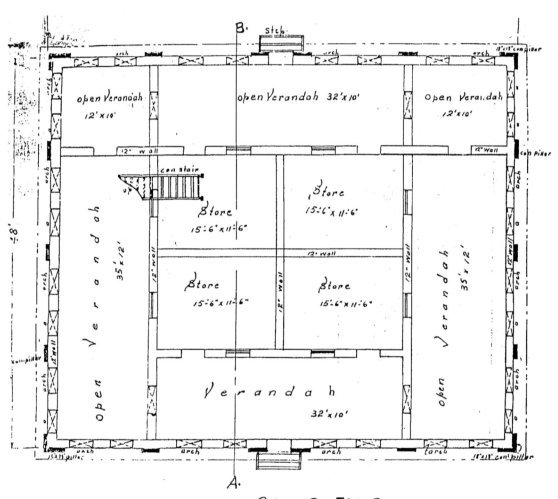

GROUND FLOOR.

the building's ultimate appearance moreover, since, in contrast to the extensive decoration seen today, the drawings for the house indicated nothing of this subsequent ornamental profusion. Photography here was more than merely a design tool. The urgent scratches on the photograph's surface suggest that its framing of the house's vast unmarked surfaces generated debates between architect and client during the ongoing construction of the building. The outcome was the floral marking of the house's entire surface, and perhaps this aspect of ornamentation can be read as an ironic gesture towards traditional body cicatrisation and body painting.

But much more than this procedural use of photography as a technique for imagining architecture in progress, is the way in which this photograph also seems to have been used to frame the building as a particular kind of portrait, one that it became the building's task, by its completion, to live up to. Very briefly put, the photograph made it possible to measure the building in progress against the work of memory that is traditionally achieved by a particular kind of altar to ancestry – the *Nduen fogbara* or so-called 'ancestral screen',[23] a distant variant of which was practiced at Okrika – that was itself the product, and a very future-seeking one at that, of photographic vision. Scholars of *Nduen fogbara* have, in other words, understood that the 'three figures against a screen' iconography too was a modern invention inspired by photographic portraiture, and that it replaced a more symbolic representation constituted by a hanging white cloth at the bottom of which were placed specific objects signifying ancestry and lineage. The house then aims in part to be an architectural image of a sculpture that was itself an image of portrait photography Nigerian style.

In effect a series of mirrored reflections on imaging, the building itself intends, it can be claimed, to be as if a photograph – that seeing the house invokes the chain of reflected associations that produces the structure's own 'development' as a stable and still recognisable object. This is precisely the kind of technological rhetoric, often involving photography and photographic vision, with which modern western architecture actively engaged. I would argue, however, especially given that this *in situ* exploration occurred some time between 1924 and 1926 (that is, in the same period in which Adolf Loos, Frank Lloyd Wright and Le Corbusier were exploring their own architectural imaginations of the future), that in Okrika, James Onwudinjo had moved beyond the goals of these European architects. He deploys familiar modernist tactics (familiar to scholars of 20th-century architectural modernism in Europe and North America), but does so in a way both more consciously critical of the fledgling state and without succumbing to the utopianism that in reality stalled the widespread implementation of modern architecture in both North America and Europe for at least a further decade. Onwudinjo is, especially if one were to insert Okrika history within a global frame, at the cutting edge of modern imagination. The critical question his building raises, therefore, is *can a history of modernity, speaking globally, include a narrative such as this one, and how?*

Sculpture

My second example is one I have addressed in a previous publication.[24] While working with the colonial photographic archive, I had been struck by a particular object said to have been once located in the town of Oka (also Awka), northwest from Okrika. Approximately 130 miles

Archival photograph of
shrine dedicated to the sun
god Anyanwu, Oka (Awka),
Nigeria, c.1913

(209 kilometres) from the coast, Oka is certainly an inland location, or part of the 'interior' during the colonial era of the 1890s, in comparison to the coastal, and perhaps more cosmopolitan, location of Okrika.[25]

The object at Oka was described in its earliest photographic caption as an altar dedicated to Anyanwu. Once the most important deity of the pantheon in the Oka area (for being the primary route of dialogue with Chukwu, or God[26]), Anyanwu, as concept, was also significantly abstracted and ethereal. Its symbolic manifestation was understood as light itself, as it was the bright white orb imagined as light's producing eye.[27] A subject of a more generalised and public veneration (in contrast to the restricted, almost private, remit of assemblies such as the 'screen' mentioned earlier), what struck me about this photograph was how unusual this particular image of Anyanwu is, as compared to other familiar images of the deity and its altars.

Typically, Anyanwu, or at least the altar at which the deity is propitiated, is always located outside, in the open, where sunlight may wash over it and over the gifts offered by petitioners. Not for this deity the secrecy or cool shade of the sacred grove. Anyanwu was always conceived in a form that was vaguely suggestive of a mound and had once come in two major kinds: it was either a clay structure, or it was a structure built up from vegetal material;[28] in any case it was made from elements close to the earth and the constituent parts of such 'natural' materials each resonated with additional meaning.[29]

Altars to Anyanwu were therefore at the heart of a religious milieu (and its set of practices) and were typically judged to be ancient. Surrounding these practices, socially, were all kinds of organisation that can be regarded as

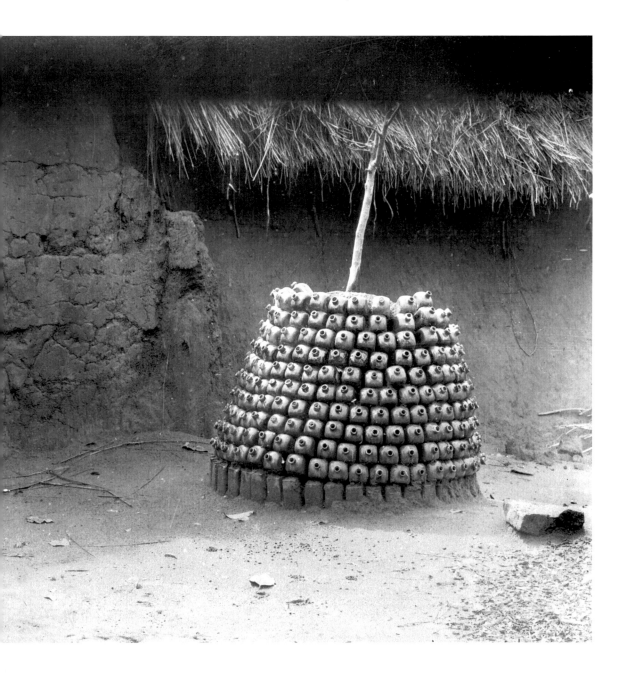

having been once at the core of Oka-Igbo identity. Anyanwu thus operated in cultural arenas more likely to be resistant to rapid change and transformation than other forms of local cultural practice. Unlike the ever-changing competitive oracles of which Oka had its fair share, Anyanwu altars were the last place one would have expected to encounter artistic experimentation and the possibility of new expressive forms for representing deity.

Notwithstanding the material history that underlies the transformation, from the initial invention by one particular sculptor of an altar assembled from bottles to the spread of identifiable versions of this new idea throughout the region for a brief moment in time, the fact is, nevertheless, that someone imagined the physical focus of the shrine in an unprecedented way. The assembly of glass bottles – obviously industrial and mass-produced – was even more estranged from its locale by virtue of the fact that its constitutive units were only available via the exchanges of trade with foreigners (often indirectly through itinerant traders). Assembling gleaming, green Dutch gin and schnapps bottles, drained of their contents (gin had been the preferred ancestor libational liquor for at least 200 years), as a kind of installation appropriate to representing Anyanwu was in many ways a brilliant modernist artistic invention, as the bottles replicate the colour of all things vegetal in reference to 'nature' as the most important source of fertility.[30]

The way in which the bottles are arranged, with their necks radiating outward, connotes fertility and nourishment by evoking the replications of the mammarian or testicular plenitude that is more familiar from Hittite and ancient Roman images of the goddess Artemis.

The bottles, placed at a slight slope, are arranged in circles of slowly diminishing radii that give them the appearance of a clay mound. Moreover, in the often-bright sunlight of the tropics, the assembly of glass bottles would have shimmered: such scintillating and dazzling qualities are indeed highly apt as visual metaphors for the animation of light in the personified being of a deity.

Perhaps more remarkable is that this radically different representation of Anyanwu works its replacement at the heart of an institution that we might have imagined to be unwelcoming to newfangled notions of experiment and innovation. The import and gravity of this transformation become clearer when we put forward a speculative hypothesis and try to imagine a western avant-garde artist being commissioned to design a votive altar complete with its crucified Christ, for an existing Catholic church in 1905. At Oka, not only did the risk of deploying subversive art within an established social institution come to be actualised, but the continued risk-taking also spread. At least three other altar installers borrowed the idea and erected Anyanwu altars based on the one recorded in the archival photograph. We may speculate that this tendency unfolded because in the settings of their own subsequent commissioning the artists influenced by the pioneer at Oka were also able to persuade local audiences that this new object was in its own way an appropriate image for the deity. Moreover it is highly probable that such artists also persuaded their patrons that the new Anyanwu actually did work (in other words that offerings proffered there in sacrifice led to an outcome hoped for by devotees). Pursuing this speculative hypothesis a bit further to reconstruct the transformation of the public imagination, reception and politics that made such innovation

possible, I would suggest that such developments would not have occurred if this society's artists did not also propose and produce new ways of thinking among significant sectors of the population. In other words, the ability of Oka artists to seek out a future-imagining vision of the world was not unlike the social and intellectual visions accompanying sculptural modernity in the West, replete with initial rejections, slow acceptance, penultimate enthusiasm and finally residual incorporation (even if only partial) by society at large as the radicality of an innovative idea not only loses its aura, but later fades into oblivion.

The historical dynamic at Oka may even have been more radical since, during the 1910s, it is hard to imagine an avant-garde installation in the manner of Duchamp's large double-paned *The Bride Stripped Bare by Her Bachelors, Even* (1915–23) being absorbed into a contemporary European institution to the extent that a stained glass window for a church would have taken on the stylistic and logical qualities of Duchamp's unclassifiable object.[31] Within their own contexts, it seems that Africans were sometimes more willing than Europeans to *be* modern.

Conclusion
It is ironic then that, in the late 20th and early 21st centuries, we still resist viewing the non-European worlds through the significance of such objects as the Anyanwu installation made of bottles. This is surely an outcome of the fact that no one at the time would have thought to collect them for European museums, but also because ephemeral structures typically exist only in the form of photographs. It may be that such photographic evidence of global modernity palls next to the fictions that continue to define African

art in this period as 'traditional'; especially when such mythologies are reinforced by the apparent facticity of the ubiquitous masks and ancestor figures that populate the African sections of contemporary museums of art, as they also do museums of ethnography.

As an example of the surprising form this resistance may take, I recall a personal experience in 1998 involving an exchange I had with French curator Jean-Hubert Martin, whose 1989 *Magiciens de la Terre* exhibition had received accolades as a conceptually progressive intervention that opened new possibilities for regarding art and its history outside the western narrative.[32] At issue in 1998 was the Lyon Biennale of 2000 in whose planning Martin was then involved, and for which he sought from me references and a photographic source for the image of Anyanwu.[33] I suggested that the Oka Anyanwu should have an actual physical presence in the exhibition and that this could be easily achieved by commissioning a replica. Martin did not seem to find that possibility attractive,[34] perhaps on account of the issues of authenticity that a replica would inevitably raise. My argument, in response, that Duchamp's *The Bride Stripped Bare by Her Bachelors, Even* has been exhibited as a replica in museums from Berlin to New York and that the original survives only as a photograph, did not win the day.[35]

Martin's response, in resisting the Anyanwu reinstallation, is not so distant from the reactions of those he might be critical of, because it forecloses the full historical significance of such objects. Even his uneasiness with the idea of utilising a replica to represent the historical truth of a modern Africa at the turn of the 19th century (given the dearth of surviving objects of this kind) ignores that the factual explanation for this museological lack is that it is the outcome of the

history of collecting by others. More ironic, of course, is the fact that the object at issue itself eschews such fetishisation of origin. In its way, the gin bottle Anyanwu too proposes new conceptualisations of the relationship between diaspora and art.

By way of conclusion, I suggest that the movement of objects, or of ideas about objects, images and representations both within and from some African locations, actively desecrates the boundaries to which art historical narration is still beholden (and within which it confines its thinking). Such art and architecture raises doubts about our accepted narratives of the modern in the 20th century, particularly in relation to the intractable flows framing such accounts in terms only of a movement to the metropole. Despite the overarching images through which our art histories map such movements, and in spite of the now canonical exhibition strategies that have claimed (with rather troubling effect) to define African art and architecture of the early 20th century precisely by excluding such examples, all manner of African artists *in Africa* – including those with no direct connection to European artistic controversies and pedagogies – were as much involved with representational strategies of modernity as were their peers in Europe.[36] They were, in other words, as attentive to experimentation, to technological poetics and to exploring new possibilities for artistic expression as they were to the traditionalist focus on the formal, significational and cultural importance of producing masks and ancestor figures.

The trajectories of the transformations I have followed have an interesting implication if viewed over longer periods than the decades that enclose them directly. The ideas that underwrite the Anyanwu altar and the house at Okrika held

sway only for a time. They were shortly replaced by more conservative approaches to art and architecture in colonial Nigeria, and it was precisely their difference or 'strangeness' as compared to other photographs of objects from the colonial era that first stirred my own interest. The innovative trajectories exemplified by the building and sculpture I have examined here were only taken up again in their locales about half a century later, and by artists and architects (by now professionalised) who approached their work with an almost completely altered subjectivity.[37] The flows of modern thinking here have, in other words, been quite spasmodic when viewed from our present, and perhaps this also marks them even more clearly as modern. More important, however, is that such movements may not always have been simply about migration, exile or estrangement into the western metropole. Artists in locations such as Oka and Okrika navigated and operated within their own currents, eddies and dangerous rapids. Furthermore, every such location represents larger universes of 'modern' action whose artistic achievements are still wanting for scholarly narration.

1. Examples include both the diasporic impulses of the Harlem Renaissance (black artists seeking refuge in Europe) and those giving rise to abstraction (kick-started by the immigrant Jewish artists from Nazi Germany). Accounts of modernity in African or Indian art also involve comparable but more exteriorised transactions (the motor of the colonial experience itself). A listing of equivalent exhibitions involving accounts constructed with travel and migration in mind would include: *International Abstraction: Making Painting Real* (curated by Marek Wieczorek, Lisa Corrin and Mary Shirley, Seattle Art Museum, 2003); *Looking Both Ways: Art of the Contemporary African Diaspora* (Laurie Ann Farrell, Museum for African Art, New York, 2004); *Transforming the Crown: African, Asian, and Caribbean Artists in Britain, 1966–1996* (Caribbean Cultural Center, New York and other venues, 1997–98); *Out of India: Contemporary Art of the South Asian Diaspora* (Jane Farver, Queens Museum, New York, 1998); *Seven Stories About Modern Art in Africa,* (Clementine Deliss, Whitechapel Art Gallery, London, 1995); and *The Other Story* (Rasheed Araeen, Hayward Gallery, London, 1989).

2. Mulk Raj Anand, *Amrita Sher-Gil*, New Delhi: National Gallery of Modern Art, 1989; Elza Miles, *Lifeline out of Africa: The Art of Ernest Mancoba*, Cape Town: Human & Rousseau, 1994; Ila Pal, *Beyond the Canvas: An Unfinished Portrait of M.F. Husain*, New Delhi: Indus, 1994; Olu Oguibe, *Uzo Egonu: An African Artist in the West*, London: Kala Press, 1995; Jonathan Brown et al., *Picasso and the Spanish Tradition*, New Haven: Yale University Press, 1996; Nkiru Nzegwu 'The Africanized Queen: Metonymic Site of Transformation', *Ijele: Art eJournal of the African World*, 1, 2, 2000, unpaginated, www.ijele.com; Lowery Stokes Sims, *Wifredo Lam and the International Avant-Garde, 1923–1982*, Austin, TX: University of Texas Press, 2002; Aśoka Vājapeyī, *Seven: Raza, Dhawan, Viswanadhan, Akhilesh, Sujata, Seema, Manish = Saptaka*, Paris: Ravi Kumar, 2003; Sylvester Ogbechie, *Ben Enwonwu: The Making of an African Modernist*, Rochester, NY: University of Rochester Press, forthcoming, 2008. Scholarship on Indian and West African artists of the 20th century is scarce. In both the most accomplished and the simplistic of these constructions of the modern, one still recognises the thematic importance of some idea of movement, either of persons or of ideas, in phenomena from global migration and displacement to artists' aesthetic choices and their interpretations by critics.

3. Yashodhara Dalmia, *Making of Modern Indian Art The Progressives*, Oxford: Oxford University Press, 2001; Yashodhara Dalmia and Salima Hashmi, *Memory, Metaphor,*

Mutations: The Contemporary Art of India and Pakistan, Oxford: Oxford University Press, 2007.

4. Ben Enwonwu, *Chiefs at Oba's 10th Anniversary, c.1942/43*, Harmon Foundation Archives, reproduced in Sylvester Ogbechie, PhD dissertation, Northwestern University, 2000, 567; Uzo Egonu, *African Masks*, 1963; Rotimi Fani-Kayode, *Bronze Head*, 1987.

5. If Enwonwu was in search of a wider arena for representing the cultural history of Onitsha Igbo, while Egonu briefly flirted with a kind of nostalgia, Fani-Kayode's glancing reference (especially as Benin is the universe of the Yoruba Ifa to which some of the work refers) is more focused in fact on the politics of the body, specifically the black gay body, in the space of late modern British photographic representation. See Sylvester Ogbechie, ibid., 214–15; Olu Oguibe, op. cit., 51 and 54; Rotimi Fani-Kayode, 'Traces of Ecstasy', *Ten.8*, 28, 1992, 36–43; Kobena Mercer, 'Mortal Coil: Eros and Diaspora in the Photographs of Rotim Fani-Kayode', in Carol Squiers ed., *Over Exposed: Essays on Contemporary Photography*. New York: New Press, 1999, 183–210.

6. In stating this, I refer not only to transformation of identity in the places from which such artists may have come, but also to the fact that identity in the imperial homeland itself was barely more stable for her established citizens. See, for instance, Annie E. Coombes, *Reinventing Africa: Museums, Material Culture, and Popular Imagination in Late Victorian and Edwardian England*, New Haven and London: Yale University Press, 1994.

7. For instance Salah Hassan and Iftikhar Dadi, *Unpacking Europe: Towards a Critical Reading*, Museum Boijmans Van Beuningen, Rotterdam: NAi Publishers, 2001.

8. My reference is to Dennis Hollier's critical account of George Bataille's writing, in particular where the latter's subversive narrative of history understands the fact of social hierarchy and authority as inevitably tied, in reality and metaphorically, to architecture's spectacular, non-panoptic representation (and later imposition) of societal order and control (including the production, as social superego, of our individualised psychologies). See Hollier, *Against Architecture: The Writings of Georges Bataille*, trans. Betsy Wing, Cambridge, MA: MIT Press, 1989.

9. It seems to me that there are two possibilities for describing such movement and its effects. One might be based on a mechanical model that imagines actors, even as they move, as nodes occupying particular locations at specific times (in geometry, such description involves measurable lines and angles and the trigonometric methods of their representation); the other is spectral,

something derived from the representations of quantum mechanics, and assumes its actors are capable of occupying several locations simultaneously, or at least assumes that our reconstructions never completely locate the individual continually in time and through space. To the degree one can, in this other system, specify the actual location of an actor in time, this is a probabilistic 'calculation' that cannot assert certainty. Of course our art historical instinct would tend to reject a juxtaposition of historical reality with a pure science, but I have been tempted by Arthur Miller towards its possible relevance for sorting our historiographies (or at least our scriptural representations in art historical writing). See Arthur I. Miller, 'Aesthetics, Representation and Creativity in Art and Science', *Leonardo*, 28, 3, 1995, 185–92.

10. By invoking darkness here, I am referring to more than merely skin colour, to denote the darkness of hair or of eyes or even of perception of a subject's culture by others whose self-constructedness as 'white' (and empowered) we have only more recently come to acknowledge. In this sense, all four artists to whom I refer illustratively are 'dark'.

11. Any idea of diaspora that is anchored in an origin is by nature already centred. The best examples may appear easy targets today, but must of course be understood in the context of their authors' attempts to grapple with rapidly transforming worlds that needed some epistemological fixing – at least initially. Nicholas Mirzoeff ed., *Diaspora and Visual Culture: Representing Africans and Jews*, London and New York: Routledge, 2000; Moyo Okediji, 'Transatlantic Renaissance', chapter 6 in Moyosore Okediji, *African Renaissance: New Forms, Old Images in Yoruba Art*, Boulder, Colorado: University of Colorado Press, 2002; Laurie Ann Farrell ed., *Looking Both Ways: Art of the Contemporary African Diaspora*, New York: Museum for African Art, and Gent: Snoeck, 2003. Jean-Loup Amselle brilliantly identifies and portrays the error of assuming a certain stability for nationality or ethnicity (as it happens in his case also in a largely African arena) through his plotting of the historical movements of Africans on the continent. The section on the Fula (or Fulani) peoples is especially admirable for its challenges to the idea of diaspora as necessarily based on movement out from a singular identifiable original homeland, notwithstanding the claims of historical subjects. See Jean-Loup Amselle, *Mestizo Logics: Anthropology of Identity in Africa and Elsewhere*, trans. Claudia Royal, Stanford, CA: Stanford University Press, 1998 (Paris, France: Payot, 1990).

12. Before migration, artists are already subject to a circulation of ideas from afar. Furthermore, even though Amselle plotted histories over vaster periods than so far can be claimed by the histories of modernity, he does suggest that even a diaspora of supposedly marked bodies is no more reliable – for being culturally identifiable in their places of ultimate destination – than is a diaspora of ideas based on an originary place of invention.

13. Ola Oloidi, 'Defender of African Creativity: Aina Onabolu, Pioneer of Western Art in West Africa', *Africana Research Bulletin* (Freetown, Sierra Leone), 17, 2, 21–49; Ola Oloidi, 'Art and Colonialism in Nigeria', in Clémentine Delisse and Jane Havell eds, *Seven Stories about Modern Art in Africa*, Paris and New York: Flammarion, 1995; Olu Oguibe, *Uzo Egonu: An African Artist in the West*, London: Kala Press, 1995; Everlyn Nicodemus, 'Bourdieu out of Europe', in Olu Oguibe and Okwui Enwezor eds, *Reading the Contemporary: African Art From Theory to the Marketplace*, London: Iniva and Cambridge, Mass.: MIT Press, 1999, 74–87, see especially 81 and 82; and Nkiru Nzegwu, 'Introduction: Contemporary Nigerian Art', in Nkiru Nzegwu ed., *Contemporary Textures: Multidimensionality in Nigerian Art*, Bingampton: ISSA, 1999, 8–11.

14. For instance, the 1961 Columbia University symposium on modern architecture made them both literally central to the event, surrounding a focus on them with an interest in two others – i.e. German émigré Walter Gropius who in the United States became even more the teacher and theorist than he was when he lived in Germany, and American Frank Lloyd Wright whose work is often seen as idiosyncratic (see *Four Great Makers of Modern Architecture: Gropius, Le Corbusier, Mies van der Rohe, Wright. The verbatim record of a symposium held at the School of Architecture, Columbia University, March–May*, 1961, New York: De Capo Press, 1970). A more recent index of the iconic status of these two architects next to others of their era is Richard Padovan, *Towards Universality: Le Corbusier, Mies and De Stijl*, London and New York: Routledge, 2002.

15. Le Corbusier is seen as having attained a kind of spatial freedom encased in a lyrical use of concrete, resulting in experiences that rival the architecture of gothic, classical and neoclassical buildings. Mies van der Rohe was a kind of opposite, working in glass and steel, beholden at least rhetorically to regularity, sleekness, simplicity, the carefully crafted line and the virtually seamless juncture.

16. In other words, with making architecture articulate, represent and even play with the opportunities and dilemmas offered by new technologies.

17. Between 1922 and 1966 there was nothing significant published on Loos, indicating his near slippage into obscurity. An interest in his work was revived after the 1983 exhibition in Berlin, for which an important catalogue monograph was produced: Dietrich Worbs, Barabara Volkmann and Rose-France Raddatz, *Adolf Loos, 1870–1933: Raumplan, Wohnungsbau: Austellungder Akademie der Künste*, Berlin: Die Akademie, 1983.

18. Adolf Loos, 'Ornament and crime'. The 'crime' of the essay's title applied, for Loos, to the European whose civility ought to mean that more be expected of him than of the Papuan (the primitive of Loos' essay). Loos' full meaning is understood only with a recall of the essay's statement that 'the lower the standard of a people, the more lavish its ornaments'. 'Ornament und Verbrechen' [1908] ('Ornament and crime', English trans. 1913), *Trotzdem (Nevertheless)*, 1931. I have worked with a more recent English translation in Ulrich Conrad, *Programs and Manifestoes on 20th Century Architecture*, trans. Jane O. Newman and John H. Smith, Cambridge, MA: MIT Press, 1970, 19–24.

19. At least not before my essay of a few years ago in the anthology *Architecture and the Visual Arts*; see Ikem Stanley Okoye, 'Scratching the membrane: photography, sculpture, and building in early twentieth-century southeastern Nigeria', in Karen Koehler and Christy Anderson eds, *The Built Surface, Vol. 2: Architecture and the Visual Arts from Romanticism to the Twenty-first Century*, Aldershot: England and Burlington, VT, USA: Ashgate, 2002, 135.

20. Not the least because Onwudinjo's career as a builder reached its apogee in the 1910s, 20s, and 30s – the period in which both Le Corbusier and Adolf Loos too were producing their most original architecture.

21. Also Ijaw, Ijō or Idzon, variant transcriptions of the label for a southeast Nigerian language group that adjoins (to the north) speakers of Igbo and Edo.

22. For a detailed exploration of this plan, see Okoye, 2002, op. cit., and also Ikem Stanley Okoye, *Hideous Architecture*, Leiden: E.J. Brill Academic Publishers, forthcoming, 2008.

23. Major Arthur Leonard (1968 [1906]), *The Lower Niger and its Tribes*, London: Frank Cass (Macmillan, 1906); Nigel Barley, *Foreheads of the Dead: Kalabari Ancestral Screens*, Washington, DC: Smithsonian Institution Press, 1988; and Okoye, 2002, op. cit.

24. Ikem Stanley Okoye, 'Tribe and Art History', *The Art Bulletin*, December 1996, 610–15.

25. The location of cosmopolitan life shifts through history, so that in an earlier period Okrika would have been a backwater of an Oka that was at the heart of a highly connected network of travelling artists often abroad. See Nancy Neaher, 'Awka Who Travel: Itinerant Metalsmiths of Southern Nigeria', *Africa: Journal of the International African Institute*, 49, 4, 1979, 352–66. See also her *Bronzes of southern Nigeria and Igbo metalsmithing traditions*, PhD dissertation, Stanford University, 1976, Ann Arbor, MI: University Microfilms International, 1979.

26. Emefie Metuh, 'The Supreme God in Igbo Life and Worship', *Journal of Religion in Africa*, 5, 1, 1973, 5 and 11.

27. *Anyawnu* may be translated literally as 'eye of the sun', although *Anyanwu* (when used simply to mean the sun) may be translated as 'the undying'. Thus Anywanu may imply the eye of the eternally living, the eye of the sun as God. See Metuh, ibid., 8 for its connection to things white.

28. Metuh, ibid., 6. Although the clay altars with which Metuh engages honour deities with other names that broadly refer to Chukwu (or God), he argues persuasively that those altars and their deities are what in Oka were instead the complex of mediational altars to Anynanwu.

29. Clay and soil evoke the additional deity Ala, or Ani, the Earth Mother and consort to other deities (Metuh, ibid., 9); vegetal material evokes farming, agriculture and nature, although one specific element of nature that always appeared in the mounds (and interestingly reappeared in the 1970s and '80s) were young palm fronds, known as *omu*, in Oka, and these have the additional meaning of symbolising both sacredness in general and fertility in particular.

30. For the processes that brought gin to such locations as Oka, see Walter Ofonagoro, *Trade and Imperialism in Southern Nigeria: 1881–1929*, New York, London and Lagos: Nok Press, 1979, 95–97.

31. For *Bachelors*, Duchamp of course worked with glass and lead, and so my reference to this artist is intentional for its obvious connection to stained glass windows.

32. Jeremy Lewison described *Magiciens* as '[...] one of the most thought-provoking of the decade because it demonstrates the shallowness of our knowledge of art and our arrogant occidental attitudes' (*The Burlington Magazine*, 131, 1037, August 1989, 587).

33. Martin had heard my paper presented at the 'Repercussions of Modernism' symposium (13 February 1997) organised by Africanists and anthropologists of the Free Univeristy, at the Haus der Kukturen der Welt, Berlin. In my paper, I had shown an image of Anyanwu. Martin had also read the article I had published earlier in *The Art Bulletin*, in which I had used the Anyanwu altar as illustration.

34. It was unclear whether this was from the perspective of ideas, or whether the Biennale's budget precluded the possibility of such commissions.

35. Martin had just been appointed Director at Lyon. We had talked about the possibility of including Anyanwu in the 5th Biennale 'Partage d'Exotismes' (Sharing Exoticisms). Martin saw the practice of exoticism as a key part of all art production, art and culture being already hybridised. Lyon offered westerners a view of their culture as subjectible to exoticisation by others, exposing the unstable ground of the idea of purity. The Anyanwu assembly revealed, by its absence from historical narratives of sculpture in early 20th-century southern Nigeria, the constructedness of 'purity'. The Biennale's theme, as I understood it, was in part an exposure of such historiographic occultation. Moreover, the Anyanwu assembly could be viewed as an early example of African artists exoticising things European. It seemed a perfect candidate for Lyon.

36. The same likely holds for some non-African artists who came to reside there too, although this other cohort has not been my concern here.

37. The fathers of both Ben Enwownu and Uche Okeke, and in Okeke's case his mother too, were traditional artists in their own right even though these parents also worked as wage earners. We can therefore point to instances in which modern metropolitan African artists emerged from a familial or other apprentice-based context led by practitioners whose careers unfolded within a more traditional cosmopolitanism – 'cosmopolitan' only by way of crossing African linguistic or ethnic spheres. Nevertheless, how an artist like Enwonwu thought, imagined, constructed and projected himself as artist was acutely different from how even the pro-modern blacksmith from Oka would have.

THE TURN OF THE PRIMITIVE: MODERNISM, THE STRANGER AND THE INDIGENOUS ARTIST

RUTH B. PHILLIPS

Lo, the poor Indian ... begins to emerge before our newly opened eyes, as artist... Our problem child ... is suddenly seen to be, in his own, a kind of genius passing our full comprehension.
New York Times, 1931 [1]

See, there's lots of stories that are told in Ojibway. But that wasn't enough for me. I wanted to draw them – that's from my own self – what they would look like... And I thought if they could be some place for a hundred – two hundred years – not for myself, but for my people.
Norval Morrisseau, 1965 [2]

Repeatedly, the history of 20th-century Native North American artistic modernism throws up a pattern of encounter and cross-appropriation that goes something like this:

A stranger-artist arrives in North America – a political refugee, an immigrant, a traveller. Wafted to the periphery by the lure of the landscape or the need for a job, he 'discovers' in the shadow of the Vanishing Indian the living native artist – an unexpected figure whose authenticity had been defined out of existence by conventional narratives of cultural evolution, progress and modernity. Recognising that he has found the Primitive Artist so valued by the modernist sensibility, the stranger becomes a mentor, [3] providing tuition in the conventions and techniques of fine art production and opening up channels that enable the native artist's work to circulate beyond the periphery. Contemporary work by native artists enters the art galleries of cosmopolitan cities and meets with an enthusiastic, but ambivalent and contradictory, critical reception. Reviewers describe the work as both primitive and modern, a last survival of pre-modern authenticity and a promise of future vitality.

Alternatively, the story can be told like this:

An aspiring indigenous artist discovers a stranger-artist, newly arrived in his community. [4] The native artist shows the newcomer his artwork, produced within the constraints of the souvenir market, directed assimilation policies, the boarding school art class, the traditional ceremony celebrated in secrecy or truncated for show. He (both stranger and native were usually 'he' in the early years) becomes aware of the moderns' admiration for Primitive Art, and finds the stranger-artist's interest and appreciation a valuable counter to a long-standing history of oppression and exclusion. Modernism's universalist ideology and stylistic eclecticism offer new and liberating possibilities that respond to urgent needs for economic subsistence, self-realisation and cultural preservation. The native artist accepts the stranger-artist's tutelage and sends his 'modernised' work to be exhibited and sold in urban centres. He travels more widely as his reputation grows. He studies the work of the modern European masters at first hand, appropriating and rejecting selectively according to needs and desires born of his historically and culturally determined difference. Through these processes of dialogic exchange, the indigenous artist turns modernist primitivism to indigenous modernity.

The pattern of encounter that is contained in these two vignettes will be immediately recognisable to students of global artistic modernity, for it has manifested itself many times in colonial and neo-colonial societies around the world. The flight of artists from Nazi Europe threw up numerous instances, some famous and some obscure. Victor Lowenfeld, for example, fled Nazi Germany for the United States and found employment teaching art to African American students at the Hampton Institute in Virginia, where he imparted his love of African art and his modernist sensibility to John Biggers and other students. Another, less well-known, story is that of Hungarian Jewish textile artist Olga Fisch who fled to Ecuador, where she assumed a leading role in promoting colonial and indigenous folk arts. She encouraged, for example, the transposition of the vignettes of village life painted by Tigua Indians from the traditional format of the fiesta drum to that of the wall-hung painting that could be marketed as naive art. The even better known case of Ulli and Georgiana Beier and Suzanne Wenger dates to the early years of African independence. Their work with writers and artists at Oshogbo, Nigeria in the 1960s was an important catalyst for African artistic modernisms.

In all of these encounters we find the same triangulated pattern, which brings into dynamic association the de-territorialised western artist, the colonised and dispossessed native artist, and the modernist European ideology of artistic primitivism. Yet, as I will argue in this chapter, the first two (North and South American) instantiations differ from the third (West African) example. In settler societies the pattern manifests itself in specific and complexly intertextual forms because the valences of displacement and indigeneity are doubled. *Both* the stranger artist *and* the indigenous artist are de-territorialised, although in different ways – the stranger as immigrant or exile and the native through colonial histories of displacement. *Both* desire, furthermore, to affirm their belonging in terms of a relationship to the land.[5] The stranger-settler seeks to put down roots in a new country and the indigene to affirm the historical priority of claims to ancestral territory. Until very recently, of course, colonial power relations enforced the dominance of the settler majority, inscribing it in discourse through tropes of disappearance that rendered invisible the persistence of indigenous visual and expressive culture. Within this historical context, the arrival of a stranger armed with a modernist European openness to the primitive has repeatedly initiated artistic movements which ran counter to such erasures.

The peculiar complexity of modernist primitivism in settler societies arises primarily from intersecting and coincident movements of indigenous resistance to colonial domination and national identity formation. Artists from Emily Carr to Jackson Pollock incorporated Native North American images and concepts into their painting as a way of distancing the cultural dominance of European mother countries. As a number of recent scholars of Native American modernisms have shown, however, such appropriations continued to locate Native art in the past, as precursor to and resource for settler art histories.[6] Yet the nostalgic sympathy for the Native they evoked both made it easier to welcome 'survivals' of Native art as they were 'discovered', and continued to confuse the question of the future viability of these arts. The kinds of encounters with European artistic modernism produced through contacts with

stranger-artists seemed uniquely able to break this impasse. While the new gaze of modernist primitivism could be acquired through the importation of artworks, books or teachers, I will seek to show that the shocks and re-territorialisations produced by immigration, exile and diaspora were even more effective in de-naturalising the myths of disappearance and promoting fresh acts of seeing.

In this chapter I will present three case studies of meetings between the stranger and the native artist, each of which represents a seminal moment in the history of Native North American modernism. Oscar Jacobson, who mentored Kiowa artists on the American Plains during the 1920s and '30s, was a Swedish immigrant, while George Swinton, who worked closely with Inuit artists in the Arctic from the late 1950s through the 1980s, was a refugee from Nazi-occupied Austria. Joseph Weinstein, who encouraged Anishinaabe painter Norval Morrisseau in Northern Ontario during the late 1950s and early '60s, is a diasporic Jew who has moved back and forth first between Montreal, France and northern Ontario, and later between France and Israel. Together, these examples might seem to comprise a kind of typology of the different kinds of displacement produced by immigration, exile and diaspora – conditions which have been differently theorised by writers such as Edward Said, Stuart Hall and James Clifford.[7] Yet, as I will argue, the three examples are more alike than different in their effects on indigenous artists. The strength and efficacy of the stranger-artists' interventions seem traceable more generally to their shared experiences of geographic and cultural estrangement and to their immersion in art worlds imbued with modernist primitivism. The three case studies also show how modernist artistic primitivism could be co-opted to serve new purposes by indigenous artists. Partha Mitter has argued that in modernist Indian art of the anti-colonial period primitivism 'indicates ... a counter-modern rather than an anti-modern tendency'.[8] In presenting these three examples from North America, I take up Mitter's challenge to explore the 'counter-modern' of the indigenous artist seeking to preserve traditional world-views, but I also use his insight to argue for the dialogic nature of the process. For in their search for connection to a new land, the stranger-artists, too, made conscious artistic choices that were out of sync with their times – counter-avant-garde rather than counter-modern – moves which were reinforced by their contacts with aboriginal artists.

Oscar Jacobson and the Kiowa Artists

When eight-year-old Oscar Jacobson (1882–1966) and his family emigrated from Sweden to the farming town of Lindsborg, Kansas, the indigenous peoples of the southern plains were experiencing unprecedented deprivation and cultural trauma. At the same time that the sudden and rapid near extermination of the bison herds during the early 1880s had deprived them of their economic base, Kiowa lands and traditional spiritual systems were coming under tremendous pressure from the growing settler population. The year of the Jacobsons' arrival, 1890, was particularly portentous. The US army suppressed the Kiowa Sun Dance, the great annual ceremony of spiritual renewal, and the government opened up Kiowa lands to non-native homesteaders, leading to the loss of most of their lands during the next decade.[9] Centuries-old art traditions were radically altered alongside every other aspect of life.

Stephen Mopope,
Kiowa Scalp Dance, 1946

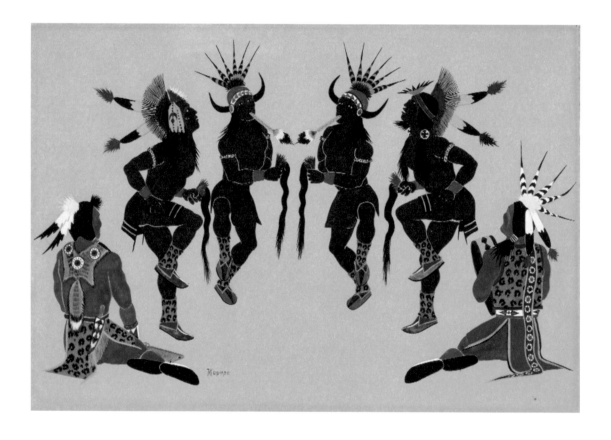

In the absence of buffalo hides and traditional forms of patronage, artists transposed their narrative pictorial tradition to sheets of paper to make pictures that could be sold to white souvenir collectors. As Janet Berlo and others have argued, these new artistic practices provided income in a time of great need and also had therapeutic value in a time of trauma.[10]

The young Kiowa artists – Jack Hokeah, Spencer Asah, Stephen Mopope, James Auchiah, Monroe Tsatoke and Lois Smokey[11] – who, aided by Oscar Jacobson, would bridge the gap between this curio market and the modernist art world, were the children and grandchildren of the last generation of buffalo hunters and warriors. Auchiah, for example, was the youngest son of the famous warrior Set-tain-te or Satanta,[12] and he and Mopope acknowledged one of the most famous traditional artists, Silver Horn, as their first teacher.[13] At the St Patrick's Mission School, the Kiowa students encountered a young Bureau of Indian Affairs teacher named Susan Peters who, unusually for the time, set up an art club, provided supplies, encouraged interested students to paint and sent their work off for sale.[14] As Lois Smokey's niece recalled years later: 'She was just a big helper among the Indian people… In those days there weren't very many … places where they sell Indian artwork.'[15]

In 1927 Peters sent some of her students' work to Oscar Jacobson, who had been hired in 1915 to found the art department at the University of Oklahoma. Jacobson was receptive, arranged for the Kiowa artists to be admitted to the University of Oklahoma as 'special students' and set up separate classes for them during 1927 and 1928 to avoid the 'corruption' of western art. Almost immediately, he also began arranging exhibitions and sales of Kiowa work in cities across the United States.[16] Only a year after their arrival, the students' work was sent to the International Congress of Folk Arts in Prague. The lasting legacy of the European tour that followed is Jacobson's *Kiowa Indian Art*, a lavish portfolio of the exhibited paintings published in France with a bilingual text.[17] Over the next decades Jacobson continued to admit and encourage Native North American students, a number of whom went on to found influential programmes for Indian artists in other colleges.[18] Jacobson also administered Depression-era federal art programmes in Oklahoma during the 1930s and commissioned numerous murals and paintings by Kiowa and other Indian artists.

A brief examination of Jacobson's own artistic formation helps to explain his receptivity to Indian painting as well as his impulse to 'protect' the artists from too much westernisation. He became interested in art while attending Bethany College in Lindsborg, Kansas, where he studied with Birger Sandzen, a Swedish artist who had studied in Stockholm with Swedish romantics such as Anders Zorn and in Paris with a follower of Seurat.[19] Although Jacobson went on to study briefly at the Louvre in 1914 and to earn a BFA at Yale in 1916,[20] his post-impressionist style and his mature focus on landscape continued to reflect Sandzen's foundational influence. In 1926, the year before the Kiowa students came to the University, Jacobson and his French wife took a sabbatical in France and North Africa. Jacobson's admiration for Primitive Art must have been inculcated or enhanced by his contact with a Parisian art world, then enthusiastically 'discovering' African and other tribal sculpture as well as living indigenous performers.[21] In this spirit, as he reported on his return to Oklahoma, he and his wife sought out the most remote

Oscar Brousse Jacobson,
Enchanting Rocks, 1926

places in Algeria, heading 'into the formidable mountain fastness of Grande Kabylie ... I to paint pictures and to trail to its lair the strange and beautiful peasant crafts that I suspect still exist among these primitive mountain folk, and Mrs Jacobson to search out their social customs, songs, legends, and religious practices.' The high plateaux of the Atlas Mountains, 'at the frontiers of civilization' reminded him of northern Arizona, and his travel essay makes clear the relish he took in seeking out the elemental and the exotic as well as his self-fashioning as a non-conformist. 'We brought back some 60 paintings, 5000 photographs, a sheaf of manuscripts and notes', he wrote, 'and a lot of Arab and Berber things of which our friends sometimes downright disapprove, but which we think beautiful.'[22]

In his 'Introduction' to the 1929 *Kiowa Indian Art*, Jacobson attempted to maintain the separate and distinctive values of the primitive and the modern while also reconciling them. Although his descriptions of the Kiowa are riddled with the racist anthropological terminology of the period, he also insisted on their contemporary cultural viability. While characterising them as a '[w]arrior people [who] have resisted with unusual virility the physical deterioration not uncommon when red men come into too close contact [with] white civilizations', he also insisted on their modernity, living in houses, driving cars and using modern farm machinery.[23] Although acknowledging that Kiowa dances are now 'given ... as an artistic spectacle only',[24] Jacobson asserts their authentic expressive value because of the Kiowas' retention of traditional arts and crafts and 'communion with the mysterious forces of nature'.[25] The Kiowa paintings are thus framed as representing the best of both worlds: 'the work of pure Indians,

only one generation removed from the hunting grounds and the war path, the work of representatives of a race which the whites are sometimes pleased to call primitive.'[26] He warns the reader, 'This art of the Kiowas should not be judged by the "white" yard stick. The[y] are created from a different racial point of view... They have an extraordinary faculty of observation, they can see with precision the human body in slow or violent movement... Their paintings are convincing because they are the records of an emotion felt by the artists themselves when participating in the ceremonies.'[27]

In a 1924 paper on 'The Meaning of Modernism in Art', Jacobson further explains the strong connection he saw between modernism and Primitive Art by proposing a kind of Wolflinian cyclical development in which the primitive continues to recur at the heart of each new era, only to become over-refined. 'In the flowering time of civilization, the finest art grew as a wild flower in what the historians prefer to call primitive art', while 'in the fruition of civilization as it has now come to white race, the highest form of art thrives only as a cultivated hothouse plant.'[28] Jacobson's own modernism is evident in his rejection of any requirement that the relationship between art and nature be mimetic: 'the modern artist is no longer satisfied to paint things, incidents, and sentiment; he wants to paint his emotions.'[29] He defends cubism and abstraction and the right of the avant-garde to disdain broad popular acceptance, but he also confesses his own lack of aesthetic pleasure in what he terms 'synchronism'.[30] In a ringing conclusion Jacobson returns us to his essentially romantic version of primitivism, understood as a technique for recovering authentic emotional and spiritual experience: 'Whatever modern art

is or is not it is not decadent, but it is a new, vigorous, powerful, sometimes vulgar force standing on the decay of an old-world order. It is primitive, barbaric, sometimes angry, so is a new age in its youth; therefore why despair of it?'[31]

At the University of Oklahoma Jacobson hired faculty with similarly modern approaches and filled its new museum not only with western, but also with Asian and North African, art. A colleague recalled that he 'completely changed the course of art study in Oklahoma [and] introduced the clear, bright palette of French moderns.' Jacobson's own 'colorful views of landscapes, [were] deemed frightfully modern by some local critics, but gladly applauded by friends in the Journalism School, art majors, and other advanced tastes.'[32] Jacobson remained a post-impressionist landscape artist throughout his life, painting scenes of deserts and mountains emptied of almost all signs of human habitation. Most of this painting was done during the summers, when he and his family retreated to a cabin on the slopes of the Rocky Mountains, seeking spiritual renewal in Colorado through strategies of simplification and isolation as he had in Algeria. To use Camayd-Freixas' distinction, Oscar Jacobson was a 'cultural' rather than an 'aesthetic' primitivist, expressing in his writing, pedagogy, criticism and patronage 'the dissatisfaction of the civilized with complex civilization, of the modern with sophisticated modernity, the attitude that a more natural and elementary life offers greater freedom and moral plenitude.'[33] Yet, as an immigrant, Jacobson's primitivism was also something more, for through his painterly recreations of a raw and unsettled land he seems also to have been clearing a space in which he could root himself in America. Tellingly, he carved and placed in the rafters of

his simple Colorado cabin a small model of a Viking ship – a sign of voyage and arrival.[34]

For Jacobson, then, the relationship between modern art and the new Kiowa art depended on resonance rather than resemblance. In 1929 the unequal power relations, the condescension and the deployment of residual essentialist stereotypes expressed in *Kiowa Indian Art* could not have been entirely avoided. John Collier, Roosevelt's liberal and reformist Commissioner of Indian Affairs, adopted a similar posture when he spoke explicitly of the value of leaving Indian students free to continue their artistic traditions.[35] 'Liberal scholarship', as Rasheed Araeen has written, 'has … been part of colonial discourse… And it seems that we really cannot deal with this subject outside this context.'[36] This approach to Indian art training produced a kind of artistic apartheid, and by the mid-20th century the hothouse conditions of segregation and protection set up at the University of Oklahoma and other institutions, and the highly defined and self-consciously folkish and naive style that had become 'traditional', began to seem a prison to aboriginal artists like Oscar Howe and Patrick Desjarlait, preventing their fuller entry into modernism. Yet this initial chapter in Native North American modernism established the base upon which a continuing stylistic evolution could turn. Art historians, both Native and non-Native, have tended to write the history of these later modernisms teleologically, according to standard formalist and conceptual progressions. Viewed from Kiowa perspectives, however, the achievement of the so-called Kiowa Five cannot be limited by such an approach. Rather, Kiowa commentators stress the holistic engagement of the artists not only in painting, but also in singing, dancing, story-telling and teaching. As James

Auchiah, a member of the first group of Kiowa artists, wrote:

We Kiowa are old, but we dance.
Ageless. Our dance is spirited.
Today's twisting path is temporary,
the path will be gone tomorrow,
but the folk memory remains.
Our forefathers' deeds touch us,
shape us, like strokes of a painting.
In endless procession, their deeds mark us.
The elders speak knowingly of forever.[37]

In this poem, Auchiah provisionally accepts the discursive category of the 'folk', as he had accepted the flat, highly detailed figurative style of the 'naive' painter, because this style could serve the Kiowa interest as a strategy of documentation for and of cultural survival. As historian Frederick Hoxie has written, 'Too often non-Indian patrons continued to view these artists as carriers of a primitive tradition … but the artists' impact was unmistakeable. Their success made it impossible to dismiss Native American traditions as simple curiosities.'[38] Neither Jacobson's mentoring nor Collier's policies created Native North American modernisms. Rather, they opened a door which artists walked through.

George Swinton and Contemporary Inuit Art
George Swinton (1917–2002) came to North America under very different circumstances from Oscar Jacobson. The son of a wealthy and cultured Viennese family, he grew up in a large house filled with ecclesiastical art, paintings by Breughel and other old masters. In 1938, following the Anschluss, he fled to Canada, joined the Canadian army and took his first art class while serving in England. After the war he

George Swinton,
*Spring Storm (Songs of my
Prairies* series*)*, 1963–64,

enrolled in art school instead of finishing the economics degree he had begun in Vienna.[39] As a student at the Montreal School of Art and Design from 1945–46 and at the Art Students League in New York from 1948–49 he came under the influence of artists who worked in a variety of modernist, but largely representational styles – Arthur Lismer, Goodridge Roberts and Jacques de Tonnancour in Montreal, and Will Barnet, Morris Kantor and Harry Sternberg in New York. Although Swinton flirted briefly with abstraction, by the mid-1950s, when he arrived in Winnipeg to take up a position teaching art at the University of Manitoba, he was, in his own words, 'increasingly departing from abstract towards what may be called straight-forward expressionism'.[40] The landscape of the prairies became his primary focus, although he also painted still life, figurative compositions and religious and other subjects.[41]

Swinton began to buy 'Eskimo' or Inuit carvings in 1950, only a year after they were first sent South for sale. The sculptures had arrived in Montreal through the auspices of another young artist, James Houston, who, travelling North to paint after a period of study in Paris, recognised the appeal of the small ivory and stone carvings made for the curio trade. He persuaded the Canadian government and the Canadian Guild of Handicrafts to sponsor an experiment in production and marketing to alleviate the dire economic conditions then prevailing in Inuit communities. The dramatic success of the first 1949 sale among Montreal art lovers with advanced modernist tastes led to a range of carving and marketing projects. Initially, Inuit carvings were sold in craft venues, alongside textiles, baskets and other functional items. As Norman Vorano has recently demonstrated, it was not in Canada, but at the inaugural

European exhibition of contemporary Inuit carvings held at London's Gimpel Fils Gallery in 1953, that the carvings were first displayed as works of Primitive Art.[42]

In the early years Inuit carvers traded their sculptures alongside their furs to local Hudson's Bay Company agents in exchange for credits that could be used to buy food and supplies. Swinton began to frequent the semi-annual unpacking of the shipments that arrived at Winnipeg, one of the two distribution points, and in 1957 the Hudson's Bay Company asked him to make a two-month trip to the Arctic to assess the artistic quality of the carving. This 'most fabulous summer of my life up north with the Eskimos'[43] was the first of the annual journeys North he would make over the next quarter century, and it launched his career as a scholar, teacher, advisor, promoter and writer on Inuit art. His 1972 book, *Sculpture of the Eskimo*, was the first to treat the carvings as fine art and, arguably, remains the definitive overview.[44]

Like Jacobson, Swinton is better known today for his promotion of Native art than for his own painting. And, also like Jacobson, the immediacy of Swinton's response was undoubtedly tied to his absorption of modernist primitivism while at art school in Montreal and New York and to a love of folk art which went back to his youth in Austria.[45] Striking evidence of this predisposition is provided by his choice of a photograph of himself wrapped in a replica of a Plains Indian buffalo hide (painted by himself with pictographic motifs) for the cover of an early one-man show in 1956. This photo bore no direct relationship to the largely landscape imagery of the works exhibited, for Swinton's primitivism, again like Jacobson's, was historical and cultural, rather than aesthetic.[46] There is a strong

resonance between a 1968 essay in which he wrote of the new Inuit art's stylistic development as progressing from 'simple and generally smooth forms' which 'reveal an elemental, primitive expression with little concern for details' to 'a growing concern for the refinements and for detail, with a corresponding decline in respect for the material',[47] and Jacobson's notion of repeating cycles of the primitive and the 'over- refined'.

For both artists, then, the primitive was, in Mitter's phrase, 'the conscience of modernity, tempering its progressivism'.[48] A short essay written just after Swinton's return from his first Arctic trip clearly reveals the posture of anti-modernity through which he initially approached Inuit life and art.[49] 'This summer', he wrote, 'when I spent several weeks with Eskimos on the North East shores of the Hudson Bay, I was vividly confronted by this peculiar emptiness of our lives as far as common philosophy is concerned... The Eskimo lives in the present, in a continuous present. But at no single moment is time master over him.'[50] Although Swinton acknowledges the impossibility of preserving such simplicity within modernity, the longing for lost innocence remained a leitmotif of his writing.[51] Like other eager southern consumers of Inuit art, he was convinced that the new art would die out within a decade or so as, inevitably, modernity came to the Inuit. In 1968 he described the new art as having the beauty of a swan song:

> Made by people singing of what they no longer are, [it] contains a dual element of tragedy and irony... Yet in addition to the swan song, there exists a new idea: the new forms, the emergence of the individuality of artists, the techniques which include economic structures as well as new media ...

John Tiktak,
*Untitled (Four Heads and
Vacant Space; Family)*, 1962

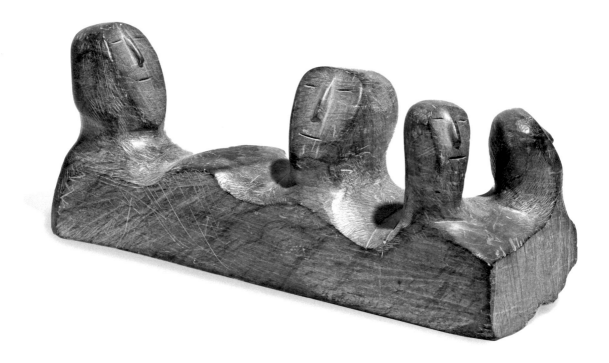

entailing the seeds and growth-hopes that are based on a new environment. The new carvings are becoming a new reality.[52]

The same contradiction is embedded in this passage as in Jacobson's text on Kiowa art. On the one hand, both believed aboriginal art to be essentially innocent and to require protective surveillance. On the other hand, neither could deny the organic process of change to which they were witness. As the Kiowa and the Inuit art engaged with processes of technological modernisation and artistic modernism, it became increasingly hard for outsiders to contain their lives and their arts within a category of the primitive, whether understood as historical, cultural or aesthetic.

Perhaps Swinton's most significant discursive intervention was the recognition of the Inuit artist's individuality. In the early years, most sculptures were exhibited anonymously as manifestations of a collective and generic 'ethnic' style. Going North, Swinton was immediately struck by the individuality of the carvers and their work. He insisted on the need to name artists and to evaluate them as individual creators, and he promoted those carvers whom he considered to be true 'primitives' according to his own formal, stylistic and conceptual criteria. Swinton's choice of artist for the first one-person show of Inuit art, which was held at the University of Manitoba's Gallery 1.1.1. in 1970, was John Tiktak, whose simplified, bold, geometric masses and minimalist detailing caused critics to compare his work to that of Henry Moore – who was an admirer. Swinton wrote later that he had chosen Tiktak because his art was more 'archaic' than other carvers, and because Tiktak was a 'creator' and not an 'illustrator'.[53]

Swinton got funding for Tiktak to travel South to see the exhibition of his work.[54] All that we know of Tiktak's thoughts as he viewed members of the white art world gathered to admire the 50 pieces on display is contained in a few translated remarks recorded in newspaper articles and reviews. These fragments of discourse suggest that Tiktak saw the carvings that were being celebrated as 'art' in a continuum with earlier touristic production: 'I have always given myself to the work of carving stone, ever since I was young, and have made small sculptures representing Eskimo faces or persons, which I sold to visitors or strangers as souvenirs of Rankin Inlet', he said. Also, 'The ones I have done about family mean a lot to me',[55] and 'everything I do is evocative of my tremendously strong feelings about my family'.[56] And finally, 'I do not think out what I will do. My thought comes out while I work. My work expresses my thought. My work is what I think. My work is my thought.'[57] In writing of his own art, George Swinton repeatedly emphasised that art's highest duty was 'communication' and 'emotion'. In so far as this subaltern artist speaks through the filter of translation and journalistic sensationalism, he is telling us somewhat the same thing. His statements begin to gloss not only his own art, but also the expressionist painting of his white patron.

Norval Morrisseau and the Weinsteins

Joseph Weinstein was born in Montreal in 1926, the child of Russian Jewish immigrants.[58] He has pursued parallel careers in medicine and art throughout his life. After earning a science degree from McGill, he attended art school at the Montreal School of Art where he overlapped with Swinton, although the two did not seem to have known each other. Like Swinton, Weinstein

acknowledges the influence of the post-impressionist landscape painter, Arthur Lismer, a member of the Group of Seven and the School's head. He also recalls the importance of a course in fresco painting which was almost certainly given by a teacher recently returned from Mexico, where he would have come to know the work of the Mexican muralists Rivera, Orozco and Siqueiros and their specifically North American version of artistic primitivism.[59] In 1947 Weinstein went to Paris to continue his studies of both medicine and art, the latter at Academie de la Chaumiére and the École des Beaux-Arts where he worked with surrealist print-maker Edouard Goerg. He also met his future wife Esther, a sixth-generation sabra who had come to Paris from Israel to study ancient Semitic languages at the Sorbonne. During their years in Paris, the Weinsteins frequented the circles of avant-garde artists and writers with whom they were connected both through Joseph's art studies and Esther's close friendship with Christina Ruiz-Picasso, wife of Picasso's eldest son Paul. The culture of the Montparnasse artists and literati in the 1940s, like that of other modernist artistic circles, was characterised by a catholic appreciation of world art traditions, a particular interest in Primitive Art and a habit of collecting.[60] Returning to Montreal, the Weinsteins, like Swinton, added examples of the new Eskimo art to the eclectic collection of world art they had begun to assemble in Paris. When in 1957 Joseph took a job as a doctor for a mining company and the family moved to the Red Lake district of Northern Ontario, they brought with them this cosmopolitan experience of Canadian and European art worlds and a commitment to the universalist principles of artistic modernism.

Esther Weinstein remembers her surprise when, two months after their arrival, she noticed 'two very unusual paintings standing on the floor' of the local general store. They struck her as 'mysterious', and 'unlike anything else' she had seen.[61] She bought them for five dollars each and left a message inviting the artist to visit the Weinstein home. The painter was Norval Morrisseau, a 28-year-old Anishinaabe [62] man whose life experiences mirrored those of his generation – poverty, a brief stay at a Catholic residential school where he suffered psychological and sexual abuse, another year or two of formal schooling and, eventually, a job clerking for a mining company. More unusually, from childhood Morrisseau had also had a very close relationship with his grandfather, a traditional shaman, who had passed on his knowledge of Anishinaabe oral traditions, beliefs and mnemonic pictography. By the time Morrisseau went to visit the Weinsteins, he had become committed to a highly original project, the preservation of traditional Anishinaabe knowledge and shamanistic practice in pictorial form.

Joseph Weinstein continued to find time to paint during his years at Red Lake. A fellow artist described him at the time as painting 'competent and individual abstracts', although his later work has been primarily representational and reflects the influence of surrealism in particular. He provided Morrisseau with good quality artist's materials such as paper and gouache paints, and with information about 'proper' art techniques. Equally importantly, he strongly encouraged Morrisseau to think of himself as a professional artist in the western sense, rather than as a producer of tourist souvenirs. When they first met, he stresses, '[Morrisseau] didn't know what art was. He was painting legends. He wanted to

Norval Morrisseau,
Untitled (Thunderbird), 1960

be a shaman.' Joseph Weinstein has also emphasised that he refrained from giving specific advice about style or subject matter. Rather, guided by the appreciation of Primitive Art, mythology and belief that had been part of his own artistic formation, he encouraged Morrisseau to continue to draw on Ojibwa traditions for his subjects. 'I have always had some interest in anthropology', Weinstein states. 'I remember visiting the famous Musée de l'Homme in Paris and seeing the various cultures throughout the world. I found a certain resemblance and identity [between Ojibwa legends] and the legends of the people of Africa.'

The Weinsteins had brought with them to Red Lake their art library, which included not only books on the modern masters, but also on ancient, medieval and indigenous arts from all over the world. They also subscribed to *Canadian Art* and other contemporary art magazines. Esther Weinstein remembers the hours Morrisseau spent looking through these books. 'Quite often', she has explained, 'Joe was at work in the hospital and Norval would come in… I had small children and I would say, "Norval, sit down, and I will make you a cup of tea or coffee". And he would sit there and he would sit there, I think on his knees or something, in our library, and just take out books and look and look.' They had also brought their wide-ranging collection of art, which included African masks, Russian icons, Australian Aboriginal carvings, contemporary Inuit sculptures and examples of Tibetan, South Asian, Jewish and ancient Egyptian art.

The Weinsteins remember that Morrisseau was particularly drawn to specific art objects and books. He was very interested in an Egyptian bas-relief dated to *c*.1200 BC, in which a servant brings food to the dead, and also in a *megilla* –

a scroll telling the story of Esther which is read on the Jewish holiday of Purim – which was mounted for display so that it could be wound and unwound. He was also very attracted to reproductions of Picasso's etchings and drawings. These preferences are telling, though in different ways. The subject matter of the ancient Egyptian piece bears striking similarities to the ritual themes and iconography of Midewiwin scrolls, many of which also focus on the passage of the soul, guided by spirits, to the afterworld. Morrisseau's interest in the *megilla* also makes sense in relation to his interest in Midewiwin scrolls, for both adopt similar formats of rolling and unrolling to record the narratives of sacred stories. These anecdotes suggest that Morrisseau's exposure to the Weinsteins' collections of books and objects made him aware that objects very similar to those made and used by traditional Anishinaabe shamans were admired, valued and collected by sophisticated art lovers. Such an awareness must have provided important affirmation for his conviction of the worth and dignity of Anishinaabe traditions.

Joseph Weinstein's recollection of Morrisseau's intense visual response to Picasso's etchings and drawings suggests a different kind of resonance, one that was more purely aesthetic. He recalls that 'Morrisseau would look at [Picasso's] line drawings and the variations with awe … and look at them and look at them.' Weinstein's phrasing is, again, striking, because it echoes accounts of the French modernists' (and possibly his own) intense visual engagements with art from non-western cultures. It suggests that Morrisseau was struck by the similarity between the elegant, economical linearity of drawings made by the man recognised as the greatest of living artists and analogous stylistic

approaches to graphic depiction that could be found in the Ojibwa pictographs he had learned from his grandfather. In the Weinsteins' house, through technologies of mechanical reproduction, Morrisseau returned the primitivist gaze of Picasso as he looked at African art through the installation technology of the Trocadero museum.[63]

When artist Selwyn Dewdney, another early patron, visited the Weinsteins with Morrisseau, he asked him to 'pick out the books of reproductions that had interested him most', whereupon Morrisseau immediately 'selected two: one of Navajo Art, the other of West Coast painting and sculpture.'[64] Dewdney hastens to point out that these new models had little direct impact on Morrisseau's style or subject matter – 'scanning the contents of either to compare them to Morrisseau's work in the same room', Dewdney wrote, 'it was clear to me that although there were a few instances where subjects coincided, the styles were poles apart.'[65] Small carvings made by Morrisseau during this formative period also reflect the influence of Inuit sculpture in the Weinsteins' collection.

Dr Weinstein remembers that Morrisseau 'would open the magazine *Canadian Art* and suddenly he was aware that there were galleries that exhibited art and you got money for it… This was a revelation because until then this was not his concept.' Morrisseau's friendship with the Weinsteins thus introduced him not only to the modernist taste culture for Primitive Art and the values, standards and conventions of the western art world, but also to the successful engagements of other indigenous artists with modernist forms of artistic production. For an artist who had been brought up to believe that adherence to the Ojibwa beliefs and traditions which resonated so strongly with many of these world arts was tantamount to an alliance with the devil, and that aboriginal visual and oral traditions were inferior, pagan and destined for oblivion, exposure to the Weinsteins, their library and their art collection had to have acted as a powerful catalyst. The relationship reaffirmed Morrisseau in his quest for an expressive format in which he could explore and preserve the Anishinaabe concepts, practices and imagistic traditions he had first learned from his grandfather.

Joseph Weinstein's advice that Morrisseau adopt the media and formats of western painting countered the more eclectic range of craft media recommended by other advisers during these years. An illuminating correspondence between Dewdney and Morrisseau reveals the latter's appropriation of the language of primitivism in aid of his own goals. When, for example, Dewdney wrote urging him not to paint on plywood because it was not a fine art medium, Morrisseau wrote that he used it as a substitute when birch bark was not available because 'the grain puts a primitive effect on the pictures'.[66] Thanks to such letters, we are able to follow the conscious and calculated way in which Morrisseau used the advice offered by the stranger-artists he discovered in northern Ontario – information which is more fragmentary for the Kiowa and Inuit artists we have discussed. We can trace his careful cultivation of the Weinsteins, Dewdney and other artists and his solicitation of their advice about how to remake himself technically and professionally. They did not offer, nor would he have accepted, advice about subject matter or style. These exchanges enabled Morrisseau to enter the modernist art world of southern Canada and, eventually, Europe, with a rapidity and level of success that matched that of Eskimo

and Kiowa art. His first Toronto show was held in 1962 at the Pollock Gallery in Toronto, a venue which handled an eclectic but cosmopolitan array of modern art. It was an immediate sell-out, Morrisseau quickly achieved national renown, and during the 1960s and '70s his artistic range developed with characteristic panache and originality. Although shamanistic themes remained central, he began to explore them on a monumental scale and with an intense colourism that could not have been imagined (and would probably have been discouraged) by his early mentors.

Conclusion

In recounting these three histories I have been seeking a pattern that is suggestive rather than prescriptive. During the decades that have been discussed, not only stranger-artists but also artists born and educated in North America mentored and encouraged indigenous artists and brought their work to the attention of lovers of Primitive Art. Space does not permit a comparative examination of the key roles played by Jacobson's contemporary Dorothy Dunn in training Pueblo Indian artists in Santa Fe, or of James Houston and Selwyn Dewdney, whose activities were just as important as George Swinton's in establishing contemporary Inuit art and Joseph Weinstein's in nurturing the career of Norval Morrisseau. Yet a detailed comparison of the interventions of these three artists from established settler backgrounds with the immigrant Jacobson, the exile Swinton and the traveller Weinstein would reveal a significant difference. Dunn, Houston and Dewdney did not push against the ready-made categories and institutions of folk art, ethnography and craft. It was Jacobson, Swinton and Weinstein who more

fully accepted the place of the contemporary primitive artist within modern art and pushed to admit indigenous work to venues of fine art rather than ethnography.

Other patterns emerge from the juxtaposition of these three case studies, and their logical interconnections illuminate the choices made among available modernist practices by *both* the stranger artists *and* first-generation indigenous modernists. I have recounted all three artists' conscious rejection of abstraction and the ways in which they distinguished their practices from those of contemporary avant-gardes. Landscape painting was important or central to all three stranger artists, and I have argued that for Swinton and Jacobson engagement with the emptied landscape was a way of establishing belonging in a new land. They exemplify the 'mystified universalism' and the 'dislocation ... expressed ... as purely psychological or aesthetic situations rather than as a result of historical circumstances' identified by Caren Kaplan.[67] Although, from the perspective of New York or Paris, all three artists would have been considered provincial or retardataire, their representations of empty landscapes, devoid of human presence, made available spaces for their own re-rooting. In the same context, their engagements with and efforts to promote indigenous art appear as complementary strategies – compensatory acts perhaps less necessary for those more thoroughly socialised as Euro-North Americans – that both acknowledged and maintained a separation between the settler's need for land and his acknowledgement of the Native primacy in it.

The unequal power relations and the contradictions that arise from all such attempts to align the primitive with the modern have

been the subject of much critical investigation. For example, as Hal Foster wrote in his penetrating critique of the Museum of Modern Art's 1984 exhibition, *Primitivism and Twentieth Century Art: Affinities of the Tribal and the Modern*,

> On the one hand, the primitivist incorporation of the other is another form of conquest ... on the other, it serves as its displacement, its disguise, even its excuse. Thus, to pose the relation of the primitive and the scientific as a benign dialogue is cruelly euphemistic: it obscures the real affiliations (affinities?) between science and conquest, enlightenment and eradication, primitivist art and imperialist power. [68]

Foster does not consider the embodied encounters of living indigenous artists in their own territories with members of the modernist-primitivist artistic diaspora. Nor does he address aboriginal artists' appropriations of modernism as a means of documenting and continuing traditions of spiritual practice, narrative and knowledge. In such cases, as we have seen, the relationships between indigenous and stranger artists could become strategic alliances, made possible by coincident, rather than identical, activities and goals. These alliances were enabled in part by the multiple levels of meaning and resultant slippages characteristic of the terms 'primitive' and 'Primitive Art'. As these three examples show, during the middle decades of the 20th century, indigenous artists used these slippages to *turn* the meaning of primitive so that modernist primitivism could become indigenous modernism.

I close with two last (true) vignettes:
In 1972, a journalist interviewed George Swinton about his major book, *Sculpture of the Eskimo*, and asked him:

> 'How does a Viennese-born painter become the author of the most authoritative reference book extant on Eskimo sculpture?' Swinton answered, 'There is a quotation from the "English Flag" by Rudyard Kipling which goes: "What do they know of England who only England know?". So I do feel that as a new Canadian I have different insights and I think that Canadians by mistake – I hope by mistake and not by arrogance – ignored the Eskimo as artist. I have very few prejudices and, therefore, I was able to see this in a wider light. After my first trip to the North, I realized that it was just a question that they had different names and different skins, but they were still human beings. They were simply another kind of Canadian.' [69]

The second vignette dates to 1989, when Jean-Hubert Martin chose Norval Morrisseau as one of three Canadian artists to be included in the Centre Pomidou's exhibition, *Magiciens de la Terre*:

> Martin was particularly interested in the 'x-ray paintings' of spirit animals typical of Morrisseau's early period as he has recently recalled.[70] His associate came to Canada to choose the works, but Morrisseau sent only one of those selected by the French curator, and included instead several of the much larger and more colourful canvasses that reflected his involvement with the new age religion, Eckankar and, perhaps,

late modernist colour field painting.
Morrisseau went to Paris for the opening,
but skipped most of the sessions the
organisers had set up to bring indigenous
artists into dialogue with each other. Instead
he went to look at Picasso's work in the
museums of Paris. He found the Blue Period
pictures disappointingly dark, and, on his
return to Canada, continued to paint his
visions, combining Anishinaabe and
Eckankar spiritual concepts in works marked
by intense colour – following his own vision.[71]

*I am very grateful to Moira Swinton, Joseph and Esther
Weinstein, and Tamar Weinstein for sharing memories and
family histories. Janet Catherine Berlo, Denise Leclerc and
Darlene Wight generously shared their own research, while
Nicole Neufeld, Kim Moinette and Kenlyn Williams provided
invaluable research assistance. I am grateful to Kobena
Mercer and the other contributors to this volume for their
sensitive comments and to Sarah Casteel and Mark Phillips
for commenting on the essay in draft.*

1. From a review of the *Exhibition of Indian Art of the United States*, 29 November 1931. Quoted in Frederick Hoxie, 'Native American Journeys of Discovery', *The Journal of American History*, 79, 3, 969–95, 1992, 987.

2. Norval Morrisseau, *Legends of My People: The Great Ojibway*, Selwyn Dewdney ed., Toronto: The Ryerson Press, 1965, 2.

3. Following Shelly Errington, I capitalise Primitive Art to distinguish the particular historical construct promoted by modernist ideology from other connotations of the word 'primitive'. See Shelly Errington, *The Death of Authentic Primitive Art and Other Tales of Progress*, Berkeley, CA: University of California Press, 1998.

4. The notion of the native artist as a discoverer is not new. For example, in 1923 critic Elizabeth Shepley Sergeant asserted that the Pueblo artist Awa Tsireh was not discovered by 'two writers, four artists, the school of American Research, and all the Indian dealers in Santa Fe', arguing that 'As a matter of fact, he probably discovered himself through his own observation of the work of his immediate precursor [Crescencio Martinez] ... certainly the other boys and girls who are beginning to render the same subject matter in the same general style, have discovered themselves through Awa Tsireh.' Quoted in Hoxie, 'Native American Journeys', 1992, op. cit., 986.

5. On landscape, immigrants and belonging see Sarah Phillips Casteel, 'Introduction', *Second Arrivals: Landscape and Belonging in Contemporary Writing of the Americas*, Charlottesville, VA: University of Virginia Press, 2007.

6. See, for example, Bill Anthes, *Native Moderns: American Indian Painting, 1940–1960*, Durham, NC: Duke University Press, 2006; Leslie Dawn, *National Visions, National Blindness: Canadian Art and Identities in the 1920s*, Vancouver: University of British Columbia Press, 2006; Charles C. Hill, Johanne Lamoureux and Ian M. Thom, *Emily Carr: New Perspectives*, Ottawa, ON: National Gallery of Canada, 2006; and W. Jackson Rushing, *Native American Art and the New York Avant-Garde: a History of Cultural Primitivism*, Austin, TX : University of Texas Press, 1995.

7. On exile see Edward Said, *Reflections on Exile and Other Essays*, Cambridge, MA: Harvard University Press, 2000; on immigration and diaspora see James Clifford, 'Diasporas', *Cultural Anthropology*, 9, 3, 1994 302–44; Stuart Hall, 'Cultural Identity and Diaspora', in Jonathan Rutherford ed., *Identity, Community, Culture, Difference*, London: Lawrence and Wishart, 1990, 222–37.

8. Partha Mitter, 'Reflections on Modern Art and National Identity in Colonial India: An Interview', in Kobena Mercer ed., *Cosmopolitan Modernisms*, London: Iniva and Cambridge, MA: MIT Press, 2005, 41–42, 47.

9. J'Nell Pate, 'Kiowa Art from Rainy Mountain: The Story of James Auchiah', *American Indian Quarterly*, 1974, 1, 3, 196.

10. See, for example, Janet Catherine Berlo, *Plains Indian Drawings, 1865–1935: Pages from a Visual History*, New York: Harry N. Abrams and the American Federation of Arts, 1996.

11. The five men are usually known as the Kiowa Five, although Lois Smokey joined them during the second year of their study at the University of Oklahoma and exhibited along with the group in their important early exhibitions.

12. Pate, 'Kiowa Art', 1974, op. cit., 193–94.

13. See Candace Greene, 'Changing Times, Changing Views: Silver Horn as a Bridge to Nineteenth- and Twentieth-Century Kiowa Art', in Robert G. Donnelley ed., *Transforming Images: The Art of Silver Horn and his Successors*, Chicago: The David and Alfred Smart Museum of Art, The University of Chicago, 2000, 24. Green writes that Silver Horn was, 'raised in an era when art was an integral part of the war system [and] he remained committed to the concept that art should be an illustration of specific events and men's individual achievements.'

14. Lydia L. Wyckoff, 'Visions and Voices: A Collective History of Native American Painting', in Lydia L. Wyckoff ed., *Visions and Voices: Native American Painting from the Philbrook Museum of Art*, Tulsa, OK: Philbrook Museum of Art, 1996, 23.

15. Quoted in Wyckoff, 'Visions and Voices', 1996, ibid., 24.

16. The first important show was in Denver, followed by a display at the annual meeting of the American Academy of Arts and a national tour. Pate, 'Kiowa Art', 1974, op. cit., 197.

17. Oscar Jacobson, *Kiowa Indian Art*, Nice: l'Edition d'Art C. Szwedzicki, 1929. The portfolio consists of 30 colour plates of works from Jacobson's own collection, printed in the exacting *pochoir* technique. Janet Berlo describes it as 'the most elegant and meticulous publication on American Indian art that had ever been offered for sale'. See Janet Catherine Berlo, *The Szwedzicki Portfolios: Native American Fine Art and American Visual Culture, 1917–1952*, Cincinnati, OH: The University of Cincinnati Digital Press, 2007.

18. A painting by Tsatoke was placed on the cover of one of the catalogues of the landmark 1931 *Exposition of Indian Tribal Arts* in New York City, the first exhibition to show both historic and contemporary Native North American art as fine art. Pate, 'Kiowa Art', 1974, op. cit., 197.

19. For examples of Sandzen's work, see http://www.sandzen.org/chronology.htm

20. Jacobson's key teacher at Yale was American impressionist painter and student of Gerome, Julian Alden Weir. See Sam Olkinetzky, 'O.B. Jacobson', in *Oscar B. Jacobson: Paintings from the Kirkpatrick Collection*, exh. cat., Oklahoma City, OK: Kirkpatrick Center, date unknown, unpaginated.

21. See Ruth B. Phillips, 'Performing the Native Woman: Primitivism and Mimcry in Early Twentieth-Century Visual

Culture', in Lynda Jessup ed., *Antimodernism and Artistic Experience: Policing the Boundaries of Modernity*, Toronto: University of Toronto Press, 2001, 26–49.

22. Oscar Jacobson, 'Fording Algeria', *University of Oklahoma Magazine*, 15, 3, 1927, 5.

23. Jacobson, *Kiowa Indian Art*, op. cit., 2–5; see also Robert J.C. Young, *Colonial Desire: Hybridity in Theory, Culture and Race*, New York: Routledge, 1995, 46–50.

24. Jacobson, *Kiowa Indian Art*, op. cit., 6.

25. Ibid., 7.

26. Ibid.

27. Ibid., 9–10.

28. Oscar Jacobson, 'The Meaning of Modernism in Art', *The American Magazine of Art*, 15, 1, 1924, 697.

29. Ibid., 698.

30. Ibid., 701.

31. Ibid., 702.

32. Leonard Good, 'Oscar Brousse Jacobson: Art Pioneer, 1882–1966', in *Oscar Brousse Jacobson: Oklahoma Painter*, exh. cat., Norman, OK: University of Oklahoma Museum of Art, 1990, unpaginated.

33. Erik Camayd-Freixas, 'Introduction: The Returning Gaze', in Erik Camayd-Freixas and José Eduardo-González eds, *Primitivism and Identity in Latin America: Essays on Art, Literature, and Culture*, Tucson: University of Arizona Press, 2000, viii.

34. Phyllis Aldridge Melton Dowling, 'The Meltons and the Jacobsons, Two Families of Friends', *Crosstimbers* (University of Science and Arts of Oklahoma Foundation), Spring 2002, 36. Jacobson's bookplate also bore the image of a Viking ship in full sail with a helmeted man and woman at the prow.

35. From 'Does the Government Welcome the Indian Arts?', a speech delivered to the 1934 convention of the American Federation of Arts, quoted in Pate, 'Kiowa Art', 1974, op. cit., 198.

36. Rasheed Araeen, 'From primitivism to ethnic arts', in Susan Hiller ed., *The Myth of Primitivism: Perspectives on Art*, New York: Routledge, 1991, 159–60.

37. Kiowa Historical and Research Society, James Auchiah folder, interview of 14 August 1974, quoted in Maurice Boyd, *Kiowa Voices: Ceremonial Dance, Ritual and Song*, Vol. I, Fort Worth, TX: The Texas Christian University Press, 1981, 1.

38. Hoxie, 'Native American Journeys', 1992, op. cit., 987.

39. Moira Swinton kindly shared the description of the house in which her father grew up (personal communication, 2 July 2006). Near the end of his life, Swinton recounted the circumstances of his flight to a journalist: 'In 1938, when he was 21, he refused to stand up when the Hitler youth anthem was played in a Vienna café. The next day, a friend who was working for the Gestapo, called with a warning. They were coming to arrest him. Swinton fled to Yugoslavia, eventually ending up in Canada as a refugee.' Gordon Sinclair Jr, *The Free Press* [Winnipeg], 21 October 1997. Untitled clipping from Swinton's artist's file, Library, National Gallery of Canada.

40. Letter of 16 April 1957 to R.H. Hubbard, Chief Curator, the National Gallery of Canada. In this letter Swinton urged that the preponderance of abstract art accepted for the National Gallery's upcoming exhibition of Canadian art was 'retrogressive'. Swinton Fonds, University of Manitoba Archives, A 97-67, Box 2, Folder 2-13.

41. Swinton's rejection of abstraction went against the grain of his artistic circle, which included Ken Lochhead and others who worked with Clement Greenberg at the summer art programme run by the University of Saskatchewan at Emma Lake, Saskatchewan in the early 1960s. In a letter headed Regina, 21 January 1963, Lochhead invited Swinton to see *New American Painters* when it toured to Regina. Swinton taught at Emma Lake in 1963 and attended the talks given by Kenneth Noland. In a letter to Lochhead headed Winnipeg, 29 August 1963, Swinton wrote that he wanted to write a response to Greenberg's 'After Abstract Expressionism' that would be 'extremely provocative… I strongly feel that both Greenberg add [sic] Kosloff … forget, the creation of art is at least also a spiritual act and not merely a technical performance.' Swinton Fonds, University of Manitoba Archives, A97-67, Box 2, Folder 2-19.

42. Norman Vorano, 'Creators: Negotiating the Art World for over 50 Years', *Inuit Art Quarterly*, 19, 3 & 4, Fall/Winter 2004, 9–17 and, by the same author, *Inuit Art in the Qallnaat World: Modernism, Musuems and the Popular Imaginary, 1949–1962*, PhD dissertation, Program in Visual and Cultural Studies, University of Rochester, 2007.

43. Letter of 16 September 1957, to Robert Hubbard, Chief Curator, National Gallery of Canada. Swinton Fonds, University of Manitoba Archives, A97-67, Box 2, Folder 2-13.

44. Toronto: McLelland and Stewart, 1972. A revised edition was published in 1990 under the title *Sculpture of the Inuit*, Toronto: McLelland and Stewart.

45. Mary Jo Hughes and George Swinton, exhibition brochure for *Desires and Imaginings: The George Swinton Collection of 'Innocent Art'*, Winnipeg: Winnipeg Art Gallery, 2000.

46. The *Winnipeg Free Press* for 15 June 1956 carried a photograph of himself and his two daughters admiring the (presumably newly painted) hide. He wears the robe on the cover of his gallery's exhibition brochure, entitled *George Swinton*, New Design Gallery, Vancouver, BC, 7–25 April 1964, Swinton Papers, Winnipeg Art Gallery.

47. G. Swinton, 'Eskimo Art – A Living Art Form', in Victor F. Valenine and Frank G. Vallee eds, *Eskimo of the Canadian Arctic*, Toronto: McClelland and Stewart, 1968, 230–31.

48. Partha Mitter, 'Reflections on Modern Art', 2005, op. cit., 42.

49. On the tradition of anti-modernity see T.J. Jackson Lears, *No Place of Grace: Antimodernism and the Transformation of American Culture, 1880–1920*, New York: Pantheon Books, 1981.

50. George Swinton, 'Faust's death and leisure: some thoughts on time and civilization on the occasion of a visit to the Eskimo', *Perspective '57*, Students' Architectural Society, The University of Manitoba, 1957, 37. Swinton Papers, Winnipeg Art Gallery, folder 'News and Reviews'.

51. Ibid.

52. George Swinton, 'Contemporary Canadian Eskimo sculpture', in *Sculpture/Inuit*, Toronto: Canadian Eskimo Arts Council and University of Toronto Press, 1968, 42.

53. Transcript of interview with Darlene White, 1987, curatorial files, Winnipeg Art Gallery.

54. In a 1987 interview, curator Darlene Wight asked Swinton to expand on his use of the word 'primitive' in relation to Tiktak's work. Swinton's answer reveals his understanding of the 'primitive' as local, non-cosmopolitan and pre- or a-rational. 'Tiktak ... hadn't the slightest idea of where he stood. When he came to his first one-man show here it was the first time he had seen so many of his own pieces... He said, "I have done all this!"... These people are working aesthetically, working through their senses, they express – a sense expression. And when they no longer have this sense expression, it becomes invalid.' Typed transcript of taped 1987 interview, curatorial files, Winnipeg Art Gallery.

55. Quoted in George Swinton, *Tiktak: Sculptor from Rankin Inlet, N.W.T.*, Winnipeg, Manitoba: Gallery 1.1.1, University of Manitoba School of Art, 1970, 1. Esther Tennenhouse quoted this statement in her review, 'Titktak Reaches Plateau with One-Man Show Here', *Winnipeg Free Press*, 19 March 1970.

56. 'Tiktak fashions soapstone into tales of Eskimo Life', *Winnipeg Tribune*, 19 March 1970.

57. Quoted in Georgen Swinton, 'The Sculptor Tiktak', *Artscanada*, 17, June 1970, 4. Caption for Tiktak's *Mother and Child* in Peter Mellen, *Landmarks of Canadian Art*, Toronto: McClellan and Stewart, 1978, 75.

58. See my essay 'Norval Morrisseau's Entrance: Negotiating Primitivism, Modernism, and Anishinaabe Tradition', in Greg Hill ed., *Norval Morrisseau: Shaman Artist*, Ottawa: National Gallery of Canada, 2006, 42–77, for a more detailed discussion of Morrisseau and his early mentors.

59. The teacher was almost certainly Eldon Grier, freshly returned from Mexico and hired in 1946 to teach fresco painting (*Annual Report of the Art Association of Montreal*, 9). The influence of the Mexican muralists in Montreal at this time is also clear from the Ecole de Beaux Art's (the other major Montreal art school) hiring in the same year of Stanley Cosgrove, who had just returned from working with José Clemente Orozco on a mural for a Mexican hospital. I am grateful to Denise Leclerc of the National Gallery of Canada for her help in establishing these connections.

60. See Molly Lee on Herbert Gans' notion of the taste culture, 'Tourism and Taste Cultures: Collecting Native Art in Alaska at the Turn of the Twentieth Century', in Ruth B. Phillips and Christopher B. Steiner eds, *Unpacking Culture: Art and Commodity in Colonial and Postcolonial Worlds*, Berkeley, CA: University of California Press, 1999, 267–81.

61. This statement and other information about the Weinsteins' relationship with Morrisseau was kindly provided by Dr and Mrs Weinstein during interviews with the author in Paris on 6–7 July 2004, unless otherwise cited.

62. Anishinaabe is a collective term, preferred today, for the Ojibwe (or Chippewa), Pottawatomie, and Odawa peoples.

63. See, for example, Picasso's interview with Andre Malraux, in Jack Flam with Miriam Deutscher eds, *Primitivism and Twentieth-Century Art: A Documentary History*, Berkeley, CA: University of California Press, 2003, 33.

64. Selwyn Dewdney, 'Birth of a Cree-Ojibway Style of Contemporary Art', in Ian A.L. Getty and Donald B. Smith eds, *One Century Later: Western Canadian Reserve Indians since Treaty 7*, Vancouver: University of British Columbia Press, 1978, 120.

65. Ibid.

66. Letter from Selwyn Dewdney to Norval Morrisseau headed '9 March 1961', Dewdney Papers, INAC 306065. In another letter he reiterated, 'I like to do art on plyboard – reminds me of birch bark.' (letter from Norval Morrisseau transcribed by Selwyn Dewdney and headed 'February 1961', Dewdney Papers, INAC 306065).

67. Caren Kaplan, *Questions of Travel: Postmodern Discourses of Displacement*, Durham, NC: Duke University Press, 1996, 4.

68. Hal Foster, 'The "Primitive" Unconscious of Modern Art, or White Skin Black Masks', in *Recodings: Art, Spectacle, Cultural Politics*, Seattle, WA: Bay Press, 1985, 196.

69. Joan Lowndes, 'Art of the Eskimos is given a boost', *Vancouver Sun*, 29 September 1972, 33. Swinton also told another interviewer in 1965, 'I have found my roots in the Prairies and in the North, and I declare my sensuous spiritual love for them as well as for the human figure in repose and for the Passion of Christ. They are not merely subject matter for me, they are my life.' Raul Furtado, 'George Swinton: Painter of the Canadian Prairies', *Art Voices*, Winter 1965, 133.

70. Email from Jean-Hubert Martin to Rhiannon Vogl, 3 April 2006.

71. Personal communication to Rhiannon Vogl from Gabe Vadas (Morrisseau's adopted son who accompanied him to Paris), April 2006.

ABORIGINAL MODERNISM IN CENTRAL AUSTRALIA

IAN McLEAN

...traditionalism and authenticity are now completely false judgments to assign to Aboriginal painting practices. This is borne out by contemporary ethnography and material history. The situation I worked in at Yuendumu demonstrated unequivocally that the Warlpiri painting I saw, even if it accepts the label 'traditional' as a marketing strategy, in fact arises out of conditions of historical struggle and expresses the contradictions of its production. This is really where its value and interest as 'serious' fine art lies; furthermore, it may also be the source of its social legitimacy. To make any other claims is to cheat this work of its position in the modernist tradition as well as to misappropriate it and misunderstand its context.
Eric Michaels, 1988 [1]

Remote Aboriginal painting earned a place in the contemporary global art world without any debts to modernism, as if it arrived fresh and new by some historical accident. The conventional art historical narrative traces the origins of the Desert art movement to the establishment of the Papunya Tula Artists Pty Ltd in 1972, at the very moment that modernism was supposedly disintegrating. While occasional claims for the modernism of Central Australian (or Western Desert) acrylic paintings were made when they caught the eye of the art world in the 1980s, they were more rhetorical than substantial. Based on superficial stylistic affinities with western modernism, they have since been discredited.[2] Curators still sometimes juxtapose these two very different traditions, but for poetic effect rather than any didactic point.

Resistance to the idea of Aboriginal modernism derives from a respect for the unique difference and identity of Aboriginal culture, and a subsequent reluctance to relate its abstract designs (derived from traditional body and ground paintings) to the aestheticised abstraction of western modernism. If these days modernism is rarely understood simply in terms of style, it is still considered the cultural front of modernity's assault on traditional European norms. While modernity also challenged traditional cultures in other parts of the globe, modernism remains the brand name of European (and more generally western) aesthetic engagements with modernity. It is presumed to be the natural inheritance of post-Renaissance European culture, but has also been understood as an alien invader that cripples and even destroys other traditions. Modernity is blamed for the destruction of Aboriginal culture rather than the inspiration for a new Aboriginality. Until recently, post-contact Aboriginal art was seen as the sad evidence of acculturation and assimilation – the very opposite of the triumphant originality of European modernism. Hal Foster, whose sense of contemporary and post-colonial art is staged by his local New York scene, exemplifies this approach. For him the Australian Desert artists are lost in some tangential third space over there, gone walkabout between the 'archaism' of traditional Aboriginal practices and the 'assimilation' of modernity.[3]

While contemporary Aboriginal art has been written about in conventional modernist terms of subversion and outsider identity (rather than acculturation and assimilation), and even as a type of conceptual (or anti-modernist) art,[4] an appreciation of its modernism has eluded contemporary critics. The art world consensus is that it is a *contemporary* rather than modernist

practice – as if the notion of the modern is not a framework that can be imposed on either the global practices of contemporary art or art that originates in non-western traditions. Indeed, because the Central Australian Aboriginal painting style is widely believed to have emerged suddenly and fully formed in the 1970s, it can hardly be said, like western contemporary art, to have a genealogy in modernism.

It might seem that the lack of a modernist genealogy should not be regretted. Since the 1970s contemporary art has disavowed modernism as irretrievably Eurocentric, masculinist, heterosexual and white. For a while 'post-modernism' was a popular term to describe this turn away from modernism, but 'contemporary' has prevailed. Indeed, the notion of the 'contemporary' has enabled a profound shift in the reception of not just Aboriginal art, but other art that, under the regime of modernism (and post-modernism), had been out of bounds.

However, I will argue that Aboriginal modernism is a productive idea. The contemporary, unlike the modern, remains an ephemeral concept – a type of pure event divorced from historical context or temporality, an ideology-free zone. If this weightlessness gives it some purchase in the fluid post-ideological field of globalism,[5] it cannot illuminate the historicity of Aboriginal art. It thus fails to account for the profundity of post-contact Aboriginal art and the full scope of its achievements in the modern world. Because the idea of modernism is part and parcel of an established historical discourse on modernity, it is capable of tracking Aboriginal art in the long march of colonial modernity through Aboriginal country and, in doing so, narrates a story that begins not in the 1970s and '80s, but much earlier with first contact. The notion of

Aboriginal modernism thus has considerable rhetorical power: it re-positions contemporary Aboriginal art in its own colonial origins, and consequently challenges art history's dominant Eurocentric discourse.

I doubt that Eric Michaels had all this in mind when, in the above quote, he decided to call Warlpiri painting 'modernist'. He was an anthropologist not an art critic, and tended to apply the terms 'modernism', 'post-modernism' and 'contemporary' to Aboriginal art more or less interchangeably, depending on the particular point he was making. His social science background meant that, for him, the notion of modernity had been something like a universal constant since the Enlightenment; and that all cultural expressions since then were manifestations of modernity's rationalisation of the world. His anthropological project in Yuendumu investigated the effects of television and video on Aboriginal culture. No wonder he saw the new paintings being made there as engagements with modernity and therefore modernist – a common-sense sociological approach that this essay also adopts.

Michaels recognised an agency in Aboriginal art that is discounted by the general assumption that modernity reduces the differences of traditional non-western cultures and subjects them to quite alien impulses. Even the post-colonial critic Nikos Papastergiadis, precisely because he is acutely sensitive to the Eurocentric bias of modernist criticism ('the silencing that occurs by the very [modernist] rules of representation in the discourse of art'), asks: 'can practices that were previously categorised as "Other" suddenly emerge within the parameters of modernity's self-identity?' This hesitation is further reiterated when he adds: 'How will the

discourse of contemporary art, which is predominantly Eurocentric and presupposes a break with the past, address non-Euro-American art practices that display a complex negotiation between tradition and modernity?'[6]

If art critics are fearful of assimilating remote Aboriginal art into Eurocentric conventions by the very methodologies they use (the methodologies of art history are, after all, classically modernist or Kantian), Aboriginal people have rarely hesitated to appropriate modern European technologies and discourses for their own ends. The fear that applying theories of the modern to remote Aboriginal art will assimilate its differences into Eurocentric concerns is paternalistic and ignores the ways in which Aborigines have, since the time of first contact, readily sought to translate, assimilate and use the cultural products of modernity. Aborigines have been as true to the Enlightenment project as many European modernists, ever willing to modernise whenever they saw advantageous alternatives to the limits of their own traditional practices.

The notion of Aboriginal modernism is consistent with the inherent 'worlding' and universal reach of modernism and modernity, and has become theoretically credible with the recent sociological and anthropological turn in art historiography. The latter has made modernism a much broader church. Instead of being narrowly focused on formal novelty and artistic autonomy, the innovative aesthetic expressions of modernism are now understood in terms of their engagements with the wider social sphere of modernity. Nevertheless, the formalism of post-contact Aboriginal art should not be ignored. In an uncanny fashion, such painting often looks like the classic aestheticised modernism that, for example, Clement Greenberg advocated. Is it possible, then, that as well as inhabiting colonial modernity, Aboriginal artists also participated in that (Hegelian) world-setting self-critical dialectical discourse that Greenberg and others identified with modernism?

The Modernity of Dreaming
For coloniser and colonised alike, the path to modernity and its liberty is theorised as a complete break with tradition (whatever its form). This is why migrant and diaspora discourses dominate critical thinking on contemporary art, and why the othering of the tribal and the indigenous is the most persistent of western beliefs. Somewhat ironically, modernity's open space of cosmopolitanism has no room for Aboriginal ancestral worship and its ideology of place. The latter (it is presumed) cannot be simply modernised, because one of modernity's principal effects is the disintegration of place – or the 'disembodying'[7] of Dreaming (the rich histories of ancestral sites and tracks that locate individual identity in particular places) from its particular sites and ecosystems. Modernity builds its edifices from ground zero: an accord between ancestor worship and cosmopolitanism is not negotiable. In rationalising time and space so that both are organised by a global, indeed universal, cartography and temporality, modernity tears the localism of pre-modern space and time from place: as Anthony Giddens argues, 'locales are thoroughly penetrated by and shaped in terms of social influences quite distant from them.'[8] This is why modernity was so catastrophic for Aboriginal societies: it was not just a matter of superior firepower, radical ecological changes or the devastating effects of exotic diseases, but entailed a process whereby:

the modes of life brought into being by modernity have swept away all traditional types of social order, in quite unprecedented fashion. ...The changes occurring over the past three or four centuries – a tiny period of historical time – have been so dramatic and so comprehensive in their impact that we get only limited assistance from our knowledge of prior periods of transition in trying to interpret them.[9]

Modernity's apocalyptic effects on all traditional societies, including Aboriginal ones, are undeniable. However, such argument easily slips into a binary logic that flattens the ambiguities of the colonial encounter and silences the historical adaptations of the colonised; thus colonising them all over again. This binary logic is a principal reason why western critics have had such difficulty in accepting the modernism of non-western and especially tribal art. In reality, the agents of tradition did what they always had: they adapted and adjusted to the new, even appropriated some of its ideas and practices. Admittedly the adjustment was often bumpy and at times contradictory, but the history of Aboriginal modernism is the story of such adaptation. While the Warlpiri might watch television, drive Fords and are successful contemporary artists, they nevertheless remain ancestor worshippers who, like their forbears, live in the Dreaming.

The theorisation of ancestor worship and cosmopolitanism within a binary politics of place and identity represses a shared history of displacement among indigenous peoples and colonial settlers: each is entangled in a similar pain for home. The nation-state, which is the characteristic sociality of modernity, is the new collective memory for those whose local ancestors were dispersed by the great migrations of our times (both within and without the nation). Indigenous Australians have not escaped the cosmopolitanism of our times. About three-quarters live away from their ancestral homelands, most being first- or second-generation migrants, or more accurately internal refugees.

The great Aboriginal exodus to urban centres occurred after the 1967 referendum, which gave Aborigines citizenship and allowed them to move freely around the country. This journey from voiceless oblivion to post-colonial subjectivity has, in the last 15 years, paid significant cultural dividends. For example, Gordon Bennett and Tracey Moffatt, the best known of such urban art practitioners, discount their Aboriginality and make art that follows, in an almost classic sense, the post-colonial paradigms of migration – of exiles, diasporas and strangers. Because these paradigms now frame much contemporary art practice around the world, such urban indigenous art is readily incorporated into the established history of Australian and western modernism. However, these paradigms privilege a particular set of experiences that do not match those Aborigines who still walk with their ancestors, the Aborigines of so-called remote Australia.

The art of the other quarter of Aborigines who still live in remote communities, mainly in the centre and North of Australia, speaks of quite different experiences to their urban counterparts. This is not to say they have not experienced displacement. In Central Australia modernity first arrived in piecemeal fashion towards the end of the 19th century, and within 50 years had caught up with the rest of the desert-dwelling Aborigines. At first confined to a relatively narrow strip up the centre of Australia and the outer periphery of the desert, modernity's vanguard (missionaries,

anthropologists, surveyors, prospectors, police and doggers) began having contact with Aborigines deep in the desert from the late 1920s. After World War II, the establishment of a military testing facility centred in Woomera, and the government's adoption of assimilation policies, resulted in the remaining Aborigines being trucked hundreds of miles to new administrative centres and missions on the edge of the desert – such as Papunya, Yuendumu and Balgo. This occurred in the mid-1960s. The Desert art movement began shortly afterwards at these places and was instigated by those who led their people out of the desert.

The distinctive look of contemporary Central Australian Desert art is (in part) due to the continuing presence of the ancestors in Aboriginal lives: in short, the exile did not take root. There are three reasons why. First, Aboriginal song, dance and painting are mnemonic maps, allowing Aborigines to carry their sense of place in their minds, wherever they happen to be. Second, with the government's apparent abandonment of assimilation for self-determination in the 1970s, many returned to their homelands in the outstation movement. Third, these desert people had for thousands of years made long journeys and interacted with different tribal groups hundreds of miles apart. The desert was a very cosmopolitan place before the arrival of modernity; so the enforced movement was not itself outside their lived experience and mythological tradition. The ancestors are great travellers.

These factors, however, do not mitigate the profound dislocation of modernity on Aboriginal lives: but the Central Australian story is one of adaptation not ethnocide. The mid-20th-century migration to the administrative centres was decisive for the art movement because its immediate sense of loss was countered by painting and singing to the ancestors as a way of imaginatively returning home. The sale of the paintings to buy Toyotas made the return real. How then do we theorise this Aboriginal pain or longing for home in the shadow of globalisation?

Papastergiadis recently observed that travel is not enough 'to broaden the mind' as he suggests that, 'there must also be the shock and pain of difference': the new cosmopolitans are not those travelling élites who by virtue of being 'constantly on the move' inhabit the 'non-places of global culture', but rather those 'who must confront the *turbulence* [my emphasis] of globalisation without leaving their homes.'[10] The remote communities are not the affluent streets of green suburban estates or chic urban centres, but amongst the most violent and degraded places in the world. Here, modernity continues to wreak its havoc and yet the residents are not strangers in their land (thus the turbulence of modernity is all the more intensified). The ancestors are but a heartbeat away and it is their continuing presence that inspires the artists. This is even the case for those who do not live on outstations that are close to their Country (an Aboriginal term for places that are particular to their Dreaming) – as with many of the artists at Balgo (a former Catholic mission, now an administrative centre). Kim Mahood described the Balgo Art Centre as 'a kind of portal' to Country:

> [Eubena, grand matriarch and number one painter] sits in her customary position on the floor of the art centre, and paints for hours on end. …All distractions including the busy *kardiya* who keep the whole enterprise running, have been excised from her consciousness. She has gone away into her country, re-inhabiting it brushmark by brushmark, like walking or breathing.[11]

Emily Kngwarrey (Eastern Anmatyerre *c*.1910–96), *Big Yam*, 1996

The poignancy of this aesthetic home-coming – of this 'future-orientated nostalgia' (to coin another of Papastergiadis' telling phrases) – is the desire to be with the ancestors, which is keenly felt by the old people, especially the painters – most of whom came of age in the desert (before the great round-up of the 1960s). However, the pull of the ancestors (or Dreaming) must be seen in the context of modernity. While much remote Aboriginal art is closely aligned with ritual revival, Dreaming survived modernity because its designs have been made into a modernism. Central Australian acrylic paintings are the direct result of modernity in the artists' lives and exhibit many of the classic characteristics of modernism – such as heightened formalism, aesthetic innovation, freedom from the demands of religious function and successful participation in the art world.

The Australian art world recognised these developments about 20 years ago, with the art of Emily Kngwarrey confirming the modernism of Aboriginal art. Now the best known and most celebrated of the remote Aboriginal artists, Kngwarrey burst into the art world in the late 1980s. Over the next several years she worked rapidly through a series of large abstract formats that were hailed for their modernism and break from the iconography of Aboriginal art – a move that has since been followed by many Aboriginal artists (including urban ones). Yet many art critics questioned the modernism of her art, pointing out she was an elderly (she was born at about the same time as Jackson Pollock) illiterate woman who knew little or nothing about the western modernists to whom her art was often compared.[12] Her paintings were so outside the normal expectations of Aboriginal art and yet so close to the aesthetic moves of western modernism that Rex Butler called her 'the impossible painter' – by which he meant that her art seems so familiar (to us western modernists) yet emerges 'from so unlikely a source'.[13]

This ambiguous achievement of remote Aboriginal art is evident in the art world's failure to integrate Aboriginal art into the history of modernism and Australian art [14] – as is plainly evident in Australia's major public art collections, where Aboriginal art is generally isolated from the gallery display of strong historical narratives of modernism and refused its own history.[15] There is no permanent collection of Aboriginal art that presents an historical sense of its aesthetic development (as there is for settler art). Curators do not even seem to know how to situate the Papunya School in the post-1970s story of contemporary settler Australian art even though it dominates the period. It is rare to find an Aboriginal exhibition that does not emphasise the traditional affiliations of the art, yet skirts its modernist genealogy. Despite some excellent research that has outlined this larger history, the occasional attempts by curators to articulate an Aboriginal modernism, while laudable, are generally superficial: usually the glib hanging of a Central Australian acrylic next to an abstract western modernist painting. Missed by both approaches (traditionalism and modernism) are the specific historical conditions of remote Aboriginal art. The former elides the social, political and aesthetic differences between traditional and contemporary practices; the latter presumes that modernism is simply a matter of style, and a style emanating from a few western centres.

The reasons for this impasse are not curatorial ineptitude but the binary logic of current art theory that regards the defining

coordinates of contemporary Desert art – modernism and Dreaming, cosmopolitanism and ancestors – as mutually exclusive. There is excellent scholarship on Central Australian painting, but what is lacking is both an appropriate theory of modernism and a full historical account of Aboriginal modernism that locates it in the story of colonial modernity – which in Central Australia is now more than 100 years old.

Towards a Theory of Tribal Modernism

Modernity is a universal condition. It inaugurated a genuine world history, inexorably pulling all cultural traditions into its orbit (conceptually, politically and economically). Thus Anthony Giddens cautions that 'modernity is not just one civilization among others' [16] and that the new post-colonial order, in which western economies are rapidly surrendering their former hegemony to non-western ones, is due to the triumph of modernity and not its decline.

Far from being a purely western or European construct, modernity is a mode of living that has taken root in many traditions, including ones often considered antithetical to it. Just as there were large urban centres, merchants, travel and even tourism before modernity, so too are there villages, kinship systems, and tribal, religious and other traditional loyalties after it. But they harbour a very different consciousness. We should not be fooled by the lifestyle of these elderly Aboriginal men and women in their outstations: their homage to Dreaming is staged by the modernity of their lives. They are not trapped between two oppositional worlds in some dysfunctional schizophrenic space, but have a coherent symbolic order that, while distinctly Aboriginal, is modernist. Their art and life demonstrate, in

the words of Aboriginal activist, Noel Pearson, that 'it is possible to choose to maintain an Aboriginal identity and be completely able to interact with modern society.' [17] Indeed, a telling symptom of modernity is the successful maintenance of just such a 'layered identity' (as Pearson calls it).

Modernity is also not something that can be pinned down to any one set of institutions or practices. In the 19th century it became a spirit that permeated everything and all places (to some degree). This notion of modernity as a *zeitgeist* has become the central organising concept in discussions of contemporary society and culture across the disciplines, and shows little sign of disappearing (despite the perceived anachronism of the term 'modernism'). Whether they relate to industrial egg production or the production of a scholarly essay, the signs of modernity are ubiquitous and instantly recognised. Like the proverbial ether, modernity is the medium in which all things now mix and, as such, is the explanatory principle, mythology or symbolic order that shapes all social meaning. Thus if modernity has many phenotypes – of which Aboriginal modernity is one – there is one shared genotype or consciousness that organises its myriad forms. With modernity, each area of life gains an autonomy in which its own practice and knowledge system is its self-justification. This radical reflexivity is, in essence, formalist and self-critical, for its action (which is the action of the scientific method) renders all content uncertain, up for revision. What prevails is the form or structure of knowing, rather than its content.

If all modernisms are reflexive, highly formalised and self-critical, how did Aboriginal modernism emerge from practices steeped in tradition? First, we may say that it erupted

spontaneously in zones of contact between settlers and Aborigines, as if passed on by some virus or microbe. One example occurred at the end of 1801, when the English naval officer Matthew Flinders anchored in King George Sound (in Western Australia) for three weeks. Modernity made a brief appearance in the form of surveying, plant collecting and sketching, and the cosmopolitan spirit of friendly exchanges between strangers. As a finale to his visit, Flinders brought the uniformed marines ashore to stage a parade for a few Aborigines who had attached themselves to the party – no doubt they were Minung people who were owners and custodians of the site where Flinders had camped. The delighted Aborigines responded with their own performance that mimicked the marine's formal drill.[18]

Mimicry might be a universal aesthetic strategy and Aborigines are renowned mimics, but the particular choreography of this performance had no precedent in Aboriginal tradition. Rather it had all the hallmarks of modernism. The abstract caricature of the Minung mimics followed a formalist or aestheticised sensibility already evident in the marine's drill. Rhythm and a sense of form are the last resort in the face of unknown or untranslatable content. Here this nascent Aboriginal modernism was essentially a cosmopolitan aesthetic that sought a space of communication or universal language between strangers, and one in which existing content or meaning was necessarily ambivalent and open for negotiation.

What was this remarkable little episode about? Was it an attempt to incorporate the visit by Flinders into the Aboriginal stories of this place and hence into Aboriginal cosmology? Was it simply having fun? Or was it satire: having

a laugh at the strangers? While we may never know the answer conclusively (it was perhaps all three), Daisy Bates reported a meeting (in King George Sound) in 1908 with Nebinyan, a Minung Elder who claimed to be the grandson of the man who led the dance with Flinders 100 years earlier. Nebinyan related that his grandfather's spontaneous mimicry had become an important sacred Koorannup (home of the dead) ceremony. The dancers' bodies were painted in red and white clay emulating the marine uniform and their choreography followed that of the ancestral beings who originally taught it to his grandfather – for Flinders and his crew were considered the spirits of ancestors returning briefly from the home of the dead across the sea.[19]

Thus the marines' drill was absorbed into traditional life as a Koorannup ceremony from the Dreaming. Yet in 1801 it had also been an aesthetic and emotional response to and engagement with the rationalist endeavours of these strangers; and one that had the reflexive and formalist attributes of what later became known as modernism. This suggests, at some level, a universal taste or comprehension of form and rhythm that made up for the lack of a shared language between the two parties – and on this view such a sense of reasoned form would be innate in humans rather than a unique expression of Enlightenment rationalism or, as Europeans previously thought, something learned from studying classical Greek statues, which, in fact, is exactly the claim of Kant and his contemporary theory of universal taste that Greenberg later called modernism.

The Enlightenment quest for the inner logic of things often led to the very places that reason had either discounted or foreclosed. It took artists straight to romanticism and then modernism: a search for the laws of art in its own purpose

and formal attributes. As early as 1772 Goethe suspected that the art of 'savages' retained an innate (animal) sense of form and formal integrity:

> Even though this [savage] picturing is composed from the most arbitrary forms, it will harmonise in spite of the fact that the forms themselves are not in proportion, for one intuitive feeling created them into a characteristic whole. This characteristic art is the only art.[20]

If Goethe is right, the vivid formalism of contemporary Aboriginal art owes as much to existing Aboriginal intuition as it does to the conditions of modernity and is perhaps why Aborigines were well placed to become modernists. In a similar vein, the anthropologist W.E.H. Stanner argued that the development of Aboriginal thought takes an 'aesthetic rather than an intellectual course',[21] and that this aesthetic sensibility – an attention to rhythm and form – is what alerts Aborigines to the force and action of Dreaming in the world. The post-creation world is not so much an allegory of fixed intellectual meanings (i.e. iconography) but an aesthetic field that must be interpreted through an intuitive feel for its symmetries and patterns. As Stanner suggested:

> If the aborigines consciously appreciate any aspect of the geometric idiom, then it is probably the aesthetic aspect.... . [For example, a circle] may be intended to show a camp, a waterhole, a secret centre [...], a sacred totemic site, a yam, a woman's breast or womb, or the moon. The range defines a category, and the ultimate

denotation of the sign is presumably the ground or principle of the category. But its nature or definition cannot be elicited by direct [intellectual] inquiry.[22]

He concluded: 'I have found no way of fixing specific social meaning on the spatial forms. They recur so frequently, however, ... that they seem a kind of "furniture of the mind".'[23] Thus, Stanner argued, 'The symbolical accompaniments of the ceremonies become loved, not for their recondite import, but for their own sake.'[24] This, he believed, gave the Aborigine 'the power to adapt the work of his imaginative mind to the unfolding of history.'[25] When the catastrophe of modernity struck, Aborigines were thus equipped with a sensibility, an aesthetic means, for meeting its challenge. The test, however, is to determine how well this Aboriginal aesthetic sensibility served them in adapting to modernity and to what extent these aesthetic adaptations are modernist (or participate in its aestheticised discourses).

Taking this brief account of cross-cultural encounter as a starting point for re-thinking Aboriginal modernism, we can see how the key terms of analysis call for a revision of the conventional art historical narrative. This narrative, repeated in nearly every text on the Desert art movement, begins with the seminal role of an art teacher from Sydney, Geoff Bardon. In 1971, he coaxed some of the leading men at Papunya to paint a mural and, after that, to paint on small boards. The narrative continues with Bardon helping the artists found the Papunya Tula Artists Pty Ltd (a cooperative that organised the production and sale of the art), and climaxes with the men painting larger works on canvas that eventually captured the attention of the art world. However, by giving Bardon such a

prominent role, as if Moses-like he led the artists out of the wilderness and founded a new era, the Papunya art movement is disconnected from both its Aboriginal history and the frontier modernity that shaped its unique form of modernism. As I will demonstrate, the history of modernity and modernism in Central Australia began well before Bardon arrived.

The post-contact history of Aboriginal art shows that whatever the downside of modernity upon Aboriginal lives, it also offered creative opportunities that many hungrily pursued when given half a chance. Aboriginal artists were particularly well placed to exploit the market for primitivism, which played a crucial role in the conception and development of European modernism. However, the authenticity of Aboriginal modernism – the truth of its endeavour – depended not on the artists' entry into the market but on the extent to which their work addressed the role of modernity in the lived experience of Aboriginal traditions. Aboriginal modernism is as much about Aboriginalising modernity as modernising Aboriginality, and the integrity of this project is evident in a history that begins from first contact (and not from Bardon arriving in 1971 or art world recognition in the 1980s). The contemporary Desert painting movement that began at Papunya over 30 years ago is just the post-colonial tip of the iceberg. At least two previous strata can be discerned underneath this recent development and these concern what I call *colonial modernism* and *anti-colonial modernism*.

Colonial Modernism: Turn of the 20th Century
Like most places, modernity first arrived in Australia on European ships and was then disseminated by camels, trucks, trains and electronic media. If in Central Australia it developed along the recognisable routes of *genus modernus*, it evolved in unique ways. The most distinctive feature about the Australian experience is that the steady march of colonisation never got much past the limits of mid-19th-century exploration. Despite further explorations, new technologies and the encroachment of missionaries, police, pastoralists, miners, tourists and art dealers in large areas of so-called remote Australia, Aborigines continue to outnumber settlers.[26] This is not to say that modernity never penetrated the desert, but that it did not come all at once; it arrived in degrees until a threshold was crossed and it became a fixture of the place. Because its Aboriginal inhabitants were not immediately besieged, and because they wanted its technologies, they adapted: they became modernists in their own particular way.

While a few explorers had quickly passed through the Centre a few years earlier, the arrival of modernity can be quite precisely dated to the construction of the Overland Telegraph Line between 1869 and 1872, exactly 100 years before the Desert art revolution pioneered at Papunya. A range of frontier modernities gradually developed along the slender corridor of the Overland Telegraph Line, but the most important in the emergence of colonial modernism was the cross-cultural interaction among Aborigines with missionaries and anthropologists. The missions were intent on modernising Aborigines, while the anthropologists were keen to document the last primitives before they disappeared altogether. Nevertheless, anthropologists were a significant influence on the development of Aboriginal modernism. Their ability to introduce artefacts into the market fostered the neo-traditionalism that became a dominant characteristic of

Baldwin Spencer,
Arrernte women dancing
to the music made by the
men, Charlotte Waters,
6 April 1901

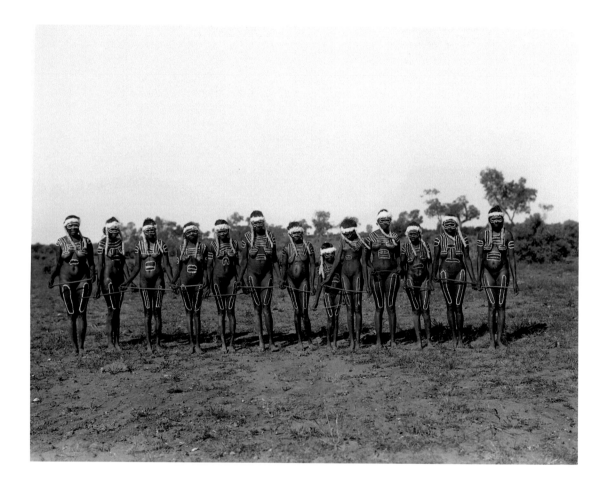

Aboriginal modernism in the latter half of the 20th century. Thus, this anthropological alliance with the ancestors was decisive in the development of Aboriginal modernism.

a. The anthropologists
Anthropologists began arriving in the Centre during the 1890s, some 20 years after the local Aborigines first came into contact with Kardiya (white men). By then the Aborigines had learnt that Kardiya preferred their artefacts decorated with coloured paint and other materials. 'Make it flash', they say. So began the first stylistic move towards an Aboriginal modernism, namely the aestheticisation of artefacts. This suited Aboriginal artists because such decorative formalisation was a traditional way of hiding inside knowledge: it simultaneously mimicked Aboriginal pedagogical art practice and European expectations of authentic primitive art.

The first important anthropologist in the area was Baldwin Spencer, who made expeditions in 1894, 1896 and 1901–2. He had such an insatiable appetite for Aboriginal artefacts (and biological specimens) that wherever he went he created a local arts industry. Spencer was after authentic Aboriginal art; he sought to document the savage life. However, he mainly stuck to established tracks, working from the small settlements around the telegraph stations – such as Alice Springs. Here, in 1894, he met his principal collaborator, the postmaster Frank Gillen. Alice Springs was also his main base in 1896. He returned five years later, when he also worked around other telegraph stations at Charlotte Waters and Barrow Creek. These were convenient places for the anthropological investigation of Aboriginal life. They were built in the middle of thriving Aboriginal communities previously untouched by European civilisation, and their novelty and modernity also attracted other Aborigines, all of whom conveniently camped nearby. For these reasons, such settlements were also the vanguard or frontier of a nascent Aboriginal modernity.

Spencer made a large and invaluable photographic record of these camps – mainly the everyday lives of their inhabitants and sometimes their ritual performances and art. By the time Spencer arrived in Alice Springs, the local Eastern Arrernte were seasoned negotiators with the Kardiya. Their leaders were his principal informants, collecting artefacts and arranging for Aboriginal performances on the edge of town for Spencer and Gillen to document. These were not actual ceremonies but entertainments performed for Spencer's camera. Judging from the photographs, these performances had a 'staged' feel to them: stiffly posed noble savages re-enacting ceremonies for a foreign audience. Spencer thought he was documenting original Aboriginal dance and art, and indeed he was; but the originality was in a modernist rather than anthropological vein – it was neo-traditional rather than traditional. As Michael North observes of African American imitations of white minstrel performers being made at much the same time: 'Black performers *are* original not because they possess originality as a quality but because they produce originality as a commodity.'[27] Spencer's interest encouraged a hybrid neo-traditionalism that became an important hallmark of Aboriginal modernism. Needless to say, it is also a hallmark of other modernisms across the globe.

Whatever their inevitability, modernity and modernism are never easy developments. There were considerable difficulties in the negotiation between tradition and neo-traditionalism. Gillen

notes in one letter to Spencer his problems in convincing a subject to be photographed naked. One publisher asked Spencer for new photographs because some of the Aborigines were clothed and a European was also in a scene.[28] Nakedness was important to the anthropologists because it was a sign of the authentic rather than modern savage. Unfortunately for Spencer, it was a rule that Aborigines be clothed while in town; and many had become attached to their clothing as symbols of modernity.[29] However, these difficulties were negligible compared to those faced by the Aborigines. The problem was the secret nature of their religion and much of its ceremony, which could only be divulged to initiates. Several Aboriginal informants were killed for revealing too much information to Kardiya. It came down to the subtle but important differences between insider knowledge restricted to indigenous groups and outsider knowledge for public consumption. Their relationship is the familiar one of deferral or *differance*: the outside is an analogy of the inside to which it defers; its form mimics the look of the inside without revealing its inner secrets. In abbreviating the full 'inside story' by highlighting a few colourful episodes, 'outside designs' play an important role in Aboriginal pedagogy by progressively taking the initiand from the outside towards the inside. They allow inside knowledge to travel widely and safely: to flex its muscles without delivering its punch or revealing its secret content. Neo-traditionalism adapts this traditional pedagogical function of outside art to the new condition of modernity, to produce marketable artworks.

If this pedagogy is what the Aborigines also sold to Spencer, then a key motive of Papunya painting – namely educating the Kardiya – was being established from the point of first contact.

From very early on, ritual designs had become a commodity to be traded as art. But where the conventional art historical narrative tends to see the loss of authenticity, from the Aboriginal perspective the Kardiya were simply paying for their education. This neo-traditional pedagogy was also the testing ground for a new type of art. Once painted on the skin of ceremonial bodies and earth, these outside designs have since been transferred to the more portable and saleable skin of canvas.

b. The missionaries
It should not be surprising that the transference from ritual to commodity first occurred in an overt sense on missions, because European missionaries were actually attempting to modernise Aborigines. The best known and most obviously modernist examples of cross-cultural artistic production in this context are the toas. Made from wood, they vary from 15 to 57 centimetres in length and feature a pointed end and a decorative shaft. They were made around 1904 on the Lutheran mission at Killalpaninna, shortly after ethnographers visiting the mission expressed interest in collecting artefacts, and when an artist, Harry Hillier, who had previous experience with tribal art, was teaching there.

Pastor Johann Reuther collected over 400 toas with the intention of selling them locally and overseas. Most were sold to the South Australian Museum in 1907. Reuther, a keen ethnographer, recorded the mythological significance of each toa but not the name of the artist. According to him, they were pegged in the ground at deserted camps to indicate the destination of the group. However, there is no evidence of such way-markers being made before 1904 or after 1906 when Reuther and

Killalpaninna toas, c.1904

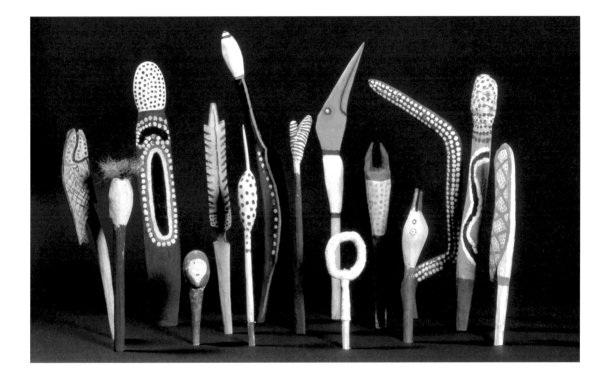

Hillier left the mission. It has been speculated that they are decorative versions of markers sometimes used to denote local resources or the edge of ceremonial grounds.

The origin of the toas remains something of a mystery. The only satisfactory explanation is their deliberate modernism, as if adapted from traditional designs to satisfy the European market for primitive art. I suspect they are secular versions of Aboriginal secret sacred objects usually held in the hand, such as turingas and bullroarers. Powerful and dangerous, these objects are storehouses of tribal knowledge upon which ceremonial body and ground paintings are based and from which their legitimacy (copyright) derives. Europeans discovered them in the 1890s. Large numbers were looted, mainly by Lutheran missionaries who sold them to German museums. Hence it makes sense to consider the toas harmless but prettier (aestheticised) replicas of these secret sacred objects, intended to meet the expectations of a new market and at the same time to protect the original secrets of such sacred objects.[30]

For most of the century, toas were considered inauthentic hybrid artefacts. The museum, anthropologists said, was victim of a deliberate hoax. Only in the mid-1980s, when the art world and anthropologists finally accepted the authenticity of tribal hybrid artefacts and the notion of contemporary Aboriginal art, were toas recognised for what they were: namely a hybrid art form – what I call colonial modernism.

In resisting the onslaught of modernity by adapting it to their traditions, a new type of Aboriginal artist emerged: the Aboriginal modernist. This was an entirely Aboriginal invention; it mimicked Aboriginal tradition, not western modernism. After all, in their time the toas looked nothing like western modernism – it would take another decade, with Picasso's cubist sculptures, before such stylistic affinity might be glimpsed. Settler Australian modernists, still struggling with an impressionist aesthetic, had no intimation of the primitivism that was just beginning to stir a small section of the European vanguard. The toas were, in the spirit of modernism, ahead of their time: the most abstract modernist art being made anywhere in the world. They herald the Desert acrylic paintings that caught the imagination of the art world some 70 to 80 years later, except they were marketed as tribal primitivism and not as modernist fine art.

Anti-colonial Modernism: Mid-20th Century

The role of World War I in sparking anti-colonial sentiment across the globe has been widely acknowledged. Settler Australians, loyal subjects of Britain and empire before the war, discovered a newfound nationalism after it. There was a move amongst some settler Australian artists to develop a new national art that drew on Aboriginal motifs, in much the same way as Mexican artists at the time hoped for a new Hispanic modernism. Australian settler art went through a rapid process of Aboriginalisation that, paradoxically, established the modernity of Australian art and a sense of identity that still figures strongly in the Australian imagination. The source of inspiration of such settler Australian modernists was Arnhem Land bark painting rather than Central Australian art. For them the primitivism of these bark paintings confirmed the modernism of their own art. However, the best-known Aboriginal artist of the day, indeed the best-known Australian artist of the day,

was the Central Australian Arrernte man, Albert Namatjira, who eschewed primitivism for a very different brand of modernism. He was the first Aboriginal painter to compete and exhibit with contemporary settler painters as a modernist.

If the Overland Telegraph Line inaugurated colonial modernism, anti-colonial modernism in Central Australia was an unexpected outcome of the railway link to Alice Springs, completed in August 1929. It opened a new market for Aboriginal art by facilitating visiting tourists and dealers in the southern capitals. It also brought settler artists to the Centre. Many visited the Lutheran Hermannsburg mission, which was conveniently located nearby in the midst of a friendly Aboriginal community. This increased interaction with Aborigines by settler artists was the catalyst for a new type of cross-cultural Aboriginal art that, for some at least, embodied a new post-Aboriginal Australian modernism.

The Lutheran missionaries were the first permanent European settlers in Central Australia. Carl Strehlow arrived in the mid-1890s but, unlike Spencer, he stayed on as a permanent resident. He brought his children up as Arrernte Christians and was the first European to speak the Arrernte language fluently, translating the New Testament and other teaching material. This incorporation of Christian stories into the Arrernte language, and the Christian mission into Arrernte culture, combined with the isolation of the place and the dedication of the missionaries, created a viable modern Aboriginal community that countered the colonial Darwinian expectations of a doomed primitive race. When Spencer, a Darwinist, visited in 1923, he could not believe how many children there were – in stark contrast to the settlements he was used to. By the mid-20th century,

Hermannsburg had become a model for a future assimilated Aboriginal society; and it was Albert Namatjira who put its achievements on the map. He, more than anyone else, destroyed the colonial Darwinian paradigm.

The Lutherans initially enforced a strict regime that did not tolerate Aboriginal customs among the faithful. Strehlow's dedicated and inspired leadership converted a small core of Arrernte Christians who administered to their fellow heathens – most of whom came and went at will. Namatjira, born in 1902, was part of this Christian core; and while he knew his Dreaming and claimed its inheritance, his art was very different to the neo-traditionalism of colonial modernism.

Strehlow's replacement, Pastor Albrecht, arrived in the late 1920s. He started a craft enterprise to make money. Within a few years, Hermannsburg had become the first Aboriginal art centre – with all the profits and problems that current art centres have. Namatjira was the leading craftsman and when artists from Melbourne began arriving he was naturally interested. Rex Battarbee's visit in 1934 was the most significant. Battarbee was an Aboriginalist: he was seeking a new vision of Australia based on an Aboriginal feel for the place. A self-taught painter, his aspiration towards a type of post-impressionist modernism is generally dismissed by that damning Australian expression: 'gum-tree painter'. Namatjira quickly surpassed him.

When Namatjira saw an exhibition of Battarbee's paintings at Hermannsburg in 1934, and realised how much they sold for, he immediately decided to be a painter. Namatjira's quick mastery of western realism baffled settler Australians. Battarbee gave him only minimal tuition in the difficult medium of watercolour and was astounded at how quickly he progressed,

Albert Namatjira,
Central Mount Wedge, 1945

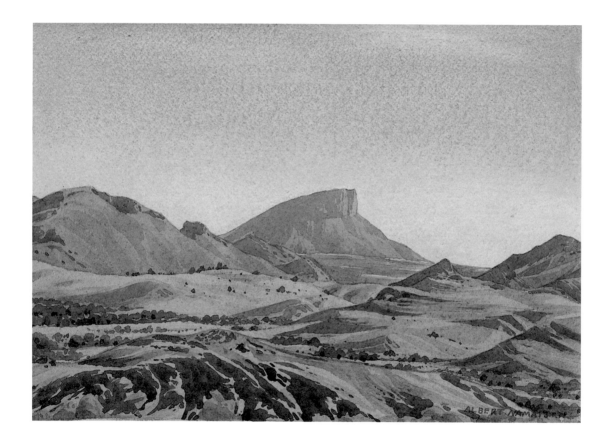

and how sure Namatjira's sense of colour and composition was. 'I have always believed', said Battarbee, 'that no ordinary white man could have done what Albert did in such a short time.' [31] Namatjira had frequent sell-out exhibitions in the capital cities and became Australia's first international celebrity artist. 'The story of the rise of Albert Namatjira', said Battarbee, 'is like fiction.' [32] In 1947, after thinking about it deeply, the American author Gordon B. Hempstead remained perplexed: 'I still have no answer to my question why this art movement started in Central Australia amongst the so-called lowest primitive race in the world … there's nothing like this movement among any other aboriginal race in the world.' [33] This widespread incredulity arose because Namatjira's art proposed a direct relationship between Aboriginal and settler cultures that was, by the logic of the day, impossible. It was as if he deliberately chose not to paint in a neo-traditionalist style because he feared that its associations with primitivism were counter-productive. Just as his contemporary, the African American writer, Richard Wright, rejected what he called the 'minstrel technique' because it merely satisfied the chauvinistic tastes of white audiences, [34] so Namatjira deliberately eschewed the primitivism of European modernism.

Namatjira produced the first Aboriginal art bought by Australia's state art galleries, and the first Aboriginal art that, to settler Australians, seemed European and modern. This was the point of the title of Battarbee's 1951 book: *Modern Australian Aboriginal Art.* But few could see past the unintended irony of the title: Namatjira could not be a modernist and make Aboriginal art – for this was a doubling that could not be focused by the Eurocentric paradigms of the day.

Battarbee believed that Namatjira's paintings 'may be nearer a real Australian art than anyone has ever been', [35] but few in the Australian art world did. Most considered him a weak copyist of second-rate art: a mimic of the mimics. Anthropologists concurred. Claude Levi-Strauss dismissed his paintings as 'the dull and studied water-colours one might expect of an old maid.' [36] The US anthropologist, Nelson Graburn, pronounced them 'assimilated fine arts' which he saw as 'characteristic of extreme cultural domination'. [37] Reviewing Battarbee's book, the Australian anthropologist Ronald Berndt complained that 'the title of the book is somewhat misleading. …The products of the school are, when all is said and done, non-indigenous art of a local Aboriginal group. One asks, what of modern Aranda [Arrernte] traditional art?'. [38]

Berndt's question was rhetorical but he had a point. Why was traditional Arrernte art not also modern Australian art? However, Berndt did not go there. He made it quite clear that Aboriginal art is strictly delimited by its traditional practices. This is why the very existence of Namatjira's art was, however you looked at it, anti-colonialist. Assimilated or not, it asserted the modernity of Aboriginal art. Namatjira remains a hero to contemporary Aborigines across the board. They saw not a fully assimilated artist, but one who painted his country and, most of all, the first Aborigine to conquer the white world and make a good living at the same time. Namatjira showed that art could be a successful anti-colonial strategy for Aborigines. Even the art world now recognises his achievement, and since the 1990s his work has been received with a post-colonial gloss. In 1992, Ian Burn and Ann Stephen wrote: 'Namatjira did not simply see with western eyes

but was mimicking that regime of vision as an access to particular knowledge.'[39] Turning the familiar complaint of settler modernists into a post-colonial critique, Burn and Stephen suggested that:

> The political and cultural potential of mimicry is central to understanding Namatjira's practice and suggests that his art can be reassessed in the context of counter-colonial strategies.... According to Bhabha, the menace of mimicry lies in that double vision which in disclosing the ambivalence of colonial discourse also disrupts its authority. It is this double vision which allows Namatjira's art its potency.[40]

However, Namatjira was no 'mimic man'. In Bhabha's scheme, mimicry is the tactic of those forced to take their bearing against the dominant discourse of the coloniser: their mimicry, argues Bhabha, at once disrupts and affirms colonial discourse. For all his modernity, Namatjira never renounced his ancestral inheritance. Namatjira does not mimic western art; he completely masters its language and, through it, makes a claim for his Aboriginal inheritance, especially for the sacred sites of Arrernte Dreaming. His best paintings evoke a classical mysticism reminiscent of (that French neo-traditionalist) Cézanne: they depict a transcendent stillness through which Namatjira claims the modernity of Arrernte spiritualism and thus the continuing presence of Dreaming. Settler artists may also have found a spiritual epiphany in the desert, but their wilderness lacks Namatjira's quiet and assured sense of belonging.

Arguably, Namatjira's art shared something with the neo-traditionalism that he eschewed: namely a classical Platonic mimesis in which inside knowledge is given an outside form. Rather than the ironic intertextuality of post-colonial mimicry, he disrupted the racist and Eurocentric assumptions of colonial discourse through Platonic or – in point of fact – Aboriginal mimesis. Only in this sense did he, as Burn and Stephen suggest, offer 'an elusive counter discourse, a model of inter-cultural exchange able to articulate a complexity of its own cultural reality.'[41]

The Hermannsburg School of painters that followed on from Namatjira took his style towards a more traditional Arrernte sensibility, creating a hybrid magic realism that accentuated the reserved and classical mysticism of Namatjira's art. This School flourishes today alongside the neo-traditionalism of the Papunya style of painting – Papunya and Hermannsburg being close neighbours. Some of the early Papunya painters knew Namatjira and had once painted in his style or a hybrid version of it. Indeed, the chief painter of the Papunya mural that inaugurated the movement, Kaapa Tjampitjinpa, was Arrernte like Namatjira, and painted in a hybrid style – much to the annoyance of Bardon, who wanted him to renounce the western affiliations of his art for a purely 'Aboriginal' abstract style. Clifford Possum, also with Arrernte connections, had spent time at Hermannsburg. Thus, there is some truth in Burn and Stephen's conclusion that 'Namatjira's art stands as a precedent for the more recent Papunya and other Aboriginal art'[42] – even though the relationship is not linear, or at least not in a stylistic sense. Namatjira is not the post-impressionist forerunner of the abstract Papunya painters; rather the Papunya painters continued a neo-traditionalist strategy begun 100 years earlier (that Namatjira himself had

disavowed). Namatjira, however, showed them
that the trick was to claim it as fine art, indeed
modernism. The luck of the Papunya painters
is that they launched their modernism at the
very moment that western modernism began
to look like Aboriginal neo-traditionalism. Only
then did the art world 'see' the contemporaneity
of Papunya painting. Since then it has been
recognised as Australia's first international art
movement: Papunya painting has become the
global sign of Australian cosmopolitanism.
Like African American jazz musicians, Papunya
artists use western technologies to so thoroughly
recreate western modernism that the latter now
imitates it. Under these circumstances, who is the
mimic and where is the original?

NOTES

1. Eric Michaels, 'Bad Aboriginal Art', *Art & Text,* 28, 1988, 59–72.
2. As in the debates around MOMA's 1984 exhibition, *Primitivism in 20th Century Art*. For particular reference to Central Australian art, see Nicholas Baume, 'The Interpretation of Dreamings: The Australian Aboriginal Acrylic Movement', *Art & Text*, 33, 1989, 110–20.
3. Hal Foster, in Hal Foster, Rosalind Krauss, Yve-Alain Bois and Benjamin H.D. Buchloh, *Art Since 1900*, London: Thames and Hudson, 2004, 618.
4. Imants Tillers, 'Fear of Texture', *Art & Text*, 10, 1983, 8–18; and Baume, op. cit.
5. However, the 'contemporary' is inevitably accumulating a greater theoretical density – as in Terry Smith's writings since 2001. See, for example, Terry Smith, 'World Picturing in Contemporary Art: The Iconogeographic Turn', *Australian & New Zealand Journal of Art*, 6, 2, 2005 and 7, 1, 2006, 34.
6. Nikos Papastergiadis, 'The Limits of Cultural Translation', in Jean Fisher and Gerardo Mosquera eds, *Over Here,* New York: The New Museum of Contemporary Art, 2004, 343, 341.
7. Anthony Giddens, *The Consequences of Modernity*, Stanford: Stanford University Press, 1990, 21.
8. Ibid., 19.
9. Ibid., 1.
10. Nikos Papastergiadis, 'Glimpses of Cosmopolitanism in the Hospitality of Art', *Broadsheet*, 35, 2, 2006, 111.
11. Kim Mahood, 'Under the skin', *Artlink*, 25, 2, 2005, 14–18.
12. See Roger Benjamin, 'A new modernist hero', *Emile Kame Kngwarreye Alhalkere Paintings from Utopia*, Brisbane: Queensland Art Gallery, 1988, 47–54; and Rex Butler, 'The Impossible painter', *Australian Art Collector*, 2, 1998, 42–45.
13. Butler, ibid.
14. Terry Smith was the first art historian to include an account of Central Australian art within a general history of Australian art, in a chapter written to update Bernard Smith's classic, *Australian Painting* (Oxford University Press), published in 1991. However, while he and others have found ways of including Aboriginal art within contemporary Australian art, it is yet to be integrated into the larger history of Australian art.
15. Not only do the major State art collections not relate remote Aboriginal art to the historical narratives evident in the galleries of western art, they also hang it in non-temporal or non-historical fashion (usually by geographic site) so that a key character of modernism, namely its self-conscious historicity, is both unnoticed and unexamined. Further, while the impact of modernity is often referred to in catalogue essays, exhibitions of remote Aboriginal art rarely make any attempt to develop connections with modernism (and then usually to disavow it) and tend to situate the work in either amorphous and undefined 'contemporary' or distinct Aboriginal contexts.
16. Giddens, op. cit., 51.
17. Noel Pearson, 'Walking in Two Worlds', *Weekend Australian*, 28–29 October 2006, 26.
18. See Matthew Flinders (1814), *A voyage to Terra Australis: undertaken for the purpose of completing the discovery of that vast country, and prosecuted in the years 1801, 1802, 1803 in His Majesty's ship The investigator*, Volume 1, facsimile edition, Adelaide: Libraries Board of South Australia, 1966, 60–61.
19. Other similar instances have been reported. See Isobel M. White, 'The Birth and Death of a Ceremony', *Aboriginal History*, 4, 1, 1980, 33–41.
20. Goethe, 'Of German Architecture', Elizabeth Gilmore Holt ed., *A Documentary History of Art*, Volume 11, New York: Doubleday Anchor Books, 1958, 367.
21. W.E.H. Stanner, 'On Aboriginal Religion 1', *Oceania*, 30, 1, 1959, 120.
22. W.E.H. Stanner, 'On Aboriginal Religion 3', *Oceania*, 31, 1, 1960, 105.
23. Ibid., 107.
24. Stanner, 'On Aboriginal Religion 1', op. cit., 126.
25. Stanner, 'On Aboriginal Religion 3', op. cit., 120.
26. See C.D. Rowley, *The Destruction of Aboriginal Society*, Ringwood: Penguin Books, 1983, 377.
27. Michael North, *The Dialectic of Modernism*, Oxford: Oxford University Press, 1994, 182.
28. D.J. Mulvaney and J.H. Calaby, *So much that is new: Baldwin Spencer, 1860–1929, a biography,* Carlton: Melbourne University Press, 1985, 166.
29. See Baldwin W. Spencer and F. J. Gillen, *The Native Tribes of Central Australia*, London: Macmillan, 1899, 17–18.
30. This is not to say the toas are not 'true': the anthropologist Ronald Berndt saw no reason to doubt their authenticity in this respect (Ronald Berndt, 'Foreword', in Philip Jones and Peter Sutton, *Art and Land*, Adelaide: South Australian Museum, 1986, 7–8). For the most considered study of the toas, see Philip Jones, *Ochre and Rust*, Kent Town: Wakefield Press, 2007, 225–82.
31. Rex Battarbee, *Modern Australian Aboriginal Art*, Sydney: Angus and Robertson, 1951, 12.
32. Ibid., 10.
33. Ibid., 47.
34. See North, op. cit., 176.

35. Battarbee, op. cit., 19.

36. Claude Levi-Strauss, *The Savage Mind*, Chicago: Chicago University Press, 1966, 89.

37. Nelson Graburn ed., *Ethnic and Tourist Arts: Cultural Expressions from the Fourth World*, Berkeley: University of California Press, 1976, 7.

38. Ronald M. Berndt, 'A review of *Modern Australian Aboriginal Art* By Rex Battarbee', *Oceania*, 22, 1 September 1951, 80.

39. Ian Burn and Ann Stephen, *Namatjira's White Mask, The Heritage of Namatjira*, Melbourne: William Heinemann Australia, 1992, 276.

40. Ibid., 276–77.

41. Ibid., 279.

42. Ibid., 278.

EXILES, DIASPORAS
& STRANGERS

THE ARTIFICE
OF MODERN(IST)
ART HISTORY
STEVEN A. MANSBACH

The dominant narrative of modern art emerged during the years immediately preceding World War II; it was instrumentalised in the decade following. This 'story of art' was decisively determined by those intellectuals most deeply affected by the political outrages of the 1920s and 1930s: the legion of émigré humanities scholars and artists from Central Europe,[1] whose lives were profoundly dislocated by the totalitarianism in their native lands. In ways both overt and subtle, they fought against their oppressors with the intellectual means at their command, principally scientific research and the writing of cultural history.[2] In this charged context, classical modern art – better known in Europe as the art of the historical avant-garde – of roughly the first half of the 20th century owes its orthodox chronicle to those Central European émigrés (and their North American and British confederates and students) who laboured creatively to institutionalise a partisan account through which to counter totalitarian prejudice.[3] By means of public art exhibitions, university courses and especially through the newly reinvented art history survey texts, these scholars endeavoured to plant safely in exile the high culture of Central Europe that had been uprooted from its native soil. Thus, we today need to acknowledge that what for us has become the conventional story of early 20th-century art is less an impartial chronicle than a calculated artifice. The prevailing history of modern art is the direct extension of the tactical response to the tragic conditions of the 1920s and 1930s in Central Europe by those who sought to counter the fascist war against liberalism and cosmopolitanism. For it was this philosophy of tolerance and the parallel praxis of free enquiry that the Continent's intellectuals individually

and collectively embodied, and which were at greatest peril.

The determined authoritarian assault on the values, often revolutionary, that pioneering modernism celebrated, and to which legions of its adherents, apologists and audiences fell victim, engendered among Europe's exiles (and their supporters abroad) a concerted response. In addition to participating actively in the world-wide combat against Nazism (and later, Soviet communism), many of the art historians who fled Europe waged a prolonged battle against the wilful ignorance and ideological blindness of the regimes that had come to power in their native lands. Perhaps the émigrés' most effective weapon was their abiding commitment to scholarship, through which they continued to exemplify the best traditions of scientific enquiry for which Germany (and the German educational model) had until recently been the universal model: liberal enquiry, scientific evidence, rational argumentation and intellectual probity (see Appendix).[4] Yet, it was in a genre of publication that was less explicitly 'scientific' – but that frequently drew on the essentially Germanic absorption with stylistic development and iconography – that the scholars registered their most successful and enduring victory over political intolerance, cultural prejudice and chauvinist ignominy: namely, through the art history survey text.

Post-1945 Survey Texts and the 'Sanitised' Avant-Garde

Although general histories of modern art began appearing with regularity in the 1920s, often authored by left-leaning critics, scholars and artists who were frequently sympathetic to the political and social(ist) aspirations that animated

much of aesthetic modernism itself, it was not until the years following the end of World War II that a new form of textbook emerged. Intended for an immense new audience in North America, the art history survey book was geared to educate the returning, victorious (mostly American) veterans of the war against fascist totalitarianism – and, just as importantly, to prepare them to battle Russian expansionism and the authoritarianism of Soviet-style communism.[5]

In the immediate post-World War II years, when art history was being introduced into the general curriculum of almost every American college and university, E. Upjohn, D. Wingert and J. Mahler, professors at Columbia University, published a pioneering general textbook through which to address the cultural needs of the tens of thousands of first-generation, middle-class students, many of whom were entering the universities at government expense. Consistent with the prevailing public sentiments of the time, this widely-adopted survey book, bearing the bold title *History of World Art* (1949), reflected residual anti-German bias as it pointedly excluded all reference to German visual culture between Leo von Klenze's *Walhalla* (1816–1842), which the authors dismissed as an 'absurdity … [that] seems to have bothered nobody', and what the professors endorsed uncritically as the 'scientific rationalism' of the Bauhaus, which they presented as a healthy antidote to Germanic authoritarianism.[6] The idea that the Bauhaus represented a salutary corrective to Teutonic conformity was in no way exclusively a home-grown attitude. Rather, it was to a significant extent derived from the émigrés' own perspective, shaped by personal experience of the politics of Central Europe and adumbrated in exile through their university lectures and ultimately

manifested in print.[7] E.H. Gombrich's *The Story of Art* (first edition, 1950), and especially H.W. (with Dora Jane) Janson's seminally influential *History of Art, A Survey of the Major Visual Arts from the Dawn of History to the Present Day* (first edition, 1962), both consistently popular among American university professors (and students) with sales exceeding four million copies, might be taken here to represent the 'field' of new post-war survey texts in terms of content and orientation. Both books celebrate the Bauhaus (1919–1933) as a creative institution where students '…were encouraged to use their imagination and to experiment boldly…', a condition juxtaposed with the official policy of the Nazis, whose Führer 'condemned [the best German architects] as "un-German"'.[8]

These introductory texts, intended for first year university courses in art appreciation and the history of art, effectively consolidated a canon of 'significant artists', cultural movements and historical developments; and by so doing, they made it possible for a new generation of middle-class Americans to grasp the pivotal figures and major monuments of western civilisation. But with respect to the art of the 20th century, the authors promoted a less impartial, more ideologically motivated world-view, one that still largely defines the meaning and perceived characteristics of classical modern art. This perspective is substantially that of heroic 'victimhood'. Stated pointedly, the authors' discussion of the progressive art of the avant-garde apotheosised those victims of totalitarian cultural terrorism – the masters of the Bauhaus, in particular – into heroic defenders of freedom, rationality and democracy. Whether, in fact, the Bauhaus artists or other utopian radicals ever incarnated the virtues that their advocates in

exile attributed to them is very much open to debate.[9] Nonetheless, it is incontrovertible that the creators of abstract art and theory did indeed face bitter opposition, though not only from the forces of political extremism. The aesthetic revolutions of the classical avant-garde were rooted in and inseparable from an activist politics and social radicalism. The masters of the Bauhaus and the founders of De Stijl, among dozens of fellow pioneers of modernism, positively perceived their anti-traditional and often non-objective art as the decisive 'social condenser' through which to construct a new world for a new humankind.[10] And it was likely that these social(ist) objectives, even more than the artists' aesthetic expression, alienated large numbers of the public, as well as antagonised European dictatorships.[11] In this emotive environment, only a few governmental officials were sufficiently courageous to promote the new art and even fewer were willing to advocate the theory behind it. The noble attempts of several bold state museum curators and directors – in Berlin, Frankfurt, Cologne, Budapest, Łódź, Lwów, among other centres of modernist activity – to acquire, display and acknowledge the revolutionary nature of abstract art stands in sharp contrast to the widespread public discomfiture with the radical 'new vision'.

It must be stressed that the inflammatory political rhetoric of the avant-garde disquieted many supporters of advanced culture, too. Many of these aesthetically progressive patrons were uncomfortable with the ideological propaganda that lay at the core of radical art. As a consequence, not a few downplayed its politically incendiary nature, a practice that reached its culmination in the 1930s, when Alfred Barr initiated at the young Museum of Modern Art in New York a series of pioneering exhibitions.[12] None of MoMA's trailblazing shows between 1932 and 1943 treated forthrightly the ideological bases of modern art, nor did they deal with the political and social perspectives that had been central to most of the artists whose works were on display in New York.[13] Nevertheless, the reasons for and the timing of Barr's exhibitions were significantly determined by the museum's influential trustees' opposition to the political events taking place in Central Europe, and their pronouncedly negative consequences for modern artists and art's own expression, display and development. The Americans' principled commitment was one of supporting the artists' free expression and opposing restrictive European governmental policies; it was in no significant way an endorsement of the artists' radical world-view. Indeed, when Barr created (c.1936) his influential hand-drawn chart illustrating the evolution of modern art,[14] he pointedly ignored the politics that lay at the origin of modern art theory and had essentially motivated the artists to turn to revolutionary formal means, and particularly to abstraction.[15]

Of MoMA's exhibitions during this period, perhaps none has received more careful scholarly attention than the 1938 exhibition devoted to the Bauhaus 'idea' during Walter Gropius' directorship (1919–1928). It has been demonstrated that Alfred Barr (and a number of former Bauhäusler then living in the United States and serving as consultants – principally Gropius, Herbert Bayer, Alfred Dorner, Josef Albers, László Moholy-Nagy and Gyorgy Kepes) was opposed to making public the social and political ambitions of the Bauhaus.[16] Indeed, the decision to ignore the German period of the Bauhaus under the politicised directorships of Hannes Meyer (Dessau) and Ludwig Mies van

der Rohe (Berlin) in favour of both the Gropius era in Germany and the Bauhäusler's activities in 1930s America – such as Josef Albers' Black Mountain College work, Moholy-Nagy's engagements at the New Bauhaus in Chicago, Bayer's artistic production in California and Kepes' aesthetic activities in Cambridge, among others – was a calculated one. By overlooking almost all of the Bauhaus' extra-aesthetic aspirations, Barr's 1938 *Bauhaus 1919–1928* exhibition '…intentionally neutralize[d] the social and political history of the Bauhaus and its radical, albeit contradictory, ideological ambitions'. The result was to institutionalise 'a distorted vision' of the Bauhaus for an American audience and to promote an Americanised conception of the Bauhaus as primarily a pioneering aesthetic enterprise whose 700 exhibited items point up modern design but avoid the political and social reforms that modern design was intended to effect.[17]

For Barr and Gropius, the apolitical attitude incarnated in their 1938 MoMA exhibition was but a continuation of practices they had exercised earlier in the decade: Barr through his 1936 exhibition *Cubism and Abstract Art* (and also in his 1932 *Modern Architecture – International Exhibition* in which his participation was somewhat less direct)[18] and Gropius in his own 1935 publication, *The New Architecture and the Bauhaus*.[19] Barr's reluctance to acknowledge in cosmopolitan New York City the revolutionary social agenda of the avant-garde was recognised almost immediately as a major failing by both the popular and scholarly press[20] and even the museum director admitted to unease with Gropius' cavalier disregard for historical truth.[21] In 1937 Meyer Schapiro criticised Barr for de-contextualising the art he chose to display.

Barr conceded Schapiro's point, at least partially. Already in the 1936 catalogue for *Cubism and Abstract Art* the museum director had granted that focusing predominantly on the aesthetic autonomy of works of art '…involves a great impoverishment of painting, an elimination of … [the consideration of] subject matter, sentimental, documentary, political, sexual, religious… But in his art the abstract artist prefers impoverishment to adulteration.'[22] Nevertheless, Gropius and many of his former Bauhaus confederates, abetted by Barr and the Museum of Modern Art, were mostly successful in erasing the political and social foundations on which modern art was originally constructed – at least for contemporaneous American audiences.

The calculated decision to sidestep a full and faithful accounting of modern art's formative philosophical phase was in no way limited to the cultural mandarins in Manhattan or Cambridge. A similar partiality was evident in the publications by most Central European scholars once they were forced into exile. First, almost none of the scholars treated directly the art of their own time.[23] The avoidance of a direct engagement with contemporary art and modern aesthetics was due only in part to the transplantation to America of the customary practice among German university academics of leaving the treatment of modern art to critics, journalists and a few museum professionals. More decisive – and the second point to keep in mind – was the émigrés' conscious strategy of eschewing modernism as part of their greater resolve to forswear the explicitly political in art. Although a number of German and Austrian émigré scholars continued investigating the principal artists of the 'Germanic' Renaissance – Erwin Panofsky, Heinrich Schwarz and Hans and Erica Tietze

(Conrat) on Albrecht Dürer (1471–1528); Jakob Rosenberg on Martin Schongauer (c.1445–c.1488) and Lucas Cranach the Elder (1472–1553); Justus Bier on Tilman Riemenschneider (c.1460–1531); Martin Weinberger on Albrecht Altdorfer (c.1480–1538); or Guido Schoenberger on Matthias Grünewald (c.1475–1528), to name but a few – each was careful to eschew emphasising the 'Germanness' of the subject. This intentional avoidance of essentialist 'racist' aspects may be understood as a strategic ploy to counter the eminently racist focus of those art historians favoured by the Nazi state. Thus, the selection of artists investigated was little affected by emigration; however, the methodology was. Almost all émigré art historians assiduously avoided interpretive methods or schemes that might result in a contemporaneous politics of race, origin or identity.[24]

Although the majority of classically-trained Central European art historians subscribed to a Kantian belief in the consummate possibility of disinterested enquiry, their faith in the absolute value of 'objective' scholarship was strengthened by the Nazis' very dismissal of it. The more Hitler devalued non-partisan art scholarship in favour of ideological engagement, the greater the commitment to the expressly apolitical on the part of the liberal academics. With the promulgation of Nazi dictates against (most) modern art beginning in 1933, and in light of the enormous domestic popularity of the 1937 Entarte Kunst exhibition in Munich (and in the various stations on its tour through Germany), many scholars felt ever more justified in opposing the intrusion of politics into their research methodologies.[25] Indeed, the specialised scholarship of the émigré art historians during the 1930s and 1940s can be characterised by an avoidance of national or racial orientation in favour of an affectless preoccupation with iconography, iconology and phenomenology.[26] And once these researchers turned attention to authoring general survey books for a broad public, the avoidance of abstraction's original ideology became instrumentalised in the English-speaking world.

In the two decades following the defeat of Hitler, it would have been almost impossible for a student of art history to find mention of either the (mostly leftist) utopian political ideology or the (not infrequent) national chauvinism that animated both the practice and theory of the classical avant-garde. In fact, art and architectural historians had effectively 'sanitised' the engagé art from the early 20th century by compressing its makers' scope of creativity to the purely aesthetic arena. Under the 'curatorship' of Janson, Gombrich, Niklaus Pevsner, Gropius and their Anglo-American colleagues, the history of modern art was presented predominantly as an evolution of style, affirmed as a Hegelian unfolding of the absolute 'spirit of abstraction', with each succeeding movement ever more self-consciously advancing non-objectivity. Little if any attention was paid to the activist politics, idealistic ideologies or nationalist aspirations for which abstraction was originally conceived and most often deployed by its makers and its cadre of apologists. Rather, the art of the inter-war era was re-presented and invoked by the exilic historians and their domestic allies as an effective agent in a larger campaign to defend what the classical avant-garde was not – or that it was only exceptionally – namely, democratic, tolerant (of competing viewpoints) and rationally scientific.

Not coincidentally, these last-named virtues, though only rarely evident in the writings of the avant-garde artists or demonstrable in their designs, were essential characteristics of the

very Germanic scholarly tradition represented by the émigrés themselves. Moreover, and more importantly, these noble attributes were championed (if not always practised at home) by their allies, who were engaged in a fateful struggle with totalitarianism: first fascist, then communist. And it was through defending the 'western liberal tradition', fatally compromised by Hitler and continuously endangered by Stalin, that a partisan story of modern art was drafted.[27]

To wage an effective campaign against Soviet ideology – and drawing on their successful struggle against fascism – the émigré art historians endeavoured early in the Cold War to enlist a new and unprecedentedly large generation of Americans. An ideal pool of potential recruits was available to them in the corps of American college students, hundreds of thousands of whom were attending university with financial support under the GI Bill of Rights.[28] These mostly first-generation university students often lacked a basic familiarity with visual culture, which the art history survey book could effectively address. But, in addition, this new class of texts fulfilled a political mission commensurate with the personal experience of the émigré authors and congruent with the dominant political stance of post-World War II America. In brief, the surveys of western art educated students to see in modernist aesthetic experimentation an affirmation of the very virtues cherished in liberal societies but decried either as 'degenerate' or as 'bourgeois formalism' by dictatorships on the right and left.

At base, the authors ignored, or at least downplayed, the historical 'facts' of the avant-garde's own advocacy of revolutionary politics, social reconstruction and utopian dogmatism.[29] Instead of attending to the artists' social radicalism, stentorially proclaimed in hundreds of manifestos and advanced by engagé critics, the émigrés concentrated on the dramatic formal innovations and the free experimentation that were the results, rather than the sources, of classical modern art. In essence, the originary ideological force of avant-garde art, which was the very philosophical basis from which so much of progressive art derived, was denatured in favour of a controlled celebration of its superficial, though visually compelling, attributes. On a formal armature of rigorously ordered compositions, restrained colour palette and (often) non-objective forms, the historians of art applied their own ideological material, more socio-political than aesthetic, that occluded the message of the modernist masters. Thus, instead of acknowledging classical modern art on its own terms as a template by which to project the artists' ideal vision of perfect relationships – social, political and aesthetic – the émigré historians reconfigured modernism as a more or less moderate, socially unthreatening attempt of rational artists to advance a stylistic imperative.

Not coincidentally, the rise of 'Formalism' as a critical perspective and forceful ideology also gained authority in this post-World War II era. Clement Greenberg's series of essays, though rooted in a radical politics of the 1930s, capitalised on and dovetailed creatively with the imperative of style as the determinant feature of modernist art, authoritatively promoted in the US by Central European émigré intellectuals. Like others who saw in art a means to project an idealistic world free from the gravity of politics, ethnicity or religion, Greenberg's critical posture elevated formal considerations above (visually perceptible) distinctions of subject matter, personal biography or national/racial attachment. Thus, he advanced a modernist art that

formalistically resolved the differences that life entails into a harmonious art history of visual logic.[30] In this totalising objective, which masked an underlying idealism with a critical empiricism, Greenberg partook of the émigrés' faith in a new history of modern art as a means 'to deepen American loyalty and American identity, promoting an integrationist rather than a particularist consciousness.'[31] Although Greenberg's powerful influence on the course of American art and criticism has been frequently studied and often analysed, there has been little recognition of the parallel positions informing what had already become 'mainstream' art history.[32]

In truth, the chronicle of style articulated by the historians is quite artful, as long as one focuses principally on the phenomenological aspects of art, architecture and designed objects. But once one penetrates the formal characteristics – or as soon as one reads the writings of the artists themselves and their contemporary defenders – one recognises the limitations of a formalist account of classical modern art. When one enquires into the social, cultural or political matrices from which this art developed as the calculated acts of the avant-garde, one is compelled to reckon with the formative role exerted on stylistic choices by extra-aesthetic forces and concerns. This realisation is in no manner revolutionary. Indeed, it has served as the foundation of art historical methodology since the establishment of 'Kunstgeschichte' as a formal academic discipline in the first half of the 19th century. Further, such lines of enquiry were brilliantly practised by generations of Central European scholars, especially by those born between roughly 1880 and 1910 in imperial Germany and Austria-Hungary.[33] One has only to recall the names of Panofsky, Gombrich, Pevsner,

Arnold Hauser, John Rewald and dozens of other émigré German, Austrian and Hungarian historians of the visual arts to appreciate the contributions they made to the sophisticated methods of the discipline: iconography, iconology, psychology and social history to mention but a few.[34] Nonetheless, it is important and paradoxical to note the very absence of these 'structurally deep' methodologies or modes of enquiry in the treatment of the classical avant-garde in the survey books by many of these self-same scholars. Their almost exclusive focus on the dynamic development of style stands in contrast to their analysis of Renaissance art or 18th-century art, for example, where the careful consideration of the pivotal role of religion and politics, or that of industrialisation and social stratification, was primary to the assessment of the production of art. This attenuation of approach by the very authors for whom social, political, religious and economic contexts had been central to their scholarship of earlier historical periods must have been as calculated as the manifestos of the modernists, which were well known during the inter-war years. Moreover, countless cultural critics and philosophically-oriented commentators had publicised and further analysed the political and social dimensions of 'progressive' modern art. From the exchanges of letters, surviving archives and even the published record of those Central European figures soon to be forced into exile, it is evident that the political views of the modern artists were common copy by the end of the 1920s.

The Occlusion of Modernism in Eastern Europe
There is a further dimension to the émigrés' strategy that bears mention here, one that carries a little noticed, academically adverse impact.

The portrayal of the classical avant-garde as a noble victim of politically-induced mass intolerance and government-sanctioned prejudice fits well with the widespread practice of idealising the casualties of injustice. That the Bauhaus ran afoul of powerful forces and that it suffered savage attacks are doleful facts of modern history. Yet it is also important to note that the Bauhaus – and similar modern groupings – had been 'embattled' long before the various German governments took official action against it. Within the contentious context of modernism itself, Walter Gropius – and similarly, J.J.P. Oud, Le Corbusier and other fathers of functionalism – contended with a legion of other progressive designers, most of whom shared an equally passionate commitment to advanced aesthetics. Moreover, many of these non-German figures from Poland, the Baltics and the Balkans likewise issued manifestos,[35] secured commissions, constructed impressive modern buildings and contributed mightily to modern painting, sculpture, set design and other modes of progressive expression. Until recently, however, these highly original (mostly) East European modernists and their works have rarely garnered the serious attention of historians, either those established in the West or active in the East.[36]

This neglect can be attributed to several factors. Here, it may suffice to acknowledge one particular paradox – that of success. Although these modernists were notably accomplished and widely recognised as architects and designers during the 1920s and 1930s, their work was concealed behind the Iron Curtain when the Soviet Union succeeded Nazi Germany as the controlling power. Thus, although significant numbers of modernist buildings in Latvia and Lithuania and, especially in Estonia,[37] for example,

survived both World War II and Soviet post-war reconstruction, few have been the subject of western study. This was surely due not only to their general inaccessibility during the Soviet imperium, but also to linguistic barriers. Most of the primary texts were written in languages little read abroad.[38] Therefore the original voices of the modern artists, architects and critics from eastern Europe were rarely heard in the West.[39]

These factors may in themselves represent only a partial explanation. A compelling, and disturbing, additional ground might be adduced to account for the failure of most scholars of classical modern art to have accommodated the surpassingly inventive architecture, art and design that had originated East (and southeast) of Germany. This reason, however, has little to do with the region's geographical or linguistic inaccessibility, but it has everything to do with ideological bias – in the West as much as the periodic antipathy of the Soviet East. Succinctly stated, the classical modern art from eastern Europe did not conform to the paradigms established for modernism in the West, neither those initially articulated by the Bauhaus and its allies in Europe and the United States, nor – and more decisively for its later fate – those advanced by the Central European émigré scholars in their canonical surveys published in the post-World War II era.

During the Soviet imperium, the study of modern art was often ideologically dangerous; its advocates were frequently branded as 'formalists' and lambasted for their 'bourgeois' embrace of what the authorities disdained as superficial and self-indulgent. Rather than adhering to the robust realism officially promoted as the visual model for a transnational, classless society of workers and peasants, those few

champions of the avant-garde were censured for favouring the forms historically associated with the experimentation and comparative liberalism of the 1920s (in Russia) and the early 1930s (in the newly-independent Baltic and Central European republics). What Soviet officialdom from Stalin through Brezhnev found particularly troubling in avant-garde art was not just its formal experimentation, but also its historical associations. Modernist art was understood, rightly, as socially threatening to the reigning order, as it was widely connected culturally – and, inexorably, politically – to the national aspirations of (European) non-Russian peoples of the USSR and the latter's allied states in eastern Europe. Official Soviet censure of modern art was part of a strategy to curtail references to historical periods of comparative political liberalism and national expression, whether that of 'Russian' suprematist and constructivist abstraction of the 'experimental period' of communism, or the various forms of modernism and functionalism that flourished in the inter-war Baltic and Central European republics, later to be stifled behind the Stalinist Iron Curtain. Consequently, the display and even study of modernist art was actively discouraged in most Soviet-styled republics during the Cold War, though the (historical) art itself was by and large preserved – although mostly inaccessible – in museum depots or in relatively remote provincial locations.[40]

The suppression of modernist art in pre-perestroika eastern Europe presented western nations, especially the United States, with an advantageous propaganda incentive to champion modern art as a celebration of creative freedom. Yet, paradoxically, few in the West took full advantage of this 'receptivity' to modern artistic expression by also championing classical avant-garde from eastern Europe, the true bane of most Soviet regimes. Although there were easily and widely accessible permanent displays and temporary exhibitions of inter-war modernist art from and throughout the West, scant attention was paid to the equally progressive contemporaneous movements and innovative forms from the East. The first general study in North America of the Russian avant-garde, for instance, appeared only in 1962 with the publication of Camilla Gray's pioneering *The Great Experiment: Russian Art, 1863–1922*.[41] The earliest general study to document a Russian avant-gardist was the book produced, originally in East Germany, by Sophie Lissitzky-Küppers on her late husband, the German-educated, Jewish modernist (and later staunch Stalinist) El Lissitzky, later translated into English.[42] The histories of Polish, Romanian, Czech, Bulgarian and other 'eastern European' avant-garde figures, movements and monuments had to wait considerably longer before being brought to the attention of English-reading audiences. And only in ensuing years were exhibitions mounted through which a western public might see at first hand the original achievements from East-Central Europe.[43]

There was a host of reasons for the tardy focus of attention on these dynamic avant-garde achievements, especially in the United States. Yet not to be dismissed was the pervasive influence exercised by the Central European émigré art historians. Their general reluctance to promote little-remembered avant-gardists from their native lands may be understandable within the politicised circumstances of the Cold War, where their own status as American citizens or legal residents was less than absolutely secure.[44]

Further, their reticence concerning a historical chapter in which the formative social idealism of the classical modernists lay mostly on the opposing side of present-day politics is also understandable in the context of America's anti-communist reaction during the early Cold War years. The controversy surrounding the contemporary politics of veteran modern artists – Picasso's embattled role in the Communist Party, post-war surrealism's revolutionary posture (in France and Poland, in particular) and the enlistment of artists in the service of national liberation struggles – might have discouraged an attempt to recover the origins of the classical avant-garde for which rebelliousness was a frequent feature. Perhaps more negatively persuasive for the émigrés, however, was the often nationalist orientation of the East European avant-garde.[45] In the years following World War II, in which the images of the deadly consequences of rabid chauvinism were vivid, concentrating attention on a (even) progressive aesthetics of nationalistic aspiration – however historically contextualised – would have been emotionally awkward. Instead, one could collaborate with willing curatorial partners to advertise an alternative model; for example, the Bauhaus, the De Stijl Group, Le Corbusier's architecture and similar enterprises to which contemporary virtues could be attributed: internationalism, rationality, economy. Moreover, there were living in America a number of German and Hungarian former Bauhaus 'masters' (and former students) actively engaged in advancing American artistic education and visual culture – and eager to participate in the sanitisation of their youthful political engagement. In short, there would have been little need and small advantage for the émigrés to 'recover' eastern European modernism from historical amnesia.[46]

If those émigrés who had privileged access to the monuments and makers of modern art from eastern Europe evinced little interest in championing them, then there was less likelihood that others without direct contact or linguistic facility would initiate an assessment of modernist art in all its manifold variants and diverse objectives. And few scholars in America seized the opportunity before the 1970s. By then, the sway of the émigré art historians began to diminish and new political conditions favoured an inspection of received opinion. Moreover, with the rise of post-modernism, licence was given to break free of historical constraints in order to bring fresh references, overlooked sources and innovative forms into the fold of accepted aesthetic and academic discourse. Nonetheless, by design or through indirection, little impetus to study modernism globally was provided by those best placed historically to do so: the legion of Central European émigré art historians whose academic training, personal experience and scholarly stature bestowed upon them unique and incisive insight. It might be claimed, ironically, that the distinctive modern art from eastern Europe fell victim for a second time to the forces of modern history. The avant-garde in Germany and their contemporaneous defenders in exile, both subjects of fascist oppression, promoted restrictive theories of advanced art and aesthetics that, for different reasons, prevented the assimilation into the historical account of numerous competing modernisms from eastern Europe.

Conclusion
Paradoxically, the 'free world' values of rationality, tolerance, liberalism and creativity might have been more forthrightly advanced by focusing

on the various 'other' historical expressions of modernism from East Europe rather than manipulating the 'Bauhaus' version of it. For it was among the architects and designers of Estonia and Lithuania, as well as of other lands along the periphery of industrialised Europe, that modernism was explicitly put at the service of liberal democracy, capitalist development and freedom of personal expression. Indeed, by attending to the aesthetic developments during the 1920s and 1930s in the region between Germany and Russia, for instance, historians would have witnessed a host of modernist styles more richly innovative – and more frequently manifested materially – than the unitary one theorised by the French, Dutch and German confederates of 'Bauhaus' functionalism.

In order to recognise these 'variant' forms of modernism, one would have to set aside the ideological blinders so firmly established in the dominant historiography of modern art and architecture. One would also have to believe less piously in the dogmatic declamations of Walter Gropius, Ludwig Mies van der Rohe, J.J.P. Oud and others who subscribed to a single, totalising form of modernist expression.[47] Instead, one would need to acknowledge the limitations of the West European fixation on an absolute style of art and life beyond the vagaries of geography, time and culture.

A consideration of modern architecture, art and design in other, less central, parts of inter-war Europe would reveal a host of competing modernisms, more often than not, pragmatic in their political claims, adaptable in their use of progressive forms, flexible in their embrace of technology and methods, sensitive in their incorporation of history and tradition, and local in their references and appeal.[48] These alternative modernisms rejected in general the totalising aspirations and universal claims that animated the 'Bauhaus vision'. Instead, eastern Europe's modernists recognised that prevailing local conditions – economic, historical and political – were far more decisive for developing a modern idiom than any appeal to universal verities. The singular requirements of each nation, especially those of the new republics that were established in the wake of World War I, presented architects, artists and designers with unique challenges and original opportunities to which they responded inventively, though with little uniformity. In the main, the solutions arrived at were creative blends of modernist forms and traditional materials, familiar methods or national references.[49] By means of such ingenious combinations, each distinctive and inflected differently from the others, eastern Europe collectively displayed new modes of and novel applications for modernist art and theory.

In place of a single, totalising theory of modernism, one might alternatively articulate new, flexible and more sensitive methodologies by which to account for those modernisms that did not conform to the tenets of the Bauhaus or do not lend themselves to the precepts of the émigré historians and their disciples.[50] The rewards for developing new critical procedures and methodological practices are more than merely 'archaeological'. In addition to uncovering major modernist monuments on the European periphery long buried by art historical neglect or purposeful propaganda,[51] we would unearth the lost richness of modern art's original creative complexity. We would then find ourselves in a welcome position to appreciate the remarkable inventiveness that flourished, however briefly, outside the scope of our survey books. By looking

at classical modern art and architecture with a broader perspective, a less restrictive focus and a more nuanced methodology, we might not only better comprehend the unique creativity that took place on the margins of industrialised Europe, but we might also reclaim the rich foundations of modern art generally. Then, and only then, might a new generation of art surveys fulfil the goals of those who authored the first texts: to apply to the history of modern art the same scientific rationalism and liberality of spirit that so much of modernist theory and practice originally envisioned.

A listing of German, Austrian, Hungarian and other Central European academic or museum-based art specialists who elected, or were forced to seek, refuge in the English-speaking nations of the United States, United Kingdom, Canada, Australia and South Africa is a long one. Among them, a good number of whom migrated between America and England, should be noted the following (which augments the lists and references compiled by Karen Michaels, 'Transfer and Transformation: The German Period in American Art History', in Stephanie Barron ed., *Exiles + Émigrés* (as in note 1); Colin Eisler, '*Kunstgeschichte* American Style', 629 (as in note 4); Ulrike Wendland, *Biographisches Handbuch deutschsprachiger Kunsthistoriker in Exil: Leben und Werk der unter dem Nationalsozialismus verfolgten und vertriebenen Wissenschaftler*, Munich: Sauer, 1999, vol. 1; and the on-line website www.dictionaryofarthistorians.org among other sources). Where full details are not given, the information is not known, or not secure:

Frederick Antal (Budapest 1887–London 1954)
Rudolf Arnheim (Berlin 1904–Ann Arbor, MI 2004)
Erna Auerbach (Frankfurt 1897–London 1975)
Ingeborg Auerbach (near Hamburg 1903–?)
Ludwig Bachhofer (Munich 1894–Carmel, CA 1976)
Kurt Badt (Berlin 1890–Überlingen 1973)
Leo Balet (Rotterdam 1878–New York 1965)
A.A. Barb
Otto Benesch (Ebenfurth, Austria 1896–Vienna 1964)
Klaus Berger (Berlin 1901–Paris 2000)
Rudolph Berliner (Niedersachsen 1886–Berchtesgaden 1967)
Frederick A. Bernett (Bernstein) (Berlin 1906–?)

Ilse Bernett (Berlin 1910–?)
Richard Bernheimer (Munich 1907–Lisbon 1958)
Margarete Bieber (Schönau, West Prussia/Przechowo, Poland 1879–New Canaan, CT 1978)
Justus Bier (Nuremberg 1899–Raleigh, NC 1990)
Senta (Dietzel) Bier (Fürth 1900–?)
Gertrude Bing (Hamburg 1892–London 1964)
Wolfgang Born (Breslau 1893–New York 1949)
Bernard von Bothmer (Berlin 1912–New York 1993)
Dietrich von Bothmer (Eisenach 1918–?)
Julia Braun-Vogelstien (Stettin 1883–New York 1971)
Edgar Breitenbach (Hamburg 1903–1977)
Otto Brendel (Nuremberg 1901–New York 1973)
Peter Brieger (Breslau 1898–Toronto 1983)
Hugo Buchtal (Berlin 1909–London 1996)
Anneliese Bulling (near Oldenburg 1900–?)
Ludwig Burchard (Mainz 1886–London 1960)
George Caro
William Cohn (Berlin 1880–Oxford 1961)
Ernst Cohn-Wiener (Tilsit/East Prussia 1882–New York 1941)
Gertrude Achenbach Coor (Frankfurt 1915–Princeton 1962)
Hanna Deinhart (Osnabrück 1912–Basel 1984)
Otto Demus (Harland, Austria 1902–Vienna 1990)
Max (Deutsch) Deri (Preßburg/Bratislava Slovakia 1878–Los Angeles 1938)
Alexander Dorner (Königsberg 1893–Naples 1957)
Liselotte Pulvermacher Egers (Berlin 1904–?)
Hans Engel
Richard Ettinghausen (Frankfurt 1906–Princeton 1979)
Leon Ettlinger (Königsberg 1913–Berkeley 1989)
Ilse Falk Silvers (Hamburg 1906–?)
Josepha Fiedler-Weitzmann (Berlin 1904–?)

Oskar Fischel (Danzig 1870–London 1939)

Paul Frankl (Prague 1878–Princeton 1962)

Robert Freyhahn

Franziska Fried-Boxer (Vienna 1904–?)

Walter Friedlaender (Glogau/Lower Saxony
1873–New York 1966)

Otto Fröhlich (Vienna 1873–London 1947)

Lili Frohlich-Bume (Vienna 1886–?)

Bruno Fürst (? 1896–?)

Arthur Galliner (Zinter/East Prussia ?–
London 1961)

Helmut Gernsheim (Munich 1913–
Castagnola 1995)

Walter Gernsheimer (Munich 1905–?)

Curt Glaser (Leipzig 1879–New York 1943)

Gustav Glück (Vienna 1871–Santa Monica,
CA 1952)

Frances Gray Godwin (Grabkowitz)
(Vienna 1908–New York 1979)

Oswald Goetz (Hamburg 1899–New York 1960)

Ludwig Goldscheider (Vienna 1896–
London 1973)

Ernst Gombrich (Vienna 1909–London 2001)

Sabine Gova (Hamburg 1901–?)

Hans-Dietrich Gronau (Italy 1904–London 1951)

Fritz Grossmann (Stanislau/Galicia now
Poland 1902–London 1984)

Hermann Gundersheimer (Würzburg 1903–?)

Yvonne Hackenbroch (Frankfurt 1912–?)

Elisabeth Hajós (Nyiregyhaza/Hungary 1900–?)

George M.A. Hanfmann (1911 St Petersburg,
to Germany by 1921–Watertown, MA 1986)

Arnold Hauser (Temesvár/Hungary
[Timisoara/Romania] 1892–Budapest 1978)

William Heckscher (Hamburg 1904–
Princeton 2000)

Adelheid Heimann (Berlin 1903–London 1993)

Julius Held (Mosbach/Baden 1905–
Bennington, VT 2002)

Hans Hell (Transylvania 1897–London 1974)

Wolfgang Herrmann (Berlin 1899–?)

Hans Hess (Erfurt 1908–England 1975)

Jacob Hess (Munich 1885–Rome 1969)

Hans Hesslein

Klaus Hinrichsen (Lübeck 1912–?)

Ursula Hoff (London 1909–?)

Edith Hoffmann (Vienna 1907–?)

Else Hofmann (Vienna 1893–New York 1978)

Walter Horn (Waldangelloch, Austria 1908–
Berkeley 1995)

Helmut Hungerland

Hans Huth (Halle 1892–Carmel, CA 1977)

Horst Janson (1913 St Petersburg to Hamburg
by 1918–en route from Zurich to Milan 1982)

Harold Joachim (Göttingen 1909–Chicago 1983)

Otto Kallir (Vienna 1894–New York 1978)

Adolf Katzenellenbogen (Frankfurt 1901–
Baltimore 1964)

Arthur Kauffmann (Stuttgart 1887–England ?)

Emil Kaufmann (Vienna 1897–Cheyenne,
WY 1953)

Stephen Kayser (Karlsruhe 1900–
Los Angeles 1988)

Ernst Kitzinger (Munich 1912–Poughkeepsie,
NY 2003)

Wilhelm Koehler (Tallinn/Estonia 1884–
Munich 1959)

Olga Koseleff-Gordon (Crimea/Russia 1904–?)

Richard Krautheimer (Fürth 1897–Rome 1994)

Trude Krautheimer-Hess (Erfurt 1902–
Rome 1987)

Ernst Kris (Vienna 1900–New York 1957)

Betty Kurth (Vienna 1878–London 1948)

Hilde Kurz (Vienna 1910–?)

Otto Kurz (Vienna 1908–London 1975)

Gerhart Ladner (Vienna 1905–Los Angeles 1993)

Franz Landsberger (Kattowitz/Upper Silesia
now Katowice/Poland 1883–Cincinnati 1964)

Susanne Lang (1907 Vienna–1995)

Gertrude Langer (Vienna 1908–Australia ?)

Paul (Heilbronner) Laporte (Munich 1904–?)

Karl Lehmann (Rostock 1894–Basel 1960)

Lotte Lenn

Charlotte Loose (Berlin 1901–?)

Ulrich Middeldorf (Saxony 1901–Florence 1983)

Elisabeth Moses (Cologne c.1893–
San Francisco 1957)

Alice Mühsam (Berlin 1889–Spring Valley,
NY 1968)

Ludwig Münz (Vienna 1889–Munich 1957)

Walter Nathan (Neustadt 1905–?)

Fritz Neugass (Mannheim 1899–New York 1979)

Günther Neufeld

Alfred Neumeyer (Munich 1901–Oakland,
CA 1973)

Leo Olschki

Max Osborn (Cologne 1870–New York 1946)

Otto Pächt (Vienna 1902–1988)

Erwin Panofsky (Hanover 1892–Princeton 1968)

Nikolaus Pevsner (Leipzig 1902–London 1983)

Lotte Brand Foerster Philip (Altona 1910–
New York 1986)

Adolf Placzek (Vienna 1913–New York ?)

Annemarie (Henle) Pope (Dortmund 1907–?)

Edith Porada

Max Raphaël (Schönlanke/Trzcianka, Poland
1889–New York 1952)

Franz Rapp (Erfurt 1885–Washington, DC 1951)

Felix Reichmann (Vienna 1899–Ithaca, NY 1987)

John Rewald (Berlin 1912–New York 1994)

Grete Ring (Berlin 1887–Zurich 1957)

Helen Rosenau (Monte Carlo 1900–London 1984)

Jakob Rosenberg (Berlin 1893–Cambridge,
MA 1980)

Ruth Rosenberg (Berlin 1905–?)

Erwin J. Rosenthal (Munich 1889–Lugano 1981)

Gertrude Rosenthal (Dresden 1906–
Baltimore 1989)

Alfred Salmony (Cologne 1890–off the
European coast 1958)

Fritz Saxl (Vienna 1890–Dulwich 1948)

Rosa Schapire (1874 Poland to Germany by
1893–London 1954)

Alvis Jakob Schardt (Frickhofen/Hesse-Nassau
1889–Los Alamos, NM 1955)

Alfred Scharf (Königsberg/Bohemia 1900–
London 1965)

Felicie Scharf (Berlin 1901–?)

Ernst Scheyer (Breslau 1900–1985)

Edmund Schilling (Neuwied 1888–
near London 1974)

Otto Schneid (Jablunkuvo/Czech Republic
1900–?)

Guido Schoenberger (Frankfurt 1891–
New York 1974)

Herta Schubert (Verden/Lower Saxony 1898–
Munich 1975)

Hilde Schüller Kurz

Heinrich Schwarz (Prague 1894–New York 1974)

Kurt Schwartz (Vienna 1909–Los Angeles 1983)

Berta Segall (West Prussia now Poland 1902–
Basel 1976)

Otto von Simson (Berlin 1912–1993)

Clemens Sommer (Cottbus 1891–
Chapel Hill, NC 1962)

Wolfgang Stechow (Kiel 1896–Princeton 1974)

Margarete Steinberg (1884–Chesterfield,
MD 1977)

Kate Traumann Steinitz (Beuthen,
Upper Silesia/Bytom, Poland 1889–
Los Angeles 1975)

Charles Sterling (? Poland 1901–?)

Ernst Strauss (Mannheim 1901–Freiberg 1981)

William Suida (Neunkirchen, Austria 1877–
New York 1959)

Georg Swarzenski (Dresden 1876–Boston 1957)
Hanns Swarzenski (Berlin 1903–Wilzhafen,
 Bavaria 1985)
Hans Tietze (Prague 1880–New York 1954)
Erica Tietze-Conrat (Vienna 1883–New York 1958)
Charles de Tolnay (Budapest 1899–
 Florence 1958)
Helmut Wallach (Munich 1901–Bern 1989)
Martin Weinberger (Nuremberg 1893–
 New York 1965)
Kurt Weitzmann (near Kassel 1904–
 Princeton 1993)
Paul Wescher (Welschingen, Baden 1896–
 Pacific Palisades, CA 1974)
Johannes [János] Wilde (Budapest 1891–
 Dulwich 1970)
Julia Wilde (Budapest 1895–London 1970)
Edgar Wind (Berlin 1900–London 1971)
Emmanuel Winternitz
Rahel Wischnitzer-Bernstein (Minsk/Russia 1885–
 New York 1989)
Karl With (Bremerhaven 1891–Los Angeles 1980)
Rudolf Wittkower (Berlin 1901–New York 1971)
Alma Wittlin-Frischauer (Lvov/Poland now
 Ukraine 1899–?)
Alice Wolfe (Tapolcsa/Hungary 1905–1983)
Heinrich Zimmer (Greifswald 1890–
 New York 1943)
Paul Zucker (Berlin 1888–New York 1971)

(Ludwig Bachhofer, Lorenz Eitner, Philipp Fehl,
Frances Gray Godwin, Oscar Hogen, Richard
Offner, Rudolph Meyer Riefstahl, Peter Selz and
Wilhelm Valentiner either left Germany before
the Hitler regime or departed Germany before
commencing university studies – or fled Austria
before the Anschluss.)

According to Michaels, 'Transfer and Transformation', 305 (as in note 16), altogether 'some 250 individuals, around one quarter of the total of art history specialists, were dismissed from their posts or prevented from continuing their studies or from working in a freelance capacity' in Germany. To this number must be added those from nations allied with Hitler's Germany or sharing its racist policies (as is indicated, for example, by the Hungarians and Romanians included in the above listing, though few beyond Lionello Venturi, Antonio Morassi and José López-Rey fled Franco's Spain or Mussolini's Italy for the United States). Although the majority of those who left their positions was forced to do so as a consequence of Hitler's anti-Semitic reform of the civil service law (1934), only three of the 30 or so ordinarius professors of Kunstgeschichte at German universities were Jewish (see Michaels, 306). The overwhelming majority of Jewish art historians, curators and researchers were at either the student or junior stages of their academic careers. It is important to realise that the forced dismissal and consequent departure of several hundred art historians of Jewish background (or spousal attachment) prompted many Gentile colleagues to resign in protest against the Nazi regime's extremist positions on 'nationality', social and educational policy, and general political orientation. Wendland documents 215 emigrating art historians, six whose efforts to emigrate failed, 11 who elected to remain in Germany and suffered persecution and six who were ultimately deported and died in concentration camps. Nonetheless, not all art historians in Hitler's Germany (and certainly comparatively few in Horthy's Hungary, Antonescu's Romania or Mussolini's Italy) stood in opposition to the

regime or its policies. Scholars of considerable academic eminence – Wilhelm Pindar (1878–1947), Hans Sedlmayr (1896–1984), Heinrich Wölfflin (1864–1945) and Dagobert Frey (1883–1962), among the most distinguished – embraced to varying degrees (and often professionally profited from) the 'New Order' being created in Central Europe. See Jonathan Petropoulos, *The Faustian Bargain: The Art World in Nazi Germany*, New York: Oxford University Press, 2000, especially chapter 4 (on 'Art Historians'), who notes on page 170 that the Allies compiled at least 110 names of academic art historians (exclusive of those scholars who worked in museums, monument preservation or as independent researchers) who 'produced explicitly National Socialist scholarship or played a role in the plundering program' (see Petropoulos, 320).

1. Although the literature on European émigrés active in North American (and British) academic life is enormous, the following studies are especially germane to the present essay: Donald Fleming and Bernard Bailyn eds, *The Intellectual Migration: Europe and America, 1930–1960*, Cambridge, MA: Harvard University Press, 1969; Anthony Heilbut, *Exiled in Paradise: German Refugee Artists and Intellectuals in America from the 1930s to the Present*, New York: Viking, 1983; Udo Kultermann, *Geschichte der Kunstgeschichte*, Frankfurt am Main: Ullstein, 1981; Heinrich Dilly, *Deutscher Kunsthistoriker, 1933–1945*, Munich: Deutscher Kunstverlag, 1988; Herbert A. Strauss ed., *Die Emigration der Wissenschaften nach 1933: Disziplingeschichtliche Studien*, Munich: K.G. Sauer, 1991; *Kunst im Exil in Grossbritannien 1933–1945*, exh. cat., Berlin: Orangerie des Schloßes Charlottenburg, 1986 (also, *Kunst im Exil in Grossbritannien 1938–1945*, Vienna: Historisches Museum der Stadt Wien, 102, Sonderausstellung, 1986); Stephanie Barron ed., *Exiles + Émigrés: The Flight of European Artists from Hitler*, exh. cat., Los Angeles: County Museum of Art, and New York: Harry N. Abrams, 1997 (with a number of essays essential to the comprehension of the depth, consequences and meanings of this European emigration for the practice of Anglo-American Art History); and Karen Koehler, 'The Bauhaus, 1919–1928: Gropius in Exile and the Museum of Modern Art, New York, 1938', in Richard A. Etlin ed., *Art, Culture, and Media Under the Third Reich*, Chicago: University of Chicago Press, 2002, 287–315. Most of these works contain a helpful bibliography.

2. The riposte of those who fled totalitarian terror in Europe clearly was not limited to conducting scholarship and publishing books. Many émigré scholars joined the allied military as translators (e.g. Philipp Fehl), as camouflage experts (e.g. Moholy-Nagy) and, in significant numbers, as fighters.

3. The history of modern art as defined through the role of émigré art historians in the United Kingdom and the Commonwealth lies outside the scope of the present essay, though its ideological outlines were generally congruent with those sketched here.

4. The 'objectivity' of German scholarship had long been admired in the United States. As Colin Eisler perceptively observed, the 'Teutonic approach [to scholarly enquiry] was favored for the relative objectivity and lack of flag-waving ... [since the time of Winckelmann]... [T]he German art historian felt the subsidiary role that the land of his birth played ..., producing texts which, in their day, were far less biased than the chauvinistic scholarly literature of France

and Italy' (Eisler, '*Kunstgeschichte* American Style', in Donald Fleming and Bernard Bailyn, op. cit, 548).

5. For a discussion of the role played by the history of art survey books in promoting anti-German attitudes among American university audiences, see S.A. Mansbach, 'Menzel's Popular Reception in the English-Speaking World', in Thomas Gaehtgens, Claude Keisch and Peter-Klaus Schuster eds, *Jahrbuch der Berliner Museen*, vol. 1, 1999, special supplement, Berlin: Gebr. Mann Verlag, 2002, 325–31.

6. Everard M. Upjohn, Paul S. Wingert and Jane Gaston Mahler, *History of World Art*, New York: Oxford University Press, 1949, 309. For a discussion of the reception of 19th-century German painting in the United States, as opposed to works of Expressionism and Abstraction brought by German émigrés, see Marion Deshmukh, 'Tradition and Modernity in German Nineteenth and Twentieth-Century Art', in *Central European History*, 35, 3, especially 400–01. See also Penny Bealle, *Obstacles and Advocates: Factors Influencing the Introduction of Modern Art from Germany to New York City, 1912–33*, PhD dissertation, Cornell University, 1990; Stephanie Barron ed., *'Degenerate Art': The Fate of the Avant-Garde in Nazi Germany*, exh. cat., Los Angeles: County Museum of Art, 1991, and Barron ed., *Exiles + Émigrés*, op. cit.

7. See Bernard S. Myers, *Art and Civilization*, New York: McGraw-Hill, 1957, David Robb and J.J. Garrison, *Art in the Western World*, revised edition, New York: Harper and Brothers, 1942, and John Ives Sewall, *A History of Western Art*, New York: Henry Holt and Co., 1953. Significantly, the scepticism apparent in American texts is almost entirely absent in British publications of the time, which more often than not proffered a balanced assessment of European and modern German culture. See Mansbach, 1999, op. cit.

More problematic for the authors were cubism (and its political anarchism), futurism (and its proto-fascism), suprematism (and its communism), neoplasticism (and its socialism), inter-war East European constructivism (and its various forms of political radicalism), German and Romanian dadaism (with its revolutionary politics), along with other activist movements, most of whose insurrectionary politics and philosophy were ignored in favour of an 'objective' emphasis on stylistic freedom and formal innovation.

8. Ernst Gombrich, *The Story of Art*, New York: Phaidon and Oxford University Press, 1950, 420. H.W. Janson, *History of Art: a Survey of the Major Visual Arts from the Dawn of History to the Present Day*, New York: Harry N. Abrams, 1962, 544. With respect to German modern art in general, and in particular regarding Germany's 19th-century artists, who were celebrated during the Third Reich for their nationalist

character, style and subject matter, one need only compare the pre-war and post-war editions of Helen Gardner's *Art through the Ages, An Introduction to Its History and Significance*, New York: Harcourt Brace & Company, 1926 (1st edition); or examine the lionised treatment of the Bauhaus in Frederick Hartt's *Art: A History of Painting, Sculpture, Architecture*, London: Thames and Hudson, and Englewood Cliffs, N.J.: Prentice Hall, 1976; in H.H. Arnason's *History of Modern Art*, New York: Harry N. Abrams, 1969; in Marilyn Stokstad's highly readable 1000-page introductory *Art History*, Englewood Cliffs, N.J.: Prentice Hall, 1995; among a host of successfully selling survey books to perceive the continuity of viewpoint apropos of modern German art. See also Mansbach, op. cit. (see note 5).

Janson's sympathy for the styles of modern art was made abundantly clear in the collections – exceeding more than 500 works of art – he assembled for Washington University in St Louis. Arriving at the university in 1941 to assume a position as assistant professor, Janson was named curator of the University's collections in 1944. During the four years of his curatorship, he remade the collection into a showcase for modern art, including important works by 'degenerate' artists and their confederates. See Sabine Eckmann ed., *Exile and Modernism: H.W. Janson and the Collection of Washington University in St. Louis*, St Louis: Washington University Gallery of Art, 2002.

9. Throughout the present essay, the 'Bauhaus' is employed synoptically to refer to a wide range of (mostly) functionalist theories and practices embraced by a host of progressive artists and critics in central and western Europe, and in North America. 'Bauhaus' is thus used here not exclusively to allude to the progressive school founded by Walter Gropius in Weimar (and continued successively in Dessau and Berlin, and more remotely in Ulm, Chicago and Budapest); rather it should be understood more as a metonym for the forms and functions of modern art (and its theories) developed broadly in Germany, France, the Netherlands, the United States and so forth between, roughly, 1913 and the early 1930s. Similarly, 'modernism' (and its adjectival variants) is generally employed here – as in much of the contemporary scholarship on modern art – in the reductivist sense of its meaning(s) and associations, as referring to those totalising philosophical, aesthetic and stylistic precepts promulgated between roughly 1905 and the late 1930s by the theorists and artists of the classical avant-garde.

Critical scholarly assessments of Bauhaus policies and practices have proliferated since the emergence of post-modernist theory. Of particular note in recent literature is the re-examination of the Bauhaus's claim of openness to 'any person of good repute, regardless of age or sex' (Gropius, from Article 3 of the *Satzungen des Staatliches Bauhauses zu Weimar*, January 1921). See Sigrid Wortmann Weltge, *Bauhaus Textiles: Women Artists and the Weaving Workshop*, New York: Thames and Hudson, 1998, and Anja Baumhoff, *The Gendered World of the Bauhaus: The Politics of Power at the Weimar Republic's Premier Art Institute, 1919–1932*, Frankfurt am Main: Peter Land, 2001.

10. For a discussion of modernist abstraction of the 1910s and 1920s as a paradigmatic 'social condenser' leading toward the dynamic collective society of the future, see S.A. Mansbach, *Visions of Totality: Laszlo Moholy-Nagy, Theo van Doesburg, and El Lissitzky*, Ann Arbor: UMI Press, 1980, 47, 52, 117 and passim.

11. See Éva Forgács, *The Bauhaus Idea and Bauhaus Politics*, translated by John Bátki, Budapest, London and New York: Central European University Press, 1991, especially Chapter 13.

12. Among the influential exhibitions reflective of Barr's aesthetic ideology, and most formative for the Museum of Modern Art's self-definition as the leading venue and emblem for modern art, architecture, photography and design, were those devoted to *Modern Architecture: International Exhibition* (1932); *Machine Art* (1934), the first MoMA design show; *Cubism and Abstract Art* (1936); *Fantastic Art, Dada, and Surrealism* (1936); and *Bauhaus 1919–1928* (1938). A further aspect of Barr's aesthetic interests and world-view is revealed in the two exhibitions of 1943, which ironically focused principally on figurative American art: *Americans 1942, Romantic Painting in America* and *American Realists and Magic Realists*. The latter two engendered considerable controversy, especially among the nation's ranks of abstract artists, most notably those members of the American Abstract Artists (AAA) and the Federation of Modern Painters and Sculptors (both of which counted émigré artists among their predominantly American membership). For an instructive overview of Barr's intentions for and participation in these exhibitions, see Irving Sandler, 'Introduction' to *Defining Modern Art: Selected Writings of Alfred H. Barr, Jr.*, New York: Harry N. Abrams, 1986.

13. One need only recall the decision of the Rockefellers, generous and courageous founder-supporters of MoMA, to obliterate the revolutionary mural the family had commissioned from Diego Rivera for Rockefeller Center during the same period the family supported equally radical émigré artists from Europe.

14. The hand-drawn chart (The Museum of Modern Art Archives, NY: Alfred H. Barr Jr Papers, 10.A.34) was modestly

reduced and then reproduced as the frontispiece to the museum's 1936 exhibition catalogue, *Cubism and Abstract Art*. Between original publication and 1941, Barr made several important revisions to his map of modern art. See Sandler, op. cit., 92.

15. See M. Schapiro, 'The Nature of Abstract Art', reprinted in Meyer Schapiro, *Modern Art, 19th and 20th Centuries*, New York: G. Braziller, 1978, 165–226. Paradoxically, Barr's reticence in comparatively 'secure' America stands in contrast to the circumstances then prevailing in the increasingly extremist and ever more intolerant environment of Germany, Italy, Hungary, Poland, Latvia, Estonia and Romania, where many of the museum advocates of modernism celebrated the social radicalism of progressive aesthetics. In part, this important difference during the 1930s may be attributed to the exploitation of modern art by liberal forces in Central Europe to counter their respective governments' restrictions of political freedoms, as opposed to Barr's concerted endeavour to secure the support of MoMA's trustees. For a representative example of the embattled modernism in East-Central Europe, see S.A. Mansbach, 'The "Foreignness" of Classical Modern Art in Romania', *The Art Bulletin*, 80, 3, September 1998, 534–54.

During the final year of World War II, Barr did publish a retrospective critical analysis of the political conditions of the Nazi's oppressive rule apropos of modern art. See Alfred H. Barr, 'Art in the Third Reich – Preview, 1933', *Magazine of Art*, October 1945, and reprinted in Sandler, op. cit., 163–75.

16. See Karen Michaels, 'Transfer and Transformation: The German Period in American Art History', in Barron ed., *Exiles + Émigrés*, op. cit., 304–316.

17. Ibid., 298.

18. Barr's role in the 1932 exhibition, *The International Style*, and its accompanying book of the same name, was secondary, Henry-Russell Hitchcock and Philip Johnson having served as principle organisers and authors. Both the installation and the accompanying text celebrated modernist architecture as a style, and they delimited its scope to accord with American expectations. Thus instead of addressing the ideological concerns of the exhibited architects and designers, Hitchcock and Johnson elected to confine themselves to such formal matters as 'architecture as volume', 'avoidance of applied decoration' and 'regularity rather than symmetry in planning', among others. See Tim Benton, 'Building Utopia', in *Modernism: Designing a New World 1914–1939*, exh. cat., London: Victoria and Albert Museum, 2006, 164–65.

19. For an explanation of additional reasons why the political dimensions of the Bauhaus were scrupulously eschewed by MoMA and Gropius, see Michaels, 'Transfer and Transformation', in Barron ed., *Exiles + Émigrés*, op. cit., especially 299–300. It is worthy of mention that many contemporary press accounts of the MoMA Bauhaus exhibition did in fact engage with the political issues Barr and Gropius so assiduously avoided (see Michaels, 301ff.).

20. See Anthony Alofsin, *The Struggle for Modernism: Architecture, Landscape Architecture, and City Planning at Harvard*, New York: W.W. Norton and Co., 2002, 163, who cites a 1937 article in the *New York Times*, which reported on the furore occasioned by the exhibition's 'unrealistically high appraisal of its achievements' (Alofsin).

21. Gropius' endeavour to excise material essential to the understanding of the Bauhaus prompted Barr to reprimand the architect, whom he had originally supported for appointment to Harvard. According to Alofsin (ibid.), Barr complained bitterly of Gropius' endeavour 'to impede an objective assessment of the Bauhaus' and, quoting Barr on the mendaciousness of the exhibition's catalogue: 'The book [on the Bauhaus] is not complete even within its field calling eventually for a more definitive and dispassionate study. I must ask you to replace these omissions in the interest of the Museum's scholarly integrity.' (Excerpted from a letter from Barr to Gropius dated 24 June 1955, Houghton ms. HL, Harvard and cited in Alofsin, ibid., 287, n.79.)

22. Excerpted in Sandler, op. cit., 86.

23. Karen Michaels, 'Transfer and Transformation', in Barron ed., *Exiles + Émigrés*, op. cit., 312, asserts that 'contemporary art, which never appeared on any syllabus in Germany until after World War II, played no major role in the émigrés' work', with the exception of Panofsky's essay on film, Alfred Neumeyer's several articles on American modern art and Paul Wescher's short study on Man Ray as a painter.

24. This practice was pointed out by Kevin Parker in his discussion of Richard Krautheimer's employment of English as part of a broader strategy to sidestep a 'German' methodological emphasis on the political content of art (and art history). See Kevin Parker, 'Art History and Exile, in Barron ed., *Exiles + Émigrés*, op. cit., 319–21; also Keith Moxey, 'Impossible Distance: Past and Present in the Study of Dürer and Grünewald', *The Art Bulletin*, 86, 4, December 2004.

For a considered discussion of the meanings, conditions and consequences of the academic 'distancing' from the politicisation on the part of German art historians, most prominently Erwin Panofsky, see Moxey, ibid., especially 754–59.

25. The important exception to this pattern is the practice of the 'social history of art', which the Hungarians Arnold Hauser (1892–1978) and Frederick (Frigyes) Antal (1887–1954) further refined and popularised during their exilic years in England. It would be worth examining the degree to which the social history of art received its decisive impulse in the famous Sunday Circle (Sonntagskreis) meetings that took place in 1918–19 in Budapest (and to what extent this orientation was transposed briefly into practice, when Antal became commissar of public education during the short-lived Hungarian Republic of Soviets). Among the engaged participants in these periodic gatherings of young (mostly Jewish) intellectuals were Georg (György) Lukács, Karl Mannheim, Charles (Károly) de Tolnay, Johannes (János) Wilde, Otto Benesch (as a guest in 1919), Hauser, Antal, to name only those who later went into American or British exile. (See S.A. Mansbach, *Standing in the Tempest: Painters of the Hungarian Avant-Garde, 1908–1930*, Cambridge, MA: MIT Press, 1991, n.8, 85; Mary Gluck, *George Lukács and His Generation, 1900–1918*, Cambridge, MA: Harvard University Press, 1985; Anna Wessely, 'Der Diskurs über die Kunst im Sonntagskreis', in Hubertus Gaßner, *Wechselwirkngen: Ungarische Avantgarde in der Weimarer Republik*, Marburg: Jonas Verlag, 1986; and Lee Congdon, *The Young Lukács*, Chapel Hill: University of North Carolina Press, 1983.)

26. Cf. Erwin Panofsky, 'The History of Art as a Humanistic Discipline', in Erwin Panofsky ed., *Meaning in the Visual Arts*, Garden City, NY: Doubleday, 1955, 1–25.

27. It is worthy of mention that none of the survey texts attended to the Russian avant-garde or its politicised art by Kazimir Malevich, El Lissitzky, Vladimir Tatlin and the confederates of suprematism, productivism and constructivism. Although the Museum of Modern Art had exhibited important works by the Russian avant-garde in the 1930s, not until the late 1960s and early 1970s did any of the principal survey texts incorporate a discussion of it.

28. GI Bill Act of 22 June 1944 (Servicemen's Readjustment Act; PL78 (346)).

29. This was clearly intentional, as the manifestos of the modernists were well known during the inter-war years. Moreover, countless cultural critics and philosophically-oriented commentators publicised and further analysed the political and social dimensions of 'progressive' modern art. From the exchanges of letters, surviving archives and even the published record of those Central European figures soon to be forced into exile, it is evident that the political aspects of the modernists were common copy in the 1920s. By the early 1930s, the various campaigns of official antipathy –

political even more than aesthetic – of authoritarian governments toward modern art were inescapable to even the most casual observer.

30. For a penetrating discussion of Clement Greenberg's formalist stance *vis-à-vis* Jewish art and apropos of his ambivalence regarding his own ethnicity, see Margaret Olin, 'C[lement] Hardesh [Greenberg] and Company', in *Too Jewish?: Challenging Traditional Identities*, exh. cat., New York: Jewish Museum, 1996, 39–59. Of particular note in Olin's analysis is the formative relationship between Greenberg's (and Harold Rosenberg's) formalist criticism and their conflicted attitudes toward Jewish art and Jewishness.

Greenberg's intellectual disciples, Rosalind Krauss and three of her long-time colleagues from the journal *October* – Hal Foster, Yve-Alain Bois and Benjamin H.D. Buchloh – have published their own survey of modern art, *Art since 1900: Modernism, Antimodernism, Postmodernism*, London: Thames and Hudson, 2005. This two-volume history of 20th and early 21st-century art is as highly ideologically motivated, politically partisan and critically partial as any of those authored by the earlier generation of figures discussed in the present study. For an extensive critical appraisal of *Art since 1900* by a host of invited reviewers – Nancy J. Troy, Geoffrey Batchen, Amelia Jones, Pamela M. Lee, Romy Golan, Robert Storr, Jodi Hauptman and Dario Gamboni, see 'Interventions Reviews', *The Art Bulletin*, 88, 2, 373–89.

31. From Peter Novick, 'Holocaust memory in America', in James Young ed., *The Art of Memory: Holocaust Memorial in History*, Munich and New York: Prestel-Verlag, 1994, 160, as quoted in Olin, ibid., 60. Olin is especially acute in her analysis of Greenberg's attraction to formalism as a manifestation of his attitudes toward traditional Judaism.

32. It might prove to be a productive exercise to consider 'Greenbergian' reductivism within the context of the émigrés' ideological posture *vis-à-vis* their 'otherness' as non-native Americans or English-speakers, as Germanically educated and – for a plurality of émigrés – as Jews. For the last-mentioned, see Olin's discussion of Jean-Paul Sartre's *Anti-Semite and Jew*, translated by George J. Becker, New York: Grove Press, 1962, as 'a tool for understanding the function of formalism in relation to [Jewish] ethnicity' (46–47).

33. By no means should one ignore those renowned scholars of art history who emigrated from Poland, the Baltic Republics, Czechoslovakia and the Soviet Union during the inter-war years. Although the political motivations for their departure from their respective homelands paralleled those of Germans, Hungarians and (to a lesser degree) Italians, a consideration of these émigrés' influence on the history of modern art in the West lies outside the present study.

Scholar-refugees from fascist Spain and Portugal, though comparatively few in number, represent still another case.

34. A helpful compendium of materials on and by Central European émigré scholars can be found in the German Intellectual Émigré Collection at the State University of New York at Albany.

35. For a helpful introduction to a well-chosen anthology of manifestos and artists' writings from Central Europe, see Timothy O. Benson and Éva Forgács eds, *Between Worlds: a Sourcebook of Central European Avant-Gardes, 1910–1930*, Cambridge, MA: MIT Press, 2002.

36. For recent studies of eastern European classical modernism (with essential bibliographies), see Dubravka Djurić and Miško Šuvaković eds, *Impossible Histories: Historic Avant-Gardes, Neo-Avant-Gardes, and Post-Avant-Gardes in Yugoslavia, 1918–1991*, Cambridge, MA: MIT Press, 2003; Timothy O. Benson ed., *Central European Avant-Gardes: Exchange and Transformation, 1910–1930*, Cambridge, MA: MIT Press, 2002; S.A. Mansbach, *Modern Art in Eastern Europe: From the Baltic to the Balkans*, New York and Cambridge: Cambridge University Press, 1999; and Elizabeth Clegg, *Art, Design, and Architecture in Central Europe, 1890–1920*, London: Yale University Press, 2006. The MIT Press, under the guidance of Roger Conover, has also brought out a number of English-language studies treating 20th-century architecture and design from eastern Europe.

Although often begrudgingly, a number of Soviet architectural and art historical studies did treat, however cursorily, the classical modern art (principally architecture) of the inter-war era. See, for example, Lithuania and Estonia SRR publications.

37. For a discussion of the singular character of modern architecture in Estonia and Lithuania, see S.A. Mansbach, 'Modernist Architecture and Nationalist Aspiration in the Baltic: Two Case Studies', *Journal of the Society of Architectural Historians*, 65, 1, March 2006, 92–111.

38. Although a number of these manifestos and critical texts were published in contemporaneous versions in German, and less frequently in Russian, they were little consulted during the post-war years.

39. Although the avant-garde art (and cultural) journals of the early 20th century carried images by, articles on and essays by progressive artists from eastern and southeastern Europe, few scholars before the 1990s turned to these primary sources. Moreover, almost none of the articles (and few of the illustrations) were reprinted in the numerous anthologies published in the United States from the 1960s through to the 1990s.

The absence in North America and western Europe of significant numbers of intellectuals from this region compounded the general western ignorance, as there were few scholars sufficiently prepared to tell the story of the advanced art and architecture from Kaunas, Pärno, Tallinn and beyond. Hungary and Poland may constitute exceptions to this general condition, as there were large numbers of émigré Hungarian and Polish scholars in positions of academic, cultural and economic authority throughout the West. Nonetheless, until the 1990s, few texts by the original avant-gardes were translated into western languages. Moreover, many superbly trained art historians in western institutions, Andrzej Turowski perhaps the most notable, continue to publish pioneering studies of eastern European modernism almost exclusively in their native languages. See, for instance, Andrzej Turowski, *Budowniczowie Świata. Z dziejów radykalnego modernizmu w sztuce polskiej*, Cracow: Universitas, 2000, as well as his seminal *Konstruktywizm Polski*, Wrocław: Zaklad Narodowy im. Ossolinskich, 1981, which has yet to be translated.

40. Several exceptions are important to note in this context. During the brief cultural 'thaw' in Poland of c.1956, both classical and contemporary avant-garde art were officially tolerated and publicly embraced. See Piotr Piotrowski, 'Odwilz' (The Thaw), in P. Piotrowski ed., *Odwilz. Sztuka ok. 1956*, Poznan: National Museum, 1996, 9–35 and 243–59; and P. Piotrowski, 'Modernism and Socialist Culture: Polish Art in the late 1950s', in Susan E. Reid and David Crowley eds, *Style and Socialism: Modernity and Material Culture in Post-War Eastern Europe*, Oxford: Berg Publishers, 2000, 133–47. In communist Hungary, the study of the nation's early 20th-century modern art began during the 1960s with the publication of *A Magyar Tanácsköztársaság képző müszeti élete* by Lajos Neméth and Dezsö Kiss (Budapest: Corvina, 1960) inaugurating the examination. Modestly-scaled exhibitions of the work of Lajos Kassák (1887–1967), who might best be understood as the impresario of the Hungarian avant-garde, were mounted in the mid-1960s, even though the artist's own freedom had been limited by all Hungarian governments: Habsburg, Soviet, fascist, democratic and communist. See Mansbach, *Standing in the Tempest* (as in note 25), passim.

For an indication of the locations of the 'banished' avant-garde art under the Soviet regime, see the sources of loans for an exhibition on Soviet revolutionary held c.1989 in East Berlin's Otto-Nagel-Haus: *Abteilung proletarische-revolutionarärer und antifastischer Kunst der Nationalgalerie der Staatlichen Museen zu Berlin* (no catalogue).

As Piotrowski has pointed out on several occasions, scholars in both Yugoslavia (post-1948) and Poland (especially during the post-1956 'thaw') were deeply interested in art historical narratives of modernity/modernism. Officially and unofficially there was a receptivity to historical discourses in culture that avoided politics; and in this context the apolitical 'modernism' of the West, prompted by the émigrés active there, was welcomed in Warsaw and Belgrade. For the Yugoslav and Polish (and to a lesser extent Hungarian) governments, such a narrative was safely endorsed as essentially truthful as it affirmed aesthetic progress without raising political danger. For scholars of independent mind, the prevailing western discourse was embraced as an expression of freedom and anti-totalitarianism (of the anti-Soviet kind). Both 'receptions' were essentially uncritical, but then the prevailing indigenous circumstances fundamentally shaped the ways in which modernist art history might be adapted to further local (as opposed to universal) needs. See Piotr Piotrowski, 'On "Two Voices of Art History"', in Katja Bernhardt and Piotr Piotrowski eds, *Grenzen überwindend: Festschrift für Adam Labuda*, Berlin: Lukas Verlag, 2006.

41. Camilla Gray, *The Great Experiment: Russian Art, 1863–1922*, New York: Harry N. Abrams, 1962. A revised and enlarged edition by Marian Burleigh-Motley was published in 1986 (New York: Thames and Hudson).

42. Sophie Lissitzky-Küppers, *El Lissitzky. Maler, Architekt, Typograf, Fotograf. Errinnerungern, Briefe, Schriften*, Dresden: VEB Verlag der Kunst, 1967; ibid., *El Lissitzky: Life, Letters, Texts*, translated by Helene Aldwinckle and Mary Whittall, with an introduction by Herbert Read, London: Thames and Hudson, 1968; and ibid., *El Lissitzky: Life, Letters, Texts*, with an introduction by Herbert Read, Greenwich, Conn.: New York Graphic Society, 1968.

43. One of the first exhibitions to survey modernist art from eastern Europe took place, not inappropriately, in West Berlin, when in 1967 the Deutsche Gesellschaft für Bildende Kunst and the Akademie der Künste conjointly organised *Avantgarde Osteuropa, 1910–1930*. An exhibition of Hungarian material was mounted at the Indiana University Art Museum in 1972, entitled *Hungarian Art: The Twentieth Century Avant-Garde*. Given the political circumstances of the Cold War era, it should not be surprising that Polish avant-garde art was displayed in France comparatively early, with the first major exhibition organised in 1957 by Michel Seuphor, *Précurseurs de l'art abstrait en Pologne. Kasimierz Malewicz, Katarzyna Kobro, Władysław Strzemiński, Henryk Berlewi, Henryk Stażewski* (Paris: Galerie Denise René).

Two years later, exhibitions treating Polish modernism were mounted in Venice (Sala Napoleonica), Copenhagen and Amsterdam. And in 1960, the New York Gallery Chalette presented *Construction and Geometry in Painting, from Malevitch to 'Tomorrow'*, which included examples from inter-war Poland.

44. Although I know of no art historian who was called to testify before the Committee on Un-American Activities of the US House of Representatives, numerous individuals originally from Central Europe were called before the Committee, many from the film industry, with which several émigré scholars were closely associated, including Laszlo Moholy-Nagy.

45. For a comprehensive analysis of the formative role played by nationalism in the generation and function of eastern European avant-garde art and aesthetics, see Mansbach, *Modern Art in Eastern Europe*, op. cit. For a dissenting view, see James Elkins' review of Mansbach, *The Art Bulletin*, 82, 4, December 2000, 781–85. See also Anthony Alofsin, Letter to Editor, *The Art Bulletin*, 84, September 2002, 539. For a discussion of the role of nationalist discourse in the art historiography for Central and Eastern Europe, see Robert Born, Alena Janatková and Adam S. Labuda eds, *Kunsthistoriographien in Ostmitteleuropa und der nationale Diskurs*, Berlin: Gebr. Mann, 2004.

46. It was at just this moment that Clement Greenberg's brand of formalist criticism provided a post-war imprimatur of progressiveness that conveniently coincided with the émigrés' objectives. Although a radical thinker during the 1930s, by the early 1950s Greenberg's political engagement was less explicitly present in his critical posture. As a consequence, formalist criticism garnered widespread interest, including among the émigré art historians, who could adapt its praxis in their own writings on modern art.

47. This perspective was, perhaps, most emphatically encapsulated by Le Corbusier, who declaimed, 'My buildings are as good for Zulus and Eskimos. They are neither dependent on the height of people nor on centuries-old cultural structures.' Originally published in Martin Wagner, *Potemkin in West Berlin*, Berlin, 1957, and quoted in Greg Castillo, 'Socialist Realism and Built Nationalism in the Cold War "Battle of the Style"', *Centropa*, 1, 2, May 2001, 91.

48. In the last decade, a number of studies have promoted a helpful perspective through which to reassess the meanings and purposes of modernist architecture. Many of those treating 'national' histories of modern architecture have appeared under the rubric Docomomo (International Working Party for Documentation and Conservation of

Buildings, Sites and Neighbourhoods of the Modern Movement). Almost all are premised on the concept of a pluralistic modernism, that is, a methodological strategy that holds that progressive architectural forms and uses defy any unitary categorical imperative. In contrast to the dominant interpretive uniformity that characterised the plurality of architectural studies from the 1930s through to the 1980s, they attribute to modernism a heterogeneity of meanings and intentions. Representative of the current historiographical orientation are Hubert-Jan Hencket and Hilde Heynen eds, *Back from Utopia*, Rotterdam: 010 Publishers, 2002; Hilde Heynen, *Architecture and Modernity: A Critique*, Cambridge, MA: MIT Press, 1999; and *Universality and Heterogeneity*, Proceedings from the Fourth International Docomomo Conference, 18–21 September 1996, Bratislava, 1997.

49. See, for example, Benson, op. cit.; Benson and Forgács, op. cit.; Djurić and Šuvaković, op. cit.; and Clegg, op.cit.

Parallel recent studies of other geographical regions might also be noted: Gennifer Weisenfeld, *MAVO: Japanese Artists and the Avant-Garde, 1905–1931*, Berkeley: University of California Press, 2002; and especially, Sibel Bozdoğan, *Modernism and Nation Building: Turkish Architectural Culture in the Early Republic*, Seattle: University of Washington Press, 2001.

50. See S.A. Mansbach, 'Methodology and Meaning in the Modern Art of Eastern Europe', in Benson, op. cit., 288–306.

51. It is not only the monuments of modernism in Ireland, Scandinavia, Iberia and the Middle East that would be revealed; but also, it is likely that a host of 'unseen', 'alternatively' modernist monuments await discovery in Germany, France and other conventional centres of artistic production. The 'Bauhaus vision' was but one of the multiple modernist perspectives competing for credibility, both 'at home' in western Europe and, especially, on the fringes of industrialised Europe during the second quarter of the 20th century.

DIASPORA AESTHETICS: EXPLORING THE AFRICAN DIASPORA IN THE WORKS OF AARON DOUGLAS, JACOB LAWRENCE AND JEAN-MICHEL BASQUIAT

SIEGLINDE LEMKE

In spite of the proliferating critical discourse of diaspora studies, the specific nature and function of 'diaspora aesthetics' still seem unclear. This fairly new and exciting scholarly enterprise has been primarily concerned with the dis/re-location of peoples, the socio-cultural consequences and the conception of theoretical frameworks. Rarely has the critical discourse been applied to the visual arts.[1] Nor is there a commonly agreed upon understanding of what diasporic art looks like.[2] Should we think of Dorothea Lange's portrait of a desperate and distressed *Migrant Mother* (1936) or of Tom Feeling's drawings of the unspeakable, *The Middle Passage* (1995)? Should we imagine a bright canvas depicting mythic homelands such as Aztlán or Timbuktu? In other words, should the subject matter of such art invariably reflect the traumatic events that precede a forced dispersal, or does it capture the nostalgic yearnings for lost origins? Moreover, is there a particular style we can identify as 'diasporic'? If so, are there variations of the diasporic style according to the different diasporic groups (Caribbean, Asian, European, US American and so forth)? What are the stylistic variations over time? Are there realist, modernist, post-modernist styles of diaspora art or can we think of other parameters of periodisation to assess the diachronic dimension?

It is safe to argue that diaspora art depicts the act or the consequences of either forced or voluntary dispersal. Sometimes diaspora art expresses a longing for a home, and frequently it tries to construct a collective identity out of its mostly heterogeneous reality. This study closely examines visual representations of the African diaspora produced by African American artists between the 1930s and the 1980s. The subsequent readings gravitate around the homonymic pun roots/routes and the metaphor of the riot. While 'roots' stands for imagined or real origins, 'routes' refers to the act of travelling which defines the diasporic condition. 'Riots' refers to another crucial aspect of the diaspora: political and cultural conflicts between the host and the diasporic community as well as clashes between different diasporic communities residing in the same neighbourhood. 'Riots', however, can also refer to symbolic acts of rebellion in which the style of representation is particularly unsettling or 'riotous'. Its bold imagery makes it especially difficult to decipher the pictorial message inscribed in these artistic riots.

To determine the thematic and stylistic characteristics of diaspora aesthetics, as well as their transformation over time, I focus on three paintings that manifest an African American diaspora.[3] *Negro in an African Setting* (1934) by Aaron Douglas traces diasporic *roots* to the ancient splendour of African spirituality. Jacob Lawrence's *Migration Series* (1941) depicts the *routes* of African-Americans travelling from the South to the North. And Jean-Michel Basquiat's *History of Black People* (1983) interweaves references to Africa, the Americas and Antiquity into a grand spectacle of diasporic history. This multilayered imagery with its multiple references amounts to an iconoclastic *riot*.

The well-established themes of roots and routes can be traced back to James Clifford's acute observation that '[d]iaspora discourse articulates, or bends together, both roots and routes to construct what Gilroy describes as alternate public spheres, forms of community consciousness and solidarity that maintain identifications outside the national time/space in order to live inside, with a difference'.[4] This compelling statement taken from his classic volume *Routes* summarises the commonplace

in diaspora discourse: namely, that an acceptance of one's otherness and cultural origins is vital to the self-understanding of a diasporic people. Without this sense of identification and solidarity, a diasporic group would hardly be able to constitute an alternative public sphere. Unfortunately, Clifford does not expound on his passing reference to the homophone roots/routes; nor is he concerned with visual representations. Nevertheless, these two concepts are helpful in describing what is fundamental to the diasporic imaginary: the myth of homeland and return to lost origins as well as the experiences of travel, migration and relocation.

Before applying the concepts roots/routes/ riots to the above-mentioned images, I shall briefly discuss two pioneering critical assessments of diasporic visual culture: R.B. Kitaj's *First Diasporist Manifesto* (1989) and Stuart Hall's explicit engagement with 'diaspora aesthetics' in his seminal essay, 'Cultural Identity and Diaspora' (1990).

According to the Jewish-American artist Kitaj, 'diasporist art' is primarily concerned with history, homelands and the scattering of a people. Apart from these pictorial predilections, this form of art has a preference for 'confounded patterns' because it illustrates feelings characteristic of diasporic life: 'transient restlessness, un-at-homeness, groundlessness'.[5] Although Stuart Hall does not mention Kitaj, they both reject a 'backward-looking conception of diaspora'[6] and embrace the art of diaspora as a 'forward-looking' art.[7] Both believe that the prime function of the arts is to affirm a diasporic identity that reflects 'the common historical experiences and shared cultural codes which provides us, as 'one people', with stable, unchanging and continuous frames of reference and meaning,

beneath the shifting divisions and vicissitudes of our actual history.'[8]

This sense of oneness, Hall concedes, is only an imagined one because the black diasporic condition is actually characterised by hybridity, contingency and diversity. Nevertheless, a diaspora aesthetic serves a prescriptive and unifying role because it provides the black community with a sense of collective identity.[9] Moreover, it always expresses an insider's perspective since it speaks from 'the heart of blackness', as Hall puts it, conflating the differences between diaspora aesthetics and black aesthetics. To conclude, these pioneering accounts of diaspora art emphasise its function for the community and its polymorphous qualities.

The volume *Diaspora and Visual Culture* (2000) takes Hall and Kitaj as a springboard to examine the nature and politics of diaspora art. Contrasting representations of Africans and Jews as well as diasporic circumstances in Brazil and Poland, it offers one of the first comprehensive cross-diasporic approaches to art.[10] Its editor, Nicholas Mirzoeff, makes a very general critical assessment about this newly emerging field when he argues that: '[d]iaspora cannot by its very nature be known, seen or qualified, even – or especially – by its own members. The notion of the diaspora and visual culture embodies this paradox. A diaspora cannot be seen in any traditional sense and it certainly cannot be represented from the viewpoint of one-point perspective.'[11]

Since the diasporic condition generates multiple-view perspectives and since the perspectives are always already expressed in diasporic art, any critical approach to diaspora visual culture must concentrate on aspects of reception. As such, this perspective provides

new insights into questions of the gaze and spectatorship. Mirzoeff builds on Derrida's notion of *différance*, Kataj's polymorphous notion of diaspora, Du Bois' concept of double-consciousness, and Shohat and Stam's idea of a 'polycentric vision', to ascertain that a multiple viewpoint perspective is particularly appropriate to determine the new diasporic ways of seeing.

Taking up Mirzoeff's suggestion, the following analysis determines the specific nature of the multiple viewpoint perspective in the three above-mentioned diasporic artworks. I shall examine intratextual aspects (such as composition, themes, symbolism, tone and style) as well as extratextual factors concerning production and exhibition.

Roots: *Negro in an African Setting*

Aaron Douglas's *Aspects of Negro Life* (1934) was only ever exhibited at one location. Produced under the funding of the Works Progress Administration, a US government-sponsored New Deal programme, this four-panel mural adorned the lecture hall of the Harlem branch of the New York Public Library.[12] In its size and grandeur, this mural cycle traces the history of the African diaspora from its mythic origins in Africa to the Jazz Age in Manhattan. Its first panel, entitled *Negro in an African Setting*, visualises the spiritual roots of the African diaspora. Painted mostly in brown, purple and a pale gold, it depicts nine sturdy warriors, two dancers and two percussionists, all of whom have similarly shaped faces with full lips and a slit for an eye. These flat figures appear like silhouettes. Most striking perhaps are the two dancers in the middle with their backwards-leaning bodies and uplifted knees. The gaze of these dancers is directed towards a small sculpture floating above

their heads. Indeed, almost every figure in the painting is staring at this fetish object with its square shoulders and bowed legs placed on a triangle. The viewer, too, is drawn to this object positioned right at the middle of the upper image border. At first sight, it seems to be the centre of attention, but if we consider the composition as a whole, another perspective emerges.

The mural is structured through progressively expanding concentric circles that differ in their degrees of luminosity. Radiating from the fetish object situated at the heart of the brightest and smallest circle, are four semi-circles that become increasingly darker as they move from the top to the largest and darkest circle at the bottom. The outer circle displays tropical plants and two drummers energetically beating their instruments. Cutting through the concentric circles is a cone of light emanating from the venerated spiritual object towards the lower right-hand corner into the eye of the drummer. Accordingly, the spectator's gaze shifts from the visual epicentre on top towards the lower right, where the music is playing, back to the exuberant dancers in the middle.

By juxtaposing several pictorial epicentres (the dancers, the magic sculpture, the warriors and the drummers), *Negro in an African Setting* rejects a single, or one-point perspective. It provokes a diasporic way of seeing because the gaze shifts from the circles towards the sculpture or the dancers in the middle. The concentric design links visual radiation to rhythmic pulsation, which is reinforced by the beat of the drummers.

The overall tone of this multiple viewpoint image is mysterious and romantic. Its aura conveys the power of spirituality and buoyancy while suggesting a longing for a time and place that is far remote from urban settings. Its style,

Aaron Douglas,
Negro in an African Setting
from *Aspects of Negro Life,*
1934

however, is quasi-cubist and displays modernist features, given that the figures appear two-dimensional and the objects are geometric. Like most diasporic art, *Negro in an African Setting* defies abstraction. It clearly depicts ancient splendour and an imagined community of African warriors. Resonating with nostalgia, the image invites the spectator to return symbolically to the diasporic homeland.[13]

Numerous critics have commented on the significance of (real or imagined) homelands for the self-definition of diasporic communities. William Safran's list of six 'features of diasporas' includes three that are related to the retrospective trend of diaspora experience.[14] The question then arises, how do these artworks construct homelands and what are the key features of diaspora art?

In her analysis of diaspora novels, Monika Fludernik pertinently argues that:

> […] the memory of the past and its re-invention as an imaginary homeland are of the utmost psychological significance. Identity operates through narrative, and narrative needs to start in the past and pace its way to a future that embraces and resolves the discrepancies between past and present. What better story than that of a return to one's origins, a negation of the present in the light of messianic redemption?[15]

Douglas offers nothing less: a symbolic return to his putative African roots. In his case, the redemption is part of a larger emancipation narrative. Douglas provides a visual equivalent to those diaspora populations that attempted to emancipate themselves by advocating a physical or spiritual return to a proclaimed African homeland. His fantasy seeks to empower African Americans by promoting a pan-African 'race' pride.[16] Douglas' image venerates an ancient cultural legacy and idealises African spiritual as well as bodily strength. Hence, his symbolic homecoming highlights what is common to the diaspora imaginary, notably that 'the motherland remain[s] frozen in the diasporic imagination as a sort of sacred site or symbol, almost like an idol of memory and imagination' to use Paranjape's definition.[17]

Nostalgic yearnings, the critic Vija Mishra suggests in another context, are often linked to the experience of trauma. Following Jacques Lacan and Renata Salecl, Mishra extrapolates on the dialectic between the romantic and the traumatic moment 'when diasporic subjects feel they were wrenched from their mother(father)-land'.[18] While the pre-colonial motif of *Negro in an African Setting* predates the Middle Passage, Douglas' second panel is a visual document of the most sombre aspects of the African diaspora. *Into Bondage* exhibits the bleak reality of forced dispersion. It captures the horror of the transatlantic slave trade and the slaves' yearning for freedom symbolised in the North Star.

While the first panel idealises a glorious pre-slavery past, the second depicts the forcible displacement of Africans and evokes the heinous fate slaves had to endure on their way to the Americas. By constructing an imaginary home in the first panel and portraying the sense of homelessness in the second, Douglas paints the history and common culture of Africans transplanted into the new world by concocting a mythology of shared displacement among Africans and African Americans.

Douglas' visual account does not stop at this point. The third panel, *From Slavery Through Reconstruction*, set in the Reconstruction Era,

depicts life after the emancipation of the African slaves. The fourth panel, *Song of the Tower*, which shows African Americans in an urban modern setting, conveys an optimistic spirit suggesting that, in the 20th century, people of African descent will have a share in 'owning' western modernity.[19]

The overall intent of the mural cycle, then, is to unfold the diversity of diasporic culture from its ancient roots to a brighter future while unifying differences across the abyss of homelessness. Most importantly, perhaps, is Douglas' mode of presenting this collective fantasy of the homeland. His art is both representational and experimental. With its flat forms, hard edges, geometric shapes, fragmented style and its two-dimensionality, it inaugurates and partakes in shaping a modernism expressive of the unceasingly fragmented diasporic condition.

If we concentrate on the message of the first panel, we should interpret Douglas' symbolic homecoming as a counterpart to the various 'back-to-Africa' movements. What began in the 19th century with the American Colonization Society and the Black Nationalist movement that formed around Edward W. Blyden and Martin R. Delany, was then continued with different goals and intentions by Marcus Garvey in the 20th century, as well as the back-to-Liberia movement, which allowed thousands of African Americans to repatriate.[20]

It should be remembered that Douglas himself had not been to Africa at the time he painted *Negro in an African Setting*. He created the African setting completely from his imagination.[21] Douglas renders his fictitious Africa in a style that some critics call 'Africanist' because it borrowed from an Africa-inspired iconography. The person who encouraged him most to use African art as a source of inspiration was his mentor, the German illustrator Winold Reiss. Later in his life, Douglas repeatedly expressed his gratitude to Reiss for encouraging his interest in African art.[22] The 'dean' of the Harlem Renaissance, Alain Locke, also played a formative role in Douglas' integration of African design. In his manifesto *The New Negro* (1925), Locke pleads with the young generation to use the African ancestral legacy as a source of artistic inspiration.

Locke realised the potential that African influences had on the making of European modernism, and on Pablo Picasso in particular, and was eager to put this form of primitivism to the ends of creating a veritable black modernism. Instead of dismissing this European fascination with *l'art négre*, which peaked in Paris between 1905 and the 1920s, Locke sought to exploit it so as to enable the creation of an African American modernism. When he facetiously asked, 'So why could they so adroitly master these mediums and not we?', Locke was saying that 'they' (the European avant-garde artists) profited immensely from imitating the African art medium (e.g. geometric, abstract, cubic designs) and that African American artists should do the same.[23]

Negro in an African Setting shows both in its subject matter and its form that Douglas heeded Locke's call. In fact, the art critic Amy Kirschke retroactively labelled Douglas as the 'father of black modernism' because of his proto-cubist style.[24] Given that Douglas' discovery of an all-black modernism was mediated through Reiss, Locke and indirectly through Europe – or more precisely through a European-inspired primitivism – he should be considered a *pars pro toto* for a black primitivist modernism, the black American counter-strike to European primitivist modernism.[25]

Like Pablo Picasso, Douglas' commemoration of Africa was rather imagined than real.

Nevertheless, his 'fabricated Africanism', as Toni Morrison might put it,[26] succeeds in inventing or posing a cultural legacy and in unifying a dispersed population symbolically. His murals suggest that idealising ancient Africa is a necessary feature of black modernism. It is an indispensable fiction because it formulates a supposedly seamless identity and concocts a cultural or metaphysical unity to stake a claim on modernism. It is an enabling fiction that allows the disenfranchised, disadvantaged and dispersed to create their own meta-narrative. Douglas' celebration of the diaspora commemorates the African American's African heritage. On second sight, however, it is generated by a blend of (imagined) European, Euro-American, African American and African visual traditions.

Routes: *In every town Negroes were leaving by the Hundreds...*

Jacob Lawrence was familiar with Douglas' spectacular engagement with the African diaspora, since he frequently visited the library on 135th Street and specifically its Division of Negro History, Literature and Prints, which later became the Schomburg Center. In 1937, at the age of 20, Lawrence exhibited some of his drawings in a group show held at that same library.[27] Four years later, the young artist produced his own grand visual epic entitled the *Migration Series* (1941). The series is composed of 60 hardboard panels (each 12 x 18 inches, 30.48 x 45.72 cm), which were created simultaneously by using the same, mostly pure, colours with little mixing. The series offers a 'connective narrative', as Lawrence himself puts it, because it is 'conceptionalized as multiple images functioning together to convey an intended meaning'.[28] Among the many series the artist produced throughout his

life, the *Migration Series* is the largest and perhaps most fascinating because of its broad scope and formal consistency.

Like most of the other panels of the *Migration Series*, the third carries a rather long title: *In every town Negroes were leaving by the Hundreds to go North and enter into Northern industry*. Despite its title, however, the panel portrays a slightly different scene. Instead of hundreds, a small group of 11 people moves up a hill; there is no town in sight, nor do we see northern industry. These migrants traverse a barren no man's land devoid of trees, animals or human dwelling. They are *en route* somewhere in-between the South and the North, caught between hope and despair. The group appears in a state of limbo and their bleak facial expressions match the desolate landscape.

Since the faces are all painted in the same dark brown, it is difficult to discern the shape of their eyes or their skin complexion. Given that most of these figures wear hats or caps, the texture of their hair cannot be determined either. Deprived of any individual character traits, this depersonalised and ungendered group comes across as an anonymous ensemble eager to travel North to start a new life. On their way from a place of origin to a place of destination, perhaps heading for the next train station, these figures in Lawrence's work seem both determined as well as downtrodden.

One of the striking features of this canvas is its simple composition. Its upper half is painted in a light blue and its lower half in a light brown. From the lower right-hand corner of the image up towards the centre and downwards to the left-hand side, the group of migrants assumes the shape of a triangle. A flock of birds moves in the same direction as the group. The birds are

Jacob Lawrence,
Migration Series,
Panel 3, 1941,
'In every town Negroes were
leaving by the Hundreds to
go North and enter into
Northern industry'

painted in such a reduced manner that they appear like paper cutouts. Given its simplicity, Lawrence's modernist style bears features of a minimalist aesthetic.[29] Reduced to a few essentials (land, sky and baggage), it foregrounds people on the move. *In every town Negroes were leaving by the Hundreds to go North and enter into Northern industry* uses in its very title verbs such as 'leave', 'go' and 'enter' to emphasise the aspect of mobility.[30]

Among the many panels in this series portraying people *en route*, there are six images whose captions refer explicitly to the movement (e.g. panel 18: *The migration gained in momentum*; and panel 23: *And the migration spread*) or to the steady flow of people (e.g. panel 40: *The migrants arrived in great numbers*; and panel 60: *And the migrants kept coming*).

Since *Negroes were leaving* and the series as a whole capture the essence of mass migration, they represent a prime example of diaspora art. No wonder that James Weldon Johnson's recollection of the Great Migration reads like a literal description of Lawrence's image: '[...] I sat one day and watched the stream of migrants passing to take the train. For hours they passed steadily, carrying flimsy suit cases, new and shiny, rusty old ones, bursting at the seams, boxes and bundles and impediments of all sorts, including banjos, guitars, birds in cages and what not.'[31]

In fact, it is very likely that Lawrence – who had done extensive scholarly research prior to painting his series – had read Johnson's 1925 account published in the famous issue of *Survey Graphic*.[32] When commenting on the *Migration Series* retrospectively, Lawrence himself said the following:

I'm seeing the works for the first time in a number of years and I realize now in looking at them that every time I see them, I see them from a different point of view. I notice the symbols. I didn't realize that there were so *many* symbols of railroad stations, bus stations, people traveling! But that's what migration is. You think in terms of people on the move, people moving from one situation to another… Crossroads, bus stations, and train stations – moments of transition – it certainly was a moment of transition in the history of America and for the race.[33]

This significant event in American history stands for many other migratory flows. Lawrence's interest in moments of transition highlights mobility and crossings. Interestingly enough, Lawrence's assessment of his own viewing experience reconfirms Mirzoeff's insistence on a multiple viewpoint perspective. Whereas Lawrence's statement concerns the series as a whole, one might ask if a simple image like *Negroes were leaving* actually entices the spectator into different or multiple ways of seeing?

Looking closely at this particular image, we might be struck – as Johnson was in his recollection – by the boxes and bags the migrants were carrying along and by the size and apparent weight of this baggage. Makeshift luggage – one might add to Lawrence's observation – is another symbol of migration. The three biggest pieces of luggage are bags painted in brown, grey and reddish colours. The bulky baggage seems to wear people down. Since all their belongings are kept in these bags, the baggage also symbolises what migrants had to leave behind. In this light, *Negroes were leaving* shows a people who

experienced loss – 'Negroes were leaving a better life behind' we might say – and therefore reminds the viewer of 'the complexities, ambiguities, expectations, and disappointments that shaped the African American condition during this time', as Lonnie G. Bunch III and Spencer R. Crew put it.[34] Loss and gain are implied in the pun inscribed in this panel's title.

Another way of looking at these bags and boxes is to see them as presents.[35] Accordingly, one would acknowledge Lawrence, as Jeffrey C. Stewart did, for conveying 'the hopeful expectations they [migrants] felt'.[36] Upon *entering* the North, this group will empty their raggedy sacks, which can be interpreted as a metaphor for the contribution migrants make to their host culture. Seen in this light, these sacks are treasure bags filled with items the South brings to the new culture that emerges out of the seething cauldron of migration. Among those critics who have drawn attention to the benefits and gains of migration is Henry Louis Gates Jr, who observes that 'the Great Migration create[d] a new culture – a cross-pollinated black culture, one northern and urban yet thoroughly southern in its roots'.[37] Metaphorically speaking, these sacks are filled with a broad range of items including the blues, soul food, slang expressions, religious and social practices. These bags then symbolise the substantial contribution migrants made to the creation of urban modernity.

Looking at the baggage in this light opens up a different perspective. The viewer can choose between two gazes. Either we see a crowd that is 'desperately diasporic' (to borrow a catchy term from Apinan Poshyananda) or we see a merry crowd that is, like the three magi on their way to Bethlehem, anticipating their arrival to deliver their symbolic presents on an almost messianic

mission.[38] Maybe they are even aspiring to the gift of hospitality, as Derrida put it, assuming that people in the North will welcome their presents. Therefore, depending on one's point of view, *Negroes were leaving* portrays either the desperately diasporic or, if you like, the deliriously diasporic.[39]

The complex nature of the diasporic gaze becomes even more intricate if we look at the series as a whole.[40] As we go from panel to panel, our gaze wanders from image to image confronting us with different facets of the migration experience as well as different possible interpretations. The mode of reception is based on a sequential logic inviting the onlooker to grapple with several possible interpretations of a specific image as well as with the multiple meanings that the series generates consecutively.[41] The metaphor *routes* then applies to the content of this kaleidoscope of 60 images as well as to its mode of reception. More than just illustrating moments of transition, as Lawrence has it, the series makes the transitions between the individual panels a pivotal moment for the viewing experience as a whole. In other words, this diasporic *Gesamtkunstwerk* (holistic artwork) invites a multiple point of view perspective because it sends our gaze *en route*.

This viewing experience is, however, not an end in itself because, through the sequencing of panels that portray northern, southern and migratory scenes, the series instructs the viewer on migrant existence and diasporic conditions. Several critics have been attuned to Lawrence's ability to combine 'a mastery of narrative with the mastery of the visual image' (Gates) and have praised him for being 'a sophisticated storyteller and modernist' (Hills).[42] Others acknowledge Lawrence's narrative modernism emphasising his

skilful incorporation of 'history, sociology, and a kind of poetry'.[43] Alain Locke anticipated such appraisals when he commented on Lawrence's 'ability to combine social interest and interpretation (he selects his own episodes from careful library readings and research) with a straight art approach...'.[44] One difference between Lawrence's diasporic art and Douglas', then, is that his visual narrative is based on scholarly sources rather than artistic ones. The two most important studies informing this series are *A Century of Negro Migration* by Carter G. Woodson (1918) and Emmet J. Scott's *Negro Migration During the War* (1920). Scott lists ten factors that caused the Great Migration, seven of which are explicitly mentioned in the titles to the *Migration Series*.[45]

To conclude, this exemplar of diasporic art combines modernism with narrative while bringing together artistic and historiographic material. Foregrounding socio-economic factors, the *Migration Series* incorporates research from the contemporary migration studies of its day but it also anticipates current findings in migration and diaspora studies. Among the contemporary critics who claim that the involuntary migration of people to foreign locations is key to the concept of diaspora are Lucie Cheng and Marian Katz. Their differentiation between migration patterns (forced relocation as a result of imperial expansion, expulsion or exile; labour diasporas into Europe and the US; and diasporas created among the entrepreneurial/professional/ intellectual élite) accords with Lawrence's vision.[46] In Lawrence's representations of the Great Migration, those who left the South were not (voluntary) labour migrants because the unbearable conditions *forced* them to abandon their homes and become strangers in an

uninviting place. While Lawrence mostly focuses on the working poor, his account of migration also includes the élite (panel 56, depicting a doctor and his patient, reads: 'Among the last group to leave the South was the Negro professional who was forced to follow his clientele to make a living').

Last but not least, it should be noted that the exhibition itself migrated. It started at Harlem's Community Art Center in June 1941. Five months later, parts of the series were seen by a national audience when *Fortune* magazine published '"...And the Migrants Kept Coming": A Negro artist paints the story of the great American minority'. Later that year, Lawrence's series was exhibited at the Downtown Gallery, thus securing a space in the lily-white art circles of Manhattan. Thanks to the support of Edith Gregor Halpert, the series went on a national tour during which it was shown at 14 museums around the country ending at the MoMA in 1944.[47] At the height of World War II, when millions of European refugees were forced to leave their homes, the *Migration Series* must have appealed allegorically to the mostly Euro-American audience.[48] Since this was the time when racial segregation was a common and legal practice in the US, and the civil rights movement was still nascent, the cross-racial appeal and national visibility of this diasporic *Gesamtkunstwerk* also represents a harbinger of de-segregation.

Riots: *Untitled: History of Black People*

Four decades later, in 1983, the young irreverent Jean-Michel Basquiat created a masterpiece of diasporic post-modernism. Catalogued under the titles *The Nile*, *History of Black People* and *Untitled*, this colourful and highly expressive triptych (68 x 141 inches, 172.7 x 358.1 cm) covers several centuries of black history, from its ancient roots (left panel), to transatlantic routes (middle), on to the fateful and tortured existence of the African slave in the US (right). At the top of the canvas, an inscription reads in Spanish 'El Gran Espectaculo', as if Basquiat was suggesting that the history of black people amounts to a grand spectacle. This heading could also refer to the canvas itself, which is a spectacular assemblage of signs, colours, images and words written in different languages. The various languages are themselves signs of the diasporic. The proliferation and chaotic juxtaposition of multiple fragments with numerous possible references conveys an unruly barbarism, a semantic riot.

In the midst of its semiotic wilderness, three signs stand out: the masks, the ship and the slave. The odd combination of images and words, drawings and colour fields (painted mostly black, pink and white), as well as the wild scribblings, all add to the visual complexity of *Untitled: History of Black People*. The ferocious imagery is not arbitrary. It surpasses pure abstractionism. Like Douglas and Lawrence, Basquiat tells a story. However, he complicates the picture by making it extremely challenging to decode the message inscribed in this representation of the African diaspora.

Consider the words 'Nuba', 'Mujer' and 'Salt' on the left-hand side of the triptych, for example. These words connote essentials of kinds and origins since Nuba stands for the origins of African civilisation. Eliminating the 'I', Basquiat deprives the highly-developed Nubian culture (once a rival to ancient Egyptian culture) of its real name. The Spanish word for woman, *mujer*, connotes human procreation: without women there would be no history. Salt was a common currency in the pre-monetary phases of

economy. With this reading, the three signifiers designate cultural, biological and economic roots.

The large ship in the middle panel can be decoded as an ancient Egyptian boat or a slave ship. In both cases it connotes routes. Reading it as a slave ship, the middle panel would then connect the left (African) side with the right (US American) side. Likewise, the ship could be read as a metonymic bridge between those who stayed in Africa and those who were forced to go overseas. The black figure has 'Esclavo, Slave, Esclavo' written on, or rather scribbled over, his dismembered body, symbolising the loss of the body and the eradication of identity that African slaves had to endure for centuries.

Untitled: History of Black People visualises the (African) roots and (dreadful transatlantic) routes of the African diaspora. The trauma of colonisation and slavery is, however, not only *depicted*; it is also *transmitted*. One can easily detect the anger with which Basquiat, and anybody who studies the history of black peoples, is inevitably confronted. The unsettling, riotous style connotes the rage; yet, it eschews heavy-handed didacticism. Far from putting across a clear message, it revels in ambiguity and indeterminacy typical of a post-modern manner.

On the upper middle section, for example, the ship sits next to a yellow, mummified *Osiris*, the Egyptian god of the dead. The Greek letters to the right can be read as misspelling *Osiris*, which should read Ὄσιρις. These signs seem closer to the Greek *phos* – spelled φως – meaning 'light', as in daylight and brightness. This slipshod citation therefore contradicts the image of *Osiris* being the god of the underworld and the dead. Basquiat's interlingual neologism teases the viewer because it suggests two mutually exclusive meanings. Another example of this

technique appears on the right-hand side of the canvas: 'Memphis' can refer to the city in the state of Tennessee or to the capital of the first Pharaoh Memes, located in an area later known as 'Thebes', which is now Luxor. The polysemy refers to very discrete geographic and cultural sites, one in Africa, the other in the US, but the painting arranges them in a counter-geographic manner given that Africa is situated on the left-hand side, and the US is evoked on the right-hand side of the triptych.

Another ubiquitous technique is the scribbling over, painting over and scratching out of letters as seen in the figure that has 'Esclavo, Slave, Esclavo' written on his chest. The function of this technique is, as Basquiat himself pointed out, to activate the spectator's imagination. He claims: 'I cross out words so you will see them more: the fact that they are obscured makes you want to read them'.[49] Once seen in light of this goal, his art deliberately disrupts the easy flow of signifiers by which viewers have tried to grasp the unspeakable. In fact, Basquiat uses several strategies to 'obscure' his canvases. Most striking, perhaps, is the composition. The strange juxtaposition of unrelated, or even mutually exclusive, fragments creates a visual tension between the different parts that either clash or fuse into creolised forms. This mixing of multiple signs and fragments results in a syncretic dynamism similar to the scratching and sampling techniques of rap artists.

Consider, for example, the drawing of the spider situated near to the slave figure, the phrase 'hemlock' and the sentence 'a dog guarding the pharaoh'. At first, this bizarre arrangement seems just coincidental but its very peculiarity invites the viewer to want to read it. Basically, there are two ways of reading this: metonymically and

Jean-Michel Basquiat,
*El Gran Espectaculo (History
of Black People)*, 1983

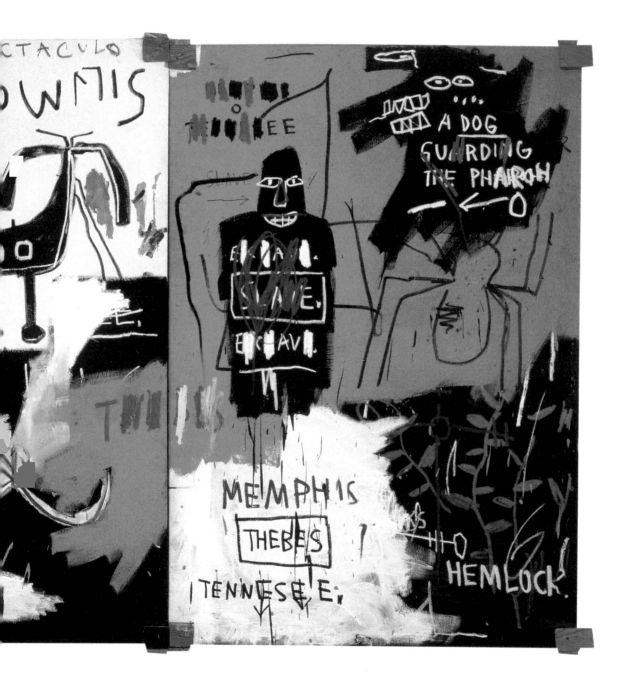

metaphorically. The spider can be taken to represent Anansi, the Ghanaian god and trickster figure. Accordingly, the dog in the phrase 'a dog guarding the pharaoh' could stand for Anubis, the Egyptian dog-shaped god of the dead. A metaphorical reading of the spider figure would presuppose an affinity between the trickster-spider and the slave. In places such as Memphis, Tennessee, slaves were considered non-human and their vulnerable status often degraded them like a despised insect. If the slave submits to the rule of his master, he is furthermore like a dog guarding his owner. If he decides that life as a slave is not worth living, he can end it by drinking hemlock, just like Socrates who aspired to the eternal life of the soul. This interpretation would suggest that suicide is one logical existential ending to the history of the black diaspora. The dialogism of the canvas allows for the coexistence of both readings while also inviting other interpretations.

Untitled: History of Black People is a model of diaspora aesthetics because it offers a history of the African diaspora while its composition and riotous imagery call for a multiple viewpoint perspective. To retrieve the full scope of its diasporic subtext, it is helpful to draw on three specific theoretical concepts: diasporic consciousness, diaspora space and diaspoetics.

Building on Bakhtin's concept of heteroglossia and dialogic imagination, Kobena Mercer developed his notion of diasporic consciousness.[50] This 'consciousness of the collision of cultures and histories', Mercer claims, has a penchant for dialogism. To him, diasporic dialogism occurs when incongruous voices and styles come together, press against each other or fuse into creolised forms. *Untitled: History of Black People* is a perfect example of the dialogism and

heterogeneity that are characteristic of diasporic consciousness and life.

Basquiat juxtaposes various facets of the African diaspora while also interlinking African and African American histories. In so doing, he opens up a pictorial and imaginary space that Avtar Brah calls 'diaspora space' because it 'includes the entanglements, the intertwining of the genealogies of dispersion with those of "staying put"'. For Brah, '[d]iaspora space is the intersectionality of diaspora, border, and dis/location as a point of confluence of economic, political, cultural, and psychic processes.'[51]

Untitled: History of Black People certainly brings together political (slavery), mythical (Osiris), cultural (Nubian masks) and psychic (anger) processes. The canvas captures the entanglements and intersectionality that are constitutive of diasporic life. To specify this space, Sudesh Mishra's notion of diaspoetics is also illuminating. Although his book *Diaspora Criticism* surveys the critical debates in literature, his term 'diaspoetics' can also be applied to the visual arts and to Basquiat's art in particular. Although somewhat jargonistic, Mishra's definition offers insights into Basquiat's individual style of diaspora aesthetics:

> Its [diaspoetics']method is a bringing forth (techne) and holding up to scrutiny all statements and exemplars, whether arborescent (rooted) or rhizomorphic (routed), that end up vouching for it. Its mode of operation is that of an intervention, the interposition of a non-witnessing witness or, rather, of a witness who attests to the act of bearing witness, but its behaviour is incontestably that of a supplement.[52]

Basquiat's triptych brings forth both the rooted (Nubian, Egyptian) and the routed (migratory, slavery) aspects of the diaspora. It is also plausible to argue that Basquiat himself remains a distanced observer/witness who playfully arranges his pictorial fragments according to the logic of the supplement. In effect, there is no singular meaning but a multi-locality of diverse and diverging parts. Basquiat's diaspoetics then amount to a semiotic discharge or rupture produced by the constant erasure and fervent displacement of signifiers. Meaning is purposely forced into exile to give space to multiple perspectives and interpretations.

The mode of reception of Basquiat's diasporic aesthetics exceeds the trivial statement that it invites multiple ways of seeing. In one of the few explicit statements about the gaze that his artworks evoke, the writer Bell Hooks maintains: 'To do justice to this work, then, our gaze must do more than register surface appearances. Daring us to probe the heart of darkness, to move our eyes beyond the colonizing gaze, the paintings ask that we hold in our memory the bones of the dead while we consider the world of the black immediate, the familiar.'[53] In other words, the dynamic qualities of Basquiat's work induce a decolonising gaze.[54]

According to Susanne Reichling, Basquiat's art invites not just a multiple point of view but three distinct types of viewers: firstly, the connoisseur of art history who enjoys his canvases as a pastiche of important trends in 20th-century art history; secondly, the Bildungsbürger familiar with European culture and ancient history who is eager to decipher Basquiat's encyclopaedic signs; thirdly, those familiar with African American art and history who enjoy the references to black cultures and Afrocentric imagery.[55]

The diasporic gaze of Untitled: History of Black People, however, goes beyond these three modes of reception, and this work is so intriguing precisely because it thwarts the viewer's desire to probe beneath the surface. Although the meaning-laden canvas entices us to decode its symbolism, its dense and cryptic visual language frustrates these attempts. To put it the other way around, its overall abstraction is disrupted by numerous recognisable signs. In effect, 'Basquiat's symbols and signs function as a trap that lures us away from the abstract and oneric purpose of these pictures', observes Marc Meyer, a curator at the Brooklyn Museum of Art who feels that Basquiat's art keeps the viewer in a 'state of half-knowing, of mystery-within-familiarity'.[56] Indeed, Basquiat's art is so tantalising precisely because the production of meaning through visual signs is not altogether eliminated from his canvases.

Whether this way of seeing makes 'space for a deeper, more spiritual state', as the Italian art critic Luca Marenzi maintains, or whether it prepares people to cope with the contingency, diversity and heterogeneity of contemporary life in the diaspora, is debatable.[57] Untitled: History of Black People amounts to a multilayered, multi-referential, multi-lingual, multicultural and multinational version of diasporic aesthetics that offers a training ground for a mode of perception that is capable of balancing out heterogeneous references and viewpoints. Its semiotic mystery calls for a diasporic gaze that embraces a perspective that is neither sequential (as in Lawrence) nor multi-focal (as in Douglas). It invites a gaze that enjoys multiplicity.

To conclude my exploration of diaspora aesthetics and the close analysis of three exemplars of the African American diaspora, I would like to

highlight that diasporic art tends to be figurative. Even in its most obscure renderings, there is a visible interest in such topics as exile, memory, migration and the psycho-social conditions of diasporic life. It may be argued that diaspora aesthetics privilege representational modes of painting to communicate what many critics have called the diasporic imaginary. Diasporic art assumes a narrative mode to engage genealogies of suffering, hopes, desires, confusion, pain and loyalty. Regarding its mode of reception, diasporic art presupposes and encourages an attendant gaze. Therefore, the critical analysis of diasporic art calls for close readings to explicate its inscribed messages and meanings.

Moreover, only by reconsidering established art historical approaches, critical tools and more broadly, the conventional art historical sequencing of realism/modernism/post-modernism will we be able to assess the transnational dimensions of art.[58] To counteract anachronistic models, Ella Shohat and Robert Stam propose a set of alternative artistic modes, notably, the archaic post-modern, the carnivalesque, the modernist anthropophagy and the aesthetics of garbage. Their list is, of course, only one among several to differentiate the various artistic and stylistic traditions in non-western or minority art. A number of other concepts come to mind that highlight cultural difference as a constitutive factor in artistic production while transcending national, religious or ethnic parameters (as in African, South Asian, Arabic, Chicano or Jewish art). Among those concepts that move beyond the area studies or ethnic studies format are, for example, cosmopolitan modernism, primitivism or primitivist modernism and, the concept that I have tried to delineate here, diasporic aesthetics.

Primitivist discourse in art history investigates the often-condescending relation between the (western) self and the non-western or racialised other, the dominant and the marginal, the Occident and the Orient. It tends to examine the dynamics of cultural difference from the perspective of the West.[59] Cosmopolitan modernism, as the volume by that title makes sufficiently clear, applies to a wide range of styles, nationalities and genres including Romare Bearden's collages, Norman Lewis' abstractions, Wilfredo Lam's (post-modern) modernism, the Bengal school's rediscovery of pre-colonial art in India and international style architecture.[60] A diasporic aesthetic differs from the primitivist counterpart because it assumes an insider's perspective. It differs from cosmopolitan modernism because its subject matter tends to be narrower. As shown above, it often portrays the act of crossing, the process of migration and what it means to live in a state of exile. In some way or another, a diasporic aesthetic is concerned with the dialectic of the 'home' and the 'host land'. Sometimes it captures the nostalgic yearning for diasporic roots or it retrieves a diasporic space in the metaphorical sense of visualising diaspora consciousness by engaging in acts of 'diaspoetics'. Its attendant mode of reception entices the spectator to grapple with multiplicity and heterogeneity, urging the diasporic gaze to wander between different visual sites. While this exploration has concentrated on representations of the African American diaspora, it would be desirable to expand the scope of enquiry to trace other diasporic visual traditions along the lines of roots, routes and riots.

1. There are numerous studies on diaspora and film but little has been published on diaspora aesthetics expressed in paintings. On film see: Kobena Mercer, 'Diaspora Culture and the Dialogic Imagination: The Aesthetics of Black Independent Film in Britain', in Jana Evans Braziel and Anita Mannur eds, *Theorizing Diaspora: A Reader*, Malden: Blackwell, 2003, 247–60; Anne Ciecko, 'Representing the Spaces of Diaspora in Contemporary British Films by Women Directors', *Cinema Journal*, 38, 3, Spring 1999, 67–90; N. Frank Ukadike, 'Reclaiming Images of Women in Films from Africa and the Black Diaspora', in Diana Robin and Ira Jaffe eds, *Redirecting the Gaze: Gender, Theory, and Cinema in the Third World*, Albany: State University of New York Press, 1999, 127–48; Gwendolyn Audrey Foster, *Women Filmmakers of the African and Asian Diaspora: Decolonizing the Gaze, Locating Subjectivity*, Carbondale: Southern Illinois University Press, 1997. The classic and most thought provoking studies on the diaspora, however, have no interest in visual culture. For example: Rey Chow, *Writing Diaspora: Tactics of Intervention in Contemporary Cultural Studies*, Bloomington: Indiana University Press, 1993; Brent Hayes Edwards, *The Practice of Diaspora: Literature, Translation, and the Rise of Black Internationalism*, Cambridge: Harvard University Press, 2003; Ruth Mayer, *Diaspora: Eine kritische Begriffsbestimmung*, Bielefeld: Transcript, 2005; Rajagopalan Radhakrishnan, 'Ethnicity in an Age of Diaspora', in Braziel and Mannur eds, op. cit., 119–31.

2. The artist and curator Pritika Chowdhry, for example, insists that the story of contemporary American art is incomplete if we fail to understand its multi- and inter-diasporic nature. Her exhibit 'Transdiasporic Art Practices', which presents paintings and sculptures of the female body, however, adds little to a better understanding of diasporic art as a programmatic concept (1 February 2007, www.pritikachowdhry.com/about/about.html).

3. Aesthetics in this context does not refer to a philosophy of (diaspora) art. I am interested in the specific modes of production and possible modes of reception characteristic of diasporic art. Granted that the concept diaspora aesthetics applies to diasporas of various kinds, it cannot be reduced to one nation or race. It is only for heuristic reasons that I concentrate on the African diaspora to assess the changes and modifications that occur over time. To examine the diachronic dimension while simultaneously investigating differences among particular diasporic visual traditions would exceed the scope of this chapter.

4. James Clifford, *Routes: Travel and Translation in the Late Twentieth Century*, Cambridge, MA: Harvard University Press, 1997, 251. See also Paul Gilroy, *The Black Atlantic: Modernity and Double Consciousness*, London: Verso, 1993; Diana Baird N'Diaye, 'New African Diasporic Communities in the United States: Community-Centered Approaches to Research and Presentation', in Sheila S. Walker ed., *African Roots/American Cultures: Africa in the Creation of the Americas*, Lanham: Rowman & Littlefield, 2001, 232–43; Christine Chivallon, 'Beyond Gilroy's Black Atlantic: The Experience of the African Diaspora', *Diaspora*, 11,3, 2002, 359–82.

5. Ronald Brooks Kitaj, 'First Diasporist Manifesto', in N. Mirzoeff ed., *Diaspora and Visual Culture: Representing Africans and Jews*, London: Routledge, 2000, 37.

6. Stuart Hall, 'Cultural Identity and Diaspora', in Padmini Mongia ed., *Contemporary Postcolonial Theory: A Reader*, New York: Arnold, 1996, 111.

7. Kitaj, op. cit., 37.

8. Hall, op. cit., 111.

9. Hall proclaims that black visual culture 'should allow us to see and recognize the different parts & histories of ourselves, to construct these points of identification, … we call in retrospect our "cultural identities".' Apart from this unifying function, Hall briefly mentions the relation that diasporic aesthetics has towards the dominant culture when he quotes Mercer's statement that black art often 'appropriates elements from the master-codes of the dominant culture and "creolises" them, disarticulating given signs and re-articulating their symbolic meanings.' (Hall, op. cit., 120).

10. See also N. Mirzoeff ed., *The Visual Culture Reader*, New York: Routledge, 2002; Jessica Evans and Stuart Hall eds, *Visual Culture: The Reader*, London: Sage Publications, 1999.

11. Nicholas Mirzoeff, 'The Multiple Viewpoint: Diasporic Visual Culture', in Mirzoeff ed., 2000, op. cit., 2.

12. The Harlem Artists Guild was very successful in helping African American artists obtain projects under the Works Progress Administration.

13. Aaron Douglas was among the first generation of academically trained African American artists to integrate African themes or imagery. As early as the mid-1920s, he tried to capture the spirit of his 'ancestors' in images such as *Invisible Music, The Spirit of Africa* (1926) and *Mangbetu Woman* (1927). Douglas' geometrical designs shaped the visual language of the Harlem Renaissance. He illustrated *The New Negro* (1925) and contributed regularly to such widely read journals as *The Crisis* and *Opportunity*. Locke celebrated him as a 'pioneering Africanist' because Douglas was among the first artists to publish images of Africa. Du Bois was particularly interested in photographs, abstractions, graphic

designs and poignant political cartoons concerned with Africa. *The Crisis* magazine commissioned such images to create a sense of affinity between its readers and Africans as a way to instil a sense of pride in the African American readers. See Amy Kirschke, 'Du Bois and *The Crisis*', in Michel Fabre and Klaus Benesch eds, *African Diasporas in the New and Old Worlds: Consciousness and Imagination*, Amsterdam: Rodopi, 2004.

14. For an excellent discussion of classical definitions of the diaspora, see Monika Fludernik, 'The Diasporic Imaginary', in Monika Fludernik ed., *Diaspora and Multiculturalism: Common Traditions and New Developments*, Amsterdam: Rodopi, 2003, xiv.

15. Ibid., xxix.

16. Commenting on the dialectic between diasporas and homelands, Elliott P. Skinner suggests that the spiritual return offered the return-to-Africa movement a way 'to achieve human dignity; to help or liberate their home communities; and by extension to aid their compatriots still in the diaspora' (Elliott P. Skinner, 'The Dialectic between Diasporas and Homelands', in Joseph E. Harris ed., *Global Dimensions of the African Diasporas*, Washington, DC: Howard University Press, 1993, 11–41). The actual return-to-Africa movement, however, remained a marginal affair since the majority of Africans in the diaspora did not intend to return physically to their ancestral lands (ibid., 15).

17. Makarand Paranjape, 'Writing Across Boundaries: South Asian Diasporas and Homelands', in Fludernik, op. cit., 243. On diasporic imaginary see Fludernik, op.cit.; on diasporic consciousness see Kobena Mercer, 'Diaspora Culture and the Dialogic Imagination', op. cit.

18. Vijay Mishra, 'The Diasporic Imaginary: Theorizing the Indian Diaspora', *Textual Practice*, 10, 3, 1996, 423. See also George Shepperson, 'Introduction', in Martin L. Kilson and Robert I. Rotberg eds, *The African Diaspora: Interpretive Essays*, Cambridge, MA: Harvard University Press, 1976, 1–10.

19. The mural is also structured through concentric circles. In the centre is the Statue of Liberty emerging between the skyscrapers that loom in the background. Right next to it stands a tall, self-assertive jazz musician with his arms lifted towards the sky. Like the Statue, his silhouette represents a symbol of hope gesturing towards a brighter future. Next to the jazz musician is a figure fleeing from slavery, another crouching figure on his left symbolises the economic hardships of African Americans. The smoke coming out of the factory chimney and the ascending stairs signal upward mobility. The mural depicts a people, climbing towards self-determination in the cities of America.

20. Ruth Mayer's study, which includes a detailed discussion of the Liberia experiment, is innovative because it juxtaposes three different diasporic traditions – notably the Jewish, the African and the Asian. On black nationalism see also Wilson J. Moses, *The Golden Age of the Black Nationalism*, 2nd edition, New York: Oxford University Press, 1998.

21. At the time, Douglas had only been to Europe. From 1928–29, he studied in Paris on a grant from the Barnes Foundation.

22. Jeffrey C. Stewart ed., *To Color America: Portraits by Winold Reiss*, Washington, DC: Smithsonian Institute Press, 1989, 123.

23. Alain Locke ed., *The New Negro*, New York: Atheneum, 1992, 256.

24. Amy Helene Kirschke, *Aaron Douglas: Art, Race, and the Harlem Renaissance*, Jackson, Miss.: University Press of Mississippi, 1995.

25. For a more detailed account of this dialectic of cultural appropriation and reappropriation through African American artists see Sieglinde Lemke, *Primitivist Modernism: Black Culture and the Origins of Transatlantic Modernism*, Oxford: Oxford University Press, 1998.

26. Toni Morrison, *Playing in the Dark: Whiteness and the Literary Imagination*, Cambridge, MA: Harvard University Press, 1992, 3.

27. Lawrence took part in a group show organised by the Harlem Artist Guild whose first president had been Aaron Douglas. However, it is unlikely that both artists met by the time that Jacobs finished his *Migration Series* since Douglas moved South in 1937 to take over the art department at Fisk University.

28. Peter T. Nesbett, 'Introduction', in Peter T. Nesbett and Patricia Hills, *Over the Line: The Art and Life of Jacob Lawrence*, Seattle: University of Washington Press, 2000, 14: 'This connectivity is the product of his unique technique whereby he began with preparatory drawings of all sixty images and then applied the fast-drying casein tempura starting with black in all the panels then adding brown, etc.'

29. Without using the term minimalist, which to my knowledge has not been applied to Lawrence's modernist style, Aline Louchheim detected in Lawrence's art that '[f]orm is simplified in order to articulate the essentials. Detail is suppressed except where it functions both as part of design and basic part of fact. His steep perspective generates immediacy', *Art News*, 15 October 1944, 15.

30. From now on I will refer to this image as *Negroes were Leaving*. Apart from the brevity, this short version captures the quintessentially diasporic quality of departure and the

use of the past participle enforces the quintessentially diasporic quality of movement.

31. James Weldon Johnson, 'The Making of Harlem', *Survey Graphic*, 51, 1 March 1925, 636.

32. Lawrence himself was an eyewitness since he moved to Harlem when he was 13: 'I was part of the migration, as was my family: my mother, my sister, and my brother. [...] I grew up hearing tales about people "coming up," another family arriving. People who'd been ... in the North for a few years, they would say another family "came up" [...]' (cited in Henry Louis Gates Jr, 'New Negroes, Migration, and Cutural Exchange', in Elizabeth Hutton Turner ed., *Jacob Lawrence: The Migration Series*, Washington, DC: The Rappahannock Press, 1993, 20). His statement foregrounds not only the fact of people entering or coming up but also the storytelling aspect of this event which Lawrence masterfully captures in his art.

33. Henry Louis Gates Jr, ibid., 21.

34. Lonnie G. Bunch III and Spencer R. Crew, 'A Historian's Eye: Jacob Lawrence Historical Reality, and the Migration Series', in Elizabeth Hutton Turner ed., op. cit., 26.

35. It took a child's perspective for me to realise this potential interpretation. I want to thank my five-year-old daughter Nilsa for suggesting this alternative way of seeing.

36. Jeffrey C. Stewart, '(Un)Locke(ing) Jacob Lawrence's Migration Series', in Elizabeth Hutton Turner ed., op. cit., 47.

37. Gates, op. cit., 17.

38. Poshyananda focuses on Asian diasporas and mentions five exhibitions on Asian diaspora art. Apinan Poshyananda, 'Desperately Diasporic', in Gerado Mosquera and Jean Fisher eds, *Over Here*, Cambridge, MA: MIT Press, 2004, 182–90.

39. Jacques Derrida, *Of Hospitality*, Stanford, CA: Stanford University Press, 2000.

40. I vividly remember talking to Lawrence in 1993. He repeatedly emphasised that he painted the panels simultaneously using the same colours. For a detailed description of his unique technique, see: Elizabeth Steele and Susana M. Halpine, 'Precision and Spontaneity: Jacob Lawrence's Material and Techniques', in Elizabeth Hutton Turner ed., op. cit., 155–59; Patricia Hills 'Jacob Lawrence as a Pictorial Griot: The Harriet Tubman Series', *American Art*, 7, 1 Winter, 1993, 47.

41. For her excellent close reading of the series as a whole see Patricia Hills, 'Jacob Lawrence's Migration Series: Weavings of Pictures and Texts', in Elizabeth Hutton Turner ed., op. cit., 148.

42. Gates, op. cit., 21; Hills, ibid., 42.

43. Stewart, '(Un)Locke(ing) Jacob Lawrence's Migration Series', op. cit., 41.

44. Quoted in Deborah Willis, 'The Schomburg Collection: A Rich Research for Jacob Lawrence', in Elizabeth Hutton Turner ed., op. cit., 33.

45. To show how close his caption titles are to Scott's assessment, I list the factors Scott mentions to explain the cause of migration adding (in brackets) Lawrence's panels, by number, that illustrate these factors: poverty and unemployment due to the labour depression in the South (panels 2, 10); failure of crops (13) due to floods (8) and the cotton boll weevil (9); lack of educational facilities (24); racist treatment in courts (14, 22); (white southern) prejudice (17, 19), lynchings and mob violence (15, 16). Scott and Lawrence are both very explicit about the terrible social conditions migrants confronted up North: the over-crowded tenement houses (46, 47, 48); the white workers' hostility towards migrants (50, 51); and the fact that African Americans met the newly arrived migrants with aloofness and disdain.

46. See Lucie Cheng and Marian Katz, 'Transnational Migration and Diasporic Communities', in Richard Maidment and Charles McKerras eds, *Culture and Society in the Asia-Pacific*, London: Routledge, 1998, 65–87.

47. At the time when his oeuvre went on a national tour, Lawrence himself was drafted into the US Coast Guard only to be discharged a year later.

48. The curators express their hopes that 'these eloquent statements by Jacob Lawrence have caused many Americans to examine their democratic beliefs', and to remind the visitors that 'Hitler has used the American negro as prime propaganda to convince people that U.S. democracy is a mockery'. The press release for the MoMA show draws attention to the significance of African Americans suggesting that 'the 13 million Negroes in this country are citizens of a shadowy sub-nation that is unknown to, or overlooked by, most of the rest of our population'. Thus, the *Migration Series* tried to end this status of invisibility. See Diane Tepfer, 'Edith Gregor Halpert: Impresario of Jacob Lawrence's Migration Series', in Elizabeth Hutton Turner ed., op. cit., 137.

49. Emmanuela Belloni, 'Interview with Jean-Michel Basquiat', in Richard Marshall ed., *Jean-Michel Basquiat*, New York: Harry N. Abrams, 1992, 72.

50. What Mercer claims for language applies also to the visual language of Basquiat's art, because he 'critical[ly] appropriates elements from the master-codes of the dominant culture and "creolises" them, disarticulating their symbolic meaning otherwise. The subversive force

of this hybridising tendency is most apparent at the level of language itself where creoles, patois, and Black English decentre, destabilise, and carnivalise the linguistic domination of "English" – the nation-language of master discourse – through strategic inflections, reaccentuations and other performative moves in semantic, syntactic, and lexical codes.' (Mercer, 'Diaspora Culture and the Dialogic Imagination', op. cit., 247.)

51. Avtar Brah, *Cartographies of Diaspora: Contesting Identities*, London and New York: Routledge, 1998, 84, 208.
52. Sudesh Mishra, *Diaspora Criticism*, Edinburgh: Edinburgh University Press, 2006, 14.
53. Bell Hooks, *Outlaw Culture: Resisting Representations*, New York: Routledge, 1994, 343.
54. Ibid., 348. Hooks also extends her argument about the decolonising gaze to the level of art criticism: 'Designed to be a closed door, Basquiat's work holds no warm welcome for those who approach it with a narrow Eurocentric gaze. That gaze which can recognize Basquiat only if he is in the company of Warhol or some other highly visible white figure. That gaze which can value Basquiat only if he can be seen as part of a continuum of contemporary American art with a genealogy traced through white males: Pollock, de Kooning, Rausenberg, Twombly, and on to Andy' (Ibid., 342).
55. Susanne Reichling, 'Jean-Michel Basquiat: Der afroamerikanische Kontext seines Werkes', Diss. Universität Hamburg, 1998 (12 February 2007, http://www.sub.uni-hamburg.de/opus/volltexte/1998/65/html/inhalt.html).
56. Marc Meyer ed., *Basquiat*, New York: Merrell Publishers Ltd, 2006, 49–50.
57. Marenzi writes: 'Through repetition the original meaning is lost, no longer remains a consideration. The same is probably true of the striking through of some words. Their shape can be used but their usual meaning is negated. The ceaseless repetition of images, especially in the drawings, must have led the artist and vicariously the viewer to a state in which the total acceptance of meaning led to a loss of meaning, or rather made space for a deeper, more spiritual state', Luca Marenzi, 'Pay for Soup/Build a Fort/Set that on Fire' (8 February 2007, http://www.marenzi.com/texts/PayForSoup.pdf).
58. Ella Shohat and Robert Stam, 'Narrativizing Visual Culture: Towards a Polycentric Aesthetics', in Mirzoeff, *Visual Reader*, op. cit., 37–59, 41.
59. Kobena Mercer ed., *Cosmopolitan Modernisms*, London: Iniva and Cambridge, MA: MIT Press, 2005.
60. For an excellent overview of different approaches to primitivism see ibid., 14–17.

ADRIAN PIPER, 1970-1975: EXILED ON MAIN STREET

KOBENA MERCER

Conceptual art gave rise to a range of practices that issued a decisive break with the object-making tradition of painting and sculpture: it was not simply another kind of art, but questioned the very nature of art itself. Adrian Piper began her career in a moment that was fully part of the late 1960s turn towards philosophy among artists who put ideas forward in the form of written propositions. At a time when logic, mathematics, cartography and cybernetics exerted equal interest as potential models for art-making, many practising artists aspired towards the rigour of philosophy, but Piper alone chose the path of actually becoming a professional philosopher. Following undergraduate studies at the School of Visual Arts in New York from 1966 to 1969, she majored in philosophy for her MA at City College New York in 1974 and then enrolled in the doctoral programme in philosophy at Harvard University, completing a dissertation entitled 'A New Model of Rationality' in 1981.[1] Adrian Piper thus occupies a wholly unique position as an artist who also became a philosopher.

Producing and exhibiting art while studying in the Anglo-American tradition of analytical philosophy, Piper was the only African American female artist in the New York scene of conceptual art during the late 1960s and early 1970s. Placed at the epicentre of this avant-garde art community – she was a receptionist at Seth Siegelaub Gallery and had art published in Vito Acconci's 0-9 press – her participation in first-generation conceptualism has guaranteed her inclusion in survey exhibitions and anthologies. Piper's work is highly visible in the historiography of conceptualism, but can we say that the reasons for her commitment to Kant are fully appreciated or widely understood? In many ways, Piper's life-long commitment to Kantian philosophy places

her at odds with the prevalent understanding of conceptual art as a historical break with dominant discourses of modernism in which a 'linguistic turn' led to the conception of the discursive construction of reality in social practices of representation and signification. Piper has fully contributed to such transformations in contemporary art from the late 1960s to the breakthrough moment of post-modernism, post-structuralism and post-colonialism in the 1980s, but her Kantian alignment makes her an exile – metaphorically speaking – when it comes to accounting for the twists and turns of recent intellectual history. The driving tendency in the mid-1970s turn towards structuralist and post-structuralist 'theory' that was inscribed in such journals as *Screen* in Britain and *October* in the United States was supported by an intellectual investment in Continental philosophy (including Freud and Marx) in which 'Kant' was very much the object of critique, identified with conservative ideologies of value-free objectivity that masked the power relations of authoritative knowledge. Against the grain of this narrative of conceptual art as a symptom of a crisis of representation, Piper's practice across art and philosophy is doubly discrepant. Her Kantian affiliation not only distinguished her from other conceptual artists such as Joseph Kosuth and the Art & Language group, who similarly questioned the idea of art as the production of visual objects, but was also a choice that set her apart from black and feminist artists working in representational or abstract practices that addressed issues of identity as a self-evident or visually obvious 'truth'.

Taking a fresh look at the body of work Adrian Piper produced between 1970 and 1975, this chapter explores the conceptual space of this double-sided discrepancy as an opportunity to

re-evaluate the cultural history of conceptualism. As she shifted away from her early post-minimalist framework, Piper moved towards a performance-based practice that documented her growing political awareness of the ways in which she was being 'marginalised' within the New York art community. During the period in which she began her doctoral training, she created a strand of work in which she constructed the 'persona' of the Mythic Being, which involved altering her physical appearance in such a way that visible signifiers of 'race' and gender were rendered highly ambiguous. Reading such documents as 'Talking to Myself: The On-going Autobiography of an Art Object (1970–1973)', the first question one asks is why the artist would refer to herself as an 'art object' rather than as a subject? By examining her notes, I want to suggest that the questions opened up by Piper's radically self-reflexive investigations may be fruitfully re-described in the vocabulary of semiotics and psychoanalysis, even though this method of approach goes against the grain of the artist's Kantian outlook. Discussing her rejection of post-structuralism, Piper has said, 'It's the perfect ideology to promote if you want to co-opt women and people of color and deny them access to the potent tools of rationality and objectivity.'[2] Questioned by critic Maurice Berger, one of Piper's closest readers, as to how she reconciles her commitment to Kant with her artistic inquiry into xenophobia – the defining theme of Piper's oeuvre from 1970 onwards – she replied:

> Kant's aesthetic theory is part and parcel of his larger project of giving an analysis of the universally applicable conditions inherent in subjectivity that enable subjects to have objective knowledge, act morally, and make valid aesthetic judgements. As an artist, my interest is not in Kant's aesthetics but rather in his metaphysics and epistemology, where he attempts to provide an overarching explanation of how science and objective knowledge in general are possible.[3]

Where such an intellectual position effectively 'exiled' Piper from the mid-1970s tendency whereby the limitations of conceptual art's self-referentiality led artists such as Martha Rosler or Victor Burgin to the semiotics of mass media images, it is striking to note that Burgin similarly rejected the claims of post-modernism during the late 1970s, but did so for entirely different reasons. In a 1982 talk published in 1984 as 'The Absence of Presence: Conceptualisms and Postmodernisms', Burgin acknowledged that, 'the conceptualism of the late 1960s was a revolt against modernism – specifically, we should add, as formulated in the writings of the American critic Clement Greenberg.'[4] Piper was also highly critical of Greenbergian formalism in texts such as 'The Logic of Modernism', although her critique is predicated on an entirely different standpoint.[5] Faced with such apparently irreconcilable differences, one may interpret Piper's discrepancies in either of two ways: as the problem of a 'misfit' whose errancy must be brought into line with an agreed-upon narrative about how conceptual art gave way to cultural theory, or as an opportunity to re-examine the break-up of modernism as a historical moment of crisis in which certain outcomes gained precedence over others. On this latter view, what makes the Mythic Being such a 'strange' construction is the way it pre-figured debates on the performative character of social identity

in advance of second-generation conceptualists, such as Cindy Sherman, who addressed such issues through strategies of appropriation based upon embedded materials derived from cinematic and photographic sources. In contrast, the notion of 'the indexical present' put forward by Piper in the 1980s reiterated the phenomenological concerns of first-generation conceptualism as the very basis for addressing xenophobia – the fear of difference – which forms the central connecting thread between art and philosophy in her practice.[6]

The prescience of Piper's early 1970s work is acknowledged in exhibitions such as *Double Consciousness: Black Conceptual Art since 1970* (2005), but the philosophical basis of Piper's working methods often eludes critical attention when the emphasis is placed on her identity as the first black female conceptualist of her generation.[7] When Piper is included in such important surveys as *Reconsidering the Object of Art: 1965–1975* (1995), another version of this quandary arises: the visible markers of 'race' and gender ensure Piper's presence, but the points of difficulty and disagreement that stem from her Kantian outlook are often overlooked or passed over in silence, thus circumscribing a symptomatic 'absence' in the literature surrounding her oeuvre.[8] While her ideal reader would be as equally adept in Kantian reasoning as with the contested genealogies of late 20th-century art (and perhaps her work still awaits such a dialogically competent reader), my aim here is merely to identify the points of dissonance and reverberation that mark out the singularity of Adrian Piper's practice as a contribution to the protean forms of conceptual art.

The Ongoing Autobiography of an Art Object

Where Piper's earliest works adhered to the minimalist grid as a starting point for investigations into the abstract properties of time and space, in 1970 she redirected her attention to examine the social, political and ethical dimension of 'selfhood' as the chosen site of her conceptual practice. To understand the turning point marked by *Catalysis* (1970), it would be useful to situate Piper's reflections on this period in relation to Peter Osbourne's critical distinction between 'those who advocate an expansive, empirically diverse and historically inclusive use of the term "Conceptual art" (such as Sol LeWitt)', whom he refers to as *inclusive* or *weak* conceptualists, and those 'championing more restricted, analytically focussed and explicitly philosophical definitions (such as Kosuth and the British group Art & Language)', whom he refers to as *exclusive* or *strong* conceptualists.[9] It may seem surprising to align Piper with the former tendency, given her subsequent philosophical training, but in notes from 1973 she stated, 'I think the work of Sol LeWitt, especially the "46 Variations on Three Different Kinds of Cube" exhibit, was the single most profound educational experience I had',[10] and in a 1988 article, 'On Conceptual Art', she distinguished her artistic affiliation from other strands of conceptualism – 'Sol's sensibility in general has influenced me enormously. I see less connection with other conceptual artists working at that time.'[11] Taken as an allusion to Kosuth and others, it may be said that strong conceptualists were primarily concerned with the idea *of* art in their questioning of the ontology of the art object as a visual phenomenon, whereas weak conceptualists were mainly concerned with ideas *as* art and thus explored a far wider remit of conceptual possibilities beyond the category of 'art' alone.

Proposing that, 'the purest definition of Conceptual art would be that it is inquiry into the foundations of the concept "art"',[12] Kosuth's 1969 essay, 'Art After Philosophy', launched an explicit attack on Greenbergian modernism. Arguing that, 'Being an artist now means to question the nature of art', and that, 'the function of art as a question, was first raised by Marcel Duchamp', his view that Duchamp's readymades 'changed the nature of art from a question of morphology to a question of function' led Kosuth to conclude: 'All art (after Duchamp) is conceptual (in nature) because art only exists conceptually …Artists question the nature of art by presenting new propositions as to art's nature.'[13] Suggesting that 'works of art are analytical propositions',[14] Kosuth's narrowly 'art definitional' model has tended to dominate the historiography of conceptualism, whereas Piper has exclaimed: 'If we have to be concerned with one particular concept to be a conceptualist, something's gone badly wrong!'.[15] Taking an alternative approach, LeWitt's 1967 'Paragraphs on Conceptual Art' proposed that 'the idea itself, even if it is not made visual, is as much a work of art as the finished product', and his emphasis on the ideational realm of self-generating rules for decision-making procedures led to his famous line – 'the idea becomes a machine that makes the art'.[16] Rather than a confrontation with the discourse of art criticism, LeWitt stressed the intuitive agency of 'the thought process of the artist', which informs the poetics of the opening line to his 1969 'Sentences on Conceptual Art' – 'Conceptual artists are mystics rather than rationalists. They leap to conclusions that logic cannot reach.'[17]

While both tendencies share common ground in the linguistic turn, Osbourne clearly demarcates Piper's distinctive position as an artist 'whose philosophical interests are not in the concept of art itself, but in the broader metaphysical notions of space, time and selfhood, the experience of which her art explores.'[18] He also raises the question of whether the so-called strong conceptualists were actually producing philosophy or whether they merely evoked the 'rhetoric' of philosophy in a contest of authority between artists and critics. Tracking Piper's journey across art and philosophy, we can see that her self-analytical vocabulary both overlapped with, but also went beyond, the exclusively 'art-definitional' focus of such works as Kosuth's *Art as Idea (as Idea)* (1969) or Art & Language's *Documenta Index* (1972).

Describing her early works such as *Concrete Infinity 6" Square* (1968) and *Here and Now* (1968), Piper wrote:

> I turned to language (typescript, maps, audio tapes etc) in the 1960s because I wanted to explore objects that can refer both to concepts and ideas beyond themselves and their standard functions, as well as to themselves: objects that both refer to abstract ideas that situate those very objects in new conceptual and spatio-temporal matrices, and also draw attention to the spatio-temporal matrices in which they're embedded.[19]

Retaining the minimalist grid in the *Hypothesis* (1968–70) series, the meaning Piper imparted to her use of the term 'object' began to take a corporeal turn, as she explains:

> In earlier pieces – my 'pure' conceptual work – I explored things, words, sounds, and pages of paper as concrete physical objects that

referred both to themselves and also outward, to the world of abstract, symbolic meaning. In the *Hypothesis* series I was interested in connecting these investigations with the investigation of my own body as equally a concrete physical object that could refer to itself as well as to other objects.[20]

As Jean Fisher observes, *Hypothesis* was significant because it marked a paradox whereby the 'non-referential, non-hierarchical replicability' of the grid 'seem[ed] to offer the model of an infinite extension of subjective possibilities in time and space', and yet, 'it is the formality of the Minimalist grid, with its illusion of ideological neutrality, that finally collapses under the weight of the socio-political content with which Piper imbues it.'[21] In sharp contrast to the notion of 'body art', which relied on the symbolic resources of pre-existing figurative codes, Piper's trajectory led her analytical interest in embodied consciousness outwards from the private settings of the *Hypothesis* series into the public spaces in which *Catalysis* was enacted on the streets.
In this series of deliberative 'actions', Piper

rode New York City's buses and subways with a large white towel stuck in her mouth; she attached helium-filled Mickey Mouse balloons to her ears, nose, and hair; she saturated her clothing with a mixture of vinegar, eggs, milk, and cod liver oil for a week, then wore them on the D train during evening rush hour; and she perused [an] exhibition ... while chewing large wads of gum and blowing up bubbles she allowed to stick to her face.[22]

Indeed, the resulting documentary photograph of *Catalysis III*, where 'she painted her clothes with white paint, put on a sign saying "Wet Paint," and went shopping at Macy's',[23] has acquired an almost iconic status in the literature on conceptual art, but an in-depth understanding of the reasoning that led the artist to embody her 'self' as an 'art object' is more or less foreclosed when it is simplistically asserted that, 'Piper had become radically aware of her own blackness and womanhood.'[24]

Piper herself recalls that *Catalysis* was precipitated by political factors: 'In the spring of 1970 a number of events occurred that changed everything for me. (1) The invasion of Cambodia; (2) the Women's Movement; (3) Kent State and Jackson State; (4) the closing of CCNY, where I was in my first term as a philosophy major, during the student rebellion.'[25] Such turmoil gave rise to the Art Workers' Coalition, which Piper joined alongside artists and critics such as Carl Andre and Lucy R. Lippard, and she withdrew *Hypothesis* from the *Conceptual Art and Conceptual Aspects* (1970) exhibition at the New York Cultural Center in protest at the shooting of students at Kent State and Jackson State universities, but her notes reveal dissatisfaction with political campaigning. In notes from October 1970, Piper registers a more fundamental dissatisfaction with both art-making as the production of discrete, self-sufficient objects and with the art world as an insular social context with routine patterns for the interaction between artwork and viewer. In relation to the former she said, 'All around me I see galleries and museums faltering or closing as the capitalist structure on which they are based crumbles. This makes me realize that art as a commodity really isn't such a good idea after all', and in relation to the latter she stated: 'This makes me think there must be something wrong with a system of aesthetic values that can be preserved only in isolation from the rest of society, and only by

Adrian Piper,
*Untitled Performance for
Max's Kansas City*, 1970

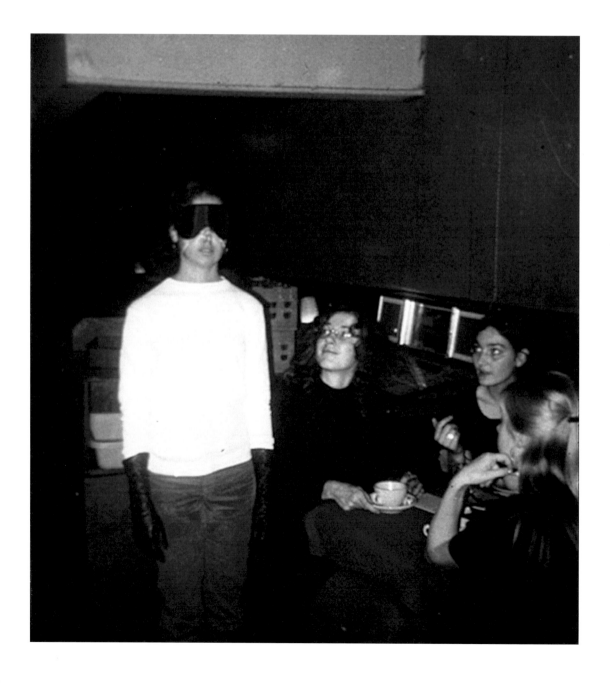

severely limiting the audience to a highly educated minority. That there must be some way of making high-quality, exciting art that does not presuppose an intensive education in Art Since 1917 in order to appreciate it.' [26]

One solution resulted in *Context #7* (1970), consisting of a ring-binder folio containing news clippings continually updated for the duration of the *Information* exhibition curated by Kynaston McShine at MoMA in summer 1970. However, Piper had rehearsed a more radical solution in April 1970 in her *Untitled Performance for Max's Kansas City* which turned to performance as a means of reducing the separation between audience and artwork, and foregrounded Piper's rejection of the art world as a self-contained 'habitus' within the field of cultural production. 'Max's was an Art Environment, replete with Art Consciousness and Self-Consciousness about Art Consciousness', she wryly commented in notes written up in 1981, as she explained her increasingly confrontational approach to the subject/object relationship:

> My solution was to privatize my own consciousness as much as possible, by depriving it of sensory input from that environment: to isolate it from all tactile, aural and visual feedback. In doing so I presented myself as a silent, secret, passive object, seemingly ready to be absorbed into their consciousness as an object. But I learned that complete absorption was impossible, because my voluntary objectlike passivity implied aggressive activity and choice, an independent presence confronting the Art-Conscious environment with its autonomy. My objecthood became my subjecthood. [27]

Shifting the locus of action from the art world to the everyday world of urban life, Piper's far-reaching analysis of the crisis of art as an institution informed her concept of 'Art as Catalysis', the title of notes from August 1970, which began by proposing:

> One reason for making and exhibiting a work is to induce a reaction or change in the viewer. The stronger the work, the stronger its impact and the more total (physiological, psychological, intellectual etc.) the reaction of the viewer. The strength of such a work is a function of the viewer's response to it. The work is a catalytic agent, in that it promotes a change in another entity (the viewer) without undergoing any permanent change itself. [28]

Bearing in mind LeWitt's 'artist-centred' model of conceptualism, it was this concern with inducing change in the viewer's response that led Piper to conceive of the artist as an embodiment of the artwork, thus abolishing art's condition of autonomy:

> The strongest impact that can be received by a person in the passive capacity as viewer is the impact of human confrontation (within oneself or between people). It is the most aggressive and the most threatening, possibly because the least predictable and the least controllable in its consequences. Because the artist is the embodiment of a particular creative process, artworks can abandon the intermediary of the discrete form and base themselves on this type of impact. The artist himself becomes the catalytic agent inducing change in the

viewer; the viewer responds to the catalytic presence of the artist as artwork.[29]

Insisting, 'This is not to be confused with life as art or the artist's personality as art', but rather implied that 'the artwork consists in artificially assumed attributes of the artist',[30] Piper circumvented the separation between audience and artist associated with theatrical settings for happenings or performance art by taking to the streets 'unannounced' and 'so she behaved coolly, as if nothing untoward was going on'.[31] Her notes of January 1971 illuminate the conceptual logic of her reasoning:

> Making artificial and non-functional plastic alterations in my own bodily presence of the same kind as those I formerly made on inanimate or nonart materials. Here the art-making process and end product has the immediacy of being in the same time and space continuum as the viewer ... because I exist simultaneously as the artist and the work. I define the work as the viewer's reaction to it.[32]

Suggesting that 'the immediacy of the artist's presence as artwork/catalysis confronts the viewer with a broader, more powerful, and more ambiguous situation than discrete forms or objects', it was this concern to preserve the 'uncategorized, undefined' nature of the encounter that propelled Piper's self-conception as an 'art object'.[33] Far from resulting in a fusion of art and life, the photograph of *Catalysis III*, showing the artist surrounded by mostly African American and Puerto Rican women who regard her presence on the street with quizzical disdain, is entirely of a piece with the facial reactions on the part of diners at Max's Kansas City, who seem equally puzzled by the strangeness of Piper's self-presentation: in both cases, she embodied an unintelligible 'otherness' that tested the boundaries of visual recognition. Once the conceptual logic through which the artist came to refer to herself as an 'art object' is understood, we can see that *Catalysis* did not enact an epiphany of black and feminist consciousness, but gradually opened up an analytical investigation into the role of the gaze in the social field of vision in which relations of identity and difference are established.

When Terry Atkinson wrote in 1969 that, 'Initially what conceptual art seems to be doing is questioning the condition that seems to rigidly govern the form of visual art – that visual art remains visual',[34] few of her international contemporaries would have recognised that in choosing the body as the 'object' of her conceptual enquiry into this condition of visuality on the part of the art object, Piper was making an intuitive leap towards an understanding of the gaze as a structuring principle of the subject/object relationship. Where Osbourne suggests that, 'Conceptual art was an attack on the art object as the site of a look',[35] one may say that Piper launched an attack on 'the look' as it differentiates among embodied 'selves' in social space. Discussing the way in which the Cartesian subject 'centres' itself in Euclidian space, Fisher observes how Piper's embodied 'otherness' de-centres the ego's illusion of autonomy as a logical corollary to the artwork's loss of objecthood:

> One consequence of this Eurocentric structuring of the self's relationship to the perceptual world is that its subject objectifies all that falls under its gaze in the field of vision. However, when another consciousness

(or sardine can, in Lacan's narrative of the gaze) unexpectedly enters the field, the self sees that it is seen from a place it cannot occupy or authorise and has thus become an object of another's gaze. This other gaze is threatening in so far as it challenges the subject's coherence and autonomy.[36]

As Norman Bryson explains, Lacan's parable of the sardine can – flotsam caught up in fishermen's nets – reveals how the ego-cogito is formed as ex-centric to a pre-existing network of signs and meanings in the symbolic order of language, and hence:

> When I look, what I see is not simply light but intelligible form: the *rays* of light are caught in a *rets*, a network of meanings, in the same way that flotsam are caught in the net of the fishermen. For human beings collectively to orchestrate their visual experience together it is required that each submit his or her retinal experience to the socially agreed description(s) of an intelligible world. Vision is socialized, and therefore deviation from this social construction of visual reality can be measured and named, variously, as hallucination, misrecognition, or 'visual disturbance.' Between the subject and the world is inserted the entire sum of discourses that [...] make visuality different from vision [...] Between retina and world is inserted a *screen* of signs, a screen consisting of all the multiple discourses on vision built into the social arena.[37]

Aligning herself on the side of the object, Piper found a way of exposing the social relations in which categories of 'race' and gender contribute to the 'screen of signs' through which retinal experience is filtered. When her art is (mis)understood as being 'autobiographical' in character, such an approach misreads the fundamental starting point of her critical interrogation of vision and visuality: as a light-skinned woman of African American and Jamaican parentage, Piper was perceived to be neither 'black' nor 'white' within the polarised visual topography of 'race' in American society and it is from this (exilic) position that her art has opened up a critical inquiry into the social functioning of 'the gaze' as it mediates the encounter between self and other.

Once her conceptualism is understood as a questioning of socially embedded relations of visuality, *Food for the Spirit* (1971) demands consideration as a further enquiry into the functioning of the gaze in the formation of selfhood. Performed in the summer of 1971 while fasting on a water and juice diet and practising yoga, this work documents Piper's experience of reading Kant's *Critique of Pure Reason*. 'The *Critique* is the most profound book I have ever read', she wrote, 'and my involvement in it was so great that I thought I was losing my mind, in fact losing my sense of self completely.' Feeling that, 'the effects of Kant's ideas were so strong ... I would have to stop reading in the middle of a sentence ... and go to my mirror to peer at myself to make sure I was still there', she set up a camera and tape recorder next to the mirror and devised a ritual so that,

> every time the fear of losing myself overtook me and drove me to the 'reality check' of the mirror, I was able both to record my physical appearance objectively and also to record

myself on tape repeating the passage in the *Critique* that was currently driving me to self-transcendence. The sight and sound of me, the physically embodied Adrian Piper, repeating passages from Kant reassured me by demarcating the visual, verbal and aural boundaries of my individual self, and reminded me of the material conditions of my mental state, that the *Critique* was a book with good ideas in it that I had chosen to study, and not (only? necessarily? really?) the entrance into a transcendental reality of disembodied self-consciousness.[38]

While Lucy R. Lippard proclaimed the 'dematerialisation' of the art object,[39] Piper risked disembodiment as a source of both pleasure and terror – a sort of conceptualist sublime. Shot in available light, Piper's denuded presence in the photographs is at times almost illegible: she undermines the gaze by threatening to withdraw from the field of vision as an intelligible form and become part of the 'screen' instead. At a time when Lacan's concept of the mirror-phase first appeared in translation,[40] this work shows that Kantian metaphysics was combined with eastern philosophies of yoga in Piper's quest for self-transcendence or freedom from selfhood. Her notes carry an echo of LeWitt's intuitive approach – 'I have always had a strong mystical streak'[41] – but the backstory to her decision to become a philosopher also reveals the way in which Piper was being 'exiled' from the prevailing model of conceptualism. As she later reflected, 'While romping in the theoretically fertile but disorganized universe of conceptual art in the late 1960s, and implicitly thinking of myself as the next *enfant terrible* of the art world, I was being systematically marginalised.'[42]

Enter the Mythic Being

'In those days, conceptual art was a white macho enclave', writes Piper in describing the predominance of exclusively language-based forms of conceptualism in the early 1970s. Her account reveals an incipient conflict between modernism's universalist ethos of artistic and intellectual freedom, which she fully subscribed to, and her emerging consciousness of the art world's exclusionary practices as a social habitus:

> I didn't realize I was being marginalized. I didn't realize it, first, because … [w]hen you are drunk on abstract conceptual metaphysics – in my case, the concrete representational limits of infinity and dimensionality – socio-political transactions of power simply do not exist. Second, the events in my case coincided with my own increasing alienation from the promotional art market and considered choice to distance myself from it. …It never occurred to me that these events had anything to do with my actual gender or racial identity.[43]

By virtue of her name, Piper was often the subject of mistaken identity: 'I repeatedly had this experience of curators coming to New York … to see my work and just being completely shocked when they realized that I was not a white male. Because of the spelling of my name, many people made the assumption that I was.'[44] Distancing herself from the art community while devoting more time towards her studies in philosophy, her 'Preparatory Notes for The Mythic Being' reveal the logic that led to her unique response. In August 1973 she conceived a 'Spectator Series' whose aim was to achieve 'freedom from roles induced by other's recognition', and she wrote,

'I should be in DRAG, dressed as a *boy*.'[45] Developing her earlier self-description as an 'art object', Piper's notes from 1972 to early 1973 all dwell upon situations in her personal history in which – as musical prodigy, fashion model and discotheque dancer – she had been positioned as the spectatorial 'object' of another's gaze. To liberate her 'self' from such objectification, she donned an Afro wig, moustache and sunglasses and the Mythic Being first appeared in this guise among advertisements in the *Village Voice* gallery pages when Piper devised a procedure whereby she would repeat each diary extract to herself in an internal monologue, creating cycles of 'dispersion' in which the former 'self' that each caption referred to, 'becomes an object for me to contemplate and simultaneously loses its status as an element in my own personality or subjecthood.'[46]

Whereas artists such as Ana Mendieta and Lynda Benglis utilised androgyny and drag to confront patriarchal mythologies of male creativity, in Piper's case the visual codification of femininity and masculinity was inter-meshed with the 'screen' of ethnic ambiguity. Bearing in mind the optical indeterminacy surrounding perceptions of Piper's identity, both as a woman and as a black American, the Mythic Being thus performed a double-sided transformation in the relationship between 'self' and 'other' as both an intra-subjective process that would free the artist's subjectivity from past attachments and as an inter-subjective process that would engage her audience with her 'difference' as a black female artist whose individual identity had gone widely unseen. Piper highlights this double-voiced mode of address when she says that the Mythic Being, 'incorporated both the ritualized repetition – and therefore exorcism – of passages in my personal journal I had written years before, to which I still felt attached ... and also the simultaneous transformation of my individual self into its seeming opposite: a third-world, working-class, overtly hostile male.'[47]

Relocating to Cambridge, Massachusetts, to begin her PhD at Harvard, the Mythic Being's performances all feature a double movement of inward and outward action across private and public settings, but as the confrontation of 'self' and 'other' acquires an increasingly aggressive element we can see how Piper foregrounds a gap between her self-image as a contributor to the universalist realm of art and ideas and the worldly realities of cultural institutions based on hierarchies of social identity. If the *Village Voice* adverts announced her gradual rejection of the New York art world, even as her work was being rejected from the hegemony that 'strong' conceptualism had attained by the mid-1970s, it is revealing to observe how closely Piper's notes confirm Osbourne's view that the 'strong' conceptualists were not actually producing philosophy at all, but a form of art writing that was protected from analytical scrutiny and rigorous debate within the discipline of philosophy by virtue of the way in which the texts, such as the *Art-Language* journal, published from 1968 to 1972, were put forward as a form of art practice with its own criteria for evaluation. Without denying the historical breakthrough achieved by the linguistic turn, it is nonetheless crucial to understand the fall-out that Piper experienced during this moment. As she recalls:

> Some of the more theoretically inclined men ... defined conceptual art in terms of its purported relation to analytical philosophy. ...As I began to study analytic philosophy

Adrian Piper,
Mythic Being: I Am the Locus,
Nos 1–5, 1975

more seriously and carve my own path into the academy, I recognized that the linguistic practices of some of these 'analytic' artists were dismissed by the academic philosophers from whom they claimed to derive inspiration. [...] They said that they repudiated analytical philosophy for political reasons. To me it looked as though they repudiated it because it was too demanding. And the more completely I embraced it, the more decisively they repudiated me and it as well.[48]

It is significant that Piper's use of the term 'repudiation' resonates with Lacan's account of *scotoma* or blindspots in the 'screen of signs' whereby the ego-cogito cannot recognise certain objects in the field of vision that have no fixed place among the pre-existing network of cognitive categories that constitute 'the gaze'. On this view, by turning to masking and masquerade as a means of embodying blackness as visibly 'other' to the white male subject, the Mythic Being mimicked the art world's misrecognition of Piper's individual identity by assuming the optical indeterminacy of an uncategorisable 'object' within the visual field. However, when she arrived at Harvard the traumatic repetition of 'repudiation' threw Piper out of the frying pan into the fire, as it were, for at a reception for new graduate students, 'The most famous and highly respected member of the faculty observed me for a while from a distance and then came forward. Without introduction or preamble, he said to me with a triumphant smirk, "Miss Piper, you're about as black as I am".'[49] Such re-marginalisation, 'brought home to me how distant I actually was from any position in the hierarchy at all. I felt above it, below it, inside

it and beyond it all at once.'[50] In the tension between these multiple and contradictory subject-positions, the Mythic Being enabled Piper to explore the conflicts and ambiguities that she experienced in an exilic condition of 'transcendental homelessness' across the fields of art and philosophy.

Altering photographs with captions handwritten in oil crayon, narrative pieces such as *A108 Kant* (1975) and *Let's Have a Talk* (1975) depict the Mythic Being in an introspective mode, with the former showing Piper in her study while captions deliver a citation from Kant: 'The original and necessary consciousness of the identity of the self ... is thus at the same time ... a consciousness of an equally necessary unity of the synthesis of all appearances ... according to concepts, i.e. according to rules, which not only make them necessarily reproducible ... but also in doing so determine an object for their intuition.' In the final panel, the Mythic Being looks back at the viewer as if to query the concluding phrase, 'i.e. the concept of something wherein they are necessarily interconnected', in regard to the subject/object relations of spectatorship.

As the Mythic Being enters public space, the tension between the conceptual realm of pure ideality and the contingent world of embodied selfhood comes to a head in *I Am the Locus* (1975). Crossing Cambridge Square, the Mythic Being's thoughts begin in the neutral and impersonal language of philosophical reasoning – 'I am the locus of consciousness ... surrounded and constrained ... by animate physical objects ... with moist, fleshy, pulsating surfaces' – only to explode into vernacular speech in the final panel: 'Get out of my way, asshole'. The signifying difference between the language of academia and the lingo of the streets draws attention to the

paradox of interdependency whereby the self's desire for freedom from others is limited by the fact that selfhood is only brought into existence by virtue of being recognised by others. Describing the piece in a 1976 *Studio International* article, Piper writes: 'I am an anonymous, third-world young boy, wandering through the crowd … surrounded only by fleshy material objects that impede my movements, limit my freedom. Someone bumps into me and I curse him and tell him to get out of my way. I am both hostile to and removed from the presence of others.'[51]

Whereas the hostility enacted in *Cruising White Women* (1975) and *Getting Back* (1975) was overtly 'staged' as an external encounter in social space, the imbrication of eroticism and aggression performed in *It Really Doesn't Matter* (1975) is decidedly more ambivalent. Confronting the spectator in three panels that bear a sequence of inscriptions – 'It really doesn't matter … if what you want to do to me … is what I want you to do for me' – the Mythic Being's utterance gives rise to a sado-masochistic subtext that marks out active and passive subject-positions: 'I am a nameless, expressionless masculine figure, looking down at you, the viewer. I slowly approach you, loom over you, my hips at your center of vision. Affirming our anonymity, I invite you to use me, thereby allowing me to use you. My hips are so close to your face that you cannot refuse. I look away.'[52]

In the sense that D.W. Winnicott suggested that 'being' comes before 'doing and being done to',[53] the liminal ontology Piper explored in such works concerns the coexistence of subject positions – active/passive, seeing/being seen, male/female, white/black – that appear to be mutually exclusive only from the point of view of the dominant ideologies that aim to secure the reproduction of the prevailing social order.

Far from having a solely personal or autobiographical referent, the Mythic Being's forays into the 'screen of signs' that render retinal experience socially intelligible followed on from her self-questioning as an 'art object': rather than seek out the 'comfort' of minoritarian identity politics, Piper's unravelling of 'the gaze' set her on a lonely but insightful path that affirmed Georg Lukacs' view that, 'Philosophy is transcendental homelessness; it is the urge to be at home everywhere.'[54]

Conclusion

At a time when feminist debates about 'the male gaze' were taking shape in Laura Mulvey's 1975 article on 'Visual Pleasure and Narrative Cinema', it is fascinating to observe that *I Embody* (1975), one of the last works Piper produced in the guise of the Mythic Being, bears a caption – 'I embody everything you most hate and fear' – that resonates with the concept of the female body as an object of male fears and fantasies.[55] However, where her philosophical orientation parted company with the sequence of intellectual shifts that had led from language-based conceptualism to linguistics and semiotics, and thence to psychoanalysis, it may be said that Piper's emphasis on the immediacy of the artist/viewer relationship was fundamentally at odds with the study of visual representations that placed a countervailing emphasis on absence, lack and the unconscious in framing post-structuralist accounts of subjectivity and desire.

Discussing her concept of 'the indexical present', Maurice Berger perceptively argues that, 'the discourse that Piper engenders in her work is that of self-knowledge',[56] and by stressing the form of the ideational framework in which her work engenders an ethics of reciprocal self-

examination on both the part of the artist and on the part of the viewer, Berger counteracts the widespread tendency to reduce Piper's oeuvre to a purely autobiographical reading. When Piper says, 'the indexical present has provided the major strategy of my work, which is direct, immediate, and confrontational', these values inform her choice of subject matter: 'Racism is not an abstract, distanced issue out there that only affects all those unfortunate other people. Racism begins with you and me, here and now, and consists in our tendency to try to eradicate each other's singularity through stereotyped conceptualization.' [57]

Demonstrating how Piper arrived at this choice through the unfolding logic of her investigations into the gaze in her early to mid-1970s practice, I have tried to highlight the originality of her open-ended and independent thinking, as well as her characteristic wit, humour and honesty, which strikes such an emphatic contrast with the aspiration towards authoritative speech that was prominent among first-generation conceptualists. By 1976, Piper discontinued her performances as the Mythic Being, and although 'whiteface' make-up and a moustache were worn in *Some Reflective Surfaces* (1976) and *It's Just Art* (1980), her subsequent return to figurative media such as drawing, in *Self-Portrait Exaggerating My Negroid Features* (1981) and the *Vanilla Nightmares* (1987) series, and gallery-based installation, in *Four Intruders plus Alarm Systems* (1980) and *Cornered* (1988), could be understood as marking a rapprochment with the mainstream art world and with the prevailing neo-conceptual genre of the image-text format. Such examples of her mid-career artistic production made her socio-political concerns visibly unequivocal, whereas the highly

ambiguous and risky situations created by Piper's performances as the Mythic Being draw our attention to a *bildungsroman* of 'becoming' whose only precedent in the intellectual history of modernism is Frantz Fanon's *Black Skin, White Masks* (1952).

Writing in his mid-20s, Fanon analysed 'the fact of blackness' not as a biographical given but as the product of a painful awareness of the 'othering' he had been subjected to under the colonial gaze. When he wrote, 'I found I was an object in the midst of other objects', Fanon's words were uncannily echoed by the startling conclusion Piper reached with *Untitled Performance for Max's Kansas City* : 'My objecthood became my subjecthood'. Writing out of the Hegelian tradition of Continental philosophy, Fanon addressed the predicament of colonial subjectivity – 'I am the slave not of the "idea" that others have of me but of my own appearance' [58] – in a universalist quest for freedom, and Piper's struggles with the visuality of her individual 'difference' could also be said to arrive at a parallel point of view, although she had travelled on a very distinct conceptual journey that led to Kant.

Reflecting on the politics of masquerade in the Mythic Being's performances, Piper has said, 'I was thinking a lot about specific alterations in physical subjectivity, ... as a way of bringing out aspects of my own identity that were not readily available – not only the fact that I am black, because many people do not realize that, but also that I have a very strong masculine component to my character.' She concluded, 'the sense of freedom that I experienced in doing this work was a real revelation to me', but adds, 'the bad part was that I got to experience what it is like for visibly black Americans to simply move through

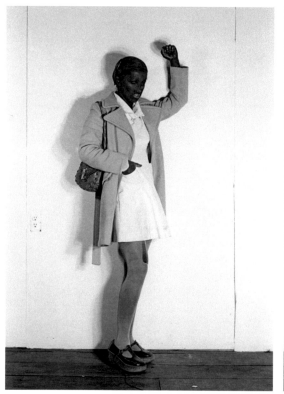

Cindy Sherman,
Untitled from *Bus Riders*,
1976/2000

the world in any social context that is primarily populated by white people.'[59] While it may seem incomprehensible to some that a black artist might not necessarily identify with the clichés of black popular culture, it is significant to observe that some of the second-generation conceptualists were taking note of the strangeness of Piper's self-presentation as an 'art object'. Cindy Sherman acknowledged, 'Adrian Piper was a really big influence on me when I was [in school] in Buffalo. I read about her work in *Avalanche* magazine. I'd never seen any of the performances except for a couple of documentation photographs on what she would do on the bus ... I loved that work and the ideas behind what she was doing.'[60]

Alluding to *Catalysis*, one can only interpret Sherman's *Bus Riders* (1976) as homage to Piper's initiative. However, where Sherman's *Untitled Film Stills* (1977), like Mulvey's work in cinema studies, referenced historically distanced imagery – such as 1940s film noir – which was readily available for appropriation, it was precisely because such source material was at one remove from the 'here and now' that post-modern conceptualism set itself apart from the immediacy of Piper's documentary photographs with their expressive handwritten captions. Whereas the prevalent 'anti-subjectivism' of the mid-1970s turn to 'theory' tended to favour highly embedded cultural materials as critical targets, the fact that Sherman's *Bus Riders* was only exhibited for the first time in 2005 suggests a hidden irony in the politics of masquerade: a white (female) artist adopting blackface may be at risk of cultural censure, whereas a black (female) artist in drag as a third-world boy may finally find the freedom that modernism had always promised as a universal right of individuality.

NOTES

1. See Adrian Piper, 'Personal Chronology', in Maurice Berger ed., *Adrian Piper: A Retrospective*, Baltimore: Fine Arts Gallery, University of Maryland, 1999, 183–96.
2. Adrian Piper, in Maurice Berger, 'The Critique of Pure Racism: An Interview with Adrian Piper', *Afterimage*, October 1990, reprinted in Berger ed., 1999, ibid., 84.
3. Piper, in Berger ed., 1999, ibid., 91.
4. Victor Burgin, 'The Absence of Presence: Conceptualisms and Postmodernisms', in Victor Burgin, *The End of Art Theory: Criticism and Postmodernity*, London: Macmillan, 1986, 29.
5. See Adrian Piper, 'The Logic of Modernism', in Adrian Piper, *Out of Order, Out of Sight, Vol. 2: Selected Writings in Art Criticism, 1967–1992*, Cambridge, MA: MIT Press, 1996a, 209–14.
6. See Adrian Piper, 'Xenophobia and the Indexical Present I: Essay' (1989) and, 'Xenophobia and the Indexical Present II: Lecture' (1992), in Adrian Piper, *Out of Order, Out of Sight, Vol. 1: Selected Writings in Meta-Art, 1968–1992*, Cambridge, MA: MIT Press, 1996, 245–52 and 255–74.
7. Franklin Sirmans ed., *Double Consciousness: Black Conceptual Art since 1970*, Houston: Contemporary Arts Museum, 2005.
8. Ann Goldstein and Ann Rorimer eds, *Reconsidering the Object of Art: 1965–1975*, Los Angeles: Museum of Contemporary Art and Cambridge, MA: MIT Press, 1995.
9. Peter Osbourne, 'Conceptual Art and/as Philosophy', in Michael Newman and Jon Bird eds, *Rewriting Conceptual Art*, London: Reaktion, 1999, 48–49.
10. Adrian Piper, 'Talking to Myself: The Ongoing Autobiography of an Art Object' (1975), in Piper, 1996, op. cit., 29–30.
11. Adrian Piper, 'On Conceptual Art' (1988), in Piper, 1996, op. cit., 241.
12. Joseph Kosuth, 'Art After Philosophy' (Pt II), *Studio International*, November 1969, reprinted in Gregory Battcock ed., *Idea Art: A Critical Anthology*, New York: Dutton, 1973, 93.
13. Joseph Kosuth, 'Art After Philosophy' (Pt 1), *Studio International*, October 1969, reprinted in Battcock, ibid., 80.
14. Ibid., 83.
15. Adrian Piper cited in Osbourne, op. cit., 56.
16. Sol LeWitt, 'Notes on Conceptual Art', *Artforum*, 5, 10 Summer 1967, 79–83.
17. Sol LeWitt, 'Sentences on Conceptual Art', *Art-Language*, 1, 1, 1969, reprinted in Ursula Meyer ed., *Conceptual Art*, New York: Dutton, 1972, 174.
18. Osbourne, op. cit., 56.

19. Adrian Piper, 'On Conceptual Art' (1988), in Piper, 1996, op. cit., 241.
20. Adrian Piper, 'About the Hypothesis series' (1992), in Piper, 1996, op. cit., 19.
21. Jean Fisher, 'The Breath Between Words: For Adrian Piper's Retrospective', in Maurice Berger ed., op. cit., reprinted in Jean Fisher, *Vampire in the Text: Narratives of Contemporary Art*, London: Iniva, 2003, 151.
22. Sirmans, op. cit., 12.
23. Tony Godfrey, *Conceptual Art*, London: Phaidon, 1999, 237.
24. Ibid., 232.
25. Adrian Piper, 'Talking to Myself' (1975), in Piper, 1996, op. cit., 30.
26. Ibid., 40 and 41.
27. Adrian Piper, 'Untitled Performance for Max's Kansas City' (1981), in Piper, 1996, op. cit., 27.
28. Adrian Piper, 'Art as Catalysis' (1970), in Piper, 1996, op. cit., 32.
29. Ibid., 34.
30. Ibid.
31. Godfrey, op. cit., 233.
32. Adrian Piper, 'Concretized Ideas I've Been Working Around' (1971), in Piper, 1996, op. cit., 42.
33. Ibid.,42–43.
34. Terry Atkinson, 'Introduction', *Art-Language*, 1, 1, 1969, reprinted in Ursula Meyer, op. cit., 9–10.
35. Osbourne, op. cit., 48.
36. Fisher, op. cit., 151.
37. Norman Bryson, 'The Gaze in the Expanded Field', in Hal Foster ed., *Vision and Visuality*, Discussions in Contemporary Culture series no. 2, Seattle: Bay Press, 1988, 91–92. See also, Jacques Lacan, *The Four Fundamental Concepts of Psychoanalysis* (1973), Harmondsworth: Pelican, 1977.
38. Adrian Piper, 'Food for the Spirit' (1981), in Piper, 1996, op. cit., 55.
39. Lucy R. Lippard, *Six Years: The dematerialisation of the art object from 1966 to 1972*, Berkeley: University of California Press, 1973.
40. Lacan's 1949 paper on 'The Mirror-phase as Formative of the Function of the I' was first translated by Jean Roussel, *New Left Review*, 51, September/October 1968, and later translated by Alan Sheridan in Jacques Lacan, *Ecrits* (1966), London: Tavistock, 1977.
41. Adrian Piper, 'Food for the Spirit,' (1981) in Piper, 1996, op. cit., 55.
42. Adrian Piper, 'Introduction: Some Very FORWARD Remarks', in Piper, 1996, op. cit., xxiv–xxv.
43. Ibid.

44. Adrian Piper, 'The Indexical Present: Lecture' (1992), in Piper, 1996, op. cit., 262.

45. Adrian Piper, 'Preparatory Notes for *The Mythic Being*' (1973–74), in Piper, 1996, op. cit., 101 and 102. See also, 'Kinds of Performing Objects I Have Been' (1972), ibid., 89–90.

46. Adrian Piper, 'Notes on The Mythic Being I-III' (1974–75), in Piper, 1996, op. cit., 117.

47. Adrian Piper, 'The Mythic Being: Getting Back' (1980), in Piper, 1996, op. cit., 147.

48. Adrian Piper, 'Introduction: Some Very FORWARD Remarks', in Piper, 1996, op. cit., xxxv.

49. Adrian Piper, 'Passing for Black, Passing for White' (1992), in Piper, 1996, op. cit., 275.

50. Adrian Piper, 'The Mythic Being: Getting Back' (1980), in Piper, 1996, op. cit., 149.

51. Piper cited in Roselee Goldberg with Laurie Anderson, Julia Heyward and Adrian Piper, 'Public Performance: Private Memory', *Studio International*, 192, 982, July/August 1976, 22.

52. Ibid., 23.

53. D.W. Winnicott, 'Creativity and its Origins', in Winnicott, *Playing and Reality*, Harmondsworth: Penguin, 1971, 99.

54. Georg Lukacs, *Theory of the Novel* (1920), Cambridge, MA: MIT Press, 1974, 65.

55. Laura Mulvey, 'Visual Pleasure and Narrative Cinema', *Screen*, 16, 3, 1975, and 'Fears, Fantasies and the Male Unconscious or "You Don't Know What is Happening, Do You Mr Jones?"', *Spare Rib*, 1973, both reprinted in Laura Mulvey, *Visual and Other Pleasures*, London: Macmillan, 1989.

56. Maurice Berger, 'Black Skin, White Masks: Adrian Piper and the Politics of Viewing', in Maurice Berger, *How Art Becomes History*, New York: Harper Collins, 1992, 109.

57. Adrian Piper, 'On Conceptual Art' (1988), in Piper, 1996, op. cit., 242.

58. Frantz Fanon, *Black Skin, White Masks*, New York: Grove, 1970, 109 and 116.

59. Adrian Piper, 'The Indexical Present: Lecture' (1992), in Piper, 1996, op. cit., 263.

60. Cindy Sherman cited in Maurice Berger, 'Styles of Radical Will: Adrian Piper and the Indexical Present', in Maurice Berger ed., 1999, op. cit., 32.

CONCEPTUALISING 'BLACK' BRITISH ART THROUGH THE LENS OF EXILE

AMNA MALIK

... exile cannot be made to serve notions of humanism. On the twentieth-century scale, exile is neither aesthetically nor humanistically comprehensible: at most the literature about exile objectifies an anguish and a predicament most people rarely experience at first hand; but to think of the exile informing this literature as beneficially humanistic is to banalise its mutilations, the losses it inflicts on those who suffer them, the muteness with which it responds to any attempt to understand it as 'good for us.' Edward W. Said, 1984[1]

Refusing to align the trauma of displacement with the humanistic impulses of western culture, Said's observation that exile is 'irremediably secular and unbearably historical'[2] places the subject's alienation at the centre of the collisions between aesthetics and politics in the late 20th century. Gavin Jantjes, Mitra Tabrizian and Mona Hatoum are key figures in the history of post-war British art, whose presence in the metropolitan centres of Europe in the late 1970s and 1980s was the consequence of political upheaval. Even if these artists would not readily classify themselves as exiles, their politicised perspectives contributed to the wider anti-humanist impulses of the post-colonial and post-modern critique of western culture that paralleled conceptual artists who, it is often noted, took up an anti-humanist view of modernism. Examining Gavin Jantjes' *A South African Colouring Book* (1974–75), Mona Hatoum's performance works (1982–85) and Mitra Tabrizian's *The Blues* (1986), I explore how their strategies constitute the negative of the nationalist narratives that Said argued is central to the politics of exile.[3] In these artists' practices the creative possibilities of exile lie in the simultaneity

of maintaining multiple perspectives, for as Said suggests:

> Seeing 'the entire world as a foreign land' makes possible originality of vision. Most people are principally aware of one culture, one setting, one home; exiles are aware of at least two, and this plurality of vision gives rise to an awareness of simultaneous dimensions, an awareness that – to borrow a phrase from music – is contrapuntal. For an exile, habits of life, expression or activity in the new environment inevitably occur against the memory of these things in another environment. Thus both the new and the old environments are vivid, actual, occurring together contrapuntally. There is a unique pleasure in this sort of apprehension, especially if the exile is conscious of other contrapuntal juxtapositions that diminish orthodox judgement and elevate appreciative sympathy.[4]

In their engagement with the politics of 'race', the multiple perspectives found in the strategies of Jantjes, Hatoum and Tabrizian can be understood as an extension of conceptual art in which the decolonisation of culture that was facilitated by the rise of post-structuralist theories becomes central. In *Culture and Imperialism* (1994), Said set out the ways that the contrapuntal awareness of the exile can inform a methodology that allows one to 'make concurrent those views and experiences that are ideologically and culturally closed to each other'.[5] Michael Newman's 1996 essay, 'Conceptual Art from the 1960s to the 1990s: An Unfinished Project', addresses the challenge to conventional models of subjectivity that subjects of alterity bring to the

project of conceptual art when he suggests that: '[conceptual art's] original epistemic bias towards reflexive self-transparency [...] is no longer compatible with the exigencies of art-making in a multicultural world'.[6] Speaking from the vantage of artistic practices in the 1980s that take conceptual art into issues of cultural alterity, Newman demarcates the historical context that gave rise to conceptual art in the politics of 1968 from questions of post-modernism.

Recent revisions of conceptual art as a global phenomenon have attended to the social and political upheavals of the era in different parts of the world, thus redressing the problem Newman identifies. Reconsidering the art historical reception of 1960s conceptualism, Lucy R. Lippard, whose own initial interest in conceptual art as a 'dematerialisation' of the art object had the greatest impact, has cited Jasper Johns amongst the pivotal figures for the post-1960s generation who adopted conceptual forms.[7] The 'cultural dandyism' attributed to the group around Johns in the mid-1950s has also been described as an 'aesthetics of indifference' to explain the oblique and veiled meanings in their work as a response to the political context of the McCarthy era that contrasts significantly with the counter-culture events of 1968.[8] Peter Wollen's comparative study of the conceptual art movement cites the political militancy of the era as an important but underplayed part of its historical context: '1967–69 was a period of unusually intense political militancy and cultural upheaval, ranging across Black Power, the student movement, solidarity with Third World struggles, the beginnings of feminism, the Summer of Love, and organised opposition to the Vietnam War'.[9] The effect of re-examining 1960s conceptual art in North America has exposed the limitations of the positions taken by artists such as Joseph Kosuth and Sol LeWitt and has also brought to the fore the wider cultural concerns of conceptual artists in Britain who were informed by Roland Barthes' *Elements of Semiology* (1964, trans. 1968) rather than analytical philosophy. Wollen argues that Kosuth's and LeWitt's respective practices often created a semantic loop whereby 'philosophical statements about artworks could be presented as artworks, functioning at the same time as a kind of manifesto for themselves'.[10] The meta-language that marked conceptual art's self-reflexivity and purported to come from Wittgenstein's *Philosophical Investigations* (1953) had been placed under pressure by Adrian Piper who questioned the veracity of this philosophical link in the justification of Kosuth's practices. In hindsight the positions of such conceptual artists appear to be closer to an aestheticism when compared to the theories of semiotics that allowed Victor Burgin to reveal art as a form of cultural work that placed it in a horizontal relationship to advertising and other forms of popular culture.[11]

From a semiotic perspective, meta-language is conceptualised as that language which myth uses to speak of itself as a 'natural' phenomenon, a second order of language concealing itself as a first order 'reality'. Barthes' attention to the mythical 'speech' of the cover of *Paris-Match* is well known: 'a young Negro in a French uniform is saluting, with his eyes uplifted, probably fixed on a fold of the tricolor'.[12] Deconstructing its meaning through a semiotic analysis he exposes its myth: 'that there is no better answer to the detractors of alleged colonialism than the zeal shown by this Negro in serving his so-called oppressors'.[13] First published in 1957, Barthes'

Mythologies offers an important parallel to Frantz Fanon's speech at the First Congress of Negro Artists and Writers held in Paris in 1956 and later published as 'Racism and Culture' in which he called for the decolonisation of culture as a weapon to attack imperialism. The impact of Fanon's *The Wretched of the Earth* (1961, trans. 1964) was the focus for Homi K. Bhabha's foreword, 'Framing Fanon', for a 2004 edition that took note of the changed historical distance since its first publication in 1964. *The Wretched of the Earth* was fundamental to the decolonisation of culture that mobilised the Black Power movement in the United States, the anti-apartheid resistance that centred on the figure of Steve Biko in South Africa, the Palestinian Liberation Organisation in the Middle East, and was also an important catalyst in the politicisation of radical Islam in Iran.[14] Fanon's attention to the 'psycho-affective' impact of colonialism as a lived experience threw into relief the psychic effects of segregation in the US, South Africa, in post-war Britain and, as I write, in Gaza and the West Bank today. If one considers 1968 as the representative moment of post-modernism when the crisis of authority first emerged, then one has to acknowledge the central role of the 'civil rights' movement as part of the international historical context of conceptual art.[15]

Gavin Jantjes' *A South African Colouring Book* (1974–75)

Far from the 'dematerialisation' of the object, Gavin Jantjes' *A South African Colouring Book* deploys different forms – including silk-screen printing and a Warholian repetition of single photographs, the use of newspaper sources and photojournalism – to create a juxtaposition of words and text that parallels works by Victor Burgin and John Stezaker, but which produces a polyphonic dimension by virtue of the insertion of photographs of museum artefacts alongside media images, such as a portrait of Angela Davis. Reviewing its exhibition at the Institute of Contemporary Art in London in 1976, Paul Overy described it as a depiction of racial oppression in South Africa, citing specifically journalists' images of the Sharpeville massacre.[16] A collection of silk-screen prints measuring 45 x 60 cm, *A South African Colouring Book* was initially planned and printed in 1974–75 as an edition of 20 in an ensemble of loose sheets enclosed in a simple black folio. In 1978, an 'Introduction' was added that included the following quote by Steve Biko: 'We must learn to accept that no group, however benevolent, can ever hand power to the vanquished on a plate. We must accept that the limits of tyrants are prescribed by the endurance of those whom they oppress.'[17] Biko's statement echoes Fanon's *The Wretched of the Earth*, although the vehemence of this call to arms is tempered by Jantjes' addition of a chilling account of Biko's death by the South African police. As an introduction it confirms the identity of the folio as a political pamphlet that targets the Verwoerd era. Described as the 'architect' of apartheid, Verwoerd was elected in 1948 and orchestrated the 'identity' of South Africa as a white republic in the face of African national liberation movements then sweeping the continent. On the basis of his vision of a white South Africa he consolidated his rule in the late 1950s and Verwoerd's policies resulted in the forcible removal of large numbers of urban blacks to the homelands, the insistence on their tribal affiliations and restrictions over their entry into metropolitan centres.[18] Described by photographer David Goldblatt as 'spatial engineering', apartheid's

Gavin Jantjes,
'Colour These Blacks White'
from the folder *A South African
Colouring Book*, 1974–75

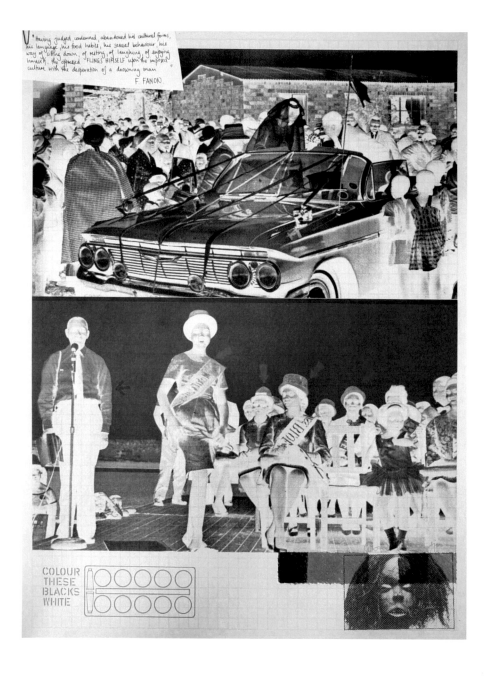

Gavin Jantjes,
'Colour This Labour Dirt Cheap'
from the folder *A South African
Colouring Book*, 1974–75

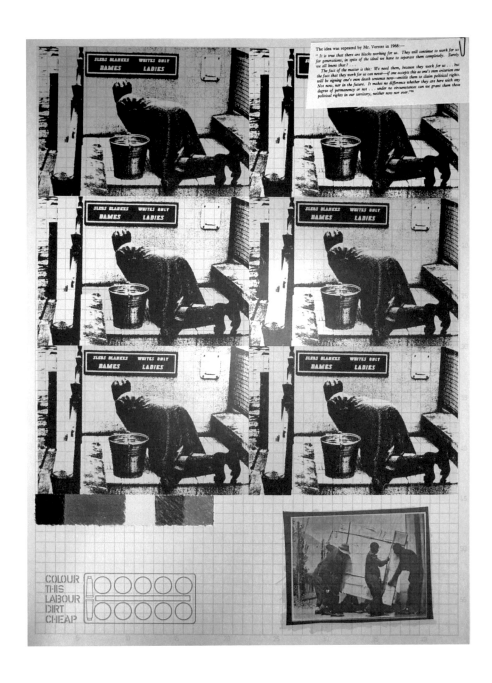

politics of displacement created a condition whereby the Bantu effectively became exiles within their own country, travelling vast distances between their dwelling places and their places of work.[19] The historical violence of this displacement and the subsequent uprisings are dealt with by Jantjes through the violence of language that Fanon argued was necessary to 'psychical' decolonisation.

The political subject's exile *within* the homeland is evident in Jantjes' choice of photographic sources, which were taken from an important publication by the exiled photographer Ernest Cole entitled *House of Bondage* (1968). The reversal from a positive to a negative print in the first folio sheet, alongside the words 'COLOUR THESE BLACKS WHITE', draws out semantic connections between the materiality of the photograph and the political pressures of assimilation amongst the black South African middle classes. The second sheet consists of a 'Warholian' repetition of a single photograph taken from a double layout in Cole's book, showing segregation in areas of the city of Johannesburg. This image reveals the economic conditions that link migrant labour to 'race' so as to naturalise culturally conditioned and historically fixed hierarchies, which is made explicit in the words 'COLOUR THIS LABOUR DIRT CHEAP'. Both sheets rely on a juxtaposition of words and images that is indicative of conceptual art as it emerged from the appropriation and use of found imagery. The juxtaposition of captions alongside a photograph of a beauty pageant and a wedding procession transforms, as Walter Benjamin argued, seemingly everyday events and banal occurrences.[20] In Cole's *House of Bondage* these images appear in a section entitled 'African Middle Class' that laments the political frailties of

this class because their 'drive for individual status' outstrips the 'nobler cause of helping to improve the lot of all Africans'.[21] Cole's text alongside the photograph of the wedding procession tells us: 'The rented car is a status symbol at middle-class marriages. Expensive weddings can leave couples broke for a year.'[22] In this light, Jantjes' reversal of the print, rendering the white veil black, becomes a reversal from celebration to mourning. Similarly, the text alongside the beauty pageant tells us: 'Miss Non-White South Africa contest. At [the] microphone is Pete Rezant, director of many social events for Africans. He teaches contestants how to walk, talk, conduct themselves in Western society.'[23] The semantics implied in Jantjes' reversal of the photograph – which transforms black skin into white – dramatises the spatial duality that Fanon sets out in *The Wretched of the Earth* and draws our attention to the recourse to a strategy of reversing the coloniser's logic. Modernity is the site of contestation indicated by Jantjes' use of a quotation, alongside the image, taken from Fanon's 'Racism and Culture' text of 1956: 'Having judged, condemned, abandoned his cultural forms, his language, his food habits, his sexual behaviour, his way of sitting down, of resting, of laughing, of enjoying himself, the oppressed *flings himself* upon the imposed culture with the desperation of a drowning man.'[24]

Jantjes' displacement of Cole's original captions does not separate culture from industrialisation, but crucially makes the vital link to colonial racism as emerging from *within* it. This is not a difference in intention between Cole and Fanon but a differentiation between quotidian instances of alienation: Jantjes repositions the snapshot photograph as a fragment of everyday life with Fanon's meta-structural analysis of

colonial power relations. More importantly, the former is now seen within a wider geographical and historical link to the argument set out in the Fanon's analysis:

> Developing his technological knowledge in contact with more and more perfected machines, entering into the dynamic circuit of industrial production, meeting men from remote regions in the framework of the concentration of capital, that is to say, on the job, discovering the assembly line, the team, production 'time', in other words yield per hour, the oppressed is shocked to find that he continues to be the object of racism and contempt.[25]

The experiences of the formerly colonised subject in the industrialised centres of the West offer an astute critique of the limits of solidarity on the part of the proletariat, as the primary subjects of alienation in Marxist accounts. Fanon's central concern in 'Racism and Culture' is the impact of the coloniser's culture as a political means of dominance experienced as alienation but conventionally understood as assimilation: 'In reality, a colonial country is a racist country. If in England, in Belgium or in France, despite the democratic principles affirmed by these respective nations, there are still racists, it is these racists who, in their opposition to the country as a whole, are logically consistent.'[26] Although first composed in 1956, the presence of Fanon's words within a work of art addressed to the South African 'emergency' of the 1970s takes on a polyphonic dimension when one considers how social hierarchies of 'race' were perpetuated within the British trades union movement of the 1970s: the contrapuntal perspectives at work in Jantjes'

strategy indicate a blind spot of leftist political traditions that applies to different national contexts.

In this light, Victor Burgin's photograph of an Asian woman factory worker in his large-scale photographic series, UK 76, first exhibited at the Robert Self Gallery in London in 1976, is a significant intervention. A reviewer for the Sunday Times immediately drew attention to this particular photograph, describing the worker's clothing in detail – 'wearing a cardigan over a sari' – and then commenting on Burgin's caption, 'ST LAURENT DEMANDS A WHOLE NEW LIFE STYLE', by observing that the text 'continues by confiding to the spectator that "Hips matter a lot" and ends by telling us that Yves' clothes "are a ramble through Eastern Europe".'[27] Burgin's choice of image is unusual for its recognition of the presence of Asians and Afro-Caribbeans as part of the flow of migrant labour into the industrialised centres of the West. Reviews of the exhibition by Richard Cork and Caroline Tisdale, however, tended to ignore this aspect of UK 76, which was perhaps symptomatic of attitudes towards the sensitive subject of 'race' within the old left.[28]

Comparing UK 76 with Jantjes' juxtaposition of Fanon's text alongside Cole's photographs, one cannot help but observe the links with gender as the privileged sign for consumption. Here we are but a few short steps from Burgin's best known work of the period, the poster Possession (1976), which suggests important comparisons with these sheets from A South African Colouring Book and also parallels John Stezaker's use of advertising imagery in Who, What, Why (1974), a four-panel work of photographs and texts. In this work, an image of a man in a car with a woman beside him is accompanied by a caption: 'Getting what you want out of life is an art'. This series connects the image of the artist to the forms of

masculinity on display as examples of sexual and economic power, by means of the use of a quote from Freud that famously attributed the artist's ambitions to the desire 'to win honour, power, wealth, fame and the love of women'.[29] In all these examples of conceptual art in the mid-1970s British context, culture becomes the privileged site of exploitation that has become subjectively internalised as part of the framework of what Fanon calls 'the concentration of capital'.[30] In other words, the signs of modernity are the structures through which the existence of alienation is read and it is through the contested identities represented within these signs of modernity that difference becomes a privileged signifier.

Rasheed Araeen's *Paki Bastard*, subtitled *(Portrait of the Artist as a Black Person) a live event with slides and sound*, which was first performed at an Artists for Democracy event in London in 1977, is highly relevant here, for in this work Araeen created a persona for an artist from the Third World as an immigrant labourer. Relegating his identity as an artist to that of a menial labourer, signified by the broom, Araeen's performance was critically directed towards 'the mythical space within which the bourgeois "freedom of artistic expression" manifests, and which is inversely proportional to the real space at the bottom of the hierarchical pyramid'.[31] Placing Stezaker's *Who, What, Why* alongside the photographic documentation of *Paki Bastard* and accompanying texts by Araeen, one can observe the shared ground of decolonisation that interrogates the 'mythology' of the bourgeois western art world as a space free of prejudice; together these strategies among British conceptual artists of the 1970s draw attention to the degree to which the art world is subject to mythologies just like the world of advertising.

Jantjes' repetition of a photograph of a 'black' cleaner, taken from Cole's photographs of the city of Johannesburg, evokes Andy Warhol's silk-screen prints of commodities like Coca-Cola and celebrities like Marilyn Monroe, but by inserting 'race' as the privileged signifier for the worker's alienation from the products of her labour, the 'black' female worker is thus shown to be doubly alienated, as Fanon points out, by her skin colour. This 'black' woman cleaning an area of a public street that is denied to her directs us to the spatial conditions that define racism. Placing the 'raced' subject in Jantjes' *A South African Colouring Book* within the circulation and distribution of commodities, like Coca-Cola, whilst also addressing its abject conditions in contrast to an idealised 'white' femininity as represented by Marilyn Monroe, Jantjes' work indicates an engagement with US imperialism as well as the racial segregation of South Africa. Alongside Burgin, Stezaker and Araeen's conceptual works of the period, Jantjes' strategy of juxtaposition brings to mind Stuart Hall's observation that 'race' is the location for class conflict within the capitalist division of labour and this would resonate for 'black' artists living in Britain's inner cities and 'black' British communities experiencing racial violence on a daily basis.

To the degree that Jantjes' work as a South African exile resonated with the generation of 'black' British artists who emerged in the early 1980s, during a period in which riots broke out in London and Liverpool, his insight into the spatial politics of apartheid suggests parallels with British experiences of racial segregation that created zones within cities like Birmingham that were demarcated as 'black' ghettos. 'Must Harlem come to Birmingham?' ran one by-line in a local paper in the mid-1970s, reinforcing Enoch Powell's

Victor Burgin,
UK 76 (panel from a series
of eleven), 1976

conflation of 'race' with immigration as a flooding of Britain by undesirable 'foreign' elements.[32] This transplantation of 'spatial engineering' led the authors of *The Empire Strikes Back* (1982) to view the surveillance of 'black' bodies as an indication of the emergence of an apparatus of 'state authoritarianism' distinct from fascism and liberal-democratic nation-states.[33] Such a transformation of the state from 'within' came about through its administration of colonialism abroad and was exercised to police those formerly colonised subjects from within the borders of the nation-state. This spatial engineering and the resistance towards it created by the emergence of 'black' Britain forms a crucial context for Mona Hatoum's performances of the early to mid-1980s.

Figuring Exile: Mona Hatoum's Performances (1982–85)

Hatoum's slow, painful progress through the spaces of Brixton in *Roadworks* (1985) met at times with laughter, at others with bemusement. Asked about the responses of local bystanders, Hatoum said: 'One comment I really liked was when a group of builders, standing having their lunch break, said, "What the hell is happening there? What is she up to?". And this black woman, passing by with her shopping, said to them, "Well its obvious. She's being followed by the police." Very cool, and just went off.'[34] Given the location and the time of this performance – Brixton had been the site of riots in 1981 and 1985 – it is significant to observe that *Roadworks* highlights the contrapuntal aspects of exilic creativity in which time and space are at times out of sync when different and multiple realities become harnessed to a single project, and this is indicative of Hatoum's location-specific performance works of the 1980s.

The 'spatial engineering' that Goldblatt noted under apartheid South Africa has its parallel in contemporary Palestine. The architectural research group, Multiplicity, has drawn attention to the construction of road networks that link Israeli settlements to each other in areas that are otherwise predominantly Palestinian. An Israeli driver can take 90 minutes to cross the West Bank from North to South but it takes up to eight hours for a Palestinian driver on the same journey. This control over movement, and the strategic position of Israeli settlements on hilltops that look down on Palestinian towns, was first created as a military infrastructure that began with Israeli fortifications along the Suez Canal in the early 1970s.[35] In this manner, Israel has effectively exiled Palestinians in their own land but has done so by conflating military and civic infrastructures that draw upon colonial power structures. An echo of this overlapping of otherwise separate spheres in the surveillance of the 'black' presence – and the geographical transplantation of colonialism – was a key theme in Hatoum's performance work.

Often clothed in a boiler suit, as in *Roadworks*, or with her head covered in a hood, as in *Variation on Discord and Divisions* (1984), her appearance played with a 'masculine' identity to create an androgynous persona that was situated uneasily between the worker, the soldier and the 'terrorist'. The utilitarian clothing and the inscription of her body engaged in specific acts, such as cutting holes for a mouth in *Variation on Discord* or crawling along the ground on her stomach in *Them and Us ... and Other Divisions* (1984), suggest a shared political outlook with 'black' British artists, although these works were made prior to any direct contact. Hatoum described this persona as follows: 'Confined by exclusion, she occupies a very different space.

Mona Hatoum,
Roadworks, 1985

A space constructed by society for those elements it refers to as *them*, the other: black people, immigrants, women, unemployed and poor.'[36] The ambiguity of her performance persona thus blurred the distinction between the socially marginalised and the politically disenfranchised, and this is suggestive of an overlap between the civic, the legal and the military that Gilroy and others noted as markers of 'state authoritarianism'. In the broader context of media representations of the 'black' (usually male) as 'other', Hatoum's evocation of a phobic projection is significant because it cuts across different but equivalent markers of the 'outsider'.

Turning to *Them and Us*..., one can gain a closer insight to the complex nature of Hatoum's staging of subject-object relations between audience and performer that determine identification or projection. This performance took place at South Hill Park in Bracknell, where Hatoum crawled in a straight line along a terrace, filled with a 'lunch-time crowd', as she slowly moved among chairs and tables to arrive at a recess in a garden wall. Guy Brett described the concluding moment of the piece as follows: 'There the anonymous figure began to scrub the stone step, making it only dirtier since the brush was filled with red paint. At the finale, she set fire to a screen of newspapers which burned away to reveal a wall chalked with racist grafitti.'[37] As Brett points out, the arduous pace of Hatoum's performance established an important temporal contrast with the leisure of the spectators, but equally her performed actions entailed a transformation of the conviviality of social relations.

Entering the space in the guise of an 'assassin' temporarily changed its function as a space of leisure to one of implied territorial conflict. Hatoum's 'occupation' of the architecture of the site by progressing along the terrace on her stomach, as though to forbid its 'civilian' and 'civilised' use, was reiterated by her act of cleaning/staining and finally exposing – through the annihilating effects of fire – the signs of hate inscribed in the graffiti. However, what is perhaps lost to the sands of historical time is the significance of the location of Hatoum's performance. As part of the Second International Festival of Performance, *Them and Us...* was held in South Hill Park, Bracknell, a publicly funded arts centre established in 1973, which was built in 1760 as a private estate for William Watts, a senior official within the Bengal government. The 18th-century landscape and architectural design of the mansion were fashioned on the model of an Italian Baroque villa and therefore embody the English aristocracy's self-identification with ancient Rome. This historical background is important because it was used to publicise the arts centre when it first opened and continues to mask the rapid modernisation of the surrounding area since the 1960s.[38] In contrast to the heritage connotations of its historic countryside location, Hatoum's clothing evokes an urban presence, whilst her body's horizontality acquires even greater significance.

As in other performances by Hatoum, her body is almost always either horizontal or positioned in a series of movements that struggle towards verticality. The endurance aspect of her bodily performance might fruitfully be understood as gestures that are culturally and socially 'inscribed' as enacting the move from animality towards civilisation, from abjection towards idealisation. In *Them and Us...*, the denial of the act of walking through a leisure space, created to direct and circumscribe one's movements

according to 18th-century models of a picturesque garden, attains further meaning when we understand it in an oppositional relationship to the rise of 'land art' that came to the fore in Britain in the 1970s. The year of the Queen's Silver Jubilee, 1977, was marked by a Festival of Public Art, held in various gardens across the country.[39] It was also the year of increased policing against revellers at the Notting Hill Carnival. Richard Long's works, such as *A Slow Air* (1976) documenting his passage along a 74-mile walk in County Clare, present a stark contrast to the violence in Britain's urban spaces directed towards the 'black' presence in Britain as 'the enemy within'. The nostalgic reaction that land art prompted in Britain, and its associations with nationalist myths of Englishness that evoked an idyllic countryside, is indicative of a disavowal of the changing nature of Britishness.[40] By virtue of its title and Hatoum's act of burning newspapers to reveal racist graffiti, *Them and Us...* links the colonial history of South Hill Park to inner city violence that visitors to the centre may have imagined they were leaving behind.

The art historian Gannit Ankori provides the necessary historical context of memory and place that is crucial to understand how the displacement of space and time that constitutes exile informs Hatoum's performances. Particularly compelling is the repeated motif of disembowelment evident in *The Negotiating Table* (1983), in which Hatoum lay naked on a table in plastic wrapping, surrounded by entrails. Ankori attributes its repetition in her later minimalist sculptures to a traumatic memory that is not Hatoum's, but that of her mother's experience of the Dir Yin massacre in 1948, a particularly brutal episode of the *Nakba* (catastrophe). The massacre was conducted by an extreme right-wing Jewish militant group who slaughtered a village of men, women and children, and according to an eyewitness account they slashed the belly of at least one pregnant woman. As reports of these atrocities spread throughout Palestine, the fear they created led Hatoum's family to flee, leaving everything they owned behind them.[41]

Marianne Hirsch's *Family Frames: Photography, Narrative and Postmemory* (1997) examines the impact that memories of violence have on second and third generations of the survivors of genocide and, in a similar vein, careful attention to the particularities of language and memory created by exile has been at the centre of psychoanalytic studies in *Lost Childhood and the Language of Exile* (2004).[42] These studies suggest that, for a child of exile, the interior landscape of one's psychic life becomes a matter of moving between different border crossings of the past, in which memories are 'housed' in different languages. A child of exile might dream in one language, write in another and speak in a third. As Ankori has pointed out, Hatoum's approach to body art can be understood as the use of yet another language for someone who has moved between three: the Palestinian Arabic spoken by her family at home, French at her school in Beirut, and later English.[43] Hatoum's experience of being re-exiled from Lebanon to London can be seen to activate a simultaneity towards time and place. In her video work, *Measures of Distance* (1988), silences and pauses in her speech become spatialised as successive screens: our comprehension is dependent on Hatoum's spoken translation of her mother's Arabic writing. The viewer is aware that meaning 'inhabits' these spaces between what one thinks one knows and what one feels. The work does not narrate the nation so much as evoke separation,

rupture and the impossibility of entering this space of the mother-land and the mother-tongue.

In this sense, the absence of 'presence' determines the value of Hatoum's approach to performance, especially when we consider the temporal nature of the physical body and the impossibility of getting at the object of art that lives only in the memories of the spectators who witness it. The loss created by this rupture evokes a separation and distance that can only be filled by subjective thoughts and is inevitably determined by fantasy. Hatoum's persona of the phobic other elicits the paranoid gaze that attempts to fix the scene as it unfolds. Her appearance, hooded and in a boiler suit, masks her identity and renders her gender and her 'race' ambiguous, whilst also placing her body at its centre. However, as Peggy Phelan suggests, 'In performance the body is metonymic of self, of character, of voice, of "presence." In the plenitude of its apparent visibility and availability, the performer actually disappears and represents something else.' [44] The additional element that might come to the fore when there is an excess of visibility is the object of the spectator's gaze, such that the sign fails to produce the referent. Performance 'uses the performer's body to pose a question about the inability to secure the relation between subjectivity and the body per se'.[45] For Phelan, performance is therefore capable of resisting the reproduction of metaphor that masks absence and difference, and upholds a hierarchy of value.[46] The radical potential of performance art lies in an ontology of subjectivity without reproduction: 'Without a copy, live performance plugs into visibility – in a maniacally charged present and disappears into memory, in the realm of invisibility and the unconscious where it eludes regulation and control.'[47] Hatoum's body evokes the 'enemy within', but by masking signs of her 'origins'– sexual or racial – she complicates the reproduction of the metaphor of racial fetishism in the stereotype which is endlessly reproduced in media representations of violent rioting and brutal policing.

Hatoum's collaboration with Stefan Szcelkun in Roadworks brings this strategy to the fore. Together they created a chain of silhouettes along the streets of Brixton in an area that was previously the site of violence by staging a temporal inscription of fallen bodies and evoking the momentary re-surfacing of historical traces of 'black' Londoners. Two figures dressed in boiler suits were engaged in a ritual of falling and being lifted up, one by the other, and they alternated positions so that each standing figure marked the outlines of the other's body, thus forming a chain. The resulting image evokes a familiar sign of urban violence and of the forensic marking of crime scenes. The repetition of the action confuses the hierarchy of victim and oppressor, suggesting the struggle exists as much within the psychic realm as the social. The absence of the Palestinians' collective memories of genocide, and their continual erasure through the prevailing emphasis on the Holocaust, forms the backdrop to a careful understanding of Hatoum's exilic practice. Only recently has the Nakba been brought into representation, in film for example, and this suggests there were previously few opportunities given to remembrance or representations amongst Palestinians. Like the trauma of slavery and the destruction of bodies through the Middle Passage, the absence of a collective representation of these events constitutes what Cathy Caruth has designated as 'unclaimed experience'.[48]

Ankori's attention to the destruction of Haifa in 1948 and its memorialising in Hatoum's work helps us locate and historicise the frequent references to the unease and discomfort that her work is said to generate. As I have suggested, the value of Hatoum's performance work lies in its attention to the erasure and necessary re-inscription of the 'black' presence in Britain that echoes a similar need to evoke the suffering and plight of the Palestinians at a time when the anniversary of the Holocaust effectively served to sideline the hidden suffering of the Palestinian people. Approached in this way, Hatoum's work suggests a certain contrapuntal relationship between the historical *tabula rasa* that erased the exilic condition of Palestine, as Said argues in his account of Israel's memorialising of the events of the World War II,[49] and the erasure of the 'black' African presence within the English countryside, such as the 18th-century author Ukawsaw Gronniosaw, who worked as a navvy and carpenter in London and elsewhere [50] but whose story was erased by the Churchillian myth of 'England' as 'an island race', which was explicitly revived under Thatcher's rule. Against this backdrop, Hatoum's performances of the 1980s refracted various phobic projections that had been historically created by different nationalist imaginaries.

Mitra Tabrizian's *The Blues* (1986–87)

The importance of the city as a space in which the spatial engineering described by Goldblatt was also evident in parts of Britain lies at the forefront of Mitra Tabrizian's *The Blues* (1986–87). Created as part of her doctoral research under Burgin's supervision, the work's multiple registers lie in its form – the photo-conceptualism developed by Burgin in the early 1980s – and her chosen subject of racial conflict between 'black' and 'white' male figures, which was influenced by Homi K. Bhabha's theory of racial fetishism and Stuart Hall's concept of inferential racism. Tabrizian's large-scale photographs draw on the genre of the film-noir movie poster to stage encounters in scenarios that are complemented by a deep saturated hue that alludes to the musical form of the blues. The work was taken up by Bhabha and Hall in their responses to Frederic Jameson's 1984 article, 'Postmodernism or the Cultural Logic of Late Capitalism', which was debated at the ICA conference, *Identity: The Real Me*, held in 1985 and published in 1986.

Discussing post-modernism as a site of competing subject positions, what was understood to be at stake in Jameson's distinction between 'surface' and 'depth' were competing claims to political visibility among 'black' and 'white' feminisms, such that the de-centring of the privileged white male subject created a vacuum that could be mined by feminist 'constructionist' approaches to woman-as-sign, but which were at odds with 'black' feminist strategies of 'coming to voice' that had marked Lubaina Himid's *The Thin Black Line* exhibition, held at the ICA in 1985.[51] The different responses to Jameson thus set the scene in which the comparative claims of a 'feminist' or 'post-colonial' subject were explored in *The Blues* – particularly 'Out Of The Past' – which can be fruitfully examined when Tabrizian's strategy is placed alongside that of Barbara Kruger's *You thrive on mistaken identity* (1983).

Created at a moment when debates among 'black' photographers in the journal *Ten. 8* questioned the political value of 'positive' and 'negative' image-making,[52] Tabrizian drew upon psychoanalysis to challenge this binary framework and to reveal instead the dilemma of being excessively marked and yet invisible, which was

given visual form in images of splitting and doubling throughout *The Blues*. As she argued:

> [W]hat is important is the understanding of the process of subjectification rather than the identification of images as positive or negative. This is certainly not the only kind of intervention. But it is one strategy that attempts to question any absolute definition of the white and of the black, the meanings of which are polarized around fixed relations of domination and subordination, displaced from the language of history to the language of 'Nature.' It is a strategy which tends to explore the ambivalence of the unconscious. If 'The woman does not exist,' we might equally say 'The black as such does not exist,' which means not that black people do not exist but their status as absolute Other, as the guarantor of the 'white man's' identity is a fraud.[53]

Tabrizian's adoption of Lacanian discourse may have seemed controversial for its time but, alongside Kobena Mercer's 1986 study of Robert Mapplethorpe's *The Black Book*, it placed sexuality at the forefront of a visual translation of Fanon's psychoanalysis of 'race' by taking up the implications of Bhabha's development of 'racial' fetishism to explore an alignment between the primal scene of racism as a question of looking and the photograph as a tableau that is historically linked to theatrical forms of *mise-en-scène*.[54]

While Burgin drew connections between advertising imagery and Freud's concept of phantasy as a *mise-en-scène* of desire,[55] which Tabrizian explored in the series *Correct Distance* (1984–85) that quotes from Freud's 'A Child Is Being Beaten', in *The Blues* the staging of fear

and phantasy is less easily categorised in terms of photographic conventions. The film-still genre used for movie posters is not so far from the cinematic tableaux that we find in *Correct Distance* or from the drama of the fashion photographer's studio in *The College of Fashion* (1980–81), but in *The Blues* Tabrizian creates scenarios that compress the space within the frame to the point of implosion. What results is neither the extreme close-ups of Barbara Kruger's or Richard Prince's re-photographed images, nor is it the tableau that Barthes identified as photography's historic connection with theatre, but a spatial ambivalence that creates a frame within a frame. The 'frame' of one photograph inserted into another was an important development from the montage strategies John Stezaker practised in the late 1970s, drawing on the format of the photo-roman to insert appropriated photographs as complete images, rather than photomontage methods that create an incision. John Walker described Stezaker's concern with the implications of maintaining the frame in the following way: 'Making relationships between frames is the *invisible* work of reading. What Stezaker does is to bring fragments/moments together to make *visible* the multiple relationships involved in narrative photography.'[56] Whereas Burgin explored issues of voyeurism by creating large-scale photographs that were combined with captions, and the conjunction of a 'frame' within a 'frame' was frequently used by Stezaker, Tabrizian's strategy in 'Out Of The Past' speaks to both these precedents but brings into play the use of mirrors to construct a relay of looks that disperses identification among different figures, without settling anywhere, thus creating a spatial ambivalence that constantly displaces the spectator's viewing position.

Mitra Tabrizian,
'Out Of The Past', from the
series *The Blues* with Andy
Golding, 1986–87

Tabrizian had explored this visual strategy in *The College of Fashion*, in which white female models pose holding circular hand-mirrors. In the accompanying text she examined the implications of a Freudian-Lacanian approach that rejects the 'innateness of femininity, the natural, which is understood not as naturalness of identity',[57] and went on to consider Laura Mulvey's attention to fetishism as it builds up 'the physical beauty of the object and transforms it into something satisfying in itself', and narcissism, which is understood not as an idealisation of 'the other' but of 'the self as other' that is first encountered in the mirror phase. The degree to which the self is constituted in the process of idealisation-as-misrecognition, and looks for its ego-ideal in subsequent stages of life, complicated Mulvey's call to destroy 'beauty', because for Tabrizian, 'the question then is no longer how to dispose of fetishistic and narcissistic imagery – that would be too simplistic – but how to foreground the threatening look, the return of the look'.[58]

In an uncanny echo of Tabrizian's distinction between the fetishistic and the narcissistic image, Craig Owens argued in his 1983 essay 'The Medusa Effect or, The Spectacular Ruse' that Barbara Kruger's practice was distinctive in its critique of the stereotype by virtue of its deployment of the pose, which he observed had isolated 'the stereotype's transformation of action into gesture, "prowess into pose" as she puts in a recent work.'[59] In a similar move to Tabrizian, Owens separates the moment of arrest from the act of seeing, arguing that what Lacan describes in his account of the look is, 'what happens when we look at a picture, any picture', adding: 'But [Lacan] is also describing the mechanism of *pose*: to strike a pose is to present oneself suspended – that is, *already a picture*. For Lacan, then, pose has a strategic value: doubling, *mimicing* [sic] the immobilising power of the gaze, reflecting it back on itself, pose forces the gaze to surrender.'[60]

Tabrizian's and Kruger's practices can be seen as articulating parallel intentions that draw on Lacan's analysis as a means of mobilising the stereotype against itself. One need only note Bhabha's attention to mimicry as a condition of the colonial stereotype to see the shared theoretical terrain between the post-modern and the post-colonial. Examining 'Out Of The Past' in detail, we can observe how the mirror makes visible the presence of three white male figures but it also stages a *deferral* of looks. Their act of looking, though 'framed' and therefore 'caught in the act', is not explicit but is deflected and inscribed onto the body of the black figure, who looks back. The black male figure's clenched fist, his look of dismay and his position in the room call to mind the phrase 'backed into a corner'. Although the text does not alleviate this ambiguity – 'Imitation / was the name of the game. / The dice were loaded, / But he had to play' – the allusion is suggestive of mimicry as a condition of the colonial stereotype. Moreover, viewing the entire series as a whole, it is striking how the clothing of the 'black' and 'white' figures implies a condition of sameness, albeit with subtle differences, as this leaves the viewer questioning who is imitating whom. Bhabha's reading of the photograph illuminates other elements: 'I was a wanderer in another city, caught in Mitra Tabrizian's image. In the leaden light of London I saw a black man freeze to stone in the shadows of a woman's wide-eyed witness. The mirror turns the troubled scene around and fills the space, before and behind, with the

hateful sight of questions of racist violence – *interrogating identity*.'[61]

The bust placed on a table beside the black male figure, together with the white figures reflected in the mirror, triangulate the spectator's field of vision. Griselda Pollock seems to overlook this detail when she writes: 'the menace of the three white men lounged across the huge mirror behind the vulnerable young black man stems from the space the viewer is in, and their target, the black man, appeals to the viewer. To read this space is to be forced to face up to our place in the scenarios of racism, to question with whom we identify.'[62] This space in question, which is visually absent in the photograph but 'psychically' apprehended by the racially marked subject, is identified by Stuart Hall in 'The Whites of their Eyes' as the place of:

> ...the 'absent' but imperializing 'white eye'; the unmarked position from which all these 'observations' are made and from which, alone, they make sense. This is the history of slavery and conquest, written, seen, drawn and photographed by The Winners. They cannot be *read* and made sense of from any other position. The 'white eye' is always outside the frame – but seeing and positioning everything within it.[63]

Through a relay of looks that never settle anywhere but keep us impossibly suspended, Tabrizian effects a return of the Medusa's gaze, although crucially this does *not* come from the 'black' man. She avoids this conceptual and visual trap by staging instead the 'blind spot' that Lacan attributes to the point at which the subject is being looked at by the gaze. Hence, in this instance, what the spectator sees is the 'gaze'

of the ideological apparatus of the media that is now bent back upon itself. The function of the bust is to unsettle the duality of the mirroring, by inserting itself as a third element. In effect, the bust is the 'specular ruse' that disrupts the place of idealisation: it is spotlit, but it is what lies in her shadows that is the true 'object' of fear and phantasy. Bhabha implies a metonymic slide between the bust and the black man when he signals the latter's 'turning to stone' in the shadows of this wide-eyed witness. Between Bhabha's and Pollock's respective readings there lies the question of the place of 'woman' in this series that complicates 'feminist' and 'post-colonial' readings alike. The position of the bust as a sign of 'woman' marks out a liminal space, cut off by the frame of the photograph: 'she' is the vital third element in a tableau 'heavy with desire, menace and question'.[64] The sense that this scene is 'out of the past' must be understood as an acknowledgement of the white woman's gaze that makes of the 'black' man's sex an object of colonial fear and phantasy.

This seems to be the key site of contestation that marks the crux of the debates on post-modernism in terms of an overlap between Jacqueline Rose's interventions on Jameson's distinction between 'surface' and 'depth' and Bhabha's and Hall's refusal of his suggestion that the conditions of alienation are modernist and therefore modes of analysing the effects of capitalism now exist only in the past.[65] For Rose the acknowledgement of woman as sign requires the recognition of the production of a gendered space in which this sign proliferates everywhere. While Bhabha regarded the mode of address articulated in Kruger's work as producing a 'white' gaze, it may be said that the artistic strategies whereby Tabrizian and Kruger insert

themselves into mass media forms, whether the film-noir movie poster or everyday advertising, both intervene in the *mise-en-scène* of phantasy as it circulates within public spaces. Despite the possible conflicts between these various intellectual positions on issues of gender and 'race', the reading of Tabrizian's work that I have put forward suggests that the 'cultural work' enacted in the conceptual strategies of exiled practitioners embodies an important art historical development that brought together a range of discourses, from the politics of urban space to the psychoanalytic account of the gaze, that were previously 'closed to one another' (as Said might say) during earlier periods of conceptual art.

Conclusion

The anti-humanist impulse of conceptual art corresponds in significant and compelling ways with the experience of exile as a contrapuntal movement between multiply refracted perspectives in the practices of Jantjes, Hatoum and Tabrizian. In turn these artists have shifted the terms in which art historical narratives that conventionally depend on nationalist identities have framed the 'black' arts movement in Britain from the moment of the *Pan-Afrikan Connection* exhibition in 1982 onwards. The contrapuntal is an important methodological tool for rethinking Eurocentric genealogies traditionally defined by classifications of style but which rarely attend to issues of location and the shifts in perspective that arise between art that 'travels' and political alliances that resist the ideologies of the nation-state. The impact of such exilic artists as Jantjes, Hatoum and Tabrizian, alongside artists such as Rasheed Araeen, Keith Piper, Ingrid Pollard, Lubaina Himid and many others, would require

a more extensive study to be fully appreciated, but the present visibility of contemporary generations – including Steve McQueen, Emily Jacir and Yinka Shonibare – can be traced to the uniquely ground-breaking work of this earlier generation.

1. Edward W. Said, 'Reflections on Exile' (1990), reprinted in R. Ferguson, M. Gever, T. Minh-ha and C. West eds, *Out There, Marginalization and Contemporary Culture*, Cambridge, MA: MIT Press, 1992, 358.
2. Ibid.
3. Ibid., 366.
4. Ibid.
5. Edward W. Said, *Culture and Imperialism*, London: Vintage, 1994, 37.
6. Michael Newman, 'Conceptual Art from the 1960s to the 1990s: An Unfinished Project?', in Peter Osborne ed., *Conceptual Art*, London: Phaidon, 1996, 289.
7. Lucy R. Lippard, 'Escape Attempts', in Ann Goldstein and Ann Rorimer eds, *Reconsidering the Object of Art 1965–1975*, Cambridge, MA and London, England: The Museum of Contemporary Art, Los Angeles and MIT Press, 1995, 19.
8. Charles Harrison and Fred Orton, 'Jasper Johns: Meaning What You See', *Art History*, 7, 1, March 1984, 91, and Moira Roth, 'The Aesthetics of Indifference', *Artforum*, xvi, 3, November 1977, 46–53.
9. Peter Wollen, 'Global Conceptualism and North American Art', in Luis Camnitzer, Jane Farver and Rachel Weiss eds, *Global Conceptualism, Points of Origin 1950s–1980s*, New York: Queens Museum of Art, 1999, 74.
10. Ibid., 76.
11. Victor Burgin interviewed by John Roberts, in John Roberts ed., *The Impossible Document: Photography and Conceptual Art in Britain 1966–1976*, London: Camerawork, 1997, 90; See also Victor Burgin, 'The State of British Art' debate, ICA, London, 1978, published transcript, in *Studio International*, 194, 989, 2, 1978, reprinted in Victor Burgin, *Between*, London and Oxford: Institute of Contemporary Arts and Basil Blackwell, 1986, 24–26.
12. Roland Barthes, 'Myth Today', in *Mythologies* (1957), selected and translated from the French by Annette Lavers, London: Vintage, 1993, 116.
13. Ibid.
14. Homi K. Bhabha, 'Foreword: Framing Fanon', in Frantz Fanon, *The Wretched of the Earth* (1961), translated by Richard Philcox with commentary by Jean-Paul Sartre and Homi K. Bhabha, New York: Grove Press, 2004, xxviii–xxx.
15. Kobena Mercer, '1968: Periodising Politics and Identity', in *Welcome to the Jungle, New Positions in Black Cultural Studies*, London: Routledge, 1994, 287–308.
16. Paul Overy, 'Footprints in the Sand: ICA, London', *The Times*, Tuesday 27 April 1976, 9.
17. Steve Biko in Gavin Jantjes, 'Introduction', *A South African Colouring Book*, Geneva: International University Exchange Fund, 1978, unpaginated.

18. Rory Bester, 'City and Citizenship', in Okwui Enwezor, *The Short Century, Independence and Liberation Movements in Africa, 1945–1994*, Munich: Museum Villa Stucka and Prestel, 2001, 219–24.
19. David Goldblatt, *The Transported of KwaNdebele*, New York: Aperture, 1989, 8.
20. Walter Benjamin, 'A Short History of Photography', in Walter Benjamin, *One-Way Street and Other Writings*, Suhrkamp Verlag, Frankfurt, 1974–76, translated by Edmund Jephcott and Kingsley Shorter, London: NLB, 1979, 256.
21. Ernest Cole with Thomas Flaherty, *The House of Bondage* (introduction by Joseph Leyland), London: A Ridge Press Book, Allen Lane and Penguin Press, 1968, 169.
22. Ibid., 170.
23. Ibid., 172–73.
24. Frantz Fanon, 'Racism and Culture' (1956), in A. Haddour ed., *The Fanon Reader*, London: Pluto Press, 2006, 25.
25. Ibid., 25–26.
26. Ibid.
27. *Sunday Times*, 31 October 1976, 37.
28. Richard Cork, 'London Arts Review: reports on the opposing camps of modern photography', *Evening Standard*, 4 November 1976, 20; and Caroline Tisdall, 'Victor Burgin', *The Guardian*, 6 November 1976, 8.
29. Sigmund Freud, *Introductory Lectures on Psychoanalysis* (1916–17), translated by James Strachey, *The Standard Edition of the Complete Psychological Works of Sigmund Freud*, Volumes XV and XVI, London: Hogarth Press, the Institute of Psychoanalysis and Allen & Unwin Press (1963), reprinted London: Pelican Freud Library, 1976, 423.
30. Fanon, op. cit., 2006, 25.
31. Rasheed Araeen, 'Paki Bastard', *Black Phoenix, Third World Perspectives on Contemporary Art and Culture*, 2, Summer 1978, 12.
32. Stuart Hall, Chas Critcher, Tony Jefferson, John Clarke and Brian Roberts, *Policing The Crisis: Mugging, The State and Law and Order*, London: Macmillan, 1978, 273.
33. Paul Gilroy et al., 'The Organic Crisis of British Capitalism and Race: The Experience of the Seventies', in Paul Gilroy et al. eds, *The Empire Strikes Back, Race and Racism in 70s Britain*, London: Centre for Contemporary Cultural Studies and Hutchinson (1982), reprinted 1986, 17.
34. Mona Hatoum, 'Interview with Sara Diamond' (1987), reprinted in Michael Archer, Guy Brett and Catherine de Zegher eds, *Mona Hatoum*, London: Phaidon, 1997, 131.
35. Eyal Weizman, 'The Architecture of Ariel Sharon', *Third Text,* Palestine and Israel Special Issue, May/July 2006, 351.

36. Mona Hatoum, 'New Work, Newcastle '86', cited in Guy Brett, 'A Hatoum Chronology', *Mona Hatoum*, Bristol: Arnolfini, 1993, 23.

37. Ibid., 17.

38. Cf. Peter Stark, Director, South Hill Park, interviewed by Hutchinson, 28 February 1975: Robert Hutchinson, *Three Arts Centres, A Study of South Hill Park, the Garden Centre and Chapter*, London: Arts Council of Great Britain, 1977, 10–11.

39. Joy Sleeman, '1977: A Walk Across the Park, Into the Forest, and Back to the Garden: The Sculpture Park in Britain', in P. Eyres and F. Russell eds, *Sculpture In The Garden*, London: Ashgate, 2006, 157–69.

40. Howard Newby argued that a resurgence of Romantic attitudes and values emerged 'despite – or perhaps because of – the economic realities of 1970s England', *Green and Pleasant Land? Social Change in Rural England*, London: Hutchinson, 1979, 13–14, cited in Sleeman, ibid., 162.

41. Gannit Ankori, 'Re-Visioning Faith: Christian and Muslim Allusions in Recent Palestinian Art', *Third Text*, Palestine and Israel Special Issue, May/July 2006, 384.

42. Marianne Hirsch, *Family Frames: Photography, Narrative and Postmemory*, Cambridge, MA and London: Harvard University Press, 1997; Judit Szekacs-Weisz, Kathleen Kelley-Lane and Judit Mészáros, 'Preface in Three Voices', in Judit Szekacs-Weisz and Ivan Ward eds, *Lost Childhood and the Language of Exile*, London: Imago MLPC and The Freud Museum Publications, 2004, 1–10.

43. Sheela Wagstaff, 'Uncharted Territory: New Perspectives in the Art of Mona Hatoum', *Mona Hatoum: The Entire World As A Foreign Land*, London: Tate Britain, 2000, 36.

44. Peggy Phelan, *Unmarked, The Politics of Performance*, London and New York: Routledge, 1992, 150.

45. Ibid., 150–51.

46. Ibid., 151.

47. Ibid., 148.

48. Cathy Caruth, *Unclaimed Experience, Trauma, Narrative and History*, Baltimore and London: John Hopkins University Press, 1996.

49. Edward W. Said, 'Edward Said, The Voice of a Palestinian in Exile', *Third Text*, 3/4, Spring/Summer, 1988, 42.

50. Kathleen Wilson, *The Island Race, Englishness, Empire and Gender in the Eighteenth Century*, London and New York: Routledge, 2003, 44.

51. Cf. Lubain Himid's discussion of Claudette Johnson's role in the BLK Art Group and later as a catalyst in propelling 'black' women artists practices, 'Inside the Invisible: For/Getting Strategy', in David A. Bailey, Ian Baucom and Sonia Boyce eds, *Shades of Black*, Durham and London: Duke University Press, Iniva and Aavaa, 2005, 43.

52. Cf. David A. Bailey's account of his photographs of the early 1980s including those of then councillor for the GLC, Paul Boateng, 'Rethinking Black Representations, From Positive Images to Cultural Photographic Practices', *Ten. 8*, 31, 1988, 36–49.

53. M. Tabrizian and A. Golding, *The Blues* in M. Tabrizian, *Correct Distance*, Manchester: Cornerhouse Publications, 1990, unpaginated.

54. Roland Barthes, *Camera Lucida, Reflections on Photography*, translated by Richard Howard, London: Vintage, 2000, 32.

55. Victor Burgin, 'Photography, Phantasy, Function', in V. Burgin ed., *Thinking Photography*, London: Macmillan Education, 1982, 204.

56. John Walker, 'Five Collages by John Stezaker', Birmingham: Ikon Gallery, 1978, cited in Brian Hatton, 'John Stezaker's Photomontage: The Image and the Cut', in *John Stezaker*, Luzern: Kunstmuseum, 1979, ix.

57. Tabrizian, op. cit..

58. Ibid.

59. Craig Owens, 'The Medusa Effect or, The Spectacular Ruse', in *We Won't Play Nature to Your Culture, Works by Barbara Kruger*, London: ICA, and Basel: Kunsthalle, 1983, 6.

60. Ibid., 10.

61. Homi K. Bhabha, 'Interrogating Identity', in Lisa Appignanesi and Homi K. Bhabha eds, *The Real Me: Postmodernism and the Question of Identity*, ICA Documents 6, 1986, 11.

62. Griselda Pollock, 'Veils, Masks and Mirrors, Some Thoughts on the Work of Mitra Tabrizian', in Tabrizian, op. cit.

63. Stuart Hall, 'The Whites of Their Eyes', in George Bridges and Rosalind Brunt eds, *Silver Linings Some Strategies for the Eighties*, London: Lawrence and Wishart, 1981, 38–39.

64. Pollock in Tabrizian, op. cit.

65. Homi K. Bhabha, 'Interrogating Identity', 11, and Jacqueline Rose, '"The Man Who Mistook His Wife For A Hat" Or "A Wife Is Like An Umbrella": Fantasies of the Modern and The Postmodern', 33, both in Appignanesi and Bhabha, op. cit.

DIASPORA, TRAUMA AND THE POETICS OF REMEMBRANCE

JEAN FISHER

When history is abolished, identity
also ceases to exist.
Everlyn Nicodemus, 2004 [1]

A symptom of modernity to which Walter
Benjamin frequently returned was the atrophy
of transmissible experience, understood as the
combination of 'contents of the individual past
with material of the collective past.' [2] This fracture
in communication resulted from the alienating
effects of modern life: assailed by the 'shocks' of
information overload, consciousness protected
itself by blocking the assimilation of the 'data of
the world' into experience. Benjamin drew his
speculations from Freud's hypothesis in *Beyond
the Pleasure Principle* that 'becoming conscious
and leaving behind a memory trace are processes
incompatible with each other in one and the
same system.' That is, 'only what has not been
experienced explicitly and consciously, what has
not happened to the subject as an experience,
can become a component of the *mèmoire
involontaire*.' [3] Freud's hypothesis derived from
his studies on trauma, where it is precisely the
unassimilability of the catastrophic 'accident'
into consciousness that produces its untimely
return in involuntary memory and pathological
symptoms. By association, Benjamin identified
the traumatic nature of modernity with trauma's
dissociation of memory from consciousness.
The significance of Benjamin's reading of Freud's
structural distinction between consciousness
and traumatic memory is, as Kevin Newmark
points out, its correspondence to the

more fundamental question of the
historical relationship between tradition
and modernity... According to this model,
then, modernity would itself be structured

like a historical 'accident' that has at some
prior moment befallen and disrupted the
homogeneous structure of experience...
That is, modernity names the moment when
the thinking subject can no longer be said
to be completely in control or conscious of
the actual events that necessarily comprise
'his' past.' [4]

And yet the traumatic nature of this
alienation from temporal continuity has greater
poignancy in relation to a more radical rupture,
where modernity is understood through the
historical 'accident' of involuntary migration and
slavery – in the psychic, economic and socio-
political consequences of cultural dispossession,
geographic dislocation and political
disempowerment. Modern life, as Toni Morrison,
points out, begins with slavery. [5]

Moreover, if the 'founding' event of the
African diaspora can be said to be the Middle
Passage, it signalled not simply a traumatic
departure *from* ancestral belonging; it inaugurated
what Cathy Caruth, in her gloss on Freud's
narrative of the Israelites' exodus from Egypt
(in *Moses and Monotheism*), refers to as a
departure *into* a 'newly established future that is
no longer continuous with the past but is united
with it through profound discontinuity.' [6] Slavery
and colonialism forced the dispossessed to
depart into a history no longer simply their
own – one marked by confrontations with radical
difference in which the dignity of humanity itself
is violently withdrawn from them. The legacy
for the surviving generations of genocide and
slavery is that the present remains resonant with
the belated effects of this horrifying past. That is,
however seemingly distant the traumatic event
may be, it does not cease consciously and

unconsciously to frame the cultural identity and memory of its contemporary survivors.

It is Benjamin's proposed correlation between consciousness and traumatic memory, tradition and modernity that informs this discussion of black diasporic visual arts in recent decades. Following a brief discussion of the traumatism of cultural dispossession, this chapter explores the way the experience of cultural trauma and remembrance animated diasporic artistic practices. *What* needs to be remembered, as Paul Ricoeur states, is precisely what is posed by involuntary memory; *how* it is to be remembered is what is posed by anamnesis, the conscious act of recall.[7] In confronting the articulation of the 'what' and 'how' by reference to the historical archive and individual testimony, black diasporic artists reassembled a body to be mourned from the fragments of the past to produce a radical revision of our representations of historical process, national culture and the construction of subjectivities.

In some respects the cultural positions of this artistic production stood in agonistic relation to prevailing post-modern discourses. Informed by post-colonial debates, they demonstrated that the 'crisis of modernity' involved not simply a class and gender struggle but also one of 'race', as W.E.B. Du Bois had predicted early in the 20th century. Still locked in an anti-colonial war for self-empowerment at variance with national assimilationist attitudes, these positions were critical of institutional multiculturalism, which they saw as contaminated by the same logic. Whilst the artists shared post-modernism's challenge to western 'master narratives', they did so not by announcing the 'end' of history, but by reopening it to 'other', concealed narratives and more complex readings in which,

rather than a 'rupture', modernity was seen to be a complex entanglement of past and present. If the post-modern subject was now 'fragmented ' or 'decentred', how did this square with the position of black practitioners who were still struggling for political agency as the authorial and historical subjects they had hitherto been denied? As Stuart Hall wryly commented, 'now that, in the postmodern age, you all feel so dispersed, I become centred. What I've thought of as dispersed and fragmented comes, paradoxically, to be the representative modern experience!'.[8] New subjective and artistic positions were to be wrought from what Edward Said advocated as a 'counter-practice of interference' in the institutional representations of hegemonic culture to 'restore the non-sequential energy of lived historical memory and subjectivity as fundamental components of meaning in representation', through which the aesthetic could be reconnected to an ongoing political and social praxis.[9]

The Traumatic Inheritance, and Beyond

In writing of his traumatic encounter with European racism in *Black Skin, White Masks*, one of the most poignant and influential analyses of the traumatic psychic and physical cost of cultural dispossession and racism, Frantz Fanon speaks with the immediacy of one who, fixed by the objectifying gaze of the Other, feels his 'corporeal self' – his body-world relation – 'burst apart', its fragments to be reassembled by another self into an alienating 'racial epidermal schema'. He experiences dislocation, shame, self-contempt, nausea.[10]

Following Fanon, we are able to understand how cultural dispossession in histories of colonialism and slavery sets in motion a

catastrophic mutilation of communal identities and social structures. Where belonging to place, language, culture and history is violently interrupted, the self has literally no ground from which to speak and hence to narrate itself with others in the world. Dispossession is *in extremis* a deprivation not only of the past but also of the will to imagine new possibilities of existence: a withdrawal into the speechless, biological state of what Agamben calls the 'inhuman'.[11] Loss of the power of self-narration is central to the traumatic experience since language is not simply an abstract tool of communication; its origins are corporeal and the means by which the body 'speaks' its instinctual drives. To shatter the body is also to fragment the power of speech.

Cultural trauma of this magnitude plunges the survivor into the desolation of melancholy and mourning, which may be inherited by successive generations as symptoms of social dysfunction, or of a memory of terror whose fear of return is an all-too-readily imagined possibility. As Freud relates, 'Mourning is regularly the reaction to the loss of a loved person, or to the loss of some abstraction which has taken the place of one, such as one's country, liberty, an ideal, and so on';[12] an observation that he extends in *Moses and Monotheism* where, as in Benjamin, traumatic memory is given a speculative historical and collective dimension. For Ricoeur,

> it is the bipolar constitution of personal and community identity that, ultimately, justifies extending the Freudian analysis of mourning to the traumatism of collective identity. We can speak not only in an analogous sense, but also in terms of a direct analysis of collective traumatisms, of wounds to

collective memory. The notion of the lost object finds a direct application in the 'losses' that affect the power, territory, and populations that constitute the substance of a state.[13]

Dominick LaCapra identifies this as 'historical' trauma as distinct from the 'structural' (or existential) trauma that afflicts any human being, but adds that it is never simply an individual experience: 'Trauma stems from interrelations with others and affects others.'[14]

Among the enigmatic traits of trauma noted by Freud was its belatedness: the catastrophic event was not consciously experienced as it occurred, and as such was unassimilable to conscious memory or understanding; it could not be incorporated into experience, but it returned from the future, as it were, in the symptoms of what is now characterised as post-traumatic stress disorder (PTSD). Melancholy is the name Freud gives to this unconscious, compulsive repetition or 'acting out' of the past – a 'forgetting' of the unforgettable, in which the self withdraws from the world into the isolation of self-abasement and self-recrimination. The survivor suffers through the trauma of the missing other, fraught with guilt, shame and bewilderment at having somehow survived unharmed. A temporal aporia in which the threat of death was missed through lack of consciousness of the experience, and which has to be constantly replayed, as Cathy Caruth points out, as an 'endless testimony to the impossibility of living'. For the survivor the crisis of surviving death is also the crisis of surviving life.[15] In so far as the traumatic event is inaccessible to the survivor's consciousness, trauma resembles the inaccessibility of the past itself.

Sonia Boyce,
Big Woman's Talk, 1984

For Freud, nonetheless, the belated appearance of symptoms is the potential ground of a 'cure': memory itself is an archive, the generator of the effects and traces of the past from which the analyst-archaeologist and sufferer could jointly begin the work of excavation and recollection, and through which the compulsive acting out of melancholy could be transformed through remembrance and reflection towards the more productive work of mourning – 'working through' – the traumatic experience towards a liberation of the self. [16] Integration of loss and separation demands therefore the re-founding of a speech and respondent through which the experience of remembering could be articulated. In as much as it demands an interlocutor or listener capable of recognising and acknowledging the testimony, the work of remembrance, as Ricoeur insists, has a social or collective dimension; indeed, the traumatic event lies first in individual and collective memory before entering the discourse of the historian. Hence, for Ricoeur, memory is the 'womb', or 'matrix' of history.[17]

Speaking and listening possess a mutual dependency that replays the ontology of self and other – after all, one hears the voice of another before one can speak. It is also what animates the reciprocity between the storyteller and listener: an essentially *collective* form of transmitting experience which, along with imagination, according to Benjamin, had been rendered obsolete by modernity's information technologies. As Benjamin relates: 'It is not the object of the story to convey a happening *per se*, which is the purpose of information; rather it embeds it in the life of the storyteller in order to pass it on as experience to those listening. It thus bears the marks of the storyteller much as the earthen vessel bears the marks of the potter's hands.'[18]

This reciprocity is invoked in the early pastel drawings and photo-collages of Sonia Boyce, in particular *Big Woman's Talk* (1984), a poetic rendering of the problematic of cultural transmission and remembrance. The work depicts a young girl seated in the lap of her mother. The surrounds and the mother's dress are densely patterned, like those in other Boyce drawings of the time, evoking both the decorative interiors of African Caribbean homes and the exuberance of William Morris prints. The girl seems to be listening in rapt attention to the voice of the mother – of her facial features we really see only the mouth – her gaze directed to some far-off imaginary space. One may speculate, as Boyce herself hints, that the mother is telling stories of that second place of African departure, the Caribbean. The work alludes therefore to the generational transmission of memory and experience noted by Benjamin – and yet, with conditions. As Gilane Tawadros points out, there is an understated diagonal in the drawing that

connects the listening child and the speaking mother, but at the same time creating a discrete space between them, circumscribing their sameness and difference, the things they share in common and the things that set them apart. The diagonal indicates both continuity and rupture between different generations and different locations. It is a migratory line, marking the point where the thread of continuous narratives has been broken by the act of migration, but where, simultaneously, new narrative strands and remembered histories begin to be formed.[19]

The disparity between different geographic imaginaries is revisited in the mixed media drawing, *Talking Presence* (1988), where two black figures silhouetted in the foreground look out over a collage of two spaces, private and public: a glimpse of a domestic interior replete with personal memorabilia of a tropical space overshadowed by the impersonal, historical landmarks of London. But it is in *Cricket Days? Domino Nights! young arrivals/new home/homeless. The streets are paved with gold in this green and pleasant land* (1988) and *Aunt Enid – The Pose* (1985) that Boyce conveys the struggle of the diasporic subject to reconcile these differences: to renegotiate subjecthood in the place of arrival and begin the task of creating 'new narrative strands', revealing, as Tawadros says, the 'gulf between expectation and reality in the experience of a whole generation of black people.'[20] Boyce presents a work of reflection sensitive to the struggles and accomplishments of a prior generation whilst grasping the creative potential of exile and the necessity of diaspora to forge new narratives to secure the future. What, then, is significant about Boyce's work is its search for a new expressive language that, in taking on the continuities and discontinuities of generational memory, moves emphatically towards the reparative space of 'working through'.

The Hinterlands of History

As Boyce's work suggests, to reclaim will and agency means negotiating a passage out of the lassitude of trauma to found new narratives to express a belonging commensurate with contemporary realities. In *The Wretched of the Earth*, Fanon plainly states that these new narratives were not to be found by dwelling nostalgically in a pre-colonial past of atrophied fragments; this was a recipe for political and cultural inertia, not the ground for action. Expressions of 'lament' or 'recrimination' may be temporarily cathartic, but were reactive responses to loss, primarily addressed to hegemonic power and too easily assimilated by it since, alone, they were ineffective in shifting the relations of power. It was the role of the intellectual and storyteller to mobilise his or her imagination to conjugate cultural memory with the realities of the present towards a new national consciousness, 'giving it form and contours and flinging open before it new and boundless horizons'.[21] Fanon's refusal to be a 'prisoner of history' in favour of endlessly creating himself in the world, finds its echo in African American writer Houston A. Baker: 'The birth of such a self is never simply a coming into being, but always also a release from *being possessed*'. That is, a divestiture of its inscription as subordinate other in the language of dominance, which he describes as a 'tunnelling out of the black holes of possession and "tight places" of old clothes, into, perhaps, a new universe.'[22]

In the British context, earlier diasporic aspirations of a promising future had withered into disappointment and resentment in a hostile environment of cultural loss, insecurity, prejudice, draconian containment policies and political exclusion, a resentment that, by the late 1970s had erupted into civil uprisings by second and third generations alienated from both their parents' and British culture. The young black artists graduating from British art schools at the turn of the 1980s emerged not only into this landscape of racial turmoil, but also into a cultural vacuum of racist exclusion from an institutional field of art that was obdurate in its belief that modernism was the exclusive prerogative of whites. Whilst art of the

African and Asian artists in Britain during the post-war decades had forged a new space for diasporic modernism, their work had fallen into oblivion in the absence of any sustained acknowledgement in the canon of British art.[23] Intellectual support therefore had to be sought elsewhere, in the politicised fields of Caribbean, African and African American music, filmmaking, literature and post-colonial criticism. Thus, from the outset, the frame of reference for black artists was transnational and interdisciplinary. Determined not to be 'possessed' by the prescriptive identities and conditions imposed by the language of dominance, self-determining identifications were to be constructed across a diversity of cultural positions, both inside and outside the national culture, which in part entailed a reconsideration of the signs and meanings of cultural roots.

It is not my intention to rehearse the entire historical trajectory of what has come to be known as the 'black arts movement', already debated elsewhere,[24] except to draw attention to Stuart Hall's summary of the 1980s as demonstrating a shift from the 'representation of politics' that inaugurated the movement in the late 1970s and early 1980s with the artists of the original BLK Art Group (Eddie Chambers, Keith Piper, Donald Rodney and Marlene Smith), to the 'politics of representation' that preoccupied most of the 1980s.[25] If the former was influenced by politically-driven discourses and galvanised by the injustices of institutional racism, the latter took up a more semiotically inflected interrogation of the media construction of the black body, attending more closely to the complexity of black sexual and gender subjectivities and was increasingly influenced by the critical poetics of women and gay artists

and filmmakers. What emerged were innovative artistic practices in which the political was inextricably embedded in the aesthetic and which firmly grasped a new language of artistic agency. (It is also important to note here that archiving their work, individually and collectively, became a central issue for this generation.[26]) In so far as what Keith Piper retrospectively described as an earlier 'aggressively didactic phase' concerned with 'grand globalised themes'[27] articulated 'reactive' responses to the iniquities of the prevailing socio-political landscape, and in as much as such responses were informed by an earlier post-colonial criticism couched in the language of antagonisms and hierarchies, one might argue that they perhaps represented a necessary but transitional phase towards the 'working through' of remembrance and reflection proper.

The moment I want to take up, therefore, is a conceptual expansion of the politicised themes of representation and racial conflict into a reflection on the dialectic of memory and history, in which the resources of the historical archive and personal testimony become more fully foregrounded. I am tempted to suggest that this moment comes into focus with Black Audio Film Collective's *Signs of Empire* (1983), and develops through the subsequent experimental films of both BAFC and Sankofa Film and Video.[28] Speaking of the aesthetic innovations of *Territories* (1984, Sankofa, dir. Isaac Julien), and *Handsworth Songs* (1986, BAFC, dir. John Akomfrah), Kobena Mercer notes that, whilst they possess continuity with the politics of racism and documentary realism of earlier black independent films, they challenge the 'mimetic conception of representation': 'By intervening at the level of cinematic codes of narration and

communication, the new films interrupt the ideological purpose of naturalistic illusion and perform a critical function by liberating the imaginative and expressive dimension of the filmic signifier as a material reality in its own right.'[29] Through the discontinuities and associations of this 'multiaccentuated, performative and reflective mode of address', an interpretative space is opened to the viewer. It is in this critical attention to forms of narration and reception that a new approach to the dialectic of history and memory is developed, emerging in visual art practice as such with, for example, Keith Piper's photo-text panels, *Go West Young Man* (1987), to reach full expression in the artist's powerful multimedia installation *A Ship Called Jesus* (1991). These works demonstrate, as Fanon had insisted, that language had to divest itself of the old political rhetoric of lament and recrimination, too easily pacified under dominant society by a few concessions, and invent a poetics and politics of affect beyond the remit of documentary realism that could penetrate beneath surface symptoms to the deeply buried psychic economy of history, 'race' and belonging.

* * *

Signs of Empire was an innovative slide-audiotape work whose elegant typographical image overlays announced the discursive spaces to be interrogated: 'In the beginning–the archive–imperialism–the hinterlands of narrative–the impossible fiction of tradition–the treatise–in national identity–the decentred autobiography of Empire–the rhetoric of race...'. A slow dissolve of archival photographs of colonisers and 'natives', many of them more typical of intimate family albums than official historical records, are sparingly interrupted by short film clips – Asian tea pickers, black industrial

workers, the fires of urban riots. Series of images cut to details of public monuments in angled shots that undermine the stability and permanence of power that such sculptures are intended to invoke. Throughout, repeated extracts from two political speeches expose the distance between myth and reality: one eulogising the multi-racial unity of the British Commonwealth, the other expressing anxiety at the alienation of diasporic youth. In this way *Signs of Empire* presents an extraordinary, condensed soliloquy on a mythic British national identity that, constructed in the confidence of Empire, was now fragmenting under the uncertainties posed by the presence of diasporas searching for their own sense of identity and belonging. The audio-track spatially extends this sombre trajectory, moving between an intimacy and distance resonant with the emotional ambivalence between whites and their immigrant neighbours. Pause and repetition pose the image as both seduction and opacity, disclosing the impenetrability of the photographic referent and the historical context from which the image derives. In sampling the archive, the historical discourse derived from it is dis-assembled, realigning the dismembered body of the past with the present to 'decentre the autobiography of Empire'. The work closes with a black field bracketed by bands of blue then red, which, we subsequently learn in *Testament* (1988), are the Ghanaian colours of mourning, as if to announce a shift away from the disabling melancholy of traumatic loss. Indeed, the oscillation between the melancholy of loss and the mournful tones of remembrance powerfully contributes to the affective charge of BAFC's films.

The question posed by *Signs of Empire* was how could a fragmented past of effects and traces and the present be made to communicate

Black Audio Film Collective,
Still from *Testament*, Tania
Rogers as Abena, 1988

with each other? BAFC's radical solution, exemplified by their acclaimed film *Handsworth Songs* (1986), was to put into play several incommensurate but complementary discursive registers to produce an innovative 'film essay' style that was both poetic and political without being didactic: a montage of imagery drawn from still photography, the staged tableau vivant or dramatisation, filmed and archival footage; a polyvocality of recorded testimonies and intercessional poetic voice-overs that, contrary to the panoptical 'explanatory' impulse of the documentary narrator, build an oblique relation to the audio-visual track; and an immersive sonic space of sampled music and original electronic or digitalised composition, autonomous from the image, but animating it with an extended conceptual resonance. The result is an anti-narrative narrative that is not 'given' through any totalising or transcendental perspective, but emerges as a virtuality in the interstices of its different registers and in its engagement with the imagination of the spectator.

Handsworth Songs circulates around the 1980s 'race riots', press coverage and archival footage of the early hopeful years of the 'Windrush' generation. The film reveals a landscape of frustration, betrayal, disillusionment and insecurity among a people in deadlock with dominant society, against which violence becomes the only possible act of enunciation. It is, alongside the outpouring of speaking that accompanies it, what Michel de Certeau calls a 'capture of speech': an act of saying that is a 'freeing of imprisoned speech', and which takes the form of a refusal precisely because its testimony finds no ground in any prior discursive formation except as 'negation'.[30] *Handsworth Songs* astutely understands the significance of

this 'capture' through attentiveness to the sounds and silences of language itself. From behind the police barricades, the camera observes the press, gathering for sensational images and headlines, contrasting them with eyewitness accounts that testify to a systemic failure in the authorities' attitudes to immigrant neighbourhoods. Political pundits and neighbourhood leaders assemble to 'explain' the causes of discontent – depressed housing, unemployment, poor educational opportunities, lack of political agency. But the film exposes the inadequacy of this language of class struggle to address a much deeper malaise at the heart of British society, one that was rooted in the inner contradictions of its imperial past. As one of the film's most quoted lines goes, 'there are no stories in the "riots", only the ghosts of other stories...'.

If *Signs of Empire* and *Handsworth Songs* explored the historical roots of a troubled British post-imperial national identity as it condensed around its diaspora communities, other films addressed the spatio-temporal complexities of cultural roots and black identities through the ghosts and geographies of the black Atlantic: the institutionally disavowed longevity of a black presence and the investment of its own history and memories in Britain of *Twilight City* (1989) and *A Touch of the Tar Brush* (1991), and, in counterpoint, the unbreachable distance between the diaspora subject and her ancestral home in *Testament*. In these films, BAFC, like Sankofa, increasingly combines archival material with dramatic staging and the voice of the witness to problematise the claims to 'truth' of the different registers of historiography and fiction.

* * *

Whilst Keith Piper's early scripto-visual, mixed media paintings had consistently drawn on

popular imagery and contemporary socio-political issues, it is with the photo-text panels of *Go West Young Man* that his interrogations of black masculinity and the inscription of the black male body in dominant culture begin to incorporate a more studied historical dimension. The work presents a dialogue between a son and his father that interpolates the intergenerational ambivalence of identification and reproach with the equally ambivalent psychic and physical economies inherent in the histories of black–white relations. The work traces a dual departure: the journey into slavery from Africa to the 'West Indies' and thence the return crossing of an immigrant work force into the hostile, racist environment of post-war Britain. These themes are rearticulated and deepened in the installation *A Ship Called Jesus,* referring to the Jesus of Lubeck, the first officially sanctioned slaver donated in 1564 by Elizabeth I to the pirate John Hawkins. As Piper dryly comments in his exquisitely succinct accompanying text, 'metaphorically we have been sailing in her ever since.' [31] Piper describes the installation as charting a progression of three stages of this voyage, to signify both the 'trauma of loss and the triumph of retention': 'Each leg of this voyage is examined in a separate installation which exists as an attempt to grapple with some of the inherent trauma, contradictions and points of resistance contained within three distinct but related cultural and historical moments': *The Ghosts of Christendom, The Rites of Passage* and *The Fire Next Time*. As Mercer, in his inspirational text on Piper's work notes, 'the installation explores the historical relationship between slavery and Christianity, and the various ways in which the fundamentalist desire for certainty, whether religious or political, expresses a response to the unrepresentable experiences of chaos, trauma and loss.' [32] The primary motif in the sculptures and computerised montages that are assembled like stained glass windows of *The Ghosts of Christendom* is a recurrent one in the artist's work at this time: the crucified or scapegoated black male figure historically sacrificed to the psychic economy of race, phantasmic desire and contempt. *The Rites of Passage* consists of a 70-foot (21.34-metre) long pool of water shaped like the hull of a ship – or a coffin – reflecting multiple projection sequences of images with typographic overlays drawn from popular culture and family albums. This almost hallucinatory visual panorama and soundscape traces the duplicity of Christian doctrine – its unethical support of slavery through the lure of wealth and 'heathen' conversion – and the paradoxes of its transformation in the black protestant churches as variously a supportive, unifying socio-political force, a site of survival of African patterns of belief and aesthetic structures, and as a conservative limit to the expression of later generations. The video and slide projection, *The Fire Next Time*, is in part an astute self-reflection, exploring the contemporary legacy of a past unretrievable into full presence, a present incertitude and what Mercer calls the 'mood of disenchantment occasioned by the loss of faith in modernist notions of revolution and progress' that drives a people into the 'security' of religious or political fundamentalism. [33] *The Fire Next Time* was, as Piper insists, a 'struggle for reconciliation with history … a struggle replete with trauma, conflicts and disillusionment.' [34] Thus, if the journeys Piper describes are on the one hand couched in terms of a reproach by its survivors, on the other hand, echoing Boyce's work, they acknowledge the struggles of prior diasporic generations and

Keith Piper,
The Rites of Passage from
A Ship Called Jesus, 1991

celebrate the resilience and inventiveness of African humanity. In as much as, through religious practice, Piper identifies the trace of the past in the present, 'tradition' becomes not the severed 'other' of the past as defined by European modernity, but part of a transformative process of contemporary reconciliation. For the viewer, *A Ship Called Jesus* was an extraordinarily liberating experience in as much as it conveyed the sense of release from the past as a burden into a resource whereby, by confronting the dynamics of repression, a path could be opened to change.

Piper was subsequently to liberate the possibilities of the archive itself through his engagement with digitalisation and the computer interface – the contemporary technological archive *par excellence* – culminating in the interactive CD-ROM, *Relocating the Remains* (1997). *Relocating the Remains* is a computer-montage archive of Piper's own artistic projects and research. He describes it as 'not only an exploration of themes around displacement and recollection but also an immediate act of relocation: the relocation of art objects and ideas from the physical space of the gallery, to the virtual space of the CD-Rom.'[35] Through it are brought into dialogue his main themes: 'the unmapped body – exploring issues around multiple perceptions of the Black body within the dominant gaze'; 'unrecorded histories – which lurk in the creases of dominant historical narratives functioning to distort and obscure black presences'; and 'unclassified – exploring the impact and implications of new technologies especially within the domain of surveillance and policing, and their impact upon contemporary notions of community, nation and racial difference.' As Mercer notes: 'In the light of

his deeply held interest in history as a political problem of memory and representation, Piper's view of the future possibilities of new technologies offers an exploration of cyberspace that is critically wired by the diaspora experiences of migration and dislocation.' [36]

The Voice of the Witness

As Mercer points out, an earlier generation of black experimental filmmakers had more or less conformed to the existing vocabulary of documentary filmmaking to disclose alternative histories to official versions. Motivated primarily by demands for economic and social justice, the tendency was to construct a *counter*-narrative, which offered a point of articulation for black political solidarity. And yet, whilst recognising the accomplishments of earlier work, for the new generation it was no longer simply a question of constructing a counter-narrative to the dominant one (which is still to acknowledge its prior authority), but of testing the limits and limitations of this model through a critical self-reflexivity and 'interruptive' strategies of disarticulating and rearticulating the language of hegemony to expose the aporias and contradictions of its master narratives. The result was a rejection of the unified or totalising narrative and the creation of what Mercer calls a radical polyphonic resonance, 'in which the possibility of social change is prefigured in collective consciousness by the multiplication of critical dialogues.' [37] This involved a creative attentiveness to what Certeau calls 'zones of silence' marginalised by hegemony: [38] the vernacular realm of stories based in individual and collective memory and the imprint or trace of the other to be found in the archive. It is in this sense one may understand Agamben's definition of the archive as the

'system of relations between the said and the unsaid'. [39]

Derrida traces the word 'archive' to the ancient Greek *arkhe*, meaning 'at the origin'; but also to *archaeion*, meaning 'the house of the magistrate who makes the law, holds the official documents, and who thus holds the power of interpretation'. In our historical time, it is hegemonic culture that has assembled the historical archive, withheld or released its contents and authorised its interpretative discourses as 'history'. Historiography is an operation of search, selection and interpretation of documents from the archive, which are 'orphaned', as Ricoeur puts it, from an original author and, unlike testimony, without any designated interlocutor. [40] History is a representation and, like any representation, is no more than the surrogate of an absent referent that cannot be recalled to full presence. As such, historical representation is never impartial, but always mediated and manipulated by the ideological biases that reflect the needs and desires of a particular historiographic moment. The archive is, therefore, open to the abuse of institutional concealment, disavowal or wilful amnesia, to a blurring of the boundaries between historiography and mythography and hence a potential ideological weapon by which the place of power obliterates the experience of the marginal.

For the diasporic artist to raid the archive and to 'relocate the remains' – to borrow Piper's title – is, then, a subversive act in so far as it usurps the power of authority to control meaning. Interpretation and translation are central to the nature of the archive since it is not some ready-to-hand body of knowledge, but a labyrinth of fragments from the past, made up of gaps and

inconsistencies as well as thematic coincidences. As such the archive is always in process, subject to additions, subtractions and reconfigurations – interventions conditioned by new experiences and perspectives. Thus, as Derrida says, 'the question of the archive is not [...] the question of a concept dealing with the past that might already be at our disposal or not [...], it is a question of the future itself, the question of a response, of a promise and of a responsibility for tomorrow.'[41]

It is response, promise and responsibility – both to those dispossessed ghosts of the past and to the generations yet to come – that animate the diasporic artist's re-articulation of the archive with individual and collective memory, by means of which testimony becomes an act of witnessing and of remembering. Most commentaries on witnessing refer to the experience of the Nazi death camps, in which testimony is named as the literary 'invention' of the Holocaust generation.[42] However, to take a longer historical view, the lineage of trauma testimony can be traced back from African American and Caribbean literature and music rooted in the black churches to the first person slave narratives of the 18th century, motivated by the necessity of testifying to black humanity itself against its inhuman status under slavery. That is, testimony is thoroughly embedded in the history of modernity.

As Stuart Hall says, testimony tells a story that inevitably speaks from a 'position', an experience inscribed politically, geographically, historically.[43] At the same time, unlike historical narrative, it positions an interlocutor in a demand for inter-subjective attentiveness. Moreover, as diasporic artistic practices demonstrate, testimony, originating in an individual memory-image, functions agonistically in relation to

historical narrative because, like poetics, it is among those expressions of life experiences that are irreducible to rationalist determinants, whilst forming, in Ricoeur's terms, the matrix from which history is made possible. Nonetheless, its very resistance to 'scientific' verification makes it vulnerable to disputes on credibility and authenticity, in as much as the listener must take on faith the veracity of the account. But this is in part what it shares with the historical narrative since the latter also cannot convey full presence; as Agamben observes, the aporia in testifying to atrocities like the death camps is the very aporia of historical knowledge: 'a non-coincidence between facts and truth, verification and comprehension'.[44]

Agamben's analysis is drawn from the accounts of Auschwitz in which, he claims, the actual object of the witness testimony is not the gas chambers, but those traumatised prisoners known as 'walking corpses', who represented a 'limit situation' in which the human crossed a threshold into the inhuman, no longer capable of witnessing anything, even their own death – an observation that equally describes the dehumanisation of the black self under slavery and racial violence. Since there exists no voice in the disappearance of voice, the survivor could only witness the absence of witness, a loss that, as we have seen, is the source of the survivor's trauma. Nonetheless, for Agamben, witnessing the absence of witness is proof of testimony's veracity in so far as the *act* of testifying reveals the visible trace linking the inhuman or living being of sensate experience that knows but cannot speak, to the pathos of the speaking subject that speaks but cannot know.[45] Testimony retraces the insoluble bond between the human and the inhuman, the 'system of

relations between the sayable and unsayable, the possibility and impossibility of speech', by which the subject itself is constituted.[46] That is, speaking and narration create the subject in a departure from an unknowable origin to which there is no return except through the silence of desubjectification.

In discussing the resistance of witness testimony to the historiographic process, Ricoeur suggests that the limit experience is untransmissible because, since the *listener* cannot incorporate such horror into ordinary lived experience, it eludes his or her comprehension: 'This comprehension is built on the basis of a sense of human resemblance at the level of situations, feelings, thoughts, and actions. But the experience to be transmitted is that of an inhumanity with no common measure with the experience of the average person. It is in this sense that it is a question of limit experiences.'[47] Thus the problem of transmission lies not in trauma as such but in the listener's incapacity to comprehend its voice. One can, therefore, understand objections to those dramatisations of atrocities that assume it is possible for representation to render up a transparent real and offer causal explanations of an event that defies any such resolution; if anything, such dramatisations reveal the 'impossible adequation of the available forms of figuration to the demand for truth arising from the heart of lived history.'[48] But, as Ricoeur continues, to say untransmissible is not to say inexpressible. To overcome this impasse demands the invention of different interventionary modes of expression capable of transmitting both the untransmissibility of the traumatic experience and a self-reflexive awareness of the limits of representation. It is precisely this that accounts for the radicalness

of, for instance, BAFC's interrogation of media coverage of the 'race riots' and its aftermath of 'explanations' in *Handsworth Songs*; or Piper's trans-temporal montages of the relationship between slavery and Christianity in *A Ship Called Jesus*. What is re-invented is a form of audio-visual storytelling, which reclaims Benjamin's dismissed storyteller as a multivocality that speaks from and to collective experience.

Memory: The Womb of History

The innovative aspect of the diasporic practices discussed here lies in what Mercer calls their 'polyphonic resonance', their layering of diverse audio-visual registers and multiple voices to create new forms of enunciation and audience address. In particular, their eschewal of the linear structure of conventional narrative forms, inherited by most documentary and cinematic genres from the 19th-century novel and historiography, present not a totalising view of events that would provide some 'explanation', a cathartic closure for the viewer, but a temporal complexity that the viewer must constantly renegotiate. In this way they offer a response to the vexed arguments about 'how' and 'what' in the limit experience is representable and expressible. Again, most of these debates derive from commentators on the Holocaust, amongst whom there is a tendency, as LaCapra puts it, to 'sacralise' the event and impose a prohibition on representation on the grounds that there is in its absolute singularity something unassimilable, immemorial and irreducible to representation, unavailable except as a void of meaning to which the only ethical response is silence. However, all genocides are equally singular, and to dissolve them into the silence of the Holocaust unjustly denies those other victims the dignity of

remembrance. Some account is necessary not only to prevent suffering from falling into oblivion, but also to make sense of the way the past haunts the present, to overcome melancholic repetition by the 'working through' of memory and to confront ethical issues of revenge, forgiveness and reconciliation. The duty to remember, says Ricoeur, 'is an imperative directly towards the future, which is exactly the opposite side of the traumatic character of the humiliations and wounds of history. It is a duty thus to tell.' [49]

That the visual arts have been under-represented in trauma debates dominated by psychoanalysis, psychiatry and literary studies is an issue addressed by the work of the artist Everlyn Nicodemus and raised in her essay 'Modernity as a Mad Dog: On Art and Trauma'.[50] The vital question, 'how it is possible for the unrepresentable to enter a visual system of meaning?' is also central to Janice Cheddie's discussion of Nicodemus' work.[51] Nicodemus speaks as a survivor of both individual traumatic experience and historical collective trauma; it is in her efforts to 'work through' the former – the 'difficulty of finding words' – that she comes retrospectively to reconnect with the latter, eventually performing the difficult roles, as she relates, of both 'witness and critical commentator, narrator and listener'.

Although Nicodemus has worked in physical isolation in several European cities, through her long association with *Third Text* and the Institute of International Visual Arts (Iniva) her 'spiritual home' has been the black British artistic and intellectual community. Nicodemus emigrated voluntarily from Tanzania to Sweden in 1973, gaining some recognition as a poet and artist. One of her first major projects was *Woman in the World* (1984–86), an exuberant series of poetry and painting installations made in Skive, Dar el Salaam and Calcutta, following intensive workshops and discussions with groups of local women. Her public statements on 'race' and women's issues, however, drew the attention of the Swedish authorities; forced into further exile, there followed several years of racial harassment that led to a catastrophic psychic and physical breakdown culminating in a near-death experience attributable to PTSD.

An obsessively repetitive series of pencil and ink drawings, *The Object* (1988), expresses her state of mind at that time. In each, the setting is a bleakly unadorned room; windows are indicated but the atmosphere is dark. Its sole occupant is a hunched figure seated in a corner on a chair too fragile to support its weight and too tall for the feet to reach the floor. The figure pathetically clutches an everyday object – handbag, walking stick, flower – as if to hold on to some slender thread of reality; but the figure's cognitive and sensory-motor faculties (head, hands and feet) are diminished and almost withdrawn into the swollen bulk of its body. Few images express so vividly the reduction of selfhood to the insensate state of the inhuman, echoing Fanon's description of the depersonalisation of the black self through the racist effects of the 'racial epidermal schema' and Elaine Scarry's account of the 'unmaking' of the world experienced under conditions of extreme duress:

> It is intense pain that destroys a person's self and world, a destruction experienced spatially as either the contraction of the universe down to the immediate vicinity of the body or as the body swelling to fill the entire universe. Intense pain is also

Everlyn Nicodemus,
*Reference Scroll on
Genocide, Massacres and
Ethnic Cleansing*, 2004

language-destroying: as the content of one's world disintegrates, so the content of one's language disintegrates; as the self disintegrates, so that which would express and project the self is robbed of its source and its object.[52]

If, on the one hand, *The Object* series expresses the compulsive 'acting out' of the traumatic experience, on the other, it represents a pivotal moment in which the silence of the dehumanised victim gives way to the garrulousness of the witness as she commences the work of mourning and remembrance. Nicodemus begins literally to write and paint herself out of the corner. In the following three years Nicodemus was to be preoccupied with over 80 paintings, collectively titled *The Wedding* (1990–94), which she describes as her struggle against death through the will to life.[53] As with other diasporic practices discussed here, a cognisance of death is present, not as morbidity, but as the productive dimension that defines human consciousness itself. Rage at injustice, however, is also never far from the surface. By 1995, Nicodemus' expansive vision, first expressed in *Woman in the World*, had reasserted itself in an ongoing series of collages, the *Black Books* (1995–) and assemblages *Con-frontiers* (1996–), where a scripto-visual collage of images, objects and news reportage signals Nicodemus' release from her psychic prison into world history. Nicodemus has reached a point where traumatic experience has indeed been translated into critical reflection: the repetition compulsion of melancholy has given way to the work of mourning and personal grief opened onto a wider social dimension to confront the collective pain of separation and loss. Nicodemus works over the trajectory of her

experiences, thoughts and art on trauma in the video *Beyond Depiction* (2005, dir. Kristian Romare). It includes the series, *Internetting*, a pun alluding to the 'internee imprisoned by her own trauma', and *Birth Masks*, in which the fragmented body is reassembled and remembered through a series of canvas assemblages where a vessel or garment alluding to the womb or unborn child is entrapped in a mesh sewn with sisal stitches resembling surgical sutures. The *Birth Masks* are, as the artist relates, 'graves that are not there – the sites of mourning', but they are also Ricoeur's memory as the womb or matrix of history.

Nicodemus turns towards history in the floor-based *Reference Scroll on Genocide, Massacres and Ethnic Cleansing* (2004). Here strips of canvas are 'sutured' together and printed with historical accounts of genocide, massacre, ethnic cleansing and disappearance alongside those articles of human rights that promised to secure a less violent future, thus paying homage to the voiceless and often disavowed ghosts of the past that haunt the archives of our collective histories. In her discussion of how, in Nicodemus' work, listening operates to transform trauma from the private to the public sphere, Cheddie notes:

> In allowing ourselves to enter into the space of trauma, we do not become participants in Nicodemus's installation event but, rather, we emerge within the space as ethical listeners engaged with a mode of responsibility. The subject is not made whole again by listening, nor is the authenticity of the experienced reified, but we are asked to connect the experience of dissolution of the self through trauma with other modes of trauma that exist in the contemporary public sphere.[54]

Here the relation between the personal and the political is very clear; as is also the ethical demand that witnessing is both a responsibility to the past to remember and a promise to the future not to forget.

What we come to understand is that the task of the survivor, caught between the necessity of speaking and the impossibility of articulating the truth of a limit experience for which there are no words, becomes not one of representing the unrepresentable, but of witnessing the 'zone of indistinction' between speechlessness and speaking. In this sense, the witness to trauma is less an invitation for us to witness – or vicariously re-live – the singularity of *their* trauma, but in some sense to witness our own: an experience that can only be grasped by listening and responding to what is felt but unknown between one traumatic history and another; and a message that, despite the desolation of the past, may be one of joy and hope.

Benjamin could not have predicted that the oral tradition of storytelling he thought lost to modernity's information technologies would be transformed and revitalised through artistic practices in which the expression of experience was bound to the reclamation of a people's cultural identity and political destiny. But the diasporic poetics of remembrance has not simply been about reclaiming 'lost' histories or establishing biographical subjects. Between disclosing the aporias of the archive and its institutionalised histories and listening to the testimonial memories of those relegated to 'zones of silence', the work has brought us to a more complex understanding of how subjectivities are constituted, transformed or lost in relations of power, and how our most urgent task concerns an ethic of human relations.

Whilst the work indeed speaks from and to particular geographical and historical constellations, it is *from* the place of diaspora that a uniquely politicised, ethical and poetic language emerged that addresses the universally felt aporias of collective human existence, and in which memory and exile may found new narratives of hope. 'Identity', as Hall insisted, 'is not in the past to be *found*, but in the future to be *constructed*.'[55] Diasporic poetics demonstrate – contrary to the claims of modernism – that art never ceases to address the past for the future; it interprets history to disclose the deeper 'truths' of our world historical situation.

1. Everlyn Nicodemus, 'Modernity as a Mad Dog: On Art and Trauma', in Gerardo Mosquera and Jean Fisher eds, *Over Here: International Perspectives on Art and Culture*, New York: New Museum of Contemporary Art and Cambridge, MA: MIT Press, 2004, 262.
2. Walter Benjamin, 'On Some Motifs in Baudelaire', *Illuminations*, trans. Harry Zohn, New York: Schocken, 1969, 158–59.
3. Ibid., 160–61.
4. Kevin Newmark, 'Traumatic Poetry: Charles Baudelaire and the Shock of Laughter', in Cathy Caruth ed., *Trauma: Explorations in Memory*, Baltimore: The Johns Hopkins University Press, 1995, 237–38.
5. Paul Gilroy, 'Living memory: a meeting with Toni Morrison', in *Small Acts*, London: Serpent's Tail, 1993, 178.
6. Cathy Caruth, *Unclaimed Experience: Trauma, Narrative and History*, Baltimore and London: Johns Hopkins University Press, 1996, 14–17.
7. Paul Ricoeur, *Memory, History, Forgetting*, trans. Kathleen Blamey and David Pellauer, Chicago and London: Chicago University Press, 2004, 3.
8. Stuart Hall, 'Minimal Selves', in Lisa Appignanesi ed., *Identity, The Real Me*, Institute of Contemporary Arts Documents 6, 1987, 44.
9. Edward Said, 'Opponents, Audiences, Constituencies and Community', in Hal Foster ed., *The Anti-Aesthetic*, Seattle: Bay Press, 1983, 157–58.
10. Frantz Fanon, *Black Face, White Masks* (1952), trans. Charles Lam Markmann, London and Sydney: Pluto Press, 1986, 109–112.
11. Giorgio Agamben, *Remnants of Auschwitz: The Witness and the Archive*, trans. Daniel Heller-Roazen, New York: Zone Books, 2002, 47–52.
12. Sigmund Freud, 'Mourning and Melancholia' (1917), *On Metapsychology. The Theory of Psychoanalysis*, The Pelican Freud Library Volume 11, trans. James Strachey, Harmondsworth: Penguin, 1984, 251–52.
13. Ricoeur, *Memory, History, Forgetting*, op. cit., 78.
14. Dominick LaCapra, *History and Memory after Auschwitz*, Ithaca and London: Cornell University Press, 1998, 47.
15. Caruth, *Unclaimed Experience*, op. cit., 62.
16. Sigmund Freud, 'Remembering, Repeating and Working-through' (1914). See LaCapra, op. cit. and Ricoeur, *Memory, History, Forgetting*, op. cit.
17. Ricoeur, *Memory, History, Forgetting*, op. cit., 87, 93–121.
18. Benjamin, op. cit., 159.
19. Gilane Tawadros, 'Nation and Narration', in *Sonia Boyce: Speaking in Tongues*, London: Kala Press, 1997, 30.
20. Ibid., 33–36.
21. Frantz Fanon, *The Wretched of the Earth* (1961), trans. Constance Farrington, Harmondsworth: Penguin, 1985, 190–94.
22. Houston A. Baker, 'Caliban's Triple Play', in Henry Louis Gates Jr ed., *'Race', Writing, and Difference*, Chicago and London: Chicago University Press, 1986, 393.
23. It is only in retrospect that we are able to assess this work as a bold and innovative syncretism of cross-cultural themes with the formal languages of European modernism. See the ground-breaking survey, *The Other Story*, catalogue to the exhibition, edited and curated by Rasheed Araeen, London: South Bank Centre, 1989; and the two prior volumes of the Annotating Art's Histories series edited by Kobena Mercer, *Cosmopolitan Modernisms* (2005) and *Discrepant Abstraction* (2006), London, Iniva and Cambridge, MA: MIT Press.
24. See David A Bailey, Ian Baucom and Sonia Boyce eds, *Shades of Black: Assembling Black Arts in 1980s Britain*, Durham and London: Duke University Press in association with the Institute of International Visual Arts (Iniva) and the African and Asian Visual Arts Archive (AAVAA), London, 2004.
25. Stuart Hall, 'New Ethnicities', in James Donald and Ali Rattansi eds, *'Race', Culture and Difference*, London: Sage Publications and the Open University, 1992, 252–59.
26. See 'The Living Archive', papers delivered at the conference organised by the African and Asian Visual Artists Archive (AAVAA) and Tate Britain, 1997, *Third Text*, 54, Spring 2001, 87–110.
27. Keith Piper, *A Ship Called Jesus*, Birmingham: Ikon Gallery, 1991, unpaginated.
28. The founding members of BAFC: John Akomfrah, Reece Auguiste, Edward George, Lina Gopaul, Avril Johnston, Trevor Mathison. The founding members of Sankofa Film and Video: Martina Attille, Maureen Blackwood, Isaac Julien, Nadine Marsh-Edwards.
29. Kobena Mercer, 'Diaspora Culture and the Dialogical Imagination: The Aesthetics of Black Independent Film in Britain', in *Welcome to the Jungle*, New York and London: Routledge, 1994, 58.
30. Michel de Certeau, *The Capture of Speech and Other Political Writings*, trans. Tom Conley, Minneapolis and London: Minnesota University Press, 1997, 11–12.
31. Piper, *A Ship Called Jesus*, op. cit.
32. Kobena Mercer, 'Witness at the Crossroads: An Artist's Journey in Post-Colonial Space', in *Keith Piper: Relocating the Remains*, exh. cat., London: Iniva, 1997, 62.
33. Ibid., 67.

34. Piper, *A Ship Called Jesus*, op. cit.
35. Artist's Statement on the CD-ROM accompanying the catalogue *Keith Piper: Relocating the Remains*, London: Iniva, 1997.
36. Mercer, 'Witness at the Crossroads', op. cit., 15.
37. Mercer, 'Diaspora Culture and the Dialogic Imagination', op. cit., 53–66.
38. Michel de Certeau, *The Writing of History*, trans. Tom Conley, New York: Columbia University Press, 1988, 79.
39. Agamben, op. cit., 145.
40. Ricoeur, *Memory, History, Forgetting*, op. cit., 169.
41. Jacques Derrida, *Archive Fever: A Freudian Impression*, trans. Eric Prenowitz, Chicago and London: The University of Chicago Press, 1996, 36.
42. Elie Wiesel quoted in Shoshana Feldman and Dori Laub, MD, *Testimony: Crisis of Witnessing in Literature, Psychoanalysis, and History*, New York and London: Routledge, 1992, 5–6.
43. Stuart Hall, 'Old and New Identities, Old and New Ethnicities', in Anthony D. King ed., *Culture, Globalization and the World-System*, Minneapolis: University of Minnesota Press, 1997, 58.
44. Agamben, op. cit., 12.
45. Ibid., 87–135.
46. Ibid., 145.
47. Ricoeur, *Memory, History, Forgetting*, op. cit., 175.
48. Ibid., 260.
49. Paul Ricoeur, 'Memory and Forgetting', in Richard Kearney and Mark Dooley eds, *Questioning Ethics: Contemporary Debates in Philosophy*, London and New York: Routledge, 1999, 10.
50. Nicodemus, op. cit., 258–76.
51. Janice Cheddie, 'Listening to Trauma in the Art of Everlyn Nicodemus', *Third Text*, 21, 84, January 2007, 79–89.
52. Elaine Scarry, *The Body in Pain: The Making and Unmaking of the World*, New York and Oxford: Oxford University Press, 1985, 35.
53. Nicodemus, op. cit., 270.
54. Cheddie, op. cit., 88–89.
55. Stuart Hall, 'Negotiating Caribbean Identities', *New Left Review*, 209, January–February 1995, 14.

p. 126
Aaron Douglas,
Negro in an African Setting
from *Aspects of Negro Life*,
1934
Gouache on Whatman
artist's board,
37.1 x 40.6 inches
(94.2 x 103.1 cm)
Estate of Solomon Byron
Smith, Margaret Fisher Fund,
Schomberg Centre New York

pp 130–31
Jacob Lawrence,
Migration Series, Panel 3, 1941
'In every town Negroes
were leaving by the Hundreds
to go North and enter into
Northern industry'
Casein tempera on hardboard,
12 x 18 inches (30.5 x 45.7 cm)
© The Estate of Gwendolyn
Knight Lawrence / Artists
Rights Society (ARS), New
York. The Phillips Collection
© ARS, New York and DACS,
London 2007

pp 136–37
Jean-Michel Basquiat,
El Gran Espectaculo
(History of Black People), 1983
Acrylic and oil paintstick
on canvas,
68 x 141 inches
(172.7 x 358.1 cm)
Private Collection
Photograph credit: BI,
ADAGP, Paris/Scala, Florence
© ADAGP, Paris 2007,
DACS, London 2007

p. 152
Adrian Piper,
Untitled Performance for
Max's Kansas City, 1970
Black and white photograph,
16 x 16 inches (40.6 x 40.6 cm)
Image courtesy the Adrian
Piper Archive and the artist

pp 158
Adrian Piper,
Mythic Being: I Am the Locus,
Nos 1–5, 1975
Oil crayon on black and
white photographs,
Each 8 x 10 inches
(20.3 x 25.4 cm)
Image courtesy the Adrian
Piper Archive and the artist

p. 162
Cindy Sherman,
Untitled from *Bus Riders*,
1976/2000
Four black and white
photographs on paper from
a series of 20,
Each 7.5 x 5 inches
(18.95 x 12.7 cm)
Courtesy the artist and
Metro Pictures

p. 170
Gavin Jantjes,
'Colour These Blacks White'
from the folder *A South*
African Colouring Book,
1974–75
Screenprint with collage,
17.7 x 23.6 inches
(45 x 60 cm)
(edition of 20 prints)
© Gavin Jantjes. Courtesy
the artist

p. 171
Gavin Jantjes,
'Colour This Labour Dirt
Cheap' from the folder
A South African Colouring
Book, 1974–75
Screen print with collage,
17.7 x 23.6 inches
(45 x 60 cm)
(edition of 20 prints)
© Gavin Jantjes. Courtesy
the artist

p. 175
Victor Burgin,
UK 76 (panel from a series
of 11), 1976
Black and white photograph,
40 x 60 inches
(101.6 x 152.4 cm)
© Victor Burgin
Courtesy Galerie
Thomas Zander, Köln

p. 177
Mona Hatoum,
Roadworks, 1985
Performance, Brixton,
London
Courtesy Jay Jopling/
White Cube, London

p. 183
Mitra Tabrizian,
'Out Of The Past' from
the series *The Blues* with
Andy Golding, 1986–87
C-type photograph,
48 x 60 inches
(121.9 x 152.4 cm)
Courtesy the artist

p. 194
Sonia Boyce,
Big Woman's Talk, 1984,
Pastel and ink on paper,
58.3 x 61 inches
(148 x 155 cm)
Photograph by Anne Cardale
Private collection
© Sonia Boyce

p. 199
Black Audio Film Collective,
Still from *Testament*, Tania
Rogers as Abena, 1988
16mm colour film, 77 minutes,
BAFC in association with
Channel Four

pp 202-3
Keith Piper,
The Rites of Passage from
A Ship Called Jesus, 1991
Installation, Ikon Gallery,
Birmingham,
Courtesy the artist

p. 209
Everlyn Nicodemus,
Reference Scroll on
Genocide, Massacres and
Ethnic Cleansing, 2004
Texts digitally printed on linen
columns stitched together,
629.9 x 57.9 inches
(1600 x 147 cm)
Photograph by Isabelle Pateer
Courtesy the artist

Marion Arnold ed., 'Art History and Geography: A New Global Perspective', *Art Book*, 12, 1, February 2005

Stephanie Barron with Sabine Eckmann eds, *Exiles + Émigrés: The Flight of European Artists from Hitler*, exh. cat., Los Angeles and New York: Los Angeles County Museum of Art and Harry N. Abrams, 1997

Daniel Boyarin and Jonathan Boyarin, 'Diaspora: Generation and Ground of Jewish Identity', *Critical Inquiry*, 19, 4, 1993, 693–725

Jana Evans Braziel and Anita Mannur eds, *Theorizing Diaspora: A Reader*, London and New York: Blackwell, 2003

Luis Camnitzer, Jane Farver and Rachel Weiss eds, *Global Conceptualism: Points of Origin, 1950s–1980s*, exh. cat., New York: Queens Museum of Art, 1999

James Clifford, 'On Collecting Art and Culture', in James Clifford, *The Predicament of Culture: Twentieth-Century Ethnography, Literature and Art*, Cambridge, MA and London: Harvard University Press, 1988, 215–51

James Clifford, 'Traveling Cultures' (1990) and 'Diasporas' (1997), in James Clifford, *Routes: Travel and Translation in Late Twentieth Century Culture*, Cambridge, MA and London: Harvard University Press, 1997, 17–46 and 244–77

Robin Cohen, *Global Diasporas: An Introduction*, London and Seattle: University College London and University of Washington Press, 1997

James Elkins ed., *Is Art History Global?* (Art Seminar series no. 3), New York and London: Routledge, 2007

Okuwi Enwezor, 'Travel Notes: Living, Working and Travelling in a Restless World', in Okwui Enwezor ed., *Trade Routes: History and Geography, 2nd Johannesburg Biennale*, exh. cat., Johannesburg: Greater Johannesburg Metropolitan Council and Prince Claus Fund, 1997, 7–12

Bruce W. Ferguson and Vincent J. Varga eds, *Longing and Belonging: From the Faraway Nearby: Site Santa Fe 1995*, exh. cat., New York: Distributed Art Publishers, 1995

Jean Fisher ed., *Reverberations: Tactics of Resistance, Forms of Agency in Trans/cultural Practices*, Maastricht: Jan van Eyck Academie, 2000

Jean Fisher and Geraldo Mosquera eds, *Over Here: International Perspectives on Contemporary Art*, New York and Cambridge, MA: New Museum of Contemporary Art and MIT Press, 2004

Donald Fleming and Bernard Bailyn eds, *The Intellectual Migration: Europe and America, 1930–1960*, Cambridge, MA: Harvard University Press, 1969

Paul Gilroy, *The Black Atlantic: Modernity and Double Consciousness*, Cambridge, MA and London: Harvard University Press, 1993

Paul Gilroy, 'Diaspora and the Detours of Identity', in Kathryn Woodward ed., *Identity and Difference* (Culture, Media and Identities series no. 1), London: Sage, 1997, 299–349

Rene Green ed., *Negotiations in the Contact Zone*, Lisbon: Assirio and Alvim, 2003

Stuart Hall, 'New Ethnicities', in Kobena Mercer ed., *Black Film/British Cinema*, ICA Documents no. 7, London: Institute of Contemporary Arts, 1988, 26–31

Stuart Hall, 'Cultural Identity and Diaspora', in Jonathan Rutherford ed., *Identity: Community, Culture, Difference*, London: Lawrence and Wishart, 1990, 222–39

Stuart Hall, 'The Local and the Global: Globalisation and Ethnicity', in Anthony King ed., *Culture, Globalisation, and the World-System*, London: Macmillan, 1991, 19–39

Hugh Honour, *A World History of Art*, London: Macmillan, 1984

Virinda Kalra, Raminder Kaur and John Hutnyk eds, *Diaspora and Hybridity*, London: Sage, 2005

R.B. Kitaj, *First Diasporist Manifesto*, London and New York: Thames and Hudson, 1989

Julia Kristeva, *Strangers to Ourselves*, New York: Columbia University Press, 1991

Steven Mansbach, *Modern Art in Eastern Europe, from the Baltic to the Balkans, ca.1890-1939*, New York and Cambridge: Cambridge University Press, 1999

Steven Mansbach ed., 'The Suppressed Avant-Gardes of East-Central and Eastern Europe of the Early Twentieth Century', *Art Journal*, 49, 1, Spring 1990

Kobena Mercer, 'A Sociography of Diaspora', in Paul Gilroy, Lawrence Grossberg and Angela McRobbie eds, *Without Guarantees: In Honour of Stuart Hall*, London: Verso, 2000, 233–44

Kobena Mercer, 'Diaspora Aesthetics and Visual Culture', in Harry J. Elam Jr and Kennell Jackson eds, *Black Cultural Traffic: Crossroads in Global Performance and Popular Culture*, Ann Arbor: University of Michigan, 2005, 141–61

Ian McLean, *White Aboriginies: Identity Politics in Australian Art*, New York and Cambridge: Cambridge University Press, 1998

Nicholas Mirzoeff ed., *Diaspora and Visual Culture: Representing Africans and Jews*, New York and London: Routledge, 1999

Hamid Naficy ed., *Home, Exile, Homeland: Film, Media and the Politics of Place*, New York and London: Routledge, 1999

Margaret Olin, 'Nationalism, the Jews, and Art History', *Judaism*, 45, 4, Fall 1996, 461–82

John Onians, *Atlas of World Art*, London: Laurence King, 2004

Erwin Panofsky, 'Three Decades of Art History in the United States. Impressions of a Transplanted European' (1953), in Erwin Panofksy, *Meaning in the Visual Arts*, Chicago: University of Chicago, 1982, 321–46

Nikos Papastergiadis, *Modernity as exile: The Stranger in John Berger's writing*, Manchester and New York: Manchester University Press, 1993

Nikos Papastergiadis, *Dialogues in the Diasporas: Essays and Conversations on Cultural Identity*, London: Rivers Oram, 1998

Nikos Papastergiadis, *The turbulence of migration: globalization, deterritorialization and hybridity*, Cambridge: Polity, 2000

John Peffer, 'The Diaspora as Object', in Laurie Ann Farrell ed., *Looking Both Ways: Art of the Contemporary African Diaspora*, exh. cat., New York and Ghent: Museum for African Art and Snoeck Publishers, 2003, 22–36

Ruth B. Phillips and Christopher B. Steiner eds. *Unpacking Culture: Art and Commodity in Colonial and Postcolonial Worlds*, Berkeley: University of California, 1998

William Safran, 'Diasporas in Modern Societies: Myths of Homeland and Return', *Diaspora*, 1, 1, Spring 1991, 83–99

Edward Said, 'Reflections on Exile', *Granta*, 13, 1984, 159–72, reprinted in Russell Ferguson, Martha Gever, Trinh T. Minh-ha and Cornel West eds, *Out There: Marginalization and Contemporary Culture*, New York and Cambridge, MA: New Museum of Contemporary Art and MIT Press, 1990, 357–66

E. San Juan, *From Exile to Diaspora*, Connecticut: Westview Press, 1998

Martica Sawin, *Surrealism in Exile: and the beginning of the New School*, Cambridge, MA and London: MIT Press, 1995

Daniel Snowman, *The Hitler Emigres: The Cultural Impact on Britain of Refugees from Nazism*, London: Chatto and Windus, 2002

David Summers, *Real Spaces: World Art History and the Rise of Western Modernism*, London and New York: Phaidon, 2003

Gilane Tawadros ed., *Map*, exh. cat., London: Institute of International Visual Arts, 1996

Mariet Westermann ed., *Anthropologies of Art*, Williamstown and New Haven: Clark Art Institute and Yale University Press, 2005

Janet Wolff, 'The Invisible Flaneuse', in Janet Wolff, *Feminine Sentences: Essays on Women and Culture*, Cambridge: Polity, 1990, 34–50

Jean Fisher

Jean Fisher studied zoology and fine art, later becoming a freelance writer on contemporary art and post-coloniality. During the 1980s whilst in New York, she was a regular contributor to *Artforum International*, co-curated exhibitions of contemporary Native American art with the artist Jimmie Durham and taught at various times in the School of Visual Arts, State University of New York at Old Westbury and the Whitney Students' Independent Study Program. She is the former editor of the international quarterly *Third Text*, and the editor of the anthologies, *Global Visions: Towards a New Internationalism in the Visual Arts* (1994), *Reverberations: Tactics of Resistance, Forms of Agency* (2000) and, with Gerardo Mosquera, *Over Here: International Perspectives on Art and Culture* (2004).

A selection of her essays, *Vampire in the Text*, was published in 2003. She has written on the work of numerous artists, most recently Francis Alÿs, Sonia Boyce, James Coleman, Jimmie Durham and Willie Doherty, and has contributed essays to the catalogues to the Venice Biennale (1997), Johannesburg Biennale (1997), Carnegie International (1999), documenta11 (2002) and the Sharjah Biennial (2005). She currently teaches at the Royal College of Art, London and is Professor of Fine Art and Transcultural Studies at Middlesex University.

Sieglinde Lemke

Sieglinde Lemke is a Professor in the American Studies Department at the Albert-Ludwigs-Universität Freiburg, Germany. She has taught at the John F. Kennedy Institute at the Free University, Berlin, at Wheelock College, Boston and in the African American Studies Department at Harvard University. She has received fellowships from the DAAD and the Rockefeller Foundation. Among her publications are *Primitivist Modernism: Black Culture and the Origins of Transatlantic Modernism* (1998); 'Berlin and Boundaries: Sollen vs. Geschehen', *Boundary 2* (2000); 'Primitivist Modernism', in *Primitivism and 20th Century Art: A Documentary History* (J. Flam and M. Deutsch eds, 2003); *Aesthetic Transgressions: Modernity, Liberalism, and the Function of Literature* (co-edited with U. Hasselstein and T. Claviez, 2006); 'Du Bois: Of the Coming of John', in *The Oxford Companion to The Souls of Black Folk* (S. Zamir ed., 2007); *The Power of Perception: Aesthetics, Visual Culture, Internationalism in Henry James* (co-edited with A.J. Lehmann, forthcoming 2007); and *Vernacular Matters: A Comparativist Approach to American Literature* (forthcoming 2008). She is currently working on an exhibit documenting 'Black Americans in Berlin' and a project entitled 'Facing Poverty: Representing the Dispossessed'.

Amna Malik

Amna Malik is a Lecturer in Art History and Theory at the Slade School of Fine Art, London. Her research addresses 'diaspora' in artistic practices and the relationship between art, cultural politics and psychoanalysis. Her recent publications include 'History in the Present', in *Ghosting, The Role of the Archive Within Contemporary Artists' Film and Video* (Jane Connarty and Josephine Lanyon eds, 2006); 'Patterning Memory: Ellen Gallagher's "Icthyosaurus" at the Freud Museum', *Wasafari*, November 2006; and 'Migratory Aesthetics: (Dis)placing the Black Maternal Subject in Martina Attille's *Dreaming Rivers* (1988)', in *Black British Aesthetics Today* (Victoria Arana ed., 2007). Forthcoming publications include 'Dialogues Between Orientalism and Modernism: Shirin Neshat's *Women of Allah* (1993-)', in *Local and Global Mediations* (Celina Jeffreys and Gregory Minissale eds, 2007); 'Shame, disgust and idealisation in Kara Walker's "Gone" (1994)', in *Shame and Shamelessness* (Ivan Ward and Claire Pajakowska eds, 2007); and 'Surface Tension, Reconsidering Horizontality Through the Practices of Contemporary Iranian Diaspora Artists', in *Identity Theft: Cultural Colonisation and Contemporary Art* (Jonathan Harris ed., 2007).

Steven Mansbach

Professor Steven Mansbach focuses his research and teaching interests on the genesis and reception of 'classical' modern art, roughly from the last quarter of the 19th century through to the middle of the 20th. His specific area of scholarly publication is the modern art of Central and Eastern Europe from the Baltic North to the Adriatic South. On this topic he has published over the last 30 years numerous books, articles, exhibition catalogues and essays, including *Visions of Totality: László Moholy-Nagy, El Lissitzky, and Theo van Doesburg* (1980), *Standing in the Tempest: Painters of the Hungarian Avant-Garde, 1908–1930* (1991) and *Modern Art in Eastern Europe, From the Baltic to the Balkans, ca.1890–1939* (1999, softcover 2000). He has also taught this subject as a Professor in Germany, Poland, Hungary and South Africa, as well as at several American universities. In addition to holding university professorships, he was Associate Dean at the Center for Advanced Study in the Visual Arts at Washington's National Gallery of Art and the founder and Dean of the American Academy in Berlin. Among his recent projects is an exhibition of the radical 'book arts' culled from The New York Public Library, entitled *Graphic Modernism from the Baltic to the Balkans, 1910 to 1935*, October 2007.

Ian McLean
Ian McLean is an Associate Professor at the University of Western Australia and is on the Advisory Council of *Third Text*. He has published extensively on Australian art in Australian art journals and internationally. His books include *The Art of Gordon Bennett* (with a chapter by Gordon Bennett, 1996) and *White Aborigines: Identity Politics in Australian Art* (1998). An anthology of writing on Aboriginal art since 1980, with the working title *How the Aborigines Stole the Idea of Contemporary Art*, is due to be published in May 2008 (jointly published by Power Publications and the Institute of Modern Art). He is currently writing a book on the history of post-contact Aboriginal art and undertaking research for an exhibition that traces the impact of Western Desert Aboriginal painting on contemporary Australian artists.

Kobena Mercer
Kobena Mercer is Reader in Art History and Diaspora Studies at Middlesex University, London, and is an inaugural recipient of the 2006 Clark Prize for Excellence in Arts Writing awarded by the Sterling and Francine Clark Art Institute. He has taught at New York University and University of California at Santa Cruz and received fellowships from Cornell University, University of California at Irvine and the New School University in New York. His articles have been translated into German, Swedish and Japanese and his contributions to exhibition catalogues include *Black Male* (1994), *Pictura Brittanica* (1998), *Adrian Piper: A Retrospective* (1999) and *Africas: A Journey and An Exhibition* (2001). His essays are featured in several anthologies including *The Gothic* (2007), *Without Guarantees: In Honour of Stuart Hall* (2000), *Frantz Fanon: Critical Perspectives* (1999) and *Black British Cultural Studies* (1996). Recent publications include 'Art as a Dialogue in Social Space', in *Re-Thinking Nordic Colonialism* (2006), 'Post-Colonial Trauerspeil', in *The Ghosts of Songs: The Film Art of Black Audio Film Collective* (2007) and 'Romare Bearden's Critical Modernism: Visual Dialogues in the Diaspora Imagination', in *Romare Bearden and the Modernist Tradition* (forthcoming 2008).

Ikem Stanley Okoye

Trained at University College London and at MIT, Ikem Stanley Okoye is Associate Professor in the Department of Art History at the University of Delaware, where he also holds a joint appointment in Black American Studies. His work on African, African American and European histories and theoretics of art, architecture and film, is published in several journals including the *Art Bulletin*, *Art Journal*, *Paideuma Mitteilungen zur Kulturkunde*, *Harvard Architectural Review*, *Interventions – a Journal of Postcolonial Studies*, *RES: Journal of Anthropology and Aesthetics* and *Critical Interventions*, as well as in anthologies including *Architecture and the Pictorial Arts from Romanticism to the Twenty First Century, Volume 2: The Built Surface* (Koehler and Anderson, 2002), *Anthropologies of Art* (Westermann ed., 2005) and *The Aftermath of Slavery* (Korieh and Kolapo eds, 2007). He has been a Member at the Institute for Advanced Study at Princeton, and a Fellow at the Institute for the Advanced Study and Research in the African Humanities at Northwestern University and the Centre for Modern Oriental Studies in Berlin. His forthcoming book *Hideous Architecture* (2008) focuses on the early modern architecture of southern Nigeria. Okoye is Editor of *Ijele*, an on-line peer-reviewed journal of modern and contemporary art of Africa and the diaspora. He also enjoys an occasional practice in architecture with Anubis Architecture, a small internationally focused atelier working out of Pennsylvania.

Ruth B. Phillips

Ruth B. Phillips is Canada Research Chair and Professor of Art History at Carleton University, Ottawa. Originally trained as an historian of African art, she has devoted most of her career to the study of historical and contemporary Native North American art. She has also undertaken curatorial work and served as Director of the University of British Columbia Museum of Anthropology from 1997–2002. Her books include *Representing Woman: Sande Masquerades of the Mende of Sierra Leone* (1995); *Trading Identities: The Souvenir in Native North American Art from the Northeast* (1998); *Native North American Art* (co-authored with Janet Catherine Berlo, 1998); *Unpacking Culture: Art and Commodity in Colonial and Postcolonial Worlds* (co-edited with Christopher B. Steiner, 1999); and *Sensible Objects: Colonialism, Museums, and Material Culture* (co-edited with Elizabeth Edwards and Chris Gosden, 2006). She directs the Great Lakes Alliance for the Study of Aboriginal Arts and Cultures (GRASAC), an international research collaboration involving indigenous communities, museums and universities. In 2004 she was elected to a four-year term as president of CIHA, the Comité International d'Histoire de l'Art. She is a fellow of the Royal Society of Canada.

We would like to thank the series editor Kobena Mercer for shaping the critical framework for this volume in the series *Annotating Art's Histories* and all the authors for their insightful texts and commitment to this project. We would also like to thank the artists, estates and copyright holders for their permission to reproduce the images in this volume.

We are extremely grateful to The Getty Foundation for their generous support without which this series would not have been possible. We would also like to thank Middlesex University for their continuing support of the project. Additional thanks to Sarah Campbell, Indie Choudhury, Roger Conover, Lisa Graziose Corrin, Kate Hall, Stuart Hall, Jessica Harrington, Glenn Howard, Uwe Kraus, Marc Lowenthal, Middlesex University library staff at Cat Hill, Janet Rossi, Linda Schofield, Shela Sheikh.